METROPOLITAN COLLEGE OF NY
LIBRARY, 12TH FLOOR
431 CANAL STREET
NEW YORK, NY 10013

THE SPIKE LEE ENIGMA

This book is part of the Peter Lang Media and Communication list.
Every volume is peer reviewed and meets
the highest quality standards for content and production.

PETER LANG
New York • Bern • Frankfurt • Berlin
Brussels • Vienna • Oxford • Warsaw

BILL YOUSMAN

THE SPIKE LEE ENIGMA

CHALLENGE AND INCORPORATION IN MEDIA CULTURE

PETER LANG
New York • Bern • Frankfurt • Berlin
Brussels • Vienna • Oxford • Warsaw

Library of Congress Cataloging-in-Publication Data
Yousman, Bill.
The Spike Lee enigma: challenge and incorporation in media culture /
Bill Yousman.
p cm
Includes bibliographical references and index.
1. Lee, Spike—Criticism and interpretation.
2. African Americans in the motion picture industry. I. Title.
PN1998.3.L44Y68 791.4302'33092—dc23 2014024787
ISBN 978-1-4331-2149-4 (hardcover)
ISBN 978-1-4539-1429-8 (e-book)

Bibliographic information published by **Die Deutsche Nationalbibliothek**.
Die Deutsche Nationalbibliothek lists this publication in the "Deutsche
Nationalbibliografie"; detailed bibliographic data are available
on the Internet at http://dnb.d-nb.de/.

The paper in this book meets the guidelines for permanence and durability
of the Committee on Production Guidelines for Book Longevity
of the Council of Library Resources.

© 2014 Peter Lang Publishing, Inc., New York
29 Broadway, 18th floor, New York, NY 10006
www.peterlang.com

All rights reserved.
Reprint or reproduction, even partially, in all forms such as microfilm,
xerography, microfiche, microcard, and offset strictly prohibited.

Printed in Germany

CONTENTS

Preface	vii
Acknowledgments	ix
Chapter 1: Introduction	1
Chapter 2: The American Film Industry, Race, and Spike Lee	11
Chapter 3: Theory and Method: Media Culture, Ideology, and Spike Lee	33
Chapter 4: *She's Gotta Have It*, but He Already Got It	65
Chapter 5: The Undecidability of Doing the Right Thing	89
Chapter 6: Lee Goes Big: Identity and Ideology in the Epic *Malcolm X*	123
Chapter 7: Spike Lee and the Paradox of the Alternative Mainstream	157
Chapter 8: The Mainstreaming (?) of Spike Lee: Challenge and Incorporation	175
Afterword	213
Notes	215
References	217
Index	235

PREFACE

I came to Spike Lee initially as a fan. When I first saw *Do the Right Thing* I was in my 20s, one of those young people who loved movies but was generally bored and disappointed by the standard Hollywood blockbusters and action films. I had grown up in primarily black neighborhoods and attended schools where, as a white Jewish kid, I was a double minority. I had been deeply interested in issues of race, racism, and racial justice since I was a teenager. I listened to black music and read black literature. As a young child in the 1960s I was afraid of the Black Panthers...by the time I was a teenager I wanted to be one. At my high school graduation in 1979 I quoted Bob Marley ("A hungry man is an angry man...") in a polemical speech on U.S. neocolonialism. How that ever got approved is still a mystery to me, but hey, it was the '70s.

A decade later Lee's film made me delirious. I loved every single bit of it, from Señor Love Daddy's roll call, to the racial slur montage, to the provocative ending and the invocation of Martin Luther King, Jr. *and* Malcolm X (!). I even laughed at the disrespect toward my beloved Boston Celtics. Lee had me at "Wake up!"

Sometime later, in the first couple of years of the 90s, when I heard he was making *Malcolm X*, I was ecstatic. Yes, I was one of those white guys, by now

approaching 30, who wore an X baseball cap, partially to hide my thinning hairline, partially as an inchoate political gesture.

When I went to graduate school to study communication and media in 1995 it seemed almost predetermined that I would write a Master's thesis on Lee and his films. In grad school I encountered critical media studies, feminism, critical race theory, and Marx. (The last of these a reintroduction of sorts as I had first been exposed to socialist philosophy by my father.) These theoretical lenses changed how I saw the films, but I remained a fan—albeit one with a more complicated relationship to Lee's body of work.

That thesis would eventually become the raw material for this book, a book that has been many years in the making. Lee's public persona remains as vibrant as ever but audiences and critics now seem to be paying less attention to his films. This is a shame, because, for all my reservations, I still regard Lee as one of the most important filmmakers of the first century of American film and one of the few media voices that has succeeded in getting mainstream audiences to reflect on social issues and political conflicts, even for just two hours at a time.

I find Lee's films to be often sexist, homophobic, classist, and generally conservative, despite a patina of radicalism. I am appalled and disgusted by his work in the advertising industry, particularly for the military industrial complex and imperialist corporations like Nike. Yet I am still a fan. This is indeed a discomforting paradox for someone who holds the political beliefs that I hold. This book is an attempt to deal with that paradox, an attempt that, like many of Lee's films, probably opens up more questions than it answers.

ACKNOWLEDGMENTS

Obama was right. No one "builds" anything all by themselves. In the case of a book there are always multiple authors, multiple voices.

Spike Lee must be acknowledged first for his massive achievements in shaking up the American film industry while constructing an incredible body of cinematic work.

I have drawn inspiration from many scholars and critics whose names are referenced throughout the text of this book. For their critical readings of previous versions of these words I want to specifically thank Elizabeth Burt, Lynne Kelly, Robert Lang, and, especially, Jack Banks who taught me so much and has provided years of knowledge and friendship. Sut Jhally, Michael Morgan, and Justin Lewis made my years at UMASS some of the best and most important years of my life. They deepened my understanding of critical and cultural media studies in ways I never imagined before I first took my seat in that dirty Machmer seminar room. David Sterritt and Douglas Kellner have recently been wonderfully generous with precious time and extremely encouraging in their support of this text.

Generations of personal influence must also be given their due. To my father, Morris Yousman: You are gone but you are not gone. Every time I glance

at the stacks of books piled high beside my bed I see your face. You were the first person to teach me to "do the right thing."

Rachel, Nathan, and Kayla are empirically, objectively, quantitatively the three best children in the world. My life would be a desert without them.

Lori Bindig is an unwavering source of support, consolation, cheerleading, optimism, and love. My PFFF. She's gotta have it.

· 1 ·
INTRODUCTION

"Pictures are for entertainment, messages should be delivered by Western Union" (attributed to Samuel Goldwyn, in Augarde, 1991, p. 91).

This disparaging remark about the role of Hollywood films in conveying social and political messages is often erroneously attributed to the influential film producer, Samuel Goldwyn (see Marx, 1976). Goldwyn, in truth, was astute enough to recognize that movies have significance that extends far beyond entertainment. The medium of film is fraught with ethical implications because cinema has the potential to open up discourse about the most pressing issues of the day—what it means to be human, sources of power and inequality in society, the catalysts and consequences of violence, how we cope with the differences that can drive us apart, alienation and discontent. Recognizing the importance of film, and other forms of media and popular culture, to contemporary society was the initial impetus behind this book: a critical examination of the films of Shelton Lee, Jr., better known as Spike Lee.

Spike Lee made his first controversial appearance on the American popular culture scene in 1986, with an independently financed film entitled *She's Gotta Have It*. In subsequent decades, Lee emerged as one of America's premier, and most polarizing, film directors and media figures. As Sterritt points out:

> Most of Lee's movies set forth pointed challenges to conventional ideas of what roles filmmaking, popular culture, and racial discourse are supposed to play in American society. Lee's very career amounts to such a challenge, for that matter—he is the only black filmmaker in history to sustain a major presence in American film over a period of decades, and his output during that time has been both varied and profuse, comprising almost fifty theatrical features, short films, and TV movies and episodes as director, almost as many as producer, and more than a dozen each as screenwriter and actor (2013, p. 3)

In this book, I propose that a close examination of some of Lee's most provocative films allows us to explore the complicated intertwining of popular culture and political ideology. Lee's films are often overtly political in nature, and he has defined himself as a politically engaged filmmaker (Lee and Aftab, 2006; Orenstein, 1989; Sterritt, 2013). Moreover, Lee is often described as a radical by critics who have depicted him as a feiry voice of political challenge (Campbell and LeDuff, 2012, Coleman and Hamlet, 2009; Orbe and Lyons, 2009; Taubin, 2002). As Harris and Moffitt put it: "His willingness to confront sensitive issues of race, politics, religion, and even sexual prowess in his films is indicative of his desire to challenge the status quo, enlighten us on matters of the world as well as champion the cause of the underprivileged" (2009, p. 303).

Yet, if Lee truly is a challenging, radical voice, then it seems almost paradoxical that he attained a large measure of status and financial success within the mainstream film and advertising industries as his career progressed. A critical political economic approach to media (as discussed in the next chapter) suggests that it is unlikely that mainstream media institutions will allow the space for truly oppositional perspectives to be widely disseminated, especially if they are not seen as surefire profit generators. Lee, then, would seem to represent an enigma: a politically and ideologically oppositional artist who has managed to utilize mainstream channels to achieve a tremendous amount of success. How then do we make sense of a filmmaker who has created texts ranging from the politically provocative *Malcolm X* (1992) and the challenging post-Katrina documentary *When the Levees Broke* (2006) to advertisements for Nike and the U.S. Navy?

There is no doubt, and this warrants emphasis, that in many of his films Lee has broken asunder the facile stereotypes of mainstream Hollywood. For example, consider what Campbell and LeDuff (2012) wrote about his 2006 Katrina documentary:

> We believe that Spike Lee's *When the Levees Broke* is an example of compelling televisual storytelling that provides unusual insight into a complicated story and that

recasts the catastrophe in New Orleans as a story of an underdog population that behaved heroically in the face of enormous government ineptitude (p. 215).

Yet, for all of the counter-hegemonic challenges he has presented over the last generation, Lee remains, in many ways, a paradox. How do we reconcile the progressive impulses of a film like *When the Levees Broke* or its 2010 follow up, *If God Is Willing and Da Creek Don't Rise*, with other aspects of Lee's career such as his shilling for major corporations or aiding the U.S. military in recruiting young men and women?

There are two explanations for this paradox that are worth considering. The first is that this really isn't a paradox at all. Considering Lee's status as a black filmmaker working in a white-dominated industry, it has been simply a matter of pragmatism for Lee to vacillate among challenging independent productions, commercial films, and advertising ventures. Lee has said that he has always wanted to produce a large body of work and this required a steady source of income:

> The generation of filmmakers above me, people like Haile Gerima and Charles Burnett and individuals like that, it seemed like they spent so much time frantically trying to raise money. Sometimes it would take two or three years to raise that money. It was hard to do films back-to-back but I really wanted to continue working (quoted in Harris, 2002, p. 135).

From this perspective Lee's more commercial films, adept self-marketing, and advertising are all tactics in a successful strategy that has allowed him to remain a public figure and a force in Hollywood for decades.

The second explanation is more damning. This explanation situates Lee firmly within the large group of artists and cultural producers who have been seduced, and ultimately compromised, by capitalist structures. From this perspective Lee is a fraud; a conservative establishment figure thriving on a veneer of radicalism, much like the advertising industry he works in that has marketed rebellion as a commodity since the 1960s (see Frank, 1997).

In the following pages I explore these conflicting explanations and provide insights not just into the films and career of one filmmaker, but also in regard to larger issues of ideology and media culture. In order to accomplish this goal, it is essential to delve into some more diffuse issues related to the influence of media and popular culture before moving to a more specific examination of Spike Lee and his films.

Returning for a moment to the disputed quote that opens this chapter, film, like other forms of media, is a powerful source of communication in technological societies. As one philosopher writes: "The power of film is indisputable. Since the beginning of movies, a little over a hundred years ago, they have captivated audiences. We want, badly, to watch" (McGinn, 2005, p. 3). Movies, and media in general, are a crucial part of the cultural landscape of society, and as such, have much greater meaning and significance than mere entertainment. They are an integral component of the popular culture that shapes societal norms, values, ideologies, and political structures (Kellner, 2010).

This book, then, is about more than just Spike Lee and some of his most critically acclaimed films. More broadly, in subsequent chapters I will explore the production of meaning within mediated texts and its relationship to political ideology and social constructions of reality. In particular, my critical approach is concerned with power: the power of film to shape our consciousness, the power of the corporate film industry to set the ground rules for acceptable discourse, the power of deep-seated stereotypes and ideologies to influence us, and the power of resistant filmmakers to challenge the norms of both Hollywood and the larger social environment. Questions of cultural domination and resistance will be examined, concentrating on the cultural and symbolic planes of mediated discourse. A type of case-study approach is thus utilized by focusing on the key works of popular filmmaker Spike Lee. I propose that Lee's films, and his status as a media icon, may be utilized as an entrance point to questions concerning ideology, power, and the media.

As alluded to above, I selected Lee as the focus of this examination because of several factors that I believe make him a particularly apt subject for this type of analysis. First, in the course of developing his career as a filmmaker and building a body of work, Lee's status has undergone something of a metamorphosis. Since his emergence in 1986 Lee has moved from Hollywood "outsider," producing his films with little to no financial and creative support from the mainstream movie studios, to Hollywood "auteur," an accomplished and well recognized filmmaker, usually (but not always) financed by the corporate film industry, whose films often garner much attention from audiences and critics alike. This transformative arc suggested to me several questions about independence versus corporate control and the degree of influence (direct or indirect) that media corporations possess in determining the nature of media content and shaping the value systems of media producers. For example, Watkins (1998) describes how Columbia Pictures had Lee run test screenings

of his second film, *School Daze* (1998). Executives from Columbia even intervened in determining the racial makeup of the test audiences, increasing the number of whites. In the end, Lee made several changes to the film based on feedback from the screenings and Columbia's recommendations.

Second, as noted above, Lee is often regarded as a radical figure challenging the prevailing social order through his sharp indictment of racist American society—both in his films and in his public persona. Lee is portrayed as a rebel with a cause by many journalists, film critics, and academics despite his connections to dominant institutions—specifically the mainstream American film industry, as well as the advertising industry and the global corporations it represents (Campbell and LeDuff, 2012; Coleman and Hamlet, 2009; Davis, 1990; Lee & Wiley, 1997; Muwakkil, 1990; Perkins, 1990; Sterritt, 2013). This offers a paradox that is not easily resolved. Therefore, I ask to what extent Lee's work actually does present a challenge to the dominant institutions and traditions of American society, and whether his financial and promotional involvement with certain corporate and military interests in any way mitigates the political thrust of his films. Furthermore, in subsequent chapters I explore whether Lee's films may indeed represent confrontational stances regarding issues of race and racism while simultaneously reaffirming traditional power inequities in other dimensions such as class, gender, and sexuality.

Third, and this element is not unique to Lee, like other filmmakers whose films represent a basically linear, realist style, Lee creates narratives that may appear to be simply reflective of the "real world." In actuality, however, media play an important role in shaping and conditioning our understanding of that world. In this way, media texts are similar to fairy tales, myths, and folklore, and their analysis can reveal much about the societies that produce and engage with those texts (Berger, 2012).

In many ways film and other forms of media operate as channels through which the mythic structure of modern societies is communicated. All human collectives have used stories to find meaning and order in their worlds. Robertson (1980) has suggested that this is just as true for contemporary civilizations as it was for pre-modern societies. In subsequent chapters I adopt the position of those who suggest that the media in modern societies have assumed a primary position as purveyors of mythic narratives, while keeping in mind Robertson's point that:

> [Myths]…provide good, "workable" ways by which the contradictions in a society, the contrasts and conflicts which normally arise among people…are somehow

reconciled, smoothed over, or at least made manageable and tolerable (Robertson, 1980, p. xv).

In this way myths, and the media that convey them, can in one sense be seen as powerful forces that help to reinforce the prevailing social order and the ideological status quo (Barthes, 1957). Yet mythic narratives have also traditionally been used by oppressed groups to sustain a sense of hope in the face of their repression (for example, the tale of the monstrous yet protective Golem in Jewish folklore). Thus, a given society may have contradictory mythic tales and narratives—some that legitimate systems of dominance and some that reject them. As noted above, Spike Lee's films are often regarded as cultural texts that challenge dominant norms and traditions. Yet some critics have maintained that his films actually offer themes and values similar to most mainstream Hollywood movies. There is an apparent contradiction here that I explore in this book. The importance of these issues becomes apparent when consideration is given to the power and pervasiveness of media in contemporary society.

Media Saturation and Media Culture

We are saturated with media images, sounds, and symbols. Television, radio, films, newspapers, magazines, books, video games, social media, the Internet—life without these mediated forms of communication has become virtually unimaginable for most. We are dependent on these systems for the fulfillment of a diverse range of needs and desires: information, entertainment, socialization, education, identity formation. Mediated images and messages are our primary connections to other cultures, other places in the world, other lifestyles. Many people encounter far more diverse personalities in their mediated lives than they do in their daily interpersonal relationships.

Children are exposed to movies, television, and other media content soon after their birth, and it remains a staple of their cultural diet throughout their lives. Nielsen reported in 2012 that Americans spend more than 33 hours every week watching video content on some type of electronic screen. While individuals may be engaged with a number of different media forms, increasingly all of these types of media are being produced by the same small number of global media conglomerates (Bettig and Hall, 2012; Crothers, 2013; Winseck, 2008). Regardless of the approach that they utilize, media analysts and theorists are in agreement on one fundamental precept—mediated culture is

ubiquitous, an unavoidable aspect of life in the modern world.[1] Kellner frames this power and pervasiveness eloquently:

> A media culture has emerged in which images, sounds, and spectacles help produce the fabric of everyday life, dominating leisure time, shaping political views and social behavior, and providing the materials out of which people forge their very identities.... Media culture helps shape the prevalent view of the world and deepest values: it defines what is considered good and bad, positive and negative, moral or evil. Media stories and images provide the symbols, myths, and resources which help constitute a common culture for the majority of individuals in many parts of the world today (1995a, p. 1).

When scholars discuss the influence of popular culture their discussion typically revolves around things like video games, magazines and comic books, sports, pornography, television reality shows, situation comedies, crime dramas, romance novels and thrillers, and (as is the case in this book) popular films. All these forms and genres are examples of cultural texts that operate and are disseminated through media institutions. How they are categorized and defined, however, is essential to whether these forms are denigrated, celebrated, or seen as a complex manifestation of ideological struggle. So-called mass culture has been castigated by theorists such as Horkheimer and Adorno (1972), for example, for promoting a mindless acceptance of dominant practices and institutions, while the term popular culture is celebrated by Fiske (1989a) and others as culture that audiences manipulate for their own subversive uses. However, as Storey (2006) points out, the determination of what constitutes popular culture is neither stable nor ahistorical. Social and historical contexts play a crucial role in defining what aspects of culture are considered to be popular or "of the people" in some essential way. The emergence of online social media sites such as Facebook, YouTube, Tumblr, Twitter, Instagram, and the like has only complicated these debates.

The debate over "mass" and "popular" culture is an important aspect in the development of critical media theory, and this debate is discussed in greater detail in Chapter III. Kellner (1995a), however, has suggested that these misleading labels be avoided all together in favor of the more inclusive term, media culture. I am sympathetic to Kellner's suggestion, and in this book I use the term media culture to refer to "...the nature and the form of the artifacts of the culture industries (i.e., culture) and their modes of production and distribution (i.e., media technologies and industries)" (Kellner, 1995a, p. 34). I also argue that Spike Lee's films are an ideal illustration of the complexity and ambiguity inherent in many media texts that have made the mass culture versus popular culture debate a theoretical dead end.

Questioning Spike Lee

The approach I take is based in critical theory, cultural studies, and political economy in examining the ideological constructions embedded in the work of a controversial filmmaker who has managed to thrive in mainstream Hollywood while simultaneously maintaining credibility as an independent artist. I argue that ideology, and the media's role in perpetuating or undermining dominant ideology, is a primary focus of all three of these critical perspectives: critical theory, cultural studies, and political economy. While sympathetic to the Frankfurt School distrust of the mainstream culture industries (see Chapter III), the multiperspectival approach I utilize also recognizes that media culture can function to simultaneously resist and reinforce dominant ideology (Kellner, 1995a). In addition, I also highlight the institutional aspects of media production as a key to wrestling with the varying ideological tendencies in Lee's films.

As discussed in more detail in subsequent chapters, critical media analysis is concerned with how power inequities in society are either legitimized and reinforced, or exposed as illegitimate and resisted, through media representations. Gender, race, and class are key social constructs related to the stratification of power in contemporary society, and each of these will be central to my analysis. Regarding gender, for example, I analyze Lee's gender politics, and I also pay attention to issues of male and female sexuality and how sexual relationships are depicted in Lee's films. Feminist scholars have accused Lee of celebrating the patriarchal hierarchy in his films. I explore whether an analysis of Lee's films supports this accusation.

Many of Lee's films deal explicitly with issues of race and racism. Therefore I examine the ideological assumptions behind Lee's depictions of race relations in American society. Lee is praised by many critics for defying the stereotypes of mainstream Hollywood and presenting an indictment of the racism of American society in his films. I explore the extent to which Lee's film challenge and/or reinforce contemporary understandings of race and racism.

Class is often a neglected issue in contemporary cultural studies, particularly in scholarship originating in the U.S. I believe it is crucial to examine issues of class as well as race, gender, and sexuality and to attend to the intersectionality of these social constructs. So, I also analyze how Lee deals with class conflict, and how class issues are depicted either directly or indirectly in his films. Some academics have accused Lee of avoiding class entirely

in his films. A Marxist perspective suggests that the issue of class will be an ever-present subtext in the films even if it goes unacknowledged. I ask whether Lee's depiction of class conflict presents a challenge to, or a reinforcement of, the hegemonic assumption of America as a classless society.

Lee is a filmmaker who began his career as an independent but was soon incorporated into the Hollywood film industry. So, I also look specifically at changes in thematic and ideological content that may have occurred over time as Lee's status within the mainstream film industry changed. I consider whether there is evidence of a shift in the ideological perspectives encoded in his films as he moved from a position of independence to one of incorporation. Furthermore, I place this analysis into a larger context by exploring what Lee's success in the mainstream film and advertising industries suggests about ideological struggles in media culture in general.

Overview of Subsequent Chapters

Lee's films are regarded by many critics as representative of both a challenging voice and a thoughtful and creative artistic vision. Others regard him as a commercial purveyor of standard Hollywood fare. Much of this disparity is related to discrepant perspectives on the worth and value of media culture itself. Furthermore, Lee has created films both independently and as part of the corporate film industry. He has made comedies, melodramas, musicals, action films, music videos and advertisements, as well as documentaries and complex dramas. This eclecticism, along with his status as a black filmmaker in an industry that is still overwhelmingly controlled by whites, makes him an ideal candidate for an exploration of the boundaries between alternative/independent and mainstream/corporate media.

In order to ground my examination of Spike Lee and his films in a social and historical context, the development of the American film industry is briefly reviewed in Chapter II, with a specific focus on the industry's approach to race and the history of black filmmakers. In addition, I review academic, trade, and popular press discussions of Spike Lee in order to provide background on the critical reception of Lee and his films.

Chapter III delves into theories of media culture as they apply to my analysis of Lee's body of work. I first offer a discussion of the contesting paradigms that influence how media theorizing and research is conducted. The critical approach to media analysis that is central to my exploration

foregrounds ideology as a key component in deconstructing the meaning of media and cultural texts, thus the development of concepts of ideology and their application to media is also considered in this chapter.

The next three chapters take a historical approach as each provides an in-depth examination of a specific film from the first stage of Lee's career, the time period when he seemed to exert the most influence on the American film industry. Chapter IV offers a close examination of Lee's first commercially distributed feature film, the groundbreaking *She's Gotta Have It* (1986). Chapter V focuses on Lee's third and most famous/notorious film, *Do the Right Thing* (1989), considered by most as Lee's masterpiece. The third film to be examined in depth, the controversial opus *Malcolm X* (1992), is analyzed in Chapter VI. Thus, I will offer close readings of what are arguably Lee's most important films. *She's Gotta Have It* was his first commercial release, the film that catalyzed his subsequent career and, as Massood (2008) argues, sparked a new wave of public and critical attention to black filmmaking. The other two films subject to in-depth analysis in this book, *Do the Right Thing* and *Malcolm X* are Lee's only films to be included in the Library of Congress's prestigious National Film Registry. Furthermore, they are the two films that Lee has identified as his own personal favorites (Harris, 2002).

In the final two chapters I place these and Lee's other films and advertisements into a larger context. The ideological perspectives suggested by my close reading of Lee's films are discussed in relationship to previous discourse on and about Spike Lee and the implications of this discourse. The final chapter explores the thematic development of Lee's films over the span of his entire career up to the moment when this book went to press.

· 2 ·

THE AMERICAN FILM INDUSTRY, RACE, AND SPIKE LEE

In this chapter I offer a brief survey of the mainstream American film industry, black involvement in that industry, and Spike Lee's emergence as a filmmaker and media figure. This historical review of race and the American film industry is not intended to be an exhaustive examination of the massive amount of scholarship that has been done in these areas. Instead, the most salient topics that are required to provide historical context for an examination of Spike Lee and his films are highlighted.

Development of the American Film Industry

Originating as a technological novelty at the end of the nineteenth century, moving pictures quickly became a dominant form of mass entertainment. By 1929, over 90 million movie tickets were sold in the U.S. every week (Lowery and De Fleur, 1983). While the film industry as a whole is a global enterprise, since World War I American film companies have generally dominated this industry both economically and aesthetically (Ellis, 1992). This domination originated with a small number of Hollywood film companies early in the twentieth century and continues to this day (Balio, 1996; Giannetti, 2011; Moran, 1996). Despite structural changes and some brief periods of divergence,

the major Hollywood studios of the first decades of the 21st century are quite similar to those that were dominant at the beginning of the 20th.

American film companies capitalized on their preeminence through the process of vertical integration—the control of all three elements of the film industry: production, distribution, and exhibition. The major film studios of the 1910s and 1920s quickly realized that control of all three aspects of the film enterprise would solidify their power base and, consequently, enhance their profit margins (Desjardins, 1995).

Vertical integration as a strategy, however, required large financial expenditures, which resulted in two overall trends that are still central to the film industry. First, American movie companies became beholden to financial institutions and Wall Street interests for capital resources (Turner, 2006). A second trend was the establishment of a small number of major movie studios in Hollywood, California, that had the financial power to exert control over the entire industry (Ellis, 1992; Moran, 1996; Turner, 2006). This control by the "Big Eight"[2] lasted from the late 1920s to about 1950 (Ellis, 1992; Powers, Rothman, and Rothman, 1996). Vertical integration allowed film studios to control every aspect in the development, production, and marketing of a film, from the earliest days of drawing up budgets and casting stars, to promotion and advertising for the finished product, to the moment when the film was displayed to an audience in a theater. Executives from the Big Eight film companies successfully established a studio system that ensured their dominance. Under this system, for example, their ownership of distribution networks resulted in 95 percent of all film rentals being paid to the Big Eight (Powers, Rothman, and Rothman, 1996).

In 1948 the United States Supreme Court ruled that control over production, distribution, and exhibition by one company was a violation of anti-trust laws. In the wake of these legal actions, film companies recognized that they could actually increase their profits by divesting their exhibition interests and concentrating on the key area of distribution. As Turner (2006) notes, distribution, putting a film in the right markets, with intelligent timing and adequate saturation, is the most essential factor in determining a film's financial success or failure.

Attendance at feature films reached an all-time peak in 1946, and for many years there was a general trend in declining audiences for theater screenings of films (Turner, 2006). There are several social and economic factors that contributed to this, but one of the obvious and important causes was the advent and proliferation of, first, television, and later, other forms of home entertainment and leisure-time competition: VCRs, DVD players, video gaming systems, personal computers, etc. (Ellis, 1992). In response to

these developments film companies adopted strategies that would incorporate other forms of media into their business operations: producing television series and movies, and eventually distributing films on video cassette, DVD, and through cable and pay-per-view channels.

Most significantly, film became an important piece in the building of multimedia conglomerates that arose in the 1960s when huge corporations began buying up motion picture companies and other entertainment concerns (Balio, 1996). This did not result in the destruction of the old Hollywood system of dominance, but merely the beginning of a transformation to the "new Hollywood" (Moran, 1996, p. 5), where the same handful of corporate conglomerates hold interests in film studios, broadcasting companies, publishing houses, cable outlets, music companies, theme parks, sports teams, and more (Moran, 1996). By the 1970s and 1980s a half-dozen corporations controlled 84 percent of the box office returns throughout the United States and Canada (Kochberg, 1996). This trend only intensified during the late 1990s and early 21st century as deregulation and refusal to enforce existing anti-monopoly and anti-trust laws became the norm (Bagdikian, 2004; McChesney, 2004).

The major American film companies are now subsidiaries of media conglomerates that hold interests in vast numbers of media channels and operations. These giant media corporations greenlight products, like films, with the aim of creating "synergy"—a geometric increase in profits through marketing tie-ins across and between various forms of media. The film begets a soundtrack, a paperback novelization, toys, video games, t-shirts, hats, and so on. Similar to the early days of the big motion picture studios, there are a small number of dominant players in the current media environment. As Bagdikian (2004) reports, corporate control over the media in general is held by a dwindling number of global conglomerates. There were fifty such controlling firms in 1984, twenty in 1990, approximately ten in 1996, and six by the 21st century (Bagdikian, 2004). Vertical integration has made a triumphant return, accompanied by horizontal integration—a branching out to all aspects of media, entertainment, and leisure commodities. Above all else, these mega-corporations' primary goal is profit. The industry is increasingly focused on creating blockbusters: high-budget movies with spectacular special effects, thrilling scenes of adventure and action, or dozens of stars, that will appeal to a large, broad-based audience and pull in instantaneous and enormous income. As Spike Lee said in a 2012 interview with *Vanity Fair*:

> I know it's becoming cliché with me, but you don't need to have tights and a cape and fly through the air. [*Laughs.*] And there's always going to be big-budget Hollywood

films, and I like many of them; I grew up on many of them. But that type of film, that type of genre, is strangling the creativity of Hollywood films, which are becoming dominated by special effects, again and again and again. They have a little space for other stuff, but the scale has been tipped way too far in the other direction, and that's because—in my opinion, I'm not a studio executive—films cost so much to make, the advertising is so much, everybody wants to hit a home run. They want every film to be a tentpole. They aren't going to make a film if they don't feel there's a sequel in it.... What's really bad is the marketing departments have an amazing amount of power. The marketing departments sit on the green-light committees. And if the marketing department at a studio says, "We can't sell it," they aren't making that motherfucker. Before it was, "We're making this film, and it's *your* job to sell it." I think that's the way to do it. Not the other way around. That's my opinion (quoted in Guerrasio, 2012, no pagination).

As these comments suggest, the consequences of these trends in media ownership raise questions about the viability of filmmakers like Lee who offer diverse perspectives and alternative viewpoints in this narrowly controlled environment. deWaard sums up Hollywood beginning in the 1980s and continuing into the first decades of the twenty-first century:

With every major studio subsumed by a huge transnational corporation and mercilessly focused on the bottom line, movies were thought of as mere products more than ever; reliable profits and growth were sought through formulaic plotlines, intense market research, a reliance on sequels and remakes, bankable movie stars, and inoffensive topics (2009, p. 346).

Smaller, experimental, or unique films and filmmakers like Lee often find it difficult to gain production and promotional support from the major studios. Films that do not gross large sales during their opening weekend are often immediately pulled and relegated to second-run theaters and the cable and video markets. Furthermore, the American dominance over the international scene has become even more entrenched than ever before (Turner, 2006). The desire to expand into global markets has encouraged the production of simplistic and violent action and adventure films in an effort to transcend language differences that could inhibit the success of a film in the international marketplace.

Although some observers hold out hope that the increasing importance of the Internet and digital media will result in a wider variety of films reaching an audience, many are not so optimistic. Promotion is still the key to a film's ability to reach a large audience and promotional muscle still requires financial muscle. Technological developments have certainly made it easier to

produce films independently and to distribute them through the Internet, but if people don't even know the film exists its potential to be seen is obviously limited. Questions must be asked about the future of films that present thematic material that is thought to be contrary to corporate interests. In general, the trends suggest that alternative or oppositional films and filmmakers stand little chance of being heard amidst the clamor of the spectacular adventure or outrageous comedy of the Hollywood blockbuster.

Specific factors have led to the current situation, including the original organization of filmmaking into a monopolistic, profit-driven industry and the commodification of films themselves. Changes in Hollywood structures, practices, and technologies since the mid-1990s have only intensified this pattern:

> The rapid spread of movies on video, the astronomical escalation of movie advertising, the depletion of government support for film preservation or new independent work (never very large to begin with), the return to a system of theater monopolies and the concomitant phasing out of independent exhibition (which allows for such alternative fare as art films and midnight movies)—what amounts, in short, to the junking of an already precarious film culture in the interests of short-term financial gains for big business...(Rosenbaum, 1997, pp. 1–2).

If all of these forces may be recognized as an intensified mainstreaming of the film industry then questions must be posed regarding the fates of filmmakers like Lee (or others who are even more challenging) whose visions do not easily fit into this narrow spectrum. Independent films have the potential to deal with more complex social issues than the average Hollywood blockbuster but are still faced with the obstacle of acquiring funding for production, distribution, and, importantly, promotion.

Furthermore, in this era of global corporate control, groups and viewpoints that fall outside the mainstream may be marginalized or neglected in a system that is geared entirely toward the maximization of profit. In the next section of this chapter, I turn my attention to black filmmakers, a group that has long been forced to function on the margins of the mainstream film industry (Rhines, 1996).

Black Filmmakers and the American Film Industry

There is little question that mainstream media in general have historically failed to portray black culture clearly and accurately. Rather, it has been common to find representations that ridicule or depict black people as deviant and

dangerous criminals (Campbell, LeDuff, Jenkins, and Brown, 2012; Deggans, 2012; Dixon, 2010; Entman and Rojecki, 2000; Gilliam and Iyengar, 2000; Giroux, 2009; Glassner, 2010; Hall et al., 1978; Hartnett, 1995; Macek, 2006; Mauer, 1999; Stabile, 2006; Rose, 2008; Yousman, 2009). Furthermore, stereotypical representations have often been the best treatment that black people could expect from a mainstream media system that more often than not ignored their presence altogether, as if they did not even exist in American society (Corea, 1995; Ewen and Ewen, 2006; Gray, 1989; Greenberg and Brand, 1994; hooks, 1992b; Hunt, 2005; Rhodes, 1993; Wilson, Gutierrez, and Chao, 2013).

Media portrayals of ethnic and racial groups are important because, as Gerbner (2003) suggests, media culture presents a symbolic picture of the world that can have a profound impact on an audience's view of "reality." Stroman, Merritt, and Matabane point out that in a polarized society, "members of other racial groups may have little opportunity to observe African American social life directly. In many instances the only source for that type of information may be the mass media…" (1989, p. 46).

Recently, more positive images of black life can be noted in mainstream media but often in contexts that serve a more subtle form of racism; a type of racism that suggests, for example, 'If Spike Lee, Bill Cosby, Oprah Winfrey, Michael Jordan, LeBron James, Condoleezza Rice, and Barack Obama can make it, then racism must truly be a thing of the past.' This line of thinking can often lead to a fallacious corollary: 'If racism is a thing of the past, then blacks who are *not* making it only have themselves to blame' (see Campbell, 1995; Jhally and Lewis, 1992). These perspectives on racism are related to the tendency of commercial media culture to focus on personal anecdotes while neglecting the larger social context within which individual 'failure or achievement' occurs.

Much of the racism and stereotyping apparent in mainstream media portrayals is related to patterns of discrimination in media employment (Corea, 1995; Deggans, 2012; Downing and Husband, 2005; Rhines, 1995). Corea (1995), Downing and Husband (2005), and Deggans (2012) all report statistics that document a pattern of underrepresentation for blacks, Latino/as, Asian Americans and Native Americans in media industries throughout the United States. In particular these groups are especially underrepresented in positions of power or authority. Shallow, inaccurate depictions are an inevitable result of a culture industry that often denies minority groups an opportunity to fully participate in media ownership and production. Spike Lee

noted in a television interview on the Oprah Winfrey Network that even in 2013 media industries still need more diverse gatekeepers if the racial divide in Hollywood is ever to be overcome.

Lack of access to mainstream media employment, and distorted representations in white controlled media, has historically spurred black efforts to create their own forms of media that could offer more nuanced images (Kessler, 1984; Miller, 1993). Although, as Hall (1992) and Leonard (2006) point out, it is important to bear in mind that the racial identity of media producers does not guarantee any particular ideology or aesthetic. Despite this, certain patterns in the development of cinema by black filmmakers have been identified by historians, including a resistance to white-authored stereotypes and mythologies.

Black Stereotypes in American Film

In the case of film, the genesis of a distinctive alternative black cinema can be traced to the earliest days of the mainstream American motion picture industry. The film that is widely considered to be the first technologically sophisticated major American feature was *Birth of a Nation*, directed by D.W. Griffith, which appeared in 1915 (see Bogle, 1993; Cripps, 1977; Lang, 1994; Miller, 1993). This film was based on a novel entitled *The Clansman*, and it represents the emergence of the Ku Klux Klan from a particularly sympathetic perspective. In the process it also presents blatantly racist and virulent images of blacks (Bogle, 1993; Cripps, 1977; Diawara, 1993; Lang, 1994; Miller, 1993; Rhodes, 1993; Wilson, Gutierrez, and Chao, 2013).

Bogle (1993) argues that this one film included all of the archetypal characters that were to form the basis for subsequent film portrayals of black people. Every era in the history of mainstream American film has stereotyped blacks in a specific manner. While the particulars of the stereotypes may have changed from era to era, the central fact of one-dimensional, generally demeaning images has been slow to change. (Although, it is important to note that Bogle's central thesis is that individual actors were able to bring personal dignity and depth to roles that had none written explicitly in them.)

Bogle refers to the various permutations in black roles as "guises" (1993, p. 17), which distracted white audiences from realizing that all blacks were being portrayed in one of a handful of ways. Bogle (1993) identifies five archetypes: the faithful tom; the ridiculous, simple coon; the tragic mulatto; the

loving mammy; and the dangerous and brutal black buck. These stereotypes were not born with the film industry, they had already existed in American popular culture and were merely appropriated by filmmakers for their own uses. "All were character types that were used for the same effect: to entertain by stressing Negro inferiority" (Bogle, 1993, p. 4).

While Griffith's film, and others made at about the same time, clearly depicted black people as monstrous villains, the films of the 1920s tended to portray blacks as comedic figures or, as Bogle suggests, "jesters" (1993, p. 19). In subsequent decades, the basic stereotypes were clad in different clothes:

> In the 1930s all the types were dressed in servants' uniforms. In the early 1940s they sported entertainers' costumes. In the late 1940s and the 1950s they donned the gear of a troubled problem people. In the 1960s, they appeared as angry militants. Because the guises were always changing, audiences were sometimes tricked into believing the depictions of the American Negro were altered, too. But at heart beneath the various guises, there lurked the familiar types (Bogle, 1993, p. 18).

Bogle (1993) identifies the 1970s as the first decade that a significant number of (male) black filmmakers (Gordon Parks Sr. and Jr., Sidney Poitier, Ossie Davis, and others) were employed as directors by the major studios. During the 1970s, film companies began to recognize that there was an audience of moviegoers beyond whites, and subsequently began to self-consciously produce films targeting black consumers. Despite this, and to Hall (1992) and Leonard's (2006) point, many of the old stereotypes continued to be prevalent in Hollywood productions, particularly in the so-called "blaxploitation" films that featured "Superblackmen" in action-oriented plots in urban settings and often glorified drug use and violence. Many of these films were written, directed, and produced by whites and deliberately promoted and marketed as "black films" (Bogle, 1993). And, as Lyne points out: "When groups such as the NAACP, CORE, and the SCLC objected to the film industry's cynical exploitation of stereotypical black sex, violence, and misogyny, Hollywood executives pointed to box office receipts and claimed that they were only giving black audiences 'what they wanted'" (2000, p. 45). Yet this was a facile response since there were so few alternatives for moviegoers to choose from if they were looking for black representation during the 1970s.

The 1980s were the decade of Reaganism, and many of the films from this era reflected the conservative values of this administration (Kellner 1995a; Ryan and Kellner, 1988). Black artists were again frequently relegated to subsidiary roles. Directors and writers who had broken through during the

previous decade once again found themselves unable to find work. Bogle refers to the early part of the decade as the "Era of Tan" (1993, p. 268) indicating that when blacks did appear, it was often in a culturally vapid context, with film portrayals that tried to deny a character's blackness at all costs.

Black Independent Cinema

The first seven decades of the mainstream film industry's portrayals of black people thus reveal a bleak and disturbing pattern of neglect, ridicule, and marginalization. Some critics, like Leonard (2006) argue that these trends continued into the latter part of the twentieth century and the early years of the twenty-first. But there is a parallel history of black independent film and filmmakers that must also be considered. Diawara defines black alternative film in this way:

> Black independent cinema is any Black-produced film outside the constraints of the major studios....Independent films provide alternative ways of knowing Black people that differ from the fixed stereotypes of Blacks in Hollywood (1993, p. 7).

Miller (1993) notes that the first independently made black film was a deliberate reply to Griffith and *Birth of a Nation*. Entitled *Birth of a Race*, this film appeared in 1918, created by the early filmmaker, Emmett J. Scott. *Birth of a Race* attempted to present images that were contrary to the demeaning stereotypes evident in Griffith's film, but many film historians consider it a flawed production, due mainly to inadequate funding. Two themes thus emerge from a consideration of this early example of alternative film: (1) the motivating impetus to respond to the neglect and abuses of the mainstream film industry and (2) the struggle for adequate financial support in the production, distribution, and exhibition of the work of black filmmakers.

These themes are a constant throughout the history of black cinema and can be recognized in Spike Lee's personal history as well. Lee's first major project at New York University's Film School was a short film entitled *The Answer* (1980), which dealt with the dilemma of a black filmmaker who was working on a remake of D.W. Griffith's 1915 celebration of the Ku Klux Klan. As Khoury notes about this early film: "The thesis was met with great resentment and opposition by the NYU faculty, who had made *Birth of a Nation* an integral part of their teaching curriculum while ignoring its racist content for years. Lee defended his film adamantly" (2002, p. 147). Later in his career

Lee's first attempt at making a feature film for commercial distribution failed due to a lack of adequate funding (Lee and Wiley, 1997).

Miller (1993) identifies the years between 1920 and the late 1940s as an important era in the history of independent black cinema. These were the days of the so-called "race movies"—all-black films made independently of the Hollywood studio system (Cripps, 1977). Oscar Micheaux is cited as the key figure in the development of independent black cinema during this era (Cripps, 1977; Leab, 1975; Stephens, 2009). According to Cripps, for twenty years Micheaux "carried the movement" (1977, p. 183). A true exemplification of an *auteur*, Micheaux was responsible for all components of his more than thirty films, from the financing, to the writing, direction, production, and distribution (Stephens, 2009). Micheaux's career was, however, indicative of a common problem for independent filmmakers—economics. He was continuously plagued by a lack of financial support, which hindered his productions and his ability to distribute them (Cripps, 1977; Miller, 1993; Rhodes, 1993). Cripps notes:

> [T]he Colored Players Corporation, and a cluster of tiny companies that rarely survived the printing of their prospectuses, formed an underground cinema that attempted a black aesthetic to fill the vacuum left by Hollywood. They did not fail so much as they were overwhelmed by the impossible (1977, p. 170).

Cripps (1977) argues that an alternative black cinema was simply overwhelmed by the consolidation and increased power and control of the Hollywood studios. They were destined to fight a losing battle on the three fronts of production, distribution, and exhibition. The more Hollywood tightened its squeeze on the film industry, the less likely independent film companies could survive. Furthermore, the dominance of ideological positions favoring assimilation resulted in the framing of black cinema as an unnecessary anomaly in a social and market environment where all are supposedly treated fairly (Cripps, 1977). As Stephens points out:

> [B]y the time the Depression rolled around, there were only a few films being made for African American audiences, and they were films produced almost entirely by whites. A number of them featured African American entertainers in scenes singing rather than acting (2009, p. 5).

Despite these obstacles and barriers, Cripps (1977) believes that the limited success of the original independent black cinema movement did provide

black audiences with some hope that they were not without recourse in combating toxic mainstream Hollywood imagery. In addition, black producers, directors, writers, artists, exhibitors and others in the field were able to gain valuable exposure and experience through the independent cinema movement (Cripps, 1977).

By the beginning of the 1950s, however, the economic and assimilationist forces arrayed against black film companies had won a partial victory, and independent black cinema lay dormant for years (Moon, 1997). This may be partly explained by a content analysis reported by Powers, Rothman and Rothman (1996) that indicates that the number of black roles in Hollywood films did increase during the 1960s, as the gains of the civil rights and Black Power movements became evident and a new structure began to form in Hollywood (Stephens, 2009). More opportunities for black artists in the mainstream film industry seem to have resulted in less motivation for some to work within the boundaries of an alternative cinema (Moon, 1997).

This does not mean that independent black filmmakers disappeared entirely. In the 1960s filmmakers like Ivan Dixon insured that a few independent black movies were still being made (From Micheaux to Lee, 1993). Diawara (1993) mentions Bill Gunn and Melvin Van Peebles as two examples of independent 1970s filmmakers who reflected an alternative aesthetic by positioning black experience and culture at the center of their work, a point that has also been made about many of Lee's films (Stephens, 2009). Masilela (1993) examines a group of filmmakers associated with a black independent film movement that emerged in Los Angeles during the 1970s. This included people like Haile Gerima and Charles Burnett (whom Lee has mentioned as his forerunners), and Larry Clark, to name just a few, who offered blatantly political perspectives in resistance to the misrepresentations of the Hollywood "blaxploitation" films of the 1970s. Later, a second wave of independent filmmakers also came out of this movement, including Bill Woodberry, Julie Dash, Bernard Nichols, and many others (Masilela, 1993). However, these independent filmmakers still struggled with inadequate systems of distribution and promotion that hindered their films from reaching as wide an audience as possible.

Thus, while independent black cinema never really disappeared entirely, at various periods it has been hidden from view by the mainstream industry's endless search for novelties that can translate into profit. This was first manifested in the "blaxploitation" films of the 1970s and, more recently, has been reinstituted by the absorption of a number of black filmmakers who have been deemed safe enough for a mainstream audience (Leonard, 2006).

Toward the end of the 1980s and the early part of the 1990s, as the film industry sought an alternative to increasingly expensive blockbusters, they turned to films by young directors like Spike Lee, John Singleton, the Hudlin brothers, and Robert Townsend (Corea, 1995; Miller, 1993; Rhines, 1995). A special effects laden blockbuster like *Jurassic Park* (1993) might bring in profit ratios of five-to-one, but less expensive black films were found to generate even better profit margins. Rhines (1995) cites the example of the Hudlin brothers' *House Party* (1990), which cost just 2.5 million dollars to make, yet grossed over 26 million dollars. Industry talk during this time period often focused on the "Black Film Renaissance" (Moon, 1997; Rhines, 1995). Many of the black directors who found success in mainstream Hollywood were signed to produce films dealing with gang violence and crime in the inner city. While many of these films successfully exposed the conditions of life in poverty stricken urban America, they have also been criticized for recreating the traditional Hollywood stereotypes of dangerous, violent black youth.

Spike Lee has been identified as the leading catalyst of the late 1980s Hollywood interest in black filmmakers (Coleman and Hamlet, 2009; Massood, 2008; Muwakkil, 1990; Perkins, 1990, Sterritt, 2013), and in many ways his work represents a blurring of the line between independent/alternative and mainstream film.

The Emergence of Spike Lee

Shelton Jackson Lee was born in Atlanta in 1957. As a student at Morehouse College he majored in mass communication. He earned his Master of Fine Arts in film production from the Tisch School of the Arts at New York University in 1983 (Little, 1986; Moon, 1997). *She's Gotta Have It* in 1986 was Lee's first film intended for the commercial market. Previously, Lee had made one other feature-length movie, *Joe's Bed-Stuy Barbershop: We Cut Heads* (1983) as a Master's thesis film. *Joe's* went on to win a Student Academy Award, and Lee was the first student filmmaker to be included in the Museum of Modern Art's New Directors New Films showcase (Lee and Aftab, 2006). Prior to 1986 he also made one aborted attempt at a film tentatively entitled *The Messenger*, but this had to be abandoned due to inadequate funding (Lee and Wiley, 1997).

Lee was not affiliated with any movie studios or distribution companies at the time of *She's Gotta Have It* and was forced to raise money for the film

on his own. Lee's economic circumstances are relevant to Miller's point that "…'independence' for some black filmmakers, is a material condition to be overcome, not necessarily an independent aesthetic, cultural or political position" (1993, p. 182).

Some analysts of Lee's work have suggested that Lee has never truly identified with an alternative or independent aesthetic or political stance. Bambara points out that Lee belonged to an organization of independent black filmmakers in the early 1980s, the Black Filmmakers Foundation, but that he deliberately chose to combine both independent and commercial strategies of filmmaking in order to reach as wide an audience as possible while maintaining what she calls, "a basically reactionary sensibility (homophobic/misogynistic/patriarchal)" (1993, p. 137).

While some filmmakers opt for independence as a conscious strategy and a political choice (Citron, 1988; Reid, 1993), in Lee's case his early independent status seems to have been a matter of necessity rather than choice. In a 1986 interview Lee said, "If I had gone to Hollywood for money for this film with an all-black cast, they'd have said, 'Forget it'. I always knew I was going to have to do this on my own" (Lee, quoted in Little, 1986, p. 67).

She's Gotta Have It was indeed an independent film created without any financial connection to the Hollywood studios. Lee had to solicit donations and loans for additional funding, and he ended up acquiring substantial personal debt in the process. The economic survival of the project was always in doubt. Through perseverance and creative short cuts Lee succeeded in completing the filming in twelve days for the cost of $175,000, an absurdly small figure for the 1980s when most Hollywood films were being produced with budgets of several million dollars. Island Pictures agreed to promote and distribute the film, which became an instant critical and commercial success (McDowell, 1989; Perkins, 1990; Pierson, 1995; Travers, 1986). During its first three weeks of exhibition it earned $1.8 million (Little, 1986), and eventually Island Pictures grossed between seven and eight million from the film (McDowell, 1989; Norment, 1989; Pierson, 1995; Sterritt, 2013).

The major Hollywood corporations instantly took notice of the disparity between the film's production costs and the profits that it earned. Columbia Pictures signed Lee to produce a second film, *School Daze*, and awarded him a six million dollar budget. The film grossed three times that amount, becoming Columbia's most profitable movie for 1988 (Bernotas, 1993; Lee and Aftab, 2006; Norment, 1989; Pierson, 1995).

In the wake of Lee's financial successes, Hollywood studios quickly adopted the strategy of signing a wave of young black filmmakers who could produce low budget films that had the potential to generate high profits (Guerrero, 2001; Kellner, 1995a; Rhines, 1995; Scott, 1996). While this trend did have the effect of, at least temporarily, providing more blacks with opportunities for employment in the mainstream film industry, and a measure of control over the industry's depiction of certain aspects of black culture, it's safe to say that equity and cultural enlightenment were not the motivating impulses behind these moves. As Guerrero notes: "In short, black films are cheap to produce and, importantly, almost always make money. But this also means that black films are unfairly held to a double standard. In order to be deemed successes in industry terms, they have to earn more money on drastically smaller production and promotion budgets than mainstream, big-budget blockbuster productions" (2001, p. 25).

In the August 1991 issue of *Ebony* magazine, Lee was quoted as saying, "Hollywood is changing because these films are making money. It's not like they're in love with Black people all of a sudden. They are making money with little investment" (Lee, quoted in Collier, 1991, p. 54). Guerrero (1993) has also noted that Hollywood will often attempt to capitalize on low-budget black films during industry slumps, while they routinely ignore black filmmakers when the industry is healthy and experiencing high profits. This is indicative of the tendency for the culture industries to appropriate artistic impulses that fall outside of the mainstream in order to find new sources of revenue.

Lee is often cited in the popular press as the primary catalyst behind the early 1990s Hollywood courting of black filmmakers (Corliss, 1991; Fitzgerald, 1995; From Micheaux to Lee, 1993; Hollywood Shuffle, 1991; Hollywood's Black Bard, 1992; White, 1991). An article in the February 1991 issue of *GQ* about young black directors appeared under the heading: "Who will be the next Spike Lee?" (Lehman, 1991, p. 69). In the late 1980s and the 1990s Lee was referred to as one of the most important filmmakers working in the industry (Norment, 1989) and as the most powerful black filmmaker in the history of Hollywood (Hollywood's Black Bard, 1992). An article in the August 1990 issue of *Business Week* called Lee the most financially successful black director in the United States and suggested that he was earning between two and four million dollars on each film, not including a share of the box-office receipts (Landler, 1990).

Popular and Academic Reception of Lee's Films

Lee's stature in the film industry and his financial success, as well as the tendency of his films to address controversial and compelling social themes, resulted in a significant amount of attention in both popular and academic forums. Lubiano dubbed this attention the "Spike Lee discourse" (2008, p. 31). This discourse has been diverse and wide-ranging, with critics and scholars of all political and ideological perspectives chiming in with a wealth of disparate interpretations of Lee's work. Often the discourse surrounding Lee and his films is contradictory (Messaris, 1993). Some observers position Lee as a creative, compelling filmmaker and others as a commercial hack; some critics and scholars draw him as a political progressive and others as a reactionary. There are three somewhat overlapping categories that responses to Lee's work may be grouped under: 1) critical evaluations of the artistic and cultural merit of Lee's work, both positive and negative, 2) specific responses to his representations of race, class, and gender, also positive and negative, and 3) variant readings of Lee's overall political agenda including perspectives that represent Lee as an oppositional critic of American society and those that frame him as a conservative who privileges traditional values and institutions.

Artistic and Cultural Merit

Besides focusing on his stature and financial success in the film industry, much of the commentary regarding Lee in both popular and academic discourse praises his contributions to the American media culture scene. Lee's movies are often regarded as important, insightful films that represent the complexities and ambiguities of American culture and society. A cover story in the February 1993 edition of *Sight and Sound* called *Malcolm X* (1992) the most important film of the decade (Kennedy, 1993). In reference to *Do the Right Thing* (1986), George wrote: "By integrating the history and sociology of his hometown into this work, Spike Lee has made a film that works as idiosyncratic art and powerful social commentary" (1991, pp. 77–78). Writing about this same film, Rosenbaum (1997) suggests that Lee challenged Hollywood conventions by refusing to clearly differentiate heroes from villains and thus presenting a complex and sophisticated statement about racial conflict.

Lee has been referred to as a brilliant director (Johnson, 1991; McGee, 1998), and he has been lauded for his honesty and boldness (Ansen, 1989), as

well as for his artistic vision (Canby, 1989). While critics have generally been quite positive in their regard for Lee's artistic achievements, there have also been those that suggested Lee's characters are one-dimensional and unreal (Quart, 1992; Simon, 1991). Some critics have derided the overall artistic value of his work and accused him of banality, blandness or mediocrity (Coe, 1996; Simon, 1991; Steele, 1992).

Representing Race, Class, and Gender

As noted above, Lee is often regarded as a filmmaker who has broken long-standing barriers in the mainstream film industry. Lee's success is said to have catalyzed Hollywood's interest in developing other black filmmakers who might produce profits by appealing to a particular segment of the audience that can be targeted by the entertainment industries (Collier, 1991; Corliss, 1991; Fitzgerald, 1995; From Micheaux to Lee, 1993; Hollywood Shuffle, 1991; Hollywood's Black Bard, 1992; Kellner, 1995a; Norment, 1989; Van Peebles, 1991; White, 1991). In 1991 an earlier independent filmmaker wrote this about Lee's influence:

> I sit up and look around and there is this wave of African American filmmakers barreling up the hill (not a solitary filmmaker, easily picked off—NO, not this time). Here they come!...an endless row of young Black filmmakers...and THERE leading the charge carrying the old banner of Self-Determination that Oscar Micheaux had stitched together so long ago, the Main-Man HIMSELF, Spike Lee (Van Peebles, 1991, p. 7).

The "banner of Self-Determination" that Van Peebles refers to suggests that Lee has managed to maintain his own cultural vision even while operating within the institutional demands of white-dominated Hollywood. Furthermore, Lee is often described as actively resisting this domination, and he is praised for his conscious efforts to employ and promote the work of black actors, directors, writers, camera operators, technicians, and others in the film industry (Grant, 1997; Norment, 1994). He has been held up as an inspiration and a mentor for black filmmakers and for black entrepreneurs and investors (Miller, 1992; Watkins, 1998; White, 1996).

In particular, Lee is frequently praised as a filmmaker who presents black culture in a highly realistic, nuanced, and complex manner that shatters the stereotypes of traditional Hollywood fare (Coleman and Hamlet, 2009; Conard, 2011; Elise and Umoja, 2009; Fuchs, 2002; Gates, 1991; George,

1991; Johnson, 1991; Jones; 1997; Kellner, 1995a; Lindroth, 1996; Massood, 2008; McMillan, 1991; Messaris, 1993; Muwakkil, 1990; Sterritt, 2013; Watkins, 1998). In 1990 U.S. News and World Report named him as the "artist who best captured the ethnic experience in America" (Hitting the Hot Button, 1990, p. 52).

Not all of the discourse regarding Lee's representations of race and racial issues is positive, however. Some critics protest that Lee's films present much of the same stereotypical and denigrating images of black culture as other Hollywood movies (A-Salaam, 1989; hooks, 1994a; Rowland and Strain, 1994; Thomas, 1989). Regarding the controversy that arose over Lee helming a film about the life of Malcolm X, Baraka wrote:

> Our distress about Spike's making a film on Malcolm is based on our analysis of the films he has already made, their caricature of Black people's lives, their dismissal of our struggle and the implication of their description of the Black nation as a few besieged buppies surrounded by irresponsible repressive lumpen (cited in Lee and Aftab, 2006, p. 181).

A few white critics have complained that Lee perpetuates racism in his films. An *Esquire* cover story from 1992 bore the headline: "Spike Lee Hates Your Cracker Ass" (Harrison, 1992, cover and p. 132). In this article the author laments that Lee made her feel like a racist, that he is convinced there can be no peaceful coexistence between blacks and whites, and that he believes all white people are racists. It is hard to imagine these sorts of accusations or headline being reversed and applied to a successful white filmmaker.

Other writers have accused Lee of being hyper-vigilant regarding racism: "Looking for racism at every turn, he finds it" (McDowell, 1989, p. 93). And he has also been condemned for advocating black supremacy and for racism and anti-semitism (Lester, 1992; Morrone, 1989). These hyperbolic responses to Lee's provocative style are countered by Sterritt who summed up Lee's first decade of filmmaking by writing:

> Look at the actual films, though, and you will find a consciousness of race that fair-minded people will find hard to confuse with the quarrelsome, obsessive racism or racialism that tendentious viewers, critics, and (occasionally) scholars read into them (2013, p. 133).

What some observers have dubbed racism others have seen as Afrocentrism or Black Nationalism. Boyd (1991) suggests that Lee presents an Afrocentric

perspective that is politically resistant and challenging to dominant United States ideology. This idea is echoed by other writers who have lauded Lee for representing a black cultural perspective that is oppositional to mainstream white society and empowering (Baker, 1993; Blake, 1990; Bowers, 1994; Elise and Umoja, 2009; Harris, 2009; Powell, 1991). Bowers, for example, argued that *Do the Right Thing* presents a conflict:

> [B]etween Eurocentric structure and Afrocentric resistance to that structure's values of prediction, control and hierarchy...the film portrays those African patterns as preferred alternatives to Eurocentric communication patterns (1994, p. 206).

But even Lee's purported Afrocentrism and black nationalist stance have been condemned by some as essentially regressive positions that disguise class inequities and the effects of structural and institutional racism in favor of a politics of cultural identity that is divisive rather than unifying (Dyson, 1993; Gilroy, 1991; Kellner, 1995a; McPhail, 1996). Reid argues that Lee's depiction of racial antagonism in *Do the Right Thing*, "lacks any constructive critique of the socioeconomic processes that promote misunderstanding between ethnic and racial working-class groups" (1993, p. 102).

In their analyses of *Jungle Fever*, Yousman (2005), Guerrero (2008), and Sundstrom (2011) each explore how Lee constructs interracial romances as taboo; driven by exotic lust and ultimately doomed to failure. Yousman (2005), Guerrero (2008) and Sundstrom (2011) all compare Lee's take on "miscegenation" to earlier eras in Hollywood, and each concludes that rather than being progressive or groundbreaking it is in fact consistent with a conservative pattern that dominated American filmmaking for decades. As Guerrero puts it:

> [N]o matter what acclaim Lee has earned as an "independent" or "guerrilla" filmmaker, *Jungle Fever* is strictly a dominant cinema commodity that rigorously upholds every expectation and prohibition of the archaic Hays Office Code on the issue of miscegenation (Guerrero, 2008, p. 81).

Regarding *Malcolm X*, several critics have suggested that Lee's film ignores the radical political and ideological stances that X developed toward the end of his life (Boyd, 1992; Georgakas, 1992; hooks, 1993b; Marable, 1992; Rhines, 1993). Writing about both the autobiography co-authored by Alex Haley and Lee's film, Marable argues that, "the ideological limitations of both Haley and Lee keep their interpretations of Malcolm located on safe, religious grounds rather than on the more dangerous terrain of race and class struggle" (1992, p. 8).

Related to critiques of the seeming lack of class-consciousness in Lee's films (Musser, 1990; Reid 1993) is the argument that he uncritically promotes consumerism and a middle-class lifestyle in his films (Christensen, 1991; Kellner, 1995a). Kellner writes:

> Lee tends to celebrate consumption and to define cultural identity in terms of style and consumption patterns. Moreover, he fails to address the reality and dynamics of class oppression. In fact, Lee does not really explore black underclass exploitation and misery in his films. Reflecting his own middle-class perspective, most of Lee's characters are middle-class and upwardly mobile blacks (1995a, p. 169).

Finally, Lee has been particularly vilified for his portrayals of women. He is frequently accused of misogyny, of marginalizing women in his films, and of idealizing the submission of women in a patriarchal hierarchy (Bambara, 2008; Burks, 1996; Cobb and Jackson, 2009; Elise and Umoja, 2009; Harris and Moffitt, 2009; Jones, 1993; Jones, 1996; Lubiano, 2008; Malveaux, 1991; McPhail, 1996; Reid, 1993; Sterritt, 2013; Wallace, 2008; Watkins, 1998). Even while acknowledging many of the groundbreaking aspects of Lee's films, bell hooks has been particularly outspoken in her critique of Lee, a critique that condemns him not just for sexism, but for homophobia and racism as well (hooks, 1992a; hooks, 1993a; hooks, 1993b; hooks, 1994a; hooks, 1994b; hooks, 2008). Even some observers who otherwise praise Lee point to his portrayals of women and gender roles as an area of concern (Baker, 1993; Elise and Umoja, 2009). A few critics, however, have refuted charges that Lee presents a patriarchal view of gender relations and have insisted that his films actually challenge these traditional views (Gates, 1991; Kauffmann, 1986).

Lee's Political Agenda

Regarding the overall political positions articulated in his films, here again we find a wealth of contradictory perspectives, clearly related to the ideological stances of the observers themselves. Lee is often regarded as a filmmaker who, in his films and public persona, submits a radical indictment of contemporary American society. This is represented as either a positive or negative quality dependent on the ideological framework of the writer.

In articles appearing in mainstream periodicals there has even been a recurring discourse that associates Lee's films with violence in black communities. The most notorious example of this was a Klein (1989) article in *New York* magazine claiming *Do the Right Thing* (1989) would encourage black

audiences to riot. Klein was not the only one to direct this type of accusation at Lee. An article in the July 1991 issue of *Newsweek* was entitled, "A Bad Omen for Black Movies? Audience Violence Could Threaten the Careers of Young Directors" (Leland, 1991, p. 48). In this article, the author grouped all black directors together and associated a few isolated incidents of violence that accompanied the opening of John Singleton's film, *Boyz 'n' the Hood* (1991), with black films and filmmakers in general. The implication is that films by black directors will automatically attract a violent black audience. Interestingly, films featuring violent white action heroes have not been greeted with similar accusations that spontaneous violence by young white men will explode in theaters that screen these films.

A year after the Leland article, an item appeared in *Variety* bearing the headline, "Exhibs Warn Warners about 'X'" (Brennan, 1992, p. 3). This article noted that film exhibitors were concerned about violence erupting during the opening of *Malcolm X* (1992). That summer, *Jet* magazine reported that a Hollywood actor had accused Lee and Singleton's films of inciting the Los Angeles riots (Lee Counters Claim, 1992). It's obvious that much of this public discourse expresses an underlying fear of blacks as dangerous and violent threats to public safety, a theme that is echoed in critical responses to rap music and other forms of black cultural expression. (Rose, 2008). Lee's reactions to these criticisms are insightful regarding the racial basis of these fears: "How is that black audiences are going to see a film and then re-enact what they saw on the screen, while the white masses can go in droves to see *Terminator 2* with no problem? How many cops did Arnold Schwarzenegger kill in the first *Terminator* movie? Did we hear any complaints from the police about that? Yet Ice T does a song which is pure fantasy ["Cop Killer," 1992], and the whole world comes down on him" (quoted in Verniere, 2002, pp. 83–84).

Even critics who praised his films also engaged with this representation of Lee as an agitator. An article with no byline that appeared in the July 1989 issue of *The Economist* referenced:

> ...charges that the irresponsible Mr. Lee...will be responsible in part for any race riots that flare up in America this summer. These charges are not ridiculous. "*Do the Right Thing*" has the humour of Mr. Lee's first film...and is as self-critical of blacks as his second...but it is also menacing (Right or Wrong?, 1989, p. 88).

This article goes on to suggest that Lee is pushing the audience to identify violence as "the right thing" by having a character played by himself participate in the film's destructive acts. This idea is echoed in an otherwise

positive review of *Do the Right Thing* that appeared a few months later (Morrone, 1989). Another article from the previous year chose one connotatively loaded word, that Lee used as a self-description, for its headline: "Spike Lee, 'the Instigator'" (Wity, 1988).

However, there is also an alternate discourse that positions Lee as oppositional but sees this as grounds for praise and commendation. Lee's films have been regarded by some as making clear statements of emancipatory politics that critique American capitalism (Gates, 1991; Mitchell, 1991; Simpson, 1992; Taylor, 1992). Blake suggested that, "Lee has made a point of working outside the establishment as an independent voice of black America" (1990, p. 136).

Contrary to the positions noted above, however, Lee is regarded by some academic analysts as oppositional only on the surface. Some critics and scholars have suggested that a closer look at Lee's films uncovers themes, images, and messages that essentially do little to challenge the core values and institutions of American society. hooks has suggested:

> Despite the hype that continues to depict him as an outsider in the white movie industry, someone who is constantly struggling to produce work against the wishes and desires of a white establishment, Lee is an insider (1994b, p. 157).

Lubiano offers a fairly scathing catalogue of sexism, homophobia, identity politics, and capitalist ideology that all come together in Lee's films, making any designation of them as progressive a questionable proposition at best. He suggests that the identification of Lee as a radical filmmaker is detrimental to the work of others who do present a true critique of American society:

> [H]aving Lee and his work deified by...members of the leftist and African American media and critical establishment, is bad news to other African American filmics who remain overshadowed by the attention granted to Spike Lee and bad news also to the larger possibility of more politically progressive and complex film production focused on African American culture and/or issues of race...any evaluation of Lee's work as radical or counterhegemonic has to be run past the question, *Compared to what?* (2008, p. 36). (Emphasis in the original).

Other observers also argue that the ideological messages in Lee's films tend to privilege the same hierarchies of class and gender that are promoted by the standard Hollywood fare (Chrisman, 1990; McPhail, 1996). As alluded to above, Lee has been accused of presenting derogatory images of gays and lesbians (Frutkin, 1995; Wallace, 1992), the working class (Baraka, 1993;

Wallace, 1988) and even of black culture (Baraka, cited in Whitaker, 1991). In general, however, I have encountered many more instances, particularly in the popular press, of a discourse that positions Lee as a radical, dissenting cultural voice who represents a challenge to American social and political mores.

As the history and discourse examined in this chapter suggest, Spike Lee is a highly complex filmmaker whose movies, advertisements and public persona have been interpreted in vastly different ways by critics, scholars, and media observers of varying ideological and professional backgrounds. I will not attempt to conclusively prove which interpretations are "true" and which are "false." Rather, following Hall's (1980) conceptualization of preferred meanings, discussed in the next chapter, I will argue that close analysis of Lee's films, enhanced by an examination of the social context of Lee's status as a black artist functioning in the American film industry, and of his endeavors in self-promotion and the marketing and advertising industries, can suggest the preferred ideological frameworks in his work. From there it is possible to examine where various aspects of Lee's films fit in a scaffolding of mainstream, alternative and oppositional media adapted from Williams (1977).

This exploration is inspired by Lubiano's suggestion that:

> The Spike Lee discourse and his production offer a site for examining possibilities of oppositional, resistant, or subversive cultural production as well as the problems of productions that are *considered* oppositional, resistant, or subversive without accompanying analysis sustaining such evaluation (2008, p. 31).

In the next chapter I offer an overview of critical theories of media and ideology, including discussions of Hall's theory of encoding and decoding and Williams' framework of emergent, dominant and residual cultural forms as they might be applied to the films and career of Spike Lee.

· 3 ·
THEORY AND METHOD: MEDIA CULTURE, IDEOLOGY, AND SPIKE LEE

In an essay about images of black masculinity in Spike Lee's films, Elise and Umoja eloquently sum up why cinematic representations should be taken seriously:

> Motion pictures are indeed profound and curious phenomena. They are instruments for socialization, mass propaganda, historical vehicles, outlets for aesthetic expression, entertainment, and commercial endeavors....Films can just as easily reinforce the status quo as usher in revolutionary ideas and expand consciousness (2009, p. 287).

In this chapter I offer a review of major paradigms in critical media studies and film theory that have sought to explicate the power and purpose of media representations. I do not intend for this chapter to provide an exhaustive review of the complex history and development of media and film theory. Rather, I provide an overview of basic assumptions and contesting paradigms in order to explore how various theoretical perspectives in media studies can be used as starting points to investigations of the cultural impact of the films of Spike Lee. I discuss how the media effects tradition asks us to consider the impact of Lee's productions on audiences, how Frankfurt School-inspired critical theory positions Lee's films and advertisements as manifestations of the dominant culture industries, how the British cultural studies tradition opens the space for multiple interpretations

of the ideological tendencies in Lee's work, and how studying the political economy of media directs our attention to the influence of corporate power over Lee's career as a filmmaker and advertiser. I also explain how Marxist approaches to ideology, feminist film theory, critical race theory, the auteur theory of film, and film semiotics all play a role in my subsequent analyses of Lee's films. Since the early days of the 20th century discussion of the social impact of commercial media has been heavily influenced by sociological theories regarding post-industrial or "mass society," therefore I begin with a brief discussion of this concept.

Mass Society and Mass Media

The conceptual basis of the familiar term "mass media" is rooted in the perspectives of social theorists such as Marx, Tönnies, Comte, and Durkheim. These scholars, each in their own way, all shared concerns regarding the transformation of traditional social formations into modern "mass societies" due to technological and cultural developments of the late nineteenth century. In their review of mass society theory, Lowery and De Fleur (1983) explore how technologies of the late nineteenth century resulted in the development of the factory system, which radically transformed systems of production and social relationships. Traditional society, prior to this transformation, was primarily agricultural and rural. Interpersonal bonds were based in familial loyalties and local customs. Most communication was oral and face-to face.

Technological innovations of the latter half of the 1800s and the early 1900s, including film, however, introduced new forms of mediated communication that could be easily mass produced and distributed to wide audiences. At the same time, relationships in the newly emerging industrial society became increasingly based on legal contracts and the exchange of labor for wages rather than servitude, loyalty, or kinship (Lowery and De Fleur, 1983). Workers of varying cultural, ethnic, and national backgrounds found themselves in close physical but distant psychological contact with each other. This was said to engender a psychological state of disconnectedness, isolation, and confusion that Durkheim (1933) called *anomie*. Ideas such as this heavily influenced early theory and research on media and its impact on individuals and society. This notion of a "lonely crowd" (Riesman, 1950) of fragmented, isolated individuals with little in the way of social ties and stability to buffer them from the influence of mediated messages proved to be an important metaphor for subsequent media theory—both mainstream and critical.

Contesting Paradigms I: Media Effects and Critical Theory

Media Effects

American social scientific research into the impact of media on society began in the late 1920s and was initially informed by the conceptualizations of mass society noted above (Lowery and De Fleur, 1983). The methodology of this research was derived from the disciplines of psychology and sociology, relying on quantitative data gleaned from survey and experimental research designs. The emphasis was on finding immediate, short-term "effects" of media exposure. So, from a media effects perspective, we might ask what impact viewing, for example, *Do the Right Thing* (1989) has on an individual member of the audience. Would viewers be encouraged to riot after watching the civil disturbance depicted in the film's climax, or perhaps be influenced to adopt antipathy toward law enforcement after viewing the police brutality that sparks the culminating violence?

In fact, some film critics expressed just these sorts of fears at the time of the film's release. Rather than speculation, however, media effects researchers would attempt to answer these questions by designing surveys or experiments that could provide quantifiable answers. This is exactly what early media researchers strived to understand about the influence of the films of their day through the first systematic inquiry into the social impact of mass media, known as the Payne Fund studies, in the late 1920s and early 1930s. Early concerns about the tendency for media to have powerful, uniform, and immediate impact on individuals, however, are now often categorized as "hypodermic needle" or "magic bullet" models of media. These ideas are now written off as unscientific or too simplistic in most reviews of media effects research (e.g., De Fleur and Ball-Rokeach, 1982; Infante, Rancer, and Womack, 2003; Lowery and De Fleur, 1983; McQuail, 2010; Severin and Tankard, 2000).

Alternatives to this early model soon arose, based on the notion that intervening variables limit or defuse the effects that mediated messages have on individuals. Psychological filters such as selective perception, attention, and retention were often proposed as natural inhibitors to the power of mediated messages (Lowery and De Fleur, 1983). The primacy of social relationships over mediated encounters was also considered an important intervening variable (Katz and Lazarsfeld, 1955). From a limited effects perspective, it could be argued that Lee's films actually have little influence over individuals' attitudes

and behaviors, paling in comparison to the influence that their social connections have over them. So, viewers might only be indirectly influenced by a film like *Do the Right Thing*, if opinion leaders in their own social circles reinforced the "messages" of the movie.

Gitlin (1978) suggests that this narrow definition of media effects as short-term and purely attitudinal or behavioral, limits the researchers in this tradition from asking some of the most fundamental questions about media. These are questions about the structure of media institutions and who benefits from the existing pattern of media control. These are also questions related to political, cultural, and social hierarchies and ideologies. As Theodor Adorno, one of the founders of the Frankfurt School of Applied Social Research, wrote about his early work with Paul Lazarsfeld, "it was…implied that the system itself, its cultural and sociological consequences and its social and economic presuppositions were not to be analyzed" (1969, p. 343).

Critical Theory and the Frankfurt School

In 1978, Gitlin identified the media effects tradition as the dominant paradigm in North American media research, and this is still an accurate designation over a generation later. This does not mean that questions that fall outside of its purview go entirely unasked, however. As McQuail (2010) points out, an alternative path of media inquiry based in a European tradition of media criticism could be found in the United States as early as the 1930s. Contrary to the dominant paradigm discussed above, this alternative paradigm set out to examine the political and ideological impact of systems of mass communication. In particular, the alternative paradigm addresses itself to issues of power inequities and patterns of domination and subordination. Thus, my concern in this book is not the impact of a specific Spike Lee film, like *Do the Right Thing*, on individual attitudes or behaviors, but on the contributions that Lee's films make to the overall ideological direction of the American film industry.

While many of the assumptions of critical theory had long been apparent in various humanistic disciplines, the late 1930s saw the first application of these ideas to the study of forms of mass communication like film. Critical examinations of media were introduced to the United States by a group of intellectuals who fled Germany to escape the Third Reich. The Frankfurt School of Applied Social Research included Theodor Adorno, Walter Benjamin, Max Horkheimer, Leo Lowenthal, and Herbert Marcuse, among others.

These theorists introduced notions of culture and ideology into the study of the systems and products of mass communication, or what they called "the culture industries" (Hardt, 1992; Horkheimer and Adorno, 1972). These theorists also shared a similar concern that systems of mass communication, like the film industry, that were becoming the dominant source of entertainment and leisure in Europe and the United States would have a perverse effect on artistic expression, turning culture into mass produced, standardized commodities (Kellner, 1995a). As Horkheimer and Adorno wrote, "culture now impresses the same stamp on everything. Films, radio and magazines make up a system which is uniform as a whole and in every part" (1972, p. 120). Scholars from the Frankfurt School believed that these forms of mass culture promoted conformity and adherence to fashionable trends while undermining authentic individuality and intellectual thought.

Furthermore, they contended that mass culture had specific ideological purposes: to legitimize capitalism, placate workers, distract them from the harsh realities of their existence, and bind them to the prevailing social order:

> By subordinating in the same way and to the same end all areas of intellectual creation, by occupying men's senses from the time they leave the factory in the evening to the time they clock in again the next morning with matter that bears the impress of the labor process they themselves have to sustain throughout the day, this subsumption mockingly satisfies the concept of a unified culture...(Horkheimer and Adorno, 1972, p. 131).

Needless to say, Horkheimer and Adorno would have castigated the cultural impact of any director like Spike Lee who is thoroughly integrated into the structures of Hollywood and Madison Avenue. Certainly, Lee's advertisements for corporations like Nike can be regarded as having exactly the mind-numbing, conformist, distracting influence that the Frankfurt School warned about.

Kellner suggests "the critical focus on media culture from the perspectives of commodification, reification, ideology, and domination provides a framework useful as a corrective to more populist and uncritical approaches to media culture which tend to surrender critical standpoints" (1995a, p. 30). Thus, the approach I take in my critical analysis of Spike Lee's body of work is one that focuses on issues of ideology, power, and commodification. Yet it is also balanced by a theoretical understanding of the multivalent possibilities of popular culture rooted in the British cultural studies tradition.

Contesting Paradigms II: Critical Theory and Cultural Studies

Limitations of the Frankfurt School Approach

Kellner (1995a) also recognizes that the Frankfurt School approach possessed some inherent limitations and weaknesses. For one, the scholars in the tradition of the Frankfurt School supported a rigid distinction between high and low culture, with "authentic art" (classical music, literature, etc.) privileged as true culture and popular films and the like denigrated as mindless, empty, "mass" culture (Kellner, 1995a, p. 29). Furthermore, they suggested that intellectual discipline is required in order to have a true appreciation for authentic art. These clear-cut boundaries are overly simplistic and leave no room for intellectually challenging yet popular forms that make a unique artistic contribution or that serve to challenge social norms, such as many of Spike Lee's films like *Do the Right Thing* (1989), *Malcolm X* (1992), or *Bamboozled* (2000).

In addition, theorists associated with the Frankfurt School (perhaps stemming from their firsthand experience with the rise of Nazism in Germany) tended to be overly pessimistic in their view of the effectiveness of the culture industries in exerting total control over the mass of individuals through propaganda. This tendency makes the possibility of resistance seem unachievable, except in the individual cries of outrage emanating from intellectuals and academics like themselves.

British Cultural Studies

A different take on popular culture emerged in Britain toward the end of the 1950s, one that sought to develop critical theory while also addressing some of the shortcomings of the Frankfurt School approach. This project is most associated with theorists like Raymond Williams, Richard Hoggart, E.P. Thompson, and, a bit later, the Birmingham Centre for Contemporary Cultural Studies and Stuart Hall (Hardt, 1992; Kellner, 1995a).

British cultural studies concerns itself with the sociological aspects of culture and how societies produce and reproduce the social order. From this perspective, popular culture may both reinforce social domination and/or empower individuals and groups to resist this domination. The founders of the British cultural studies tradition viewed society as a hierarchical web of

empowering and disempowering relationships based in class, gender, race, and other social stratifications (Kellner, 1995a).

This emphasis on both domination and resistance within the framework of media culture provided an alternative to the overly pessimistic view of the Frankfurt School. From the perspective of cultural studies, cultural artifacts like popular films are invested with varied and complex ideological tendencies and are used in multiple ways by the audiences who engage with them. From this perspective, viewers, readers, and listeners are not simply uncritical consumers swallowing the culture industries' messages whole, but rather they are active readers and interpreters of cultural texts (Butsch, 2015).

Stuart Hall (1980), one of the leading figures in the British cultural studies movement, makes a distinction between the messages that are *encoded* into cultural artifacts and the messages that may be *decoded* by media audiences. It is worthwhile to examine this argument in some depth, because the power of audiences to resist and subvert cultural domination is at the core of the distinction between cultural studies and Frankfurt School critical theory.

Hall finds "no necessary correspondence" (1980, p. 47) between the encoded message and the decoded message. This means encoders (filmmakers like Spike Lee, media producers, authors, institutions, etc.) can have intended or preferred messages in their texts, with no guarantee that these are the messages that decoders (readers, viewers, listeners) will glean from the material. Hall points out that there will usually be some level of agreement or correspondence between the two, or else communication itself would be impossible, but there is rarely a perfect relationship because this would mean communication is a flawless method for the simple transmission of messages.

Hall (1980) identifies three potential categories of meaning that a reader/viewer/listener may derive from a media text. The first, which Hall calls the "dominant-hegemonic position" (1980, p. 47), closely aligns with the intended or preferred message of the media producer. This would be equivalent to an uncritical reading of a Lee film like *She's Gotta Have It* (1986) that takes the narrative at face value without questioning the assumptions of the language used, images portrayed, and (patriarchal) perspectives privileged. Hall remarks that the standard practices and frameworks provided by media professionals tend to reinforce this type of position. For example, journalists routinely rely on government officials for news stories about military operations without any acknowledgment that these officials only provide one particular perspective on issues such as national security, the need for military interventions overseas, and defense budgets. These frameworks are presented

as informed, natural, and logical, but they eliminate a wealth of alternative perspectives from consideration. By way of example, Messaris (1993) points out that reviews of *Do the Right Thing* (1989) offered definitive opinions about the "message" of the film that tended to ignore inherent ambiguities in the text.

The second potential position, which Hall labels the "negotiated code or position" (1980, p. 48), accepts the dominant view in a large, global, or abstract sense, but provides a different reading to local or personal implications. For example, viewers of a news broadcast about government surveillance may generally accept the view that personal rights of privacy must be compromised to ensure national security, while at the same time taking exception to the idea that their own social media may be accessed. Similarly, a female viewer of *She's Gotta Have It* might thoroughly enjoy the film and embrace the characters while simultaneously insisting that she would never let a man do to her what Jamie does to Nola. Audiences of *Do the Right Thing* may feel outrage at the bigotry that Lee exposes and yet continue to behave in a bigoted fashion in their own lives. As Hall points out, there are obvious contradictions inherent in these negotiated positions, but under most conditions these contradictions will be unacknowledged.

Finally, Hall identifies the "oppositional code" (1980, p. 49) implemented when viewers reject both the global and the local implications of a media text and provide their own contrary reading to what is suggested by the images, sounds, language, etc. This oppositional perspective has the potential to become a highly politicized point of view; critical of, and resistant to, the dominant ideological assumptions of media texts. Feminists who were outraged by the patriarchal violence of *She's Gotta Have It* are one such example of oppositional respondents.

Whether an audience member adopts a dominant, negotiated, or oppositional reading of a particular media text is dependent on a wealth of variables including the social and cultural position of the perceivers themselves as well as the relative ambiguity of the text that they are decoding. An ambiguous text like *Do the Right Thing* provides a large swath of conceptual space for multiple readings and interpretations. Kellner (1995a) suggests that some texts are more open to a multiplicity of readings than others, which tend to be relatively definite and closed in terms of the potential for diverse interpretation. Spike Lee's films, for example, are often subjected to a wide range of interpretations, which suggests that they are complex and nuanced texts that are relatively open to various decoding possibilities.

Thus, while Frankfurt School theorists identified media culture pejoratively as "mass culture," the cultural studies tradition prefers the term "popular culture" which emphasizes what people actually do with the materials that the culture industries provide. As Kellner points out, cultural studies focuses on "struggle and resistance…against structural relations of inequality and oppression" (1995a, p. 32) and sees popular culture as a resource that provides rich materials for oppositional perspectives.

Celebratory Cultural Studies

This perspective on popular culture as empowering is not unproblematic, however. Kellner (1995a) and Butsch (2015) both note that as the cultural studies approach developed, especially in the United States, a tendency to celebrate all forms of media culture and all variations of audience reception as equally oppositional or resistant emerged. Thus in the work of cultural studies scholars like John Fiske (1989a, 1989b), the nature of the resistance is often neglected, leading to the glorification of apolitical, mostly symbolic gestures. An example of this would be the wearing of ripped jeans or other forms of stylistic posturing (body piercing, tattoos, "grunge" style), which, one could argue, are examples of conformity to the imperatives of fashion. The widespread appropriation of Malcolm X-inspired apparel that accompanied the release of Lee's film biography in 1992 can be seen as this type of cultural expression that plays out through the conspicuous display of commodities.

The celebratory trend in cultural studies aligns with corporate perspectives that tend to validate and legitimize the culture industries themselves (Gitlin, 1997; Golding and Murdock, 1996; Kellner, 1995a; McGuigan, 1992). Political, social, and economic repression and inequities may become lost amidst the celebration of "resistance." Gitlin's sarcastic tone doesn't detract from the importance of his insight when he writes:

> However unfavorable the balance of political forces, people succeed in living lives of vigorous resistance! Are the communities of African Americans or Afro-Caribbeans suffering? Well, they have rap! (Leave aside the question of whether all of them want rap in equal measure) (1997, p. 33).

The dilution of the political thrust in cultural studies occurs when the possibility of opposition blurs with the assumption that audiences are always actively and politically resistant. Going to the mall to buy a Malcolm X hat after seeing Lee's film should not be mistaken for an act of political resistance.

As Tester (1994) argues, it is a huge conceptual leap from the statement that audiences have the *potential* to resist dominant ideologies to the statement that this is what actually happens in everyday media use. Butsch writes: "Unfortunately, usage of the term [resistance] has gravitated toward a suggestion of something more forceful, self-conscious, politically motivated, fully formed, and *effective* than was originally intended" (2015, p. 91, italics in the original).

These very different theoretical perspectives, the Frankfurt School at one end of the continuum and Fiske at the other, are both open to critique based on their tendency to represent the cultural industries as either (1) monolithically powerful and totalizing, or (2) basically ineffectual due to the inherent tendency for audiences to resist and deconstruct media images and stories.

Contesting Paradigms III: Cultural Studies and Political Economy

A response to some of the shortcomings of both of these paradigms can be offered by integrating the theoretical and methodological perspectives of political economy into a critical cultural studies project. This statement is actually an ironic one because, as Garnham points out, cultural studies began as a project based in Marxist and political economic perspectives, and these perspectives remain at the center of its theoretical foundation:

> The founding thrust of cultural studies in the work of Raymond Williams and Richard Hoggart, was, first of all, the revalidation of British working-class or popular culture as against elite, dominant culture, as part of an oppositional, broadly socialist political movement. Thus, cultural studies took for granted a particular structure of domination and subordination and saw its task as the ideological one of limitation and mobilization (1997, p. 57).

Political economy concerns itself with how systems of material production condition and influence social relations in a given economic structure. In regard to culture and communication, Golding and Murdock state the basis for this line of theory and research clearly and succinctly: "Different ways of financing and organizing cultural production have traceable consequences for the range of discourses and representations in the public domain and for audiences' access to them" (1996, p. 11).

As Garnham (1997) points out, culture is an intrinsic part of capitalism as it is in any political or economic system. No economic system

can survive without cultural institutions that validate and legitimize its existence. Under capitalism, media and culture are treated as commodities just as material goods are. Therefore cultural products exist simultaneously in the economic and ideological spheres. These roles are often compatible, as when ideologically conservative films like *Rambo* (1982), *Top Gun* (1986), *Black Hawk Down* (2001), or *Zero Dark Thirty* (2012) are also successful economic products. But these roles can also come into conflict, for instance, in the need for media to constantly present novel and sometimes challenging ideas from artists like Spike Lee in order to sustain audience interest. While a political economic perspective recognizes that "culture is produced within relationships of domination and subordination and thus reproduces or resists existing structures of power" (Kellner, 1997a, p. 105), it also recognizes that, in actual practice, this process does not occur this simply or in any direct, guaranteed fashion. The rather schizophrenic role that media culture plays in capitalist society as both intellectual and material capital results in some inherent ruptures when ideologically challenging positions leak through in commercially produced texts. Some of the more controversial moments in Spike Lee's films (Nola Darling's sexual adventurism in *She's Gotta Have It*, Mookie's act of rebellion in *Do the Right Thing*, Malcolm X's calling out of white supremacy in *Malcolm X*, etc.) explored in subsequent chapters are prototypical examples of this type of stretching of hegemonic boundaries.

The examination of these tensions is essentially the theoretical basis for the original projects of both cultural studies and political economy. But, as Kellner (1997a) points out, cultural studies as it developed and spread, seemed to turn away from its basically Marxist, political economic roots as it shunned any type of work that might possibly be given the dreaded label of "economic reductionism." Regarding trends in cultural studies, Kellner writes: "[E]conomics, history, and politics are decentered in favor of emphasis on local pleasures, consumption, and the construction of hybrid identities from the material of the popular" (1997a, p. 104). This neglect of history, economics, and politics in favor of consumption and the pleasures derived from media culture is startlingly close to the mission of the culture industries themselves. Thus, by losing touch with its political economic roots, cultural studies risks losing its power as a politically radical movement while becoming essentially an apologist for the culture industries. In subsequent chapters I thus attend to the content and reception of Lee's films *and* to the political economic factors behind their production and distribution.

In fact, elements of all of the contesting paradigms reviewed in the previous pages are incorporated into my critical inquiry into Lee's films: the media effects tradition's concerns about the impact of film and other media on social relations, the textual examination of ideology favored by the Frankfurt School, the insights of cultural studies into multivalent audience interpretations of meaning, and the political economic analysis of the modes of capitalist production in the film industry are all utilized in a multiperspectival approach to the prolific output in cinema and advertising created by Spike Lee since 1986.

Butsch (2015) argues for a critical project that recognizes both audience resistance to, and incorporation by, the media industries. Kellner (1995a) proposes a transdisciplinary, multiperspectival approach to media culture. My focus on ideology highlights one element of concern that is common to three of the paradigms noted above (critical theory, cultural studies, and the political economy of communication). Ideology and hegemony are key components to a critical understanding of media artifacts like Spike Lee's films and advertisements, thus in the next section of this chapter I offer a brief review of the development of these concepts as they pertain to critical media studies.

Origins of Ideology

In her critical take on Lee's *She's Gotta Have It* (1986), hooks points out that "every aesthetic work embodies the political, the ideological as part of its fundamental structure. No aesthetic work transcends politics or ideology" (2008, p. 2). The examination of ideology in media texts highlights the role that mediated culture like popular cinema plays in legitimizing, reinforcing, questioning, or at times challenging, the political hegemony of capitalist modes of production. As Hall has suggested, "…in any theory which seeks to explain both the monopoly of power and the diffusion of consent, the question of the place and role of ideology becomes absolutely pivotal" (1982, p. 86).

Ideology, however, is a slippery term whose meaning has changed as it has developed over time. There is little agreement among scholars on what precisely ideology is, never mind the more complex questions of how it functions or what role it plays in social formations. Whether ideology plays any role whatsoever in the modern world has itself been questioned by some scholars (e.g., Bell, 1960) as well as by many postmodernists (see Chambers, 1996; Grossberg and Hall, 1986). Much of the debate regarding ideology is grounded in the fluctuating definitions of the term itself (Waxman, 1968).

Originating around the time of the French Revolution the term ideology was used as a categorization of the scientific study of ideas, an attempt to understand the human psyche scientifically rather than metaphysically (see Eagleton, 1991; Lichtheim, 1967; Williams, 1976). This sense of ideology carries little of the negative connotations that would soon come to be associated with the term. Napoleon Bonaparte is often cited as the figure most responsible for attaching a pejorative association to the word (Eagleton, 1991; Lichtheim, 1967; Williams, 1976). Williams (1976) points out that Napoleon's use of the term to attack any type of social theory (and in particular, *revolutionary* ideas) as disconnected with the operations of the "real" world was successful in that it soon became the popular sense of the word.

Marxist Perspectives on Ideology

Eagleton (1991) and Williams (1976) both trace the next stage in the development of the concept of ideology to Marx and Engels, particularly in the 1846 work, *The German Ideology*. Here we find: "Life is not determined by consciousness, but consciousness by life" (Marx and Engels, 1981, p. 47). This insistence that the way we perceive the world is not arbitrary, but rather that it is grounded in the realities of our material existence, is a rejection of the prevailing metaphysics of nineteenth-century Germany and sets the stage for Marxist revolutionary politics. As Eagleton (1991) alludes, if the delusional thinking that Engels called "false consciousness" (cited in Williams, 1976, p. 155) is rooted in the inequities of the systems of material production, then one can only attempt to eradicate social illusions by attacking the institutions that are their source.

There is a connection here to a positivist claim that ideology is a distortion of objective reality. Marx and Engels, however, go far beyond a simplistic positivist stance by recognizing the social and historical factors that influence how reality itself is perceived:

> The ideas of the ruling class are in every epoch the ruling ideas, i.e. the class which is the ruling *material* force of society, is at the same time its ruling *intellectual* force. The class which has the means of material production at its disposal, has control at the same time over the means of mental production, so that thereby, generally speaking, the ideas of those who lack the means of mental production are subject to it (Marx and Engels, 1981, p. 64).

Marx's conceptualization of ideology is further complicated by an eventual shift from his position that ideology is primarily the province of the elite,

the means by which the ruling class sustains its dominance, to his later work, which suggests that there is a potential for class struggle to be found in competing ideological perspectives. In 1859, Marx referred to "[T]he legal, political, religious, aesthetic, or philosophic—in short ideological forms in which men become conscious of this [economic] conflict and fight it out" (Marx and Engles, 1968, p. 183). Eagleton (1991) makes the point that this statement contained no reference to falsehood or illusion. Marx came to conceptualize ideology as the province of all classes, not just the elite. Williams in fact identified three versions of Marx's conceptualization of ideology:

> (i) a system of beliefs characteristic of a particular class or group; (ii) a system of illusory beliefs—false ideas or false consciousness—which can be contrasted with true or scientific knowledge; (iii) the general process of the production of meanings and ideas (1977, p. 55).

The third version suggests the centrality of ideology in the processes of representation and signification that are channeled through media. The central questions I explore regarding the ideological values of Spike Lee's films and advertisements are derived from this conceptualization of ideology, albeit a conceptualization enhanced by the advancements of Louis Althusser and Antonio Gramsci.

Althusser on Ideology

Since the 1970s, critical media and cultural studies scholarship has drawn on Althusser's neo-Marxist conceptualizations of ideology. Althusser delineates two institutions of social control: "the Government, the Administration, the Army, the Police, the Courts, the Prisons, etc...the Repressive State Apparatuses" (1971, p. 143) and the "Ideological State Apparatuses" (p. 143): religious, educational, legal, familial, and political systems, as well as cultural institutions. The cinema may thus be thought of as a primary component of the Ideological State Apparatuses. Cinematic productions such as the films of Spike Lee therefore offer fertile ground for digging into the ideological assumptions of a culture.

Althusser writes, "the Repressive State Apparatus [RSA] functions 'by violence' whereas the Ideological State Apparatuses [ISA] function 'by ideology'"(1971, p. 145). Amending this, he goes on to note that both apparatuses actually rely on violence *and* ideology, but the primacy of the method differs. For example, the military rely on propaganda to win consent to their

violent missions. From this perspective, Lee's advertising campaigns for the U.S. Navy may be considered a primary instance of the cozy relationship between the ISA and the RSA.

While Althusser (1971) briefly suggests that the ISA are the arenas where class struggles are contested, he maintains that ultimately "the ideology by which they function is always in fact unified, despite its diversity and its contradictions, beneath the ruling ideology, which is the ideology of 'the ruling class'" (1971, p. 146). It is this closure in his theory that has been most disputed (e.g., Bennett, 1982; Hall, 1982). Bennett suggests that Althusser's theory "tends to represent capitalism as a totally coherent social system... lacking internal conflict at either the economic, political or ideological levels" (1982, p. 53). According to critics, this tendency leads to an overly functionalist position that belies the contradictions and tensions inherent in capitalism. These contradictions are often revealed in media culture texts like films and television shows. For example, the conflicting archetypes of the "lone rugged individual" versus that of the "devoted family man" displayed in many media texts, including Lee's 1990 film, Mo' Better Blues. Or, we could find contradictions in Lee's glorification of the military in his recruiting ads, and in much of his WWII film Miracle at St. Anna (2008), coupled with his criticisms of the police in several films. Do the Right Thing (1989), for example, offers a particularly powerful indictment of quasi-militaristic policing in black communities. As Guerrero argues:

> More than any other issue on Do the Right Thing's complex representational agenda, though, the film's astute and timely focus on police brutality, in all of its attendant, corrupt expressions, will always rank it as one of the most socially relevant and prophetic masterpieces of American cinema...the issues that Do the Right Thing has most expressly framed and persistently forecast—police brutality, racial profiling and the pervasive, differentially ill, treatment of communities of colour by the nation's police departments—are still stubbornly with us (2001, pp. 70–71).

So, contrary to what Althusser's (1971) framework might suggest, even when in the hands of the same auteur there are moments when the ISA might profoundly challenge the practices of the RSA (Do the Right Thing), while at other times they work in harmony with one another (Lee's recruiting ads for the Navy, most of his 2008 WWII film Miracle at St. Anna). Althusser ultimately argues that only the "bad subject" (1971, p. 181), the social deviant, is in need of the RSA to hold their deviance in check. Lukes deals explicitly with this notion of subjection to the social order when he writes that individuals

"accept their role in the existing order of things, either because they see it as natural and unchangeable, or because they value it as divinely ordained or beneficial" (1975, p. 24).

Althusser offers the example of a person on the street interpellated by the policeman's cry of "Hey, you there!" The person freezes, looks over their shoulder, certain that they themselves are being hailed. Instantly the innocent individual becomes a subject of the surveillance state. Compliance is expected and usually given. We could consider Lee's recruiting ads as a call to good subjects to respond to the needs of the national security state, or his advertisements for Nike as an interpellation of his fans as good consumers, while, in a contradictory fashion, many of Lee's films interpellate the audience as sympathetic to critiques of powerful institutions like fraternities (*School Daze*, 1988), the police (*Do the Right Thing*, 1989), big time college athletics (*He Got Game*, 1998), the television industry (*Bamboozled*, 2000), pharmaceutical companies (*She Hate Me*, 2004) international banking (*Inside Man*, 2006), or organized religion (*Red Hook Summer*, 2012).

Hegemony and Counter-Hegemony

While agreeing with many of his basic propositions, Stuart Hall (1982) critiques Althusser for painting dominant ideologies as all-powerful. He offers Gramsci's understanding of hegemony as a more useful insight into processes of both social control and social conflict. Hall says from a Gramscian perspective "reality could no longer be viewed as simply a given set of facts: it was the result of a particular way of constructing reality" (1982, p. 64). Gramsci analyzes the ways that the ruling class in a given society tries to win consent to their power. This is the process of hegemony. While closely related to certain conceptualizations of ideology, there are some crucial distinctions between the two terms. Both Williams (1977) and Eagleton (1991) examine the relationship between hegemony and ideology and suggest that hegemony is a broader concept that explains more about the total process by which intellectual control is defended in a society. Hegemony does function ideologically, but it also has cultural, political, and economic force (Eagleton, 1991). Williams writes:

> Hegemony is...not only the articulate upper level of "ideology" nor are its forms of control only those ordinarily seen as "manipulation" or "indoctrination." It is a whole body of practices and expectations, over the whole of living: our senses and assignments of energy, our shaping perceptions of ourselves and our world. It is a lived system of meanings and values...It thus constitutes a sense of reality for most people

in the society, a sense of absolute because experienced reality beyond which it is very difficult for most members of the society to move (1977, p. 110).

Hegemony works when it is invisible, suffused through the practices of day-to-day routines. Gramsci (1971) saw the notion of "commonsense" as crucial to hegemonic ways of thinking. Critical scholars have identified this as a key to understanding how hegemony helps to invisibly support the status quo (e.g., Gitlin, 1980; Williams, 1977). When hegemonic, particular ways of thinking are thought to be universal, simply a matter of the "natural order of things."

Culture and media play a powerful role in establishing hegemonic "ways of seeing" (Berger, 1972). For example, Walter Cronkite would sign off his 1960s and 70s evening news broadcast with the assured and assuring phrase, "…and that's the way it is," after having just presented to viewers *a particular* way of looking at unfolding events. This can even happen with obviously fictitious forms of media. Lubiano (2008) points out that Spike Lee's films are often discussed in public discourse as if they are representative of a "real" picture of social conditions.

The importance of media culture in defining a generation's notion of "commonsense" is central. There are a bevy of hegemonic ideas that have taken on the status of commonsense values in various eras of United States history including: the virtues of individualism and consumerism; the perception of America as a classless society and of poverty as a moral failing; the acceptance of a patriarchal and ethnocentric hierarchy; and the need for a large, well-armed military even in times of peace, to name just a few. Even forms of media culture that on the surface seem to suggest a spirit of rebellion can often be found to reinforce hegemonic notions. The "angry" rock band The Who told us they "Won't Get Fooled Again" (featured on the soundtrack of Lee's *Summer of Sam* in 1999) by the call for political revolution. "Meet the new boss, same as the old boss" they cynically sang in 1971—to audiences who were presumably still at least a little hopeful that the social movements of the 1960s could generate real change. The idea encoded in this song's lyrics, that political activism leads nowhere, or as Kavanagh notes "every revolution just leads to worse tyranny" (1990, p. 309), is a hegemonic idea disguised as commonsense. As I argue below, this dismissal of collective political action echoes through many of Lee's films from *Do the Right Thing* (1989) to *Bamboozled* (2000). Elevating a particular perspective such as this to the status of commonsense can often deflect analysis and critique.

So far, not so removed from Althusserian conceptualizations. However, Gramsci notes that as powerful as hegemonic ways of seeing may be, they are not unchanging. Hegemonic notions are always in process, always evolving.

In the United States, for example, in the 1950s, political and social conformity was expected as the cultural norm by the white middle and upper classes, but during the 1960s and 1970s this norm was challenged and transformed by social movements for peace, women's liberation, civil rights, and gay rights, only to retrench during the 1980s when Lee's first few films would challenge the reassertion of conservative social and political values in the age of Reagan.

Drawing on Gramsci, Williams argues hegemony "has continually to be renewed, recreated, defended, and modified. It is also continually resisted, limited, altered, challenged by pressures…" (1977, p. 112). Hegemony always exists in a dialectical tension with counter-hegemonic forces. Feminism, for example, challenges hegemonic assumptions about gender. The Black Power movement challenged white supremacy. Movements for gay rights challenge heteronormative assumptions. As Williams note there are always "forms of alternative or directly oppositional politics and culture" (1977, p. 113) countering hegemonic power structures. I draw on this notion in this book by examining the work of a filmmaker who, through the complexity of his films, advertisements, and public persona, seems to defy any simple categorization as mainstream, alternative, or oppositional.

Mainstream, Alternative, and Oppositional Media

Williams' (1977) work on counter-hegemonic cultural expression identifies that it is not only audiences that may be resistant to dominant ideological assumptions, but cultural texts themselves may privilege positions that represent some manifestation or combination of at least three potential ideological perspectives: mainstream, alternative, oppositional. In the following sections, I offer some broad definitions for each of these terms, bearing in mind that it is the nature of hegemony to be in a constant state of flux, adapting and changing to social forces and movements. Therefore, what is mainstream, alternative or oppositional in relation to the hegemonic order must be considered as mutable and historical rather than fixed and eternal.

Mainstream Media

Mainstream media may be considered those cultural forms that represent dominant ideological perspectives that serve to reinforce the hegemonic ideals of a given period in a given society although, due to the mutability of

hegemony, this is not an uncomplicated mission. For example, discussing 20th century capitalist society, Gitlin suggests:

> In the United States, at least, hegemonic ideology is extremely complex and absorbitive; it is only by absorbing and domesticating conflicting definitions of reality and demands on it, in fact, that it remains hegemonic...it urges people to work hard, but proposes that real satisfaction is to be found in leisure...there is a tension between the affirmation of patriarchal authority...and the affirmation of individual worth and self-determination...(1994, pp. 516–536).

Thus, the dominant ideology of the United States in any given historical era is rife with contradictions, with basically paradoxical notions working together to reinforce the existing social order of power inequities. This reinforcement is not always completely successful. Sometimes ruptures occur that threaten the stability of the system. For example, consider one of Lee's central concerns as a filmmaker: race. America has always been conflicted in regard to the values of freedom, justice, and equality that are considered an essential part of the American experience. The white supremacist ideology that now dwells mostly under the surface, however, is inadvertently displayed in films and television shows that present stereotypical and demeaning portrayals of nonwhite culture. Occasionally these contradictions are brought to the surface by organized social movements, by sporadic outbursts of civil unrest, or even by the work of the rare filmmaker like Lee who forces moviegoers to confront racial disparities and animosities.

White privilege is now often cloaked in the ideological ideal of a "colorblind" society where all participants should be afforded opportunities without *any* regard to race. Advocates of this position frequently look to the successes of media icons while ignoring empirical evidence that opportunities and resources are not equally distributed in the day-to-day world. As Leonard puts it: "The predominance of black artists and artists of color, from J-Lo to Beyonce, within consumer culture, as well as their personal and financial successes, overshadow the realities of segregated schools, police brutality, unemployment, and the white supremacist criminal justice system" (2006, p. 10). The election, and subsequent reelection, of Barack Obama as president of the United States has only seemed to fuel the notion that we now live in a truly post-racial society (Wise, 2012). Lee's own successes in Hollywood and on Madison Avenue seem to many to embody this notion of a post-racial environment. Even Lee himself was quoted in a 2008 *New Yorker* profile saying that Obama's election: "Changes the whole dynamic. If we have a black president, maybe

it will change peoples' psyche. This is a sweeping movement. It's bigger than him, it's bigger than all of us. I think this is going to be such a pivotal moment in history that you can measure time by B.B., Before Barack, and A.B., After Barack"(quoted in Colapinto, 2008).

However, while a color-blind society may be a worthy utopian ideal, it is not the reality of everyday life where, as Cornel West suggested in the title of his landmark 1994 book, *Race Matters*. Critical race theorists point out that the hegemonic depiction of America as a land of equal opportunity disguises the reality of ongoing inequities and racial discrimination while masking the essentially racist positions behind outcries against "racial preference" (see, for example, Bonilla-Silva, 2014; Delgado and Stefancic, 2001; Wise, 2010; West, 1994). The ideology of colorblindness also teaches us much about those critics who responded to Lee's films that deal explicitly with issues of racial conflict by accusing Lee himself of perpetuating racism. The myth of a post-racial society is a primary example of how hegemonic ideology can absorb contradictory perceptions of reality.

There is one constant, moreover, one core theme that is most indicative of the ideological values privileged by American hegemony (and by mainstream media). Gitlin identifies this essential stance in this way:

> [T]he dominant ideology has shifted toward sanctifying consumer satisfaction as the premium definition of "the pursuit of happiness," in this way justifying corporate domination of the economy. What is hegemonic in consumer capitalist ideology is precisely the notion that happiness, or liberty, or equality, or fraternity can be affirmed through the existing private commodity forms, under the benign, protective eye of the national security state (1994, p. 536).

This equating of happiness and freedom with commodities, what many critics refers to as "consumer culture" (Kellner, 1995b, p. 329), is the ideological core of what may be considered mainstream media in the United States. The sanctity of this ideology explains why a supposedly radical public figure like Spike Lee can simultaneously operate as a shill for a colonialist international mega-corporation like Nike.

Alternative Media

Unlike mainstream media, alternative media culture represents images, lifestyles, and perspectives that offer a "distinct but supplementary and containable view of the world" (Gitlin, 1994, p. 536). As discussed in the previous

chapter, the mainstream media often marginalize, neglect, and stereotype large segments of American society. As Kellner (1995a) points out, the dominant ideological subject position under western capitalism is most often the privileged positions of the dominant groups in those societies: white, male, heterosexual, middle-to-upper class. Those who do not fit this mold must create their own forms of media that represent an alternative to the mainstream (Downing and Husband, 2005; Kessler, 1984). Lee has often explicitly referred to his mission as a filmmaker as offering an alternative to mainstream Hollywood's demeaning and one-dimensional representations of black life.

Rodriguez defines the essential quality of alternative media as the attempt to regain the power that is implicit in representation:

> [G]enuine alternative media provides the opportunity to create one's own images of self and environment; the ability to recodify one's own identity with one's own signs…the chance to become one's own story-teller, regaining one's own voice, and the reconstruction of one's own community and culture (1996, pp. 63–64).

Thus, historically in the United States, there have always been efforts by various social groups—racial and ethnic minorities, women, gays and lesbians, radical political parties, non-traditional religious and philosophical communities—to create their own newspapers and magazines, radio broadcasts, videos, and independent films (Downing and Husband, 2005; Kessler, 1984). Today many of these alternative productions proliferate on the Internet.

Alternative media are also an alternative source of power for individuals and communities that are often depicted as powerless by media scholars and critics. While acknowledging the power that alternative cultural production offers, we must also recognize that this power is limited. Although some corporate-sponsored media texts may represent alternative views or lifestyles (for example, the recent proliferation of GLBTQ characters on television, see Sender, 2004, or key moments in many of Lee's films, particularly his early feature films and his more recent documentaries), more often alternative media are shackled by low budgets, inferior technology, and limited distribution capabilities that translate to small audiences. This is still the case in the age of the Internet as bloggers and independent music and video producers still face the very difficult task of making their work known to a potential audience (McChesney, 2013).

This power is also limited because alternative media texts (unlike oppositional media texts considered below) do not challenge the core hegemonic positions of the mainstream. The power that comes from regaining one's own

voice should not be confused as synonymous with an oppositional stance. As Riggins (1992) points out in his analysis of ethnic minority media, alternative forms of media are often economically or politically conservative in outlook and are not immune to perspectives that support and reinforce the dominant ideology. Thus, as Gitlin (1994) suggests, alternative media can present novel, unconventional ideas without really challenging the foundation of a society's institutional values. This, in fact, is a critique that has been aimed at Spike Lee's overall body of work (see Denzin, 2009; Guerrero, 1991; Lubiano, 2008; among others).

Oppositional Media

Truly oppositional media does exist (on both the left and the right—consider Adbusters' anti-corporate publications and website as well as the media of far-right hate groups) but it tends to be poorly funded and limited in the range and number of people that it reaches. Oppositional media that question the most basic assumptions of latter-day capitalism—the classless colorblind society, the sanctity of consumerism, the importance of national security, and other sacred notions—is much rarer and cannot be as easily absorbed into the hegemonic order as alternative media may be:

> Alternative material is routinely *incorporated*: brought into the body of cultural production. Occasionally oppositional material may succeed in being indigestible; that material is excluded from the media discourse and returned to the cultural margins from which it came, while *elements* of it are incorporated into the dominant forms (Gitlin, 1994, p. 536). (Emphasis in the original).

Gitlin (1994) refers to the example of the television drama *Roots*, which was alternative in its depiction of the cruel realities of American history, but not oppositional in its concluding promise of upward mobility and hope for the future. This is signified by ABC having changed Alex Haley's subtitle, "The Saga of an American Family" to "The Triumph of an American Family." Similarly, the political comedian Bill Maher, who had often criticized corporations and the government on his ABC talk show, found himself off the air, when, shortly after 9/11, he commented: "We have been the cowards. Lobbing cruise missiles from two thousand miles away. That's cowardly. Staying in the airplane when it hits the building. Say what you want about it. Not cowardly."

One of the issues I tackle in this book is the extent to which corporate-funded commercial media culture will tolerate ideologically oppositional

perspectives. Most critical media theory suggests that oppositional cultural expression will be rejected by mainstream media institutions. This leads to the question of how a filmmaker like Spike Lee, whose films seem to present radical and confrontational themes, has managed to not only survive but to thrive within the mainstream corporate film and advertising industries. I will attempt to answer this question in the subsequent chapters that turn their attention to an empirical and interpretive analysis of Lee's career and films.

Applying Critical Theory to the Films of Spike Lee

The theoretical paradigms I have discussed in this chapter provide the grounding for my analysis of ideology in Spike Lee's films. While this type of ideological analysis will always be an interpretive one, a rigorous application of theory and methodology can be utilized that will serve to ground this interpretation. In this book, my examination of ideology in Lee's films is conducted through a multidisciplinary approach that combines techniques from the field of film studies with a semiotic approach that is drawn from the field of linguistics and adapted for media studies. As explained above, my approach is largely derived from critical cultural studies and political economic analysis, both of which provide the overall context for interpretation. To explore Lee's films I utilize what Kellner (1995a) identifies as a multiperspectival approach to studying media culture. Kellner suggests that bringing a wide variety of theoretical and methodological approaches to the analysis of cultural artifacts enables more cogent reading of media texts. In the next section, I explain the techniques and procedures used to structure my analysis, and I discuss the various methodological approaches utilized in my close reading of Spike Lee's texts.

Why These Films?

Relying on a purposive sampling technique (Babbie, 2012), I chose three of Lee's major films for in-depth analysis. According to Babbie (2012), a purposive sampling technique is utilized when a researcher chooses a subset of units for analysis from a larger pool based on an evaluation of the nature of the research being conducted. While Lee has directed more than twenty feature films to date, I chose *She's Gotta Have It* (1986), *Do the Right Thing* (1989), and *Malcolm X* (1992), as representative of Lee's most important and most politically engaged films. All three films generated considerable controversy in both academic journals and the popular press regarding the politics of their

narratives and imagery. While *She's Gotta Have It* was Lee's first commercial release, the film that brought him national attention, *Do the Right Thing* and *Malcolm X* are his only two films chosen by the Library of Congress for inclusion in their prestigious National Film Registry.

In subsequent chapters I present my close analysis of the images, sounds, and language used in each of these films. In addition, I discuss ancillary media related to Lee and his films including movie reviews, trade journal stories, and popular press coverage of Lee's status within the mainstream film and advertising industries and his identity as a media figure. In the concluding chapter I expand my scope to a discussion of all of Lee's major films and where they fit in his overall body of work. I examine all of these texts by utilizing a number of applied theoretical practices: the auteur theory of film, feminist film theory, critical race theory, structural semiotics, the political economy of media industries, and ideological analysis.

Critical Film Theory

In studying Lee's films I have been influenced by several schools of thought regarding how film analysis is best conducted. Critics from the influential French film society, the *Cahiers du Cinema*, have pointed out that all films represent a particular ideological perspective or view of reality. According to Comolli and Narboni (1992), filmmakers have the potential to both reproduce and resist the dominant ideologies of their society (or to present a complex and contradictory combination of both resistance and reinforcement). Films may be subject to critical analysis to determine exactly how this potential is realized.

Regarding the ideological analysis of films, however, Turner (2006) cautions against the overly simplistic notion that movies unproblematically reproduce the dominant ideology. Often the ideology represented in a film will appear contradictory or ambiguous. Cinema simultaneously criticizes and celebrates the norms, values and traditions of a given society (Elsaesser, 1972). Some critics have suggested that Spike Lee's movies are an ideal exemplification of films that appear ambiguous or contradictory. My analysis highlights the ideological complexities and contradictions inherent in the work of this director who is paradoxically regarded as both a progressive and reactionary filmmaker. Three particular traditions in film analysis provide a theoretical grounding to this ideological analysis: the auteur theory of film, feminist film theory, and film semiotics.

The *auteur* theory of film (Wollen, 1992) suggests that a complete analysis of a filmmaker requires examining their work within the context of their entire range of productions. This can aid in uncovering the essential themes and meanings that lie at the heart of a filmmaker's body of work. Patterns of thematic meaning can only be revealed by examining an artist's creations as they relate to one another throughout a career and as they relate to the broader social context and media culture. As Sarris noted, institutional practices in the film industry can restrict what a filmmaker can and cannot do, but an auteur still eventually prevails in establishing their own style and vision: "The strong director imposes his [sic] own personality on a film" (1976, p. 246).

In a collection of essays on Lee and his films, Everett (2008), Harris (2008), and Watkins (2008), among others, note that Lee is exactly the type of filmmaker that the auteur theory celebrates. While classic auteur theory can often downplay the institutional and collaborative factors behind the production of cinema, deWaard argues that contemporary auteur theory has responded to poststructural challenges to the notions of authorship by shifting the focus from the lone individual to the individual embedded in a larger and more complex organizational and social web: "Rather than perceiving an auteur film as some sublime expression of individual genius, it is now regarded as a site for the interaction of biography, institutional context, social climate, and historical moment" (2009, p. 348).

By these updated criteria I agree with those like Lamb (2009) who contend that Lee should indeed be considered a contemporary auteur, despite the influence that Hollywood studios have had on his films since *She's Gotta Have It* (1986) (see Watkins, 1998, for one example of Hollywood intervention into the content of Lee's films). My analysis of Lee's films thus regards each as part of a greater whole, placing them in the contexts of both his other work as a filmmaker and advertiser and his status as an incorporated member of the mainstream culture industries.

Feminist film theory as developed by Haskell (1987), Mulvey (1992), and Rosen (1974), among others, is concerned with, "the exposure of the sexist content of cinematic narrative and the construction of images of women that simply express male fantasies..." (Thornham, 1997, p. xiii). 1970s feminist film theorists applied the work of feminist scholars like de Beauvoir, Friedan, and Millett, specifically to a project of deconstructing the patriarchal cinematic representations (and misrepresentations) of women, and identifying the political purpose of these images as a form of social control (Thornham, 1997). Feminist film theory has branched out into many varying theoretical positions,

including those that recognize that films may be read in a variety of ways both accepting and resistant to patriarchal ideologies (see Haskell, 1987). Feminist theory has been foundational to my exploration of representations of masculinity and femininity, sexuality, violence, and gender politics in Lee's films.

Furthermore, latter-day feminism embraces the notion of intersectionality—that class, race, ethnicity, sexuality, gender, etc. must all be taken into account when conducting cultural analysis. Therefore, I also draw on the precepts of critical race theory in my readings of Lee's films. Specifically, critical race theorists contend that race itself is a social construction, yet racism is an everyday, "normal" aspect of social life, because both the elite and the white working class benefit from systems of white supremacy. Furthermore, and central to my analysis of Lee's cultural contributions, Delgado and Stefancic argue that critical race theorists subscribe to the notion of a unique voice of color: "[B]ecause of their different histories and experiences with oppression, black, Indian, Asian, and Latino/a writers and thinkers may be able to communicate to their white counterparts matters that the whites are unlikely to know. Minority status, in other words, brings with it a presumed competence to speak about race and racism" (2001, p. 9).

Finally, in terms of method, Metz (1974) suggested that the structural linguistics method of semiotics may be utilized in film analysis as a means of determining the intended meanings of a film. This method is central to the development of textual analysis in cultural studies and to my approach to Lee's films and is therefore reviewed at some length in the following section.

Semiotics and Structuralism in Film Studies

Structural analysis of film and film semiotics are closely related theoretical perspectives. While semiotics is primarily concerned with language and texts, structuralism also engages with the cultural factors behind the texts themselves. Berger suggests that, "Semiology—the science of signs—is concerned, primarily, with how meaning is generated in 'texts' (films, television programs, and other works of art)" (1991, p. 3). Structuralism identifies the deep structures of relation and opposition that are inherent in all social, cultural, and communicative systems (Fiske, 1990; Seiter, 1992) and that can be uncovered in the texts produced by those systems. Regarding these techniques being applied specifically to the cinema, Giannetti suggests that "semiology is concerned with the systematic classification of types of codes used in the cinema; structuralism is the study of how various codes function within a single structure, within one movie" (2011, p. 475).

Both structuralism and semiotics are derived from the linguistic theories of Saussure (1959) who identified two elements to all signs: a signifier (a word, sound or image) and a signified (the concept evoked). The relationship between the two elements when it comes to language is arbitrary; there is no natural connection between a word and its meaning, we create the meaning through our conventional uses of language. Peirce (1992) introduced the idea that an interpreter is a necessary player in what can now be considered a triad of meaning: the mutual relationships of the sign to the object or idea and the interpretation suggested by the sign.

Because the meaning of words is arbitrary, they must be learned by the interpreters—members of the culture who use these signs. Words and many images, then, work through codes. These codes help us to understand our society and our own place within that society (Fiske, 1990). Barthes (1977) noted the difference between denotative and connotative significations of coded signs like words. Denotation is the direct relationship between the word/image and the idea it represents. Connotation can be thought of as still another level of meaning, one that is conditioned by personal or cultural associations.

By way of example, when Spike Lee opens his film *Jungle Fever* (1991) with alternating shots of Harlem and Bensonhurst the denotative meaning is simply "here are two neighborhoods in New York City." One possible connotative meaning: "despite integration, we still live in essentially segregated and polarized communities." This is suggested by the rhythms of the back-and-forth alternating shots of whites in Bensonhurst and blacks in Harlem. As Fiske says, "Denotation is *what* is photographed; connotation is *how* it is photographed" (1990, p. 86), while Seiter notes, "Connotative meanings land us squarely in the domain of ideology: the worldview (including the model of social relations and their causes) portrayed from a particular position and set of interests in society" (1992, p. 39). As Guerrero noted about the opening credit sequence of *Jungle Fever*: "One can often find a film's ideological perimeters early on in the manner and style in which its opening titles are rendered" (2008, p. 77). In this case, Lee's film reveals its antagonistic perspective on interracial romances right from the first moments:

> Symbolizing the fixity of Lee's perspective, the sign that announces the production is a "Spike Lee Joint" has a ONE WAY sign distinctly displayed underneath it. Adding to this visual cue the film's title itself is templated on the international, red, WRONG WAY traffic symbol. Moreover, the drift of these opening significations is re-enforced by the film's title, which taints the issue of intimate interacial relationships—i.e., miscegenation—with the metaphor of disease, a fever that one, presumably, is in danger of catching, but that can be cured (Guerrero, 2008, pp. 77–78).

These examples from *Jungle Fever* (1991) also highlight Saussure's essential argument that signs must be examined in relationship to one another. *Difference* is thus essential to both denotative and connotative meaning (Saussure, 1959). The relationship between signs in a larger sign system like a Spike Lee film can be examined from a structuralist perspective in order to determine these oppositionalities and the overall concept that ties them together (Berger, 1991). Berger uses the example of the opposing concepts of "rich" and "poor" being subsets of the broader conceptualization of "wealth" (1991, p. 7). This approach was the basis of Levi-Strauss' (1968) structural anthropological studies of myth and the coded messages contained within mythic structures of binarily opposed concepts. I utilize this approach with the films that I examine in subsequent chapters by delineating and charting the binary oppositions that aid in structuring meaning in the films.

Barthes (1957) was also concerned with myths, which, like Levi-Strauss, he viewed as the stories a culture uses to understand and explain reality. Regarding the way people actually use myths, however, Barthes and Levi-Strauss presented very different perspectives:

> For Levi-Strauss myth is a narrative that is recognized as a myth even if its meanings are not consciously negotiated by the people using it. For Barthes myth is an associated chain of concepts: people may well be conscious of the meanings of this chain, but not of its mythic character. Myth, for Barthes, disguises its very operation and presents its meanings as being natural; for Levi-Strauss, its operation is open, its meanings are what is hidden (Fiske, 1990, p. 132).

Thus, Barthes (1957) believed that myths ensure dominant ways of thinking in a given culture while presenting themselves as natural and non-ideological. Barthes' conceptualization of myth is similar in this way to Gramsci's (1972) notion of commonsense and hegemony.

Media culture, like film, may be considered the primary mode of expression for modern myths. Thus structural semiotic analyses of Lee's films can provide insights into the mythic and ideological underpinnings of these texts. My analysis thus aims to explain the mythic qualities of Lee's films and the hegemonic assumptions associated with these qualities. Metz (1974) developed a semiotic method specific to the study of cinema that I employ in analyzing Lee's films. Metz identified five primary channels of cinema: images, written language, and the three elements of the soundtrack: voice, music, and sound effects. I consider all of these channels in my close analysis of Lee's films.

Metz also proposed that cinema may be analyzed using the semiotic concepts of paradigms and syntagms. Paradigmatic analysis examines individual signs or units of meaning. Each shot in a film contains a multiplicity of signs that work together to suggest something to the viewer (Giannetti, 2011). These signs are encoded by numerous filmic conventions involving photography, mise-en-scene, movement, editing, sound, acting, setting, decor, costuming, narrative plot, and screenplay (Giannetti, 2011). Paradigmatic analysis is paired with syntagmatic analysis which examines how a number of signs are organized together sequentially into a sign system. Editing, montage, camera work and mise-en-scene determine how the individual signs will be ordered into a syntagm.

When creating a film individual signs must always be chosen from a set of available signs. From a structuralist perspective these can always be opposed to those that were *not* chosen. "The meaning of a given syntagm derives in part from the absence of other possible paradigmatic choices" (Seiter, 1992, p. 46). In a film, creative personnel like the director, writer, cinematographer, and editor choose what paradigms will be included and what will not, often working within the constraints of what the film studio and ratings board will allow. A given sequence of shots can be analyzed based on the choices that were made, as well as how these signs relate to one another in the sequence of order. As Woollacott (1982) points out, a structural reading of a film requires an examination of how different elements signify based on their relationship to one another in the larger structure. My analysis attends to the semiotic choices that Lee (as a director and writer) made in creating these films, and how the individual signs work together to present a coherent world within the confines of the screen.

By way of example, in *Do the Right Thing* (1989), a conversation about interracial romance plays out in front of a brick wall that has a graffiti scrawled on it. This message reads, "Tawana Told The Truth," a reference to a 1987 controversy when a young black woman claimed that she had been assaulted by a group of white men. Unremarked on in any other way in the film, this graffiti is an example of a paradigmatic sign and represents a conscious choice employed by Lee in an attempt to signify a particular point of view (see Dyson, 1993). An attempt may be made to decode this image by examining this sign paradigmatically (the choice of this sign rather than other choices that Lee could have made—another graffiti message, simply a blank wall) and how this sign is used syntagmatically with other signs in the film: the images and dialogue that play out in front of this graffitied wall, or the sequence of when this scene occurs in terms of the narrative demands of the film.

The final ordering of the sequence of all of the shots into a single film is an example of a syntagmatic chain, but syntagms can exist on a larger plane also. Seiter (1992) points out that the relationships *between* texts can also be examined paradigmatically and syntagmatically. The concept of intertextuality suggests that, "[t]he meanings generated by any one text are determined partly by the meanings of other texts to which it appears similar" (Fiske, 1990, p. 166). This can be realized through an examination of a particular genre or, as in the case of this book, by considering several of Lee's films chronologically as a syntagm. Giannetti suggests that, "[s]tructuralism is strongly eclectic and often combines the techniques of semiotics with other theoretical perspectives, such as auteurism, genre studies, ideology, stylistic analyses, and so on" (2011, p. 475). This is precisely what I do in subsequent chapters, with a particular emphasis on ideological analysis of Lee's films and advertisements.

Methods of Ideological Analysis and Spike Lee

Finally, in his review of methods of rhetorical criticism, Hart (1990) makes several points regarding Marxist criticism that are applicable to my focus on ideology. First, as noted above, economics is considered a crucial factor in shaping any form of text. Therefore, I consider the economic factors behind the creation of Lee's films as an essential part of the overall project of analyzing the texts themselves. My exploration of these factors is conducted through an examination of articles in trade journals, published interviews with Lee, and sections of Lee's published diaries that discuss the economic background behind the production of these films.

Second, this analytic approach proposes that all texts contain ideological messages that can be explicated. According to Hart, "The basic critical operation for the Marxist is one of 'rewriting' a text so that its ideological imprintings can be observed" (1990, p. 401). My detailed analysis of the five channels of meaning in Lee's films is just this sort of "rewriting."

Furthermore, Marxist critique considers texts to be representative of particular historical situations: "Ideological analysis is based on the assumption that cultural artifacts—literature, film, television, and so forth—are produced in specific historical contexts, by and for specific social groups" (White, 1992, p. 63). My examination of Lee's films places them in a social and historical context that identifies which of the many possible meanings of the films are indeed what Hall (1980) would call the preferred meanings. This historical context illuminates the conflicting and oppositional forces represented in the

THEORY AND METHOD 63

films and which forces tend to be favored. Giannetti proposed that, "every film has a slant, a given ideological perspective that privileges certain characters, institutions, behaviors, and motives as attractive, and downgrades an opposing set as repellent" (2011, p. 403).

My analysis of Lee's films, however, is also informed by Kellner's point that media culture texts:

> [R]arely coalesce into a pure and coherent ideological position. They attempt to provide something for everyone to attract as large an audience as possible and thus often incorporate a wide range of ideological positions. Still…certain media cultural texts advance specific ideological positions which can be ascertained by relating texts to the political discourses and debates of their era, to other artifacts concerned with similar themes, and to ideological motifs in the culture that are active in a given text (1995a, p. 93).

Thus, I explore the ideological ambiguities inherent in Spike Lee's work through a two-part process: focusing on the ideological tendencies of Lee's films and advertisements while also exploring Lee's evolution and development in the mainstream culture industries and the place of his output in the broader context of media culture and its social impact. This chapter has made transparent the theoretical positions that ground my subsequent analysis. Having established this framework we can now turn to the heart of the matter—the texts themselves.

·4·
SHE'S GOTTA HAVE IT, BUT HE ALREADY GOT IT

The next three chapters are devoted to what are arguably Spike Lee's most influential films. In order to offer a holistic analysis and interpretation of the ideological stances that are privileged in Lee's films, each of these chapters utilizes a multiperspectival approach (see Kellner, 1995a) by examining four aspects of the selected films: the political economic factors behind the production and distribution of each film, the films' narrative structures, critical reception of the films, and the semiotic structure of each film. The first film I turn my attention to is Lee's first major feature, *She's Gotta Have It* (1986). *She's Gotta Have It* is considered by many to be an historic film:

> [I]t inspired a critical dialogue about its filmmaker, its images, its place in independent film, and its status as an African American film at a time when black films and filmmakers were absent from the national and international scene…and it is not an overstatement to credit Lee with influencing a new wave of contemporary black filmmaking, a New Black Cinema movement, over the subsequent years (Massood, 2008, p. xviii).

Production Background

After graduating from the Tisch School of Fine Arts at New York University in 1982, Lee began his career as a financially struggling independent filmmaker,

completely disconnected from the corporate Hollywood milieu (Lee, 1987). As noted above, *She's Gotta Have It* was Lee's first film to garner commercial distribution but it was not his first attempt at commercial film production. In the summer of 1984 Lee attempted to shoot a film called *The Messenger*, which dealt with the travels of a bike messenger in New York. The production of this film was aborted due to a lack of funding, and the published version of Lee's journal is strewn with recriminations regarding the failure of this project (Lee, 1987). Lee did not let this setback derail his ambition however, and his journal also includes many references to retrenching and ensuring that *She's Gotta Have It* didn't meet the same fate. Lee used his previous failure as both a learning and motivational experience. Many comments in the production notes for *She's Gotta Have It* reflect his inner drive to see the film through to completion:

> My reputation was somewhat blemished from the fiasco this summer. I have to do everything within my power to see that this doesn't ever happen again...WHEN THE TIME IS RIGHT, *She's Gotta Have It* will get made (1987, p. 109).

> I pray to my maker every night that on this project...things will turn out all right. Lord knows I don't need another heartbreaker like *Messenger* (1987, p. 117).

> No way is what happened to me last summer happening again...My faith in my ability is unwavering, I will prevail with the film I envision, the movie I want to make (1987, p. 146).

Lee's commitment to filmmaking was a key factor in the successful completion of *She's Gotta Have It*, a film produced without any financial support from corporate funders or the Hollywood film studios. The entire budget for the film was pieced together from funds garnered from grants, small individual investors, and personal expenditures and debt incurred by Lee. Lee began with a script he had written about a sexually aggressive woman and her three male lovers. Recognizing that funding would again be an issue with this project as it was with his earlier endeavor, Lee wanted a film that could be made with very little money and still have commercial appeal (Lee, 1987).

Lee had earned an $18,000 grant from the New York State Council on the Arts intended for *The Messenger*, but the Council allowed him to apply it toward the making of *She's Gotta Have It* after the first film was abandoned. $10,000 came from a grant from the Jerome Foundation. Lee also applied for funding from several other sources including the National Endowment for the Arts, the Film Fund, the American Film Institute, the Brooklyn Arts and Cultural

Association, and the New York Foundation for the Arts. While some of these organizations did award him small sums of money ($525 from BACA, $4,500 from NYFA), many turned him down. Unlike the New York State Council on the Arts, the American Film Institute told Lee that a $20,000 grant awarded to *The Messenger* was not applicable to any other film. The Film Fund rejected Lee's application after reviewing the initial script for the film and deciding that his treatment of female characters was, in their judgment, sexist. This would prove to be a criticism that would dog Lee throughout his career.

Lee was forced to raise additional funds from private investors, taking out personal loans, and accumulating debt. Many entries in Lee's journal refer to being behind on his bills and living on meager groceries so that he could put most of his financial resources into getting *She's Gotta Have It* made. During this time Lee also became disillusioned with the life of an independent filmmaker and the reliance on nonprofit funding sources. After being told that he had been turned down by AFI, Lee wrote: "Hopefully I won't ever have to apply to another funding place. We all know I was robbed" (1987, p. 151). He continually cut the budget, determined to get the film made for whatever amount of money he could raise: "Every day the budget gets smaller and smaller. I'll do without a lot. This film has to get done" (1987, p. 178). He was also able to convince his cast and crew to work on a deferred payment schedule and was therefore able to begin filming prior to obtaining much of the funding for the film.

Shooting for *She's Gotta Have It* began on July 6, 1985 and was finished in just twelve working days by July 20. Lee then did all of the editing in his New York City apartment working with rented equipment. The film premiered at a San Francisco film festival in March of 1986. The popular response to this initial screening was extremely favorable and film distribution companies took notice. Three distribution companies submitted bids for the rights to the film, which had received a standing ovation from the audience that attended the premiere. Lee eventually selected Island Pictures as the distributor. In a journal entry dated April 2, 1986, Lee wrote that representatives of Island seemed genuinely enthusiastic and that "Island is a loose kind of company, not as corporate as Goldwyn" (1987, p. 274). Lee also sensed that Island would be more willing to meet the figures that he wanted to propose for the rights to the film: $300,000 for domestic and $150,000 for worldwide rights with $150,000 upfront upon signing the contract (Lee, 1987). Island's promotion of Lee's film was fairly aggressive in comparison to the efforts devoted to many independent pictures. Additionally, word-of-mouth from enthusiastic

audiences seemed to account for much of the rapid-fire success that the film generated (Pierson, 1995). During the first month of screenings in New York nearly every showing of the film was sold out (Pierson, 1995).

Lee's achievement was a significant one and he recognized it as such. He wrote: "Imagine, this is my first FEATURE FILM, and I PRODUCED, STARRED, WROTE, EDITED and DIRECTED it. This is a major, major accomplishment" (1987, p. 223). This statement from Lee's journal indicates two points that are central to any analysis of Lee as a filmmaker. The first is that Lee was completely involved in every aspect of the creative development of this film. This is also true for most of the subsequent work that Lee has created. As with the work of other cinematic auteurs, Lee's films may be interpreted as a representation of his own personal aesthetic vision and political worldview, although we should also take note that this vision is ultimately shaped by the imperatives of commercial film production. As Watkins notes: "In exchange for financial capital, the studios often impose their own priorities on the creative process in order to create product that will appeal to large segments of the film-going audience and, as a result, return a handsome profit on their financial investment" (1998, p. 116).

Second, Lee was fully aware that the development of *She's Gotta Have It* from rough idea to a commercially successful feature film without any financing from the giant Hollywood mega-corporations was an important milestone for black independent filmmakers. This realization, however, did not alter Lee's desire to leave independent filmmaking behind and join with the corporate forces that could allow him to realize the dream that he articulated when he wrote: "I knew that, once I made them [films], I didn't want hundreds of people to see them, I wanted millions of people to see them" (Lee and Wiley, 1997, pp. 92–93). While some alternative filmmakers make a conscious decision to remain independent in order to preserve their freedom to present challenging or offbeat material (Citron, 1988; Reid, 1993), Lee's early independent status was a matter of necessity rather than choice. Lee's journal entries and subsequent career path make it clear that Lee is a prototypical example of Miller's statement that for some filmmakers independence "is a material condition to be overcome, not necessarily an independent aesthetic, cultural or political position" (1993, p. 182). Lee's dream was realized when Island Pictures picked up Lee's film and devoted almost two million dollars to promoting and distributing it. Lee was able to produce the film on a strictly independent basis, but the film's widespread distribution and commercial success were dependent on the capital that only a well-funded corporation could provide.[3]

Made on a budget of $175,000 during a decade when most films were being made for several million dollars, eventually *She's Gotta Have It* would gross more than eight million dollars at the box office (Patterson, 1992). The major Hollywood studios were not about to ignore profit ratios like this, and the financial success of Lee's film sparked a newfound interest in black filmmakers on the part of the mainstream film industry. Spike Lee's success is often identified as the catalyst behind this phenomenon, and Lee has used his status to promote the careers of many black artists and craftspeople in the film industry. It is important, however, to recognize the late 1980s and early 1990s Hollywood enthusiasm for black films and filmmakers for what it was. This era does not represent a sudden embrace of political multiculturalism on the part of the mega-corporations that comprise the New Hollywood. It does represent Hollywood's realization that low-budget films focused on black culture had the potential to bring in tremendous cost-to-profit ratios by appealing to black moviegoers that have been estimated to comprise 25–30% of the U.S. film audience despite being about 13% of the American population (Guerrero, 1993). One investor in *She's Gotta Have It*, for example, estimated that 75% of the audience for the film's initial run in New York was black (Pierson, 1995). By promoting films by black directors that featured black casts, Hollywood hoped to capitalize on the potential profits that films like *She's Gotta Have It* proved they could generate. This is representative of a general tendency of media institutions to occasionally introduce new or alternative points of view into the mainstream in order to continue providing novel content that will attract large audiences (Kellner, 1995a).

Subsequent to the success of *She's Gotta Have It*, Lee was soon identified as a commodity by the corporate Hollywood studios that saw in him a filmmaker who had the potential to make relatively low-budget films that could generate high profits. His goal of not having to implore private investors and non-profit organizations for funding had been reached. As early as the distribution deal with Island, however, Lee did begin to feel the pressure that corporate entities could exert on his creative autonomy. Lee's contract with Island called for a number of small changes to be made in the film including the cutting of two short scenes involving interactions among female characters (Pierson, 1995). While the total amount of film that was expected to be cut totaled less than four minutes, this corporation-induced change further reduced the already limited role that female characters other than Nola, the protagonist, would play in the film. Furthermore, Lee's contract also required that the film receive an R-rating, which led to Lee having to repeatedly re-edit the film's sex

scenes after the MPAA initially gave the film an X-rating (Glicksman, 2002a; Pierson, 1995). Lee has expressed a belief that the MPAA's interference was related to race: "And when it comes to black sexuality, they especially don't know how to deal with it. They feel uncomfortable. There are films with more gratuitous sex and even violence. 9½ Weeks got an R. And look at Body Double" (quoted in Glicksman, 2002a, p. 6).

Since this experience of other people influencing the outcome of his film, Lee has insisted on final cut for his subsequent movies (Fuchs, 2002), although he was not always able to achieve this, notably with Old Boy in 2013 when the commercially distributed version was substantially different than the film Lee himself wanted released (Khatchatourian, 2013). Regarding She's Gotta Have It, although indicative of the restrictions on creative control that corporate funding can impose on a filmmaker, the changes imposed were relatively minor and, primarily because of its genesis as an independent film, She's Gotta Have It debuted as a nearly unadulterated Spike Lee creation.

Narrative Structure

She's Gotta Have It is the story of a young woman, Nola Darling, and her three male lovers: Jamie Overstreet, Greer Childs, and Mars Blackmon (played by Spike Lee). The film is shot in black and white in a pseudo-documentary style as characters address the camera directly as if answering questions from an off-screen interviewer. This "documentary" style lends an air of authority to the film, suggesting that these characters are like "real" people, mirroring the behaviors and concerns of people in the real world. All of the dramatic scenes in the film are essentially visualized flashbacks of stories that are being told to the nonexistent interviewer behind the camera. Of course, this interviewer is located in the same space as an actual viewer of the film, so the characters also seem to address the audience directly. The film begins with Nola crawling out from under the covers on her bed and announcing that she will now tell her own story in order to clear up misconceptions about her identity. This opening scene shot in Nola's bed immediately establishes that sex and sexuality are key themes of this film.

Nola's expressed desire to tell her own story, to represent herself in order to clear up distortions that have been imposed by others' representations of her, is similar to the motivating force behind the production of much alternative media by marginalized societal groups. Nola herself is simultaneously a member of two such groups in American society. Nola's narrative and the

film's status as an independent production by a black filmmaker are parallel in this way. Ironically, the silencing of women is simultaneously perpetuated in this film as the female voice—Nola's "own story"—is actually a recitation of words written by a man.

Although primarily about Nola and her male suitors, the film also introduces two other female characters, Clorinda Bradford, Nola's ex-roommate, who tells the camera that she moved out because Nola's promiscuity was disturbing her, and Opal Gilstrap, a friend of Nola's who attempts to engage Nola in a sexual affair. These female characters are auxiliary to the core of the film's plot, however, which centers on the three men who are all attempting to win sole access to Nola's bed (which Nola identifies as the only place where she can have sex). As noted above, the distribution deal with Island imposed further limitations on the role that these women would play in the film.

The film is divided into three acts: the beginning, where each of the main characters is introduced and addresses the camera directly, a middle section that shows scenes of Nola's relationship with each man, and the climax and denouement where Nola is raped by one of the men and then forsakes the others in order to devote herself entirely to the man who raped her. This is followed by a brief coda that seems to repudiate the implications of the penultimate sequences of the film.

The Beginning

The three men are introduced one by one as the narrative of the film unfolds. The first suitor that is introduced is Jamie Overstreet. It is appropriate that Jamie is introduced first, because, as connoted by his last name, Jamie holds the top position in the hierarchy of Nola's lovers. Jamie addresses the camera and confesses his belief in monogamy and the search for a soul mate. While Nola's other men are ridiculous comic figures, Jamie is the straight man, the man who represents romantic love and masculine stability, the man whose only flaw is that he is perhaps too earnest in his affections.

Nola tells the invisible interviewer behind the camera that she finds most men to be insincere but Jamie was different. The next sequence of shots is a flashback to Jamie and Nola's first encounter. Jamie sees Nola on the street. He is immediately taken with her and he follows her. Jamie momentarily loses her in the crowd and then Nola appears just around a corner waiting for him. Jamie asks Nola if she will date him and their relationship begins playfully and romantically.

The next man introduced is the comic Mars Blackmon, played by Lee, who appears on a bicycle hurtling out-of-control down a steep hill. Nola brings Mars up to her apartment where her walls are covered with images of black cultural and political resistance: a collage of Malcolm X addressing a crowd, headlines that report on incidents of police brutality, posters of Bob Marley and anti-apartheid slogans. Nola tells Mars that she shares the same birthday as Malcolm X. This declaration and the artwork decorating her walls signify that Nola is a politically aware person. This very brief scene (seventeen seconds in duration), however, is one of the rare instances in the film when Nola is identified as having any motivating impulses besides sex. Still, the film does present an essentially respectful view of political awareness and activism, unlike Lee's third picture, *Do the Right Thing* (1989), which spends a considerable amount of time ridiculing and denigrating characters who exhibit a political consciousness (see Chapter V).

Before Nola's third male lover is introduced there is a scene of Opal trying to lure Nola into a love affair, which Nola rejects. Finally Greer Childs is introduced to the audience. Like Mars, Greer is a comic figure, not a serious rival for Nola's long-term affections. Greer is a male model with a perfect physique and well-oiled, slicked-back hair. He is completely self-absorbed and only interested in Nola because of her looks and her intense sexuality. He aspires to upward mobility and is disparaging of Nola, her background and her neighborhood. He wears a perpetual sneer as he says lines like: "Nola was rough when I started seeing her. A Brooklyn tackhead. But I refined her" (1987, p. 302) and, "Nola got led astray by common street trash. All of my hard work was undone. If she would have listened to me and moved out of Brooklyn we would be together this very day. It's not civilized over there" (1987, p. 302). Again, it is interesting to note that in Lee's first film, Greer's upwardly mobile aspirations and materialistic attitudes are a source of humor and ridicule, while later films like *Do the Right Thing* (1989) will present monetary accumulation and capitalist achievement as a virtue while political consciousness becomes the subject of derision.

The Middle

From this point on the film shows various aspects of Nola's relationships with all three men. Scenes of Nola's sexual encounters are a central and recurring motif throughout the film. This middle section of the film culminates in Nola's apartment where she has cooked a Thanksgiving dinner for all three men. The men exchange verbal jabs and insults until Nola in exasperation

announces that she is going to bed. The men play a waiting game as Jamie lies next to Nola in the bed and the other two refuse to leave. Finally, Greer and Mars give up and leave Nola's bedroom.

As Nola and Jamie sleep, the linear narrative is once again interrupted by a dream sequence where three women, the imagined girlfriends of Jamie, Greer and Mars, stand over Nola's bed cursing her and then setting the bed on fire. Nola wakes up screaming and Jamie tells her she was dreaming. He then announces that he is seeing another woman and that if she wants him to stay with her she will have to renounce her other men.

The End

The film builds to its dramatic climax with a scene of Jamie lying in bed with another woman. Nola phones Jamie and tells him that she needs to see him. At first Jamie resists, but then he reluctantly gives in. At her apartment Nola begs Jamie to make love to her. Jamie begins to leave but then turns around and pushes Nola down and begins to brutally penetrate her from behind. Lee's script notes that Jamie is: "trying his best to hurt her feelings, he's demeaning her" (1987, p. 349), but nowhere in Lee's original script or production notes for the film is this sequence described as a rape. Twenty years later, Lee would admit that the scene actually did depict a rape (Lee and Aftab, 2006).

In subsequent scenes Nola seems grounded and reinvigorated by Jamie's brutality. She reestablishes her relationship with her ex-roommate, Clorinda, and then goes to Greer and Mars and tells them that she cannot see them anymore. She meets Jamie in the park and announces that she is finally ready to devote herself entirely to him but that she will remain celibate for a while first. Jamie is at first ready to accept her but when he hears the news about her celibacy, he chastises her and announces that he will not accept this: "I'm moving forward not backwards. Later for Nola Darling" (1987, p. 360). Lee's script includes this note: "For months he's had to share Nola and when she's finally decided to come around she joins the nunnery" (1987, p. 360). Finally, Jamie relents and takes her back.

Coda

The film ends where it began, in Nola's apartment, which has been restored to its original decor. Nola is in bed facing the camera. She announces that

neither her plans for celibacy nor her relationship with Jamie lasted for very long. Nola declares her independence and then pulls the covers back over her head, and the film ends as mournful minor key music is heard on the soundtrack. This brief sequence at the end of the film is jarring. It seems to repudiate and contradict the implications of the closing scenes between Nola and Jamie, ending the film, as many of Lee's films end, on an ambiguous note.

Critical Reception

She's Gotta Have It received mixed reviews in the popular press. While some critics (Little, 1986; Travers, 1986) praised the film for its humor and noted that it displayed a tremendous amount of potential on the part of its young director, many others felt that it was rough, amateurish or flawed (see Pierson, 1995). Many of the major publications like *The Washington Post, The Chicago Tribune, The New York Times,* and *Variety* published reviews of the film that were guardedly favorable or that evaluated the film as mediocre (all cited in Pierson, 1995).

Pierson (1995) points out that many critics seemed reluctant to praise the film and attacked it for not being as smooth and slick as most big-budget mainstream Hollywood products. While reviewers generally criticized the film from an aesthetic point of view, the gender politics of the film and the negative depiction of its only non-heterosexual character were typically ignored by mainstream critics (Pierson, 1995). On the rare occasions when these issues were addressed in the popular press it was often from the point of view typified by a review in *The New Republic* which praised the film for depicting, "The liberation of black women from the sexual chauvinism of black men" (Kauffmann, 1986, p. 30).

Much of the mainstream responses to the film must be tempered by McMillan's admonition that:

> I don't trust white critics' judgment about most things that deal with black life, particularly when a black person is the creator. It never fails. White critics always seem to misinterpret *us* because they don't understand *us* (or don't care to)…(1991, p. 21)[4]

However, it was not only white critics in the mainstream press that had problems with Lee's film. Academic responses to *She's Gotta Have It,* by diverse scholars, were also critical, based not so much on aesthetics or by standards of comparison to high-budget mainstream Hollywood movies, but rather on Lee's portrayal of gender roles and sexual politics.

While some analysts felt that the film represented a liberating and progressive view of female power and sexuality (Baker, 1993), much of the academic literature on the film disputes this contention. Some have suggested that the film is presented entirely from a masculinist point of view and that the character of Nola is only realized through the meaning that the male characters give to her (Jones, 1996; Lubiano, 2008). Harris, while otherwise laudatory about Lee's work, notes that Nola is constructed not as a real woman but as "a man in a woman suit" (2009, p. 33).

While the film is purportedly about a woman in control of her own destiny, feminist critics noted that Nola only exhibits control in the sexual sphere and that women in the real world must also find power politically and economically as well (Simmonds, 1988). Furthermore, critics writing in both popular and academic settings have pointed out that the film eventually punishes Nola for her independent sexuality by having the man that she favors most subject her to a brutal and humiliating rape (Baraka, 1993; Malveaux, 1991; Wallace, 1988). hooks (2008) notes that Nola refers to this violence only as a "near rape" and that many of the people she discussed the movie with did not even seem to notice that there was a rape in the film. Emblematic of this absence, in an interview with Lee, Glicksman (2002a) provides a synopsis that completely skips over Jamie's assault as if it never appears in the film. During that same interview, Lee goes unchallenged when he says, "I think my love of women is reflected in the work," before admitting that Jamie committed a "horrible act" but never calling it rape (Lee, quoted in Glicksman, 2002a, p. 9). hooks (2008) argues that this scene, and the (non) reactions to it, are consistent with the pornographic sexualization of violence. Eventually, Lee came to accept these sorts of criticisms. Twenty years after *She's Gotta Have It* debuted Lee expressed regret over how he portrayed this scene:

> The rape scene, that is the one scene in all of my films that I would redo. I think the rape and especially its aftermath were too flippant. I didn't really show the violation that it is. It was ill thought out and ill conceived—all the ills that you can get. It just made light of rape, and it really comes down to immaturity on my part (Lee and Aftab, 2006, p. 63).

Lee blames immaturity, but Reid (1993) argues that *She's Gotta Have It* is a misogynist and homophobic film that presents a demeaning view of both heterosexual women and lesbians. He notes that Nola is verbally, sexually, and psychologically abused throughout the film, and that even the coda, noted above, only confuses the issue without offering any resolution to Nola's question about

who would be in control of her body and mind. It is important to reiterate, however, that feminist critiques such as these were primarily absent from the popular discourse on *She's Gotta Have It*, which focused more on the aesthetic and comedic aspects of the film and made frequent comparisons to Spike Lee as a "black Woody Allen" (see McMillan, 1991; Pierson, 1995).

The following semiotic analysis of *She's Gotta Have It* engages with feminist critiques by examining whether the dialectical oppositions that structure the film do indeed privilege a patriarchal stance on gender and sexuality.

Analysis of Structural Oppositions in *She's Gotta Have It*

A close semiotic reading of *She's Gotta Have It* reveals a number of dimensions of the film that can be charted as binary oppositions (see Figure 1).

Men/*Women*
Morality/*Immorality*
Romanticism/*Lust*
Stability/*Turbulence*
Domestication/*Sexuality*
Fidelity/*Promiscuity*
Heterosexuality/*Homosexuality*

Figure 1. Structural Oppositions in *She's Gotta Have It*

Derrida (1982) has criticized structural analysis for being too simplistic in its tendency to reduce difference to a rigid binary scheme. While much of the critique proposed by poststructuralists like Derrida does offer important points of criticism (and will be taken up in Chapter V), I adopt Hall's (2013) position that a structuralist approach that takes into account issues of ideology and power may provide useful entry into a text. One of Derrida's (1982) arguments is that the poles in binary oppositions are rarely neutral in terms of power relations. He suggests that oppositions do not coexist in peaceful harmony but rather in a "violent hierarchy" (1982, p. 41). In any text or discourse it is possible to identify the dominant pole (or the pole that represents the privileged position). Building on this idea, Hall (2013) has suggested that structural analysts should acknowledge and mark these dominant positions

when exploring binary oppositions in a text. Figure 1 charts the oppositions identified by my structural analysis of the film *She's Gotta Have It*. Following Hall (2013), the dominant positions represented in the film are presented in bold and the secondary positions in italics.

Men/Women *and the Privileges of Gender*

The primary oppositional tensions in *She's Gotta Have It* are based in gender roles. This opposition between men and women is immediately established by the quote from Zora Neale Hurston that appears on the screen prior to the opening credits:

> Ships at a distance have every man's wish on board. For some they come in with the tide. For others they sail forever on the horizon, never out of sight, never landing until the Watcher turns his eyes away in resignation, his dreams mocked to death by Time. That is the life of men.
>
> Now, women forget all those things they don't want to remember, and remember everything they don't want to forget. The dream is the truth. Then they act and do things accordingly (1995, p. 175).

Lee's film bears some important resemblances to the structure of the 1937 novel that these lines were taken from, *Their Eyes Were Watching God*. Both tales focus on a female protagonist trying to tell her own story about her struggles for power with three men who attempt to control her behavior. Lee's dedication of the film to the memory of Hurston is acknowledgment of the inspiration that she provided to his creation of Nola Darling and her story. Bond (1993) points out that these opening words of *Their Eyes Were Watching God* indicate to the reader that the novel is about deep-seated cultural and psychological differences between the genders. In much the same way, Lee's choice of this quote as an epigram for the film signifies the key structural opposition encoded within the film—the opposition between men and women.

The film represents this opposition as a struggle for power and control. As Nola will announce at the end of the film, "It's really about control, my body, my mind. Who was going to own it? Them?" (Lee, 1987, p. 361). Both the paradigmatic choice of introducing Nola at the beginning of the film as the teller of her own tale, and the coda at the end of the film that has Nola questioning who will control her body and mind, seem to initially privilege

the position of women over men. In the juxtaposition of the rape scene toward the end of the film and the coda that follows, however, the contradictory nature of Lee's film is most evident. Lee seems torn between ideological positions, first depicting the brutalization of Nola as a natural consequence of her sexually liberated behavior, and then following that with Nola's proclamation of independence from male dominance.

Further analysis of the opening and closing scenes that frame the film reveals the limitations of Lee's vision of feminine independence. Both scenes are shot in Nola's bed, the only place where she allows herself to make love. The bed, placed in the center of the room and surrounded by candles, dominates the scenes shot in Nola's apartment. Her bed is a signifier of Nola's sexual independence and freedom, but also establishes this arena as the primary place where she has obtained any type of power or control. Nola's core sense of identity can be found in this bed. Her entire sense of self is thus defined by her sex life. The film begins with a shot of her crawling out from under the covers of her bed and ends with her retreating back under them, further signifying the bed as a place where Nola withdraws from the battles that women must fight on a daily basis. Additionally, the closing scene of Nola declaring her independence, and then crawling under the covers, is underscored by a soundtrack of mournful, minor key music, reinforcing the ambiguous nature of this declaration.

Most of the scenes that are shot outside of the bedroom mitigate any sense of Nola as a powerful figure by depicting men in control of Nola, rather than vice-versa. For example, during the Thanksgiving dinner sequence, Nola serves while the three men eat. Neither of Nola's female friends is present. At one point during this scene, Mars offers to flip a coin with Jamie to see who will gain sole possession of Nola. He then offers to split her with Jamie, "You can have four days. I get three...I get the weekends, though" (Lee, 1987, pp. 330–331). During the scene of Nola and Jamie's reconciliation in the park, Jamie is a stationary and stoic figure throughout all of the shots which depict Nola beseeching him, Nola walking away with her head down, and Nola docilely returning to his side when he agrees to take her back.

Whatever control and freedom the audience is supposed to believe Nola possesses is ultimately bound up and inseparable from her relationships with men. hooks points out:

> Superficially, Nola Darling is the perfect embodiment of woman as desiring subject—a representation which does challenge sexist notions of female sexual passivity... though desiring subject [she], acts on the assumption that heterosexual female sexual

assertion has legitimacy primarily as a gesture of reward or as a means by which men can be manipulated and controlled by women (2008, p. 3).

Not only sexual, but also social and familial relationships in Nola's life also privilege men over women. Nola's friend Opal, for example, attempts to get Nola to explore her sexuality with another woman, but the otherwise sexually adventurous Nola refuses all of her overtures. Nola's relationship with her ex-roommate is also limited and shaped by her relationships with men. Her ties to Clorinda disintegrate after Clorinda complains about all of the men coming in and out of the apartment they share. Nola chooses the men over Clorinda and Clorinda moves out. After sharing this background information with the film's documentary-like invisible interviewer, Clorinda vanishes from the film, reappearing only toward the end when Nola reaches out to her female friend in the wake of Jamie's rape and abandonment of her. Men are also dominant in the familial relationships depicted in the film. Nola's father, Sonny, is "interviewed" to help establish Nola's identity, but her mother is only briefly referred to and never appears on screen. At one point Nola announces that she would someday like to have children, but they must be *male* children: "Five rusty-butt boys" in her words. Lee's paradigmatic choices as the director and writer of the film thus tend to privilege male identity despite the presence of a female protagonist. This tendency in Lee's script was further reinforced by Island's demand that two scenes of woman-to-woman interaction be cut from the film before its release (Pierson, 1995).

Perhaps the clearest privileging of male/female over female/female relationships comes during the nightmare sequence. Nola dreams that three women attack her and set her bed on fire in retaliation for her disruption of their relationships with men. While candle flames connote romance and passion during the film's heterosexual love sequences, in this scene fire is representative of the hatred and animosity between Nola and the other women. During the attack, Lee's script has the women saying lines like: "There goes that homewrecker...I know she's trying to steal my man...I don't blame Greer, I blame her...It's sisters like her who are corrupting our men" (Lee, 1987, pp. 333–334). Through Lee's authorial and directorial choice of having the women set Nola on fire in her bed, the site of pleasure for Nola and her men becomes a site of pain inflicted by woman upon woman. Nola's bed therefore becomes a powerful signifier of both Nola's dependence on men and her alienation from women.

Despite Lee's choice of a female character as the ostensible protagonist of the film, it is the men in this film, as in most of Lee's films (see Chapter VII), who drive the action. The men are the pursuers. Nola is the pursued, and eventually victimized, object of their desire. This is consistent with the role of women throughout Lee's body of work. They are often auxiliary to the narrative, existing on the outskirts of the dramatic action, active and engaged only when it comes to sexual relations. In the fairly graphic sex scenes depicted in *She's Gotta Have It*, Nola's body is often photographed in extreme close-up, fragmenting her into disconnected pieces: a lingering shot of a breast here, a photographic caress of a leg there. The camera pans her naked body slowly, putting her on exhibition for the pleasure of a presumably male, presumably heterosexual, audience who can thus vicariously identify with the men on screen who are depicted as deriving pleasure from her body. Lee's script describes one of these scenes in this manner:

> We are CLOSE on two brown, firm breasts. Wait a minute, there is some doubt as to what it is we are actually looking at. Is it or isn't it? They look like breasts but it might also be some Himalayan mountains. As we stare longer it becomes apparent that they are the breasts of Nola Darling (1987, p. 316).

Lee's metaphor of Himalayan mountains lends support to Reid's statement that Nola's body represents "a conquered terrain where men game, hunt and create territorial boundaries" (1993, p. 97).

This catering to the male gaze (Mulvey, 1992) is a thematic constant in the body of work that Lee has created as a cinematic auteur. For example, completely unconnected to the film's narrative, *Do The Right Thing* (1989) opens with an extended shot of the actress Rosie Perez dancing aggressively and hypersexually in front of a blue backdrop. As the scene continues the camera increasingly focuses on her breasts and buttocks, and the clothes she is wearing become increasingly more revealing. Although she is wearing boxing gloves and the music she is dancing to is a song by the political rap group Public Enemy, "Fight The Power," this sequence has more to do with the exhibition of a woman's body for the pleasure of a male audience than it does with any other ideological message that may be associated with the song or the film. Later in the film, Lee's character will make love to this woman in a sequences of shots that harken back to the love scenes in *She's Gotta Have It* as Perez's body is fragmented into separate parts that the camera slowly explores in extreme close-up.

While the opposition of **men/women** is the primary tension that helps to structure the meaning of *She's Gotta Have It*, there are other oppositions depicted in the film which also frame the ideological positions encoded in this media text. Several of these are established by signifiers of the differences between the main characters of the film. These differences point the way to identifying certain characters as archetypes of particular ideological positions.

Defining Morality/Immorality—Enculturation Through Modern Myth

Through the introduction of characters that represent differing archetypes, Lee fashions *She's Gotta Have It* into a mythic tale of morality vs. immorality. The film depicts traits such as **romanticism, stability, female domestication, fidelity,** and **heterosexuality** as moral virtues, while *lust, turbulence, female sexuality, promiscuity,* and *homosexuality* are represented as moral failings that are clearly distinct from the virtues they oppose.

Through language, music, visual imagery, and narrative Jamie Overstreet is encoded as the figure who signifies romanticism in the film. He is depicted reading love poetry (which Mars ridicules) and spouting lines such as: "I believe that there is only one person, only one in this world that is meant to be your soul mate, your lifelong companion" (Lee, 1987, p. 280). His romantic spirit is signified by shots of him massaging Nola's back and bringing her food when she is sick in bed. Lee also employs two non-linear sequences to signify the differences between Jamie, Nola, and her other suitors. First, in a sequence of shots that Lee calls the "dog scene" (1987, p. 104) Lee inserts close-ups of the faces of twelve men uttering insincere and absurd pick-up lines. At the end of this sequence, Nola says "One guy was different" (Lee, 1987, p. 288) and the camera cuts to a close up of Jamie.

The second device that establishes a clear distinction between the romanticism represented by Jamie and the sexuality represented by both Nola and her other suitors (male and female), is Lee's use of a musical interlude shot in color in an otherwise black and white film. Jamie is the initiator of this scene as he surprises Nola by writing a song and hiring dancers to perform for her birthday. Lee's script notes that "For the first and only time in this film we are in COLOR. The saturated COLORS jump right off the screen at us like the TECHNICOLOR of the old MGM musicals" (1987, p. 309). A scene of

Nola and Jamie in bed together follows this sequence. Nola tells Jamie that the dance must have cost too much money and Jamie replies, "I'll starve a week for you anytime." A ringing phone shatters their romantic bliss. Mars is on the phone begging Nola to let him come over: "Just let me smell it" (Lee, 1987, p. 313). Thus the romance signified by Jamie's initiation of the color musical sequence is juxtaposed with Mars's lustful request in a parallel to the earlier juxtaposition of the dog sequence and the image of Jamie's sincere face.

The opposition between Jamie and Mars is also that of **stability**/*turbulence*. The clothing and physical appearance of each character function as signifiers of these opposing characteristics. Jamie has a short, neatly trimmed haircut. He wears white button-down shirts underneath solid or mutely patterned blazers. His clothes are always neatly pressed and his posture is firm and erect. In contrast, Mars's first appearance on the screen codes him as unpredictable, unstable, almost out-of-control. Lee's script provides a description of this scene:

> We are at the bottom of Dead Man's Hill. The very steep street is empty. A person on a ten-speed bike rides toward us from the top of the hill. He's flying and he's screaming he has no brakes. Just when it looks as if he might collide head-on into the camera he puts on the brakes, and just in the nick of time. His face is a mere foot from the lens and we have a TIGHT CLOSEUP OF MARS BLACKMON. He laughs like a madman.

Mars's bicycle signifies his immaturity and childishness. Lee continues by describing Mars as a person who is often mistaken for a teenager. He wears Nike sneakers, a New York Knicks jacket, very short shorts, and a large medallion around his neck that spells out his interplanetary name. These articles of clothing signify Mars's social position as a "b-boy"—a young man of the 1980s who finds his identity in hip-hop culture. Mars and Jamie are truly binary opposites and Lee's dialogue establishes a clear contrast between Jamie's romanticism and Mars's lust for Nola. Mars addresses the invisible, off-camera "interviewer" and says: "I know Nola Darling. What about it?...I thought she was a freak, y'know, freaky-deaky...Why did I see her?...The sex was def. Nola had the goods and she knew what to do. Look, all men want freaks, we just don't want them for a wife" (Lee, 1987, pp. 290–291). Mars, like Nola's third man, Greer, functions in the film as comic relief. There is never any doubt that Jamie is the only one of the three that Nola takes the slightest bit seriously. Thus, the virtues of romanticism and stability that Jamie signifies through his language, appearance, actions, and narrative function are positioned as the dominant or preferred poles in the film's binary oppositional structure.

In much the same way that the male characters can be contrasted from each other in the moral qualities that they signify, Nola can be contrasted from the other female characters in the film in terms of semiotic and narrative significance. An oppositional tension between **domestication**/*sexuality* is established early in the film through the introduction of Nola's ex-roommate Clorinda Bradford. Read syntagmatically, the sequence of scenes that open the film develop the opposition between domestication and sexuality as represented by Nola and Clorinda. The initial dramatic scene in the film is shot in Nola's apartment, a living space dominated by a huge bed placed directly in the center of the room. The bed is framed by a large headboard covered with candles. A close up of the bed shows a body writhing under the covers (the viewer initially believes it is two bodies engaged in lovemaking), and Nola emerges from beneath the covers, heavy-lidded and disheveled, wearing a tight sleeveless t-shirt. She stares seductively into the camera before she begins to speak. The music is soft, slow, and sensual. All of the visual and sonic imagery in this sequence connotes sex and sexuality. This is the viewer's first introduction to Nola Darling.

Nola's sexuality is made explicit in the next sequence, which portrays Nola seducing and making love to Jamie in her enormous bed. They are surrounded by candles, which she has lit prior to slowly removing her clothes and displaying her body. Nola is completely unashamed of her nakedness and sexuality. Lee's close-ups of her face, eyes glowing, mouth wide open in ecstasy, clearly signify the tremendous pleasure she derives from her sexuality.

The next shot immediately after these scenes introduces Clorinda. The camera pans through her apartment and the viewer sees various signifiers of domesticity: a bookcase filled with books, knick-knacks, and a framed photograph of a young girl wearing a fancy dress, a potted plant, a table lamp and a large comfortable chair. While Nola's apartment is dominated by the bed and is lit by candles, Clorinda's apartment is sunlit and airy. Two sounds are audible on the soundtrack: the sound of children at play, and the whir of a sewing machine. Clorinda is shot from the rear, bent over the sewing machine hard at work. She turns and faces the camera and lets out a sigh of momentary relief from her labor. While the sewing machine is a specific paradigmatic choice that Lee made as the director, Lee as the screenwriter was certain that Clorinda would be associated with some sign of female domestication. In the original script for the film, the first shot of Clorinda has her standing at a sink, doing dishes.

Clorinda tells the invisible interviewer that she and Nola had a falling out over all of the men coming in and out of the apartment. Clorinda states that she herself had one boyfriend who would occasionally spend the night, but that Nola always had strange men sleeping over. The next scene is a shot of Nola addressing the camera, playfully talking about her experiences with different men and their come-ons. This leads to the "dog scene"—the sequence of twelve different men delivering their pick-up lines to the camera.

In addition to the opposition between **domestication**/*sexuality*, Lee also uses these scenes to establish the opposition between **fidelity**/*promiscuity* that is the key to the film's violent climax. Clorinda signifies the "good girl" in her wholesome domestication and fidelity to her one boyfriend. Nola, however, is the prototypical seductress, the "whore" in the Madonna/whore opposition that is standard in mainstream Hollywood's stereotypical depictions of women. Examined intertextually, Lee's construction of this opposition bears a striking resemblance to mainstream Hollywood cinema. As the unwritten rules of Hollywood film dictate, the whore must be punished for her actions and Jamie's rape of Nola is the punishment that is meted out in this film. Earlier in the film Nola tells Jamie, "Most men I've dealt with don't know a thing about a woman's body" (Lee, 1987, p. 283). This line of dialogue signifies both Nola's promiscuity and that she has the temerity to enjoy sex and know exactly how she wants it. By Hollywood standards once Nola utters those words she is doomed to be punished.

All three of Nola's lovers are united on one issue—they are all uniformly against her sexually free ways. As Mars tells us, "All men want freaks, we just don't want 'em for a wife" (Lee, 1987, p. 291). Greer suggests that Nola is a sexual addict who needs therapy. In one of the most significant lines of the film Greer says, "You need some professional help. A nice lady doesn't hump from bed to bed" (Lee, 1987, p. 321). Nola does see a female sex therapist, who assures the invisible interviewer that Nola is not sexually dysfunctional, rather she is normal and healthy. Here again the film presents a contradictory or ideologically ambiguous stance. The sex therapist is positioned as the voice of authority. Lee's script describes her in this way: "Dr. Jamison is a distinguished-looking, late-thirties black woman. She is a well respected sex therapist, an expert in particular on the sexuality of black women" (1987, p. 322). Her proclamation that Nola's sex drive is healthy, juxtaposed with the ridiculous Greer being the one to suggest that Nola is a sexual addict, mitigates against a reading of the film as privileging fidelity over promiscuity. Despite this, the statement that "A nice lady doesn't hump from bed to bed"

(Lee, 1987, p. 321) is perhaps the thesis statement for the entire film. This becomes most clear in the climatic rape sequence.

Jamie's rape of Nola is foreshadowed by the angry and hostile statements that he directs to the camera:

> I got sick and tired of being a spoke in a wheel, which is what I was. To Nola we were all interchangeable, it didn't matter who as long as it was a warm body. She had no devotion, allegiance or loyalty whatsoever.... That "you can't tell the players without a scorecard" shit had to go. When we made love I found myself wondering how many other men were getting it. Doing things with her pussy. I had done enough sharing to last me the rest of my life. Nola hurt me to the core but she's gotta have it. (Lee, 1987, pp. 320–321).

The "it" in "she's gotta have it" becomes ambiguous in this statement. Is the "it" still what the audience has assumed "it" to be in the title—sex? Or is Jamie referring to the punishment that he will eventually mete out to her?

In a sequence of shots prior to the climatic rape scene, Lee focuses on a candle burning beside Nola's bed and then on Nola's naked body stretched out on the mattress. This time Nola is alone, masturbating and deriving pleasure from her own body. These scenes are shot in extreme close-up, again fragmenting parts of her body. These shots signify Nola's insatiable sexual appetite and her willingness to be comfortable with and explore her own body. In the following scenes, the logic of Hollywood that Lee seems to have accepted dictates that Nola must be punished for her brazen sexuality.

Nola calls Jamie and begs him to come over. She tells him she needs him and Jamie replies, "And all the men in Brooklyn." He then tells her, "Once a freak always a freak" (Lee, 1987, p. 348). In quick succession Jamie throws Nola onto the bed and, pulling down the zipper on his pants, penetrates her from behind. Lee's dialogue and choice of visual images clearly indicate that this act is the long-awaited consequence of Nola's promiscuity. The scene is shot from the level of the bed with Jamie looming over Nola in half-light. Jamie snarls as he rapes her, "Is this the way you like it? Does Greer do it like this?" (Lee, 1987, p. 349). Breaking once again from a realist narrative style, Greer's image momentarily replaces Jamie's on the screen and Greer continues to penetrate Nola from behind. Jamie yells, "What about Mars?" (Lee, 1987, p. 350) and Mars is now shown continuing this symbolic gang rape. Jamie yells, "Who else? Who else?" (Lee, 1987, p. 350). Throughout this sequence, Nola is depicted as unresisting and compliant to this degradation. She now cries, "You're hurting me" and Jamie codifies his colonization of Nola's body

by insisting, "Whose pussy is this?" (Lee, 1987, p. 350). Nola is now depicted as participating in her own debasement by responding with physical pleasure to Jamie's penetration. She responds verbally also: "It's yours" (Lee, 1987, p. 350). A note in Lee's script says that Jamie notices that Nola is enjoying herself and he stops and pulls out. There is a close-up of him shoving Nola's face into the bed before leaving. Later scenes employ signifiers that suggest that Nola has been somehow cleansed and reinvigorated by this humiliation. A series of scenes signify that Nola wants to conform to Jamie's expectations of a woman. In an extended sequence she is shown redecorating her apartment, changing the Afrocentric decor and throwing away the candles that have been used as signifiers of her unbridled sexuality, removing the silken sheets from her bed, reestablishing her relationship with the domesticated Clorinda, and breaking off with the other men in her life. She then goes to Jamie and begs him to take her back.

At first Jamie ignores her presence as Nola is depicted imploring him. In these scenes he makes little eye contact with her, stoic and in control of the situation. He at first rejects Nola and in slow motion she walks away from him, her head down. Jamie then says her name and she returns to his side. Throughout this sequence the figure of Jamie has not moved. Sternly, he says to Nola, "Mess up one more time...." Coming chronologically after the rape scene, the threat implicit in his voice is unmistakable. Punishment will be meted out if Nola does not conform to Jamie's standards of behavior. Through the meaning established by these scenes syntagmatically, fidelity has been established as the dominant or preferred ideological position in the **fidelity/** *promiscuity* opposition.

Finally, the film also carries a moral and ideological message regarding homosexuality. Lee has been accused by some critics of presenting stereotypical and degrading images of homosexuals in this film, as well as in later films like *School Daze* (1988) (Bambara, 2008). In this film, the rigid binary opposition between **heterosexuality**/*homosexuality* is signified primarily through the character of Opal Gilstrap, the only non-heterosexual character in the film. Like Mars, Greer, and Jamie, Opal also wishes to possess Nola sexually. While Jamie can just barely tolerate Nola's relationship with the other men, at least for a time, he finds Opal's interest in Nola to be intolerable. Whereas Nola's sexual openness is presented as immoral and deserving of punishment, any flirtation with lesbianism is presented as beyond promiscuity in the severe moral condemnation that is directed toward it. Lee presents a one-dimensional depiction of Opal, whose only purpose in the film is to

pursue Nola and attempt to "indoctrinate" her into lesbianism. Lee's own suspicions and fears regarding homosexuality and lesbianism are revealed in the description of Opal that appears in the film's script:

> Opal is very pretty, one who could easily get the attention of almost any man if she so desired. But that's the rub. Opal has no use for men whatsoever. She is a lesbian. This isn't written on her sleeve or painted on a sign around her neck. You just can't tell nowadays (Lee, 1987, p. 293).

In her first appearance on screen, Opal addresses the camera and immediately begins proselytizing: "Nola may have been straight as an arrow but I wanted her to be open-minded. Check it out. Then decide. That's all" (Lee, 1987, p. 293). In the following scene, Nola is sick in bed and Opal comes over ostensibly to take care of her. It soon becomes apparent that Opal has a (not so) hidden agenda as she sits on Nola's bed and makes a sexual overture to her. Opal is depicted as predatory, almost serpentine, in her role of evil temptress. Lee focuses on close-ups of her face foregrounding exaggerated nonverbal expressions of lust and manipulation. Opal delivers lines like, "You'll come around" (Lee, 1987, p. 296) with syrupy inflections, sidelong glances, and coyly arched eyebrows. Opal is single-mindedly flirtatious with her wide, rolling eye movements, winks, and knowing grins. When Jamie arrives at the apartment, Opal and he dance around each other warily, never coming too close. They are shown to be waging battle and staking their claims on Nola. Jamie tells Opal to leave and she replies, "It's not over yet, Jamie." Although the line does not appear in the final version of the film, Lee's original script has Jamie muttering, "Fucking lesbo" (Lee, 1987, p. 299). The script also has Jamie telling Nola, "They always try to turn people around" (Lee, 1987, p. 300).

Jamie's stereotypical accusation is given authority by Opal's limited narrative function in the film. In every instance, Opal is depicted as "trying to turn Nola around." In a later scene Opal tries to capitalize on Nola's distress over Jamie seeing another woman by again attempting to seduce her. Opal begins to kiss her and Nola, with disgust in her voice, tells Opal to leave. Through the film's one-dimensional depiction of Opal and the stereotypical signifiers of her lesbianism, heterosexuality is established as the moral ideological position. Homosexuality and lesbianism are equated with deviance and even criminal behavior as in another line of dialogue when one of the women in Nola's dream states that, "The decent black men are all taken. The rest are in prison or homos" (Lee, 1987, p. 334). In the hierarchy established by the structure of *She's Gotta Have It*, men hold the dominant position, followed

by domesticated and monogamous women. Women who pursue heterosexual sexual freedom are in a morally subordinate position in this film, yet they are still one step higher in the film's ideological and moral hierarchy than either gay men or lesbians.

In this chapter I offered an analysis of the structural oppositions that are key to signification in the film, *She's Gotta Have It*. Furthermore, I also proffered an argument regarding the preferred ideological positions that are semiotically encoded in the visual imagery, soundtrack, and language of this media text. This analysis suggests that despite the film's genesis as an independent production, in many ways the film represents an ideological stance on gender and sexuality that is quite similar to that presented in mainstream Hollywood fare. While there are some areas of contradiction and ambiguity, the ideological positions that are privileged in the film, at least as they pertain to issues of gender and sexuality, are in many ways congruent with traditional, patriarchal American values and beliefs. In the next chapter I turn my attention to the film Lee is most known for, *Do the Right Thing* (1989). Produced three years after *She's Gotta Have It*, by the time of *Do the Right Thing* Lee had begun to work within, rather than outside, the corporate Hollywood system.

· 5 ·

THE UNDECIDABILITY OF DOING THE RIGHT THING

Spike Lee's third commercial feature, *Do the Right Thing* (1989), is considered by many to be his masterpiece. In fact, it could be argued that Lee's reputation as a filmmaker has, over the years, suffered because he created his most enduring work so early in his career. *Do the Right Thing* is Lee's most controversial and most important work, a film that is still challenging and provocative, a film that warrants continued discussion, debate, and analysis (Finnegan, 2011; Guerrero, 2001; Patterson, 1992; Reid, 1997; Sklar, 1990). Guerrero has noted "*Do the Right Thing* came to spark more media attention and critical debate than any other film in the history of black American film-making…" (2001, p. 17). Journalists claimed that *Do the Right Thing* was prophetic in its anticipation of the post-Rodney King civil disturbances of 1992 (MacCambridge, 1992). Television programs like *The Oprah Winfrey Show* and *Nightline* featured entire episodes on the significance of this film (Guerrero, 2001). Lee's screenplay was nominated for an Academy Award and the film garnered the Best Director and Best Picture Awards from the Los Angeles Film Critics Association. This film was also the first commercial production by Lee that directly confronted issues of white racism. At the time of its release Lee called the film his most political work up to that point. *Do the Right Thing*'s unflinching representation of racial violence generated a considerable amount

of attention from the popular press. During the five months subsequent to the film's release over sixty articles appeared in the nation's major newspapers (Denzin, 1991). *Do the Right Thing* catapulted Lee to celebrity status as intensive media attention was focused on Lee himself as well as on the film. Finnegan states:

> *Do the Right Thing* remains a film to be reckoned with. The film continues to engender acute discomfort among audiences (especially, but not exclusively, white audiences), raising a number of questions about why its confrontation of what Lee calls the single most pressing problem in America—race and racism—is so threatening to generally held assumptions about race in America (2011, p. 75).

This chapter, following the structure of the previous chapter's analysis of *She's Gotta Have It* (1986), again adopts a multiperspectival approach in analyzing *Do the Right Thing*. As in the previous chapter, my analysis begins with an examination of the film's production background, narrative structure, and critical reception. The chapter then culminates in a semiotic exploration of the oppositional tensions that structure *Do the Right Thing*.

Production Background

Lee's first two commercial features, *She's Gotta Have It* in 1986 and *School Daze* in 1988, were both financial successes. *She's Gotta Have It* cost $175,000 to make and brought in approximately 8 million dollars, *School Daze* cost 5.8 million and earned 14 million (Grant, 1997). Hollywood film studios were beginning to regard Lee as a commodity—a "name" director whose films represented the potential for extremely favorable cost-to-profit ratios for studios that were willing to finance films that stretched the boundaries of traditional Hollywood fare. Lee's early films eschewed the Hollywood star system[5] and presented controversial and challenging thematic material. As examined in Chapter IV, *She's Gotta Have It* dealt with a sexually uninhibited black woman and her three lovers. *School Daze* presented a critical look at intragroup prejudice and sexual abuse in higher education. *Do the Right Thing* was primarily about racial animosity and violence. This was not the stuff of most 1980s mainstream Hollywood cinema that usually avoided or diluted controversial material and either ignored black cultural themes or represented them from a white perspective (Grant, 1997; Kellner, 1997b). For example, Grant (1997) cites Hollywood films of this era such as *Cry Freedom* (1987), *Mississippi Burning*

(1988), and *Glory* (1990) that used black struggles for equality as no more than a backdrop for the exultation of white heroic figures. Conversely, *Do the Right Thing* and Lee's other films offered a clear focus on black characters from the perspective of a black auteur. In a reference to this film in his published journal Lee wrote, "It will be told from a Black point of view. I've been blessed with the opportunity to express the views of Black people who otherwise don't have access to power and the media" (Lee and Jones, 1989, p. 34).

Lee thus expresses the spirit of alternative media even in the midst of his collaboration with mainstream corporate media institutions. It was despite this spirit, however, not because of it, that Hollywood exhibited an interest in Lee and other black, exclusively male, directors during the late 1980s and early 1990s. Hollywood corporations were willing to finance, and sometimes even sought out, filmmakers that represented alternative perspectives if they felt that the opportunity for profit was great enough. As Guerrero points out, the Hollywood industry, "privileges economics and short-term profit before all other human, aesthetic, or philosophic possibilities or concerns" (1993, p. 2). Thus, even a historically conformist institution like the American film industry has periodically looked to members of various subcultures to bring new material to the screen in order to attract audience attention. Lee was fully aware of the basis for the corporate support that he had gained, finishing the statement noted above with the words, "I have to take advantage of this while I'm still bankable" (Lee and Jones, 1989, p. 34).

Subsequent to the success of *She's Gotta Have It*, Lee signed a deal with Columbia to finance and distribute *School Daze* and was awarded a budget of 6.5 million dollars. Lee had achieved his dream of not having to scrounge for funds anymore and, in a comparison to the $175,000 that the previous film had cost, Lee wrote, "*Daze* was a real movie...." (Lee, 1991, p. 14). Despite Lee's spirit of independence noted above, this statement is indicative of Lee's somewhat contradictory belief that corporate funding is somehow representative of legitimation. Everything was not ideal with Lee's alliance with Columbia, however. One issue that Lee and other black filmmakers have consistently had to deal with is underfunding of their films, even after they have managed to acquire Hollywood backing. 6.5 million does represent a huge increase relative to the cost of *She's Gotta Have It*, but a more useful comparison is to other late 1980s Hollywood films that averaged budgets of $18 million, or nearly three times the figure that Lee was able to procure despite the financial success that his films had generated (Lee and Jones, 1989).

Furthermore, Lee was disappointed with Columbia's promotion of *School Daze*, and the involvement of executives who he felt interfered with him while he was directing the film (Grant, 1997; Lee and Jones, 1989). Lee felt that Columbia's poor marketing efforts were racially based. He wrote:

> I learned that there will be no television advertising period. Also no ads in *Essence*, *Ebony*, or *Jet*, which I feel is a disgrace, a slap in the face of the Black consumer and the Black media.... Columbia wants to put me on the road...and work me like a Georgia mule so they don't have to spend a dime to promote *School Daze*.... When you come down to it, it's racism, sad but true. All they see is niggers: nigger director and nigger audience, second-rate, second-class shit; therefore the project is not worth their time and money (Lee and Jones, 1989, p. 57).

Despite Columbia's lack of support for the film, due to Lee's hard work it still managed to become one of Columbia's few profitable films of the late 1980s (Grant, 1997). When it came time to find a deal for *Do the Right Thing*, then, Lee was convinced that he would not go to Columbia. Although Island had successfully promoted and distributed *She's Gotta Have It*, Lee believed they did not have the financial resources or industry clout to handle his new picture in the way he wanted it to be handled. However, he would soon discover that many of Hollywood's major corporations were not particularly eager to invest in a script that was as direct and confrontational as they viewed *Do the Right Thing* to be. Lee originally negotiated with Paramount and Touchstone but neither deal would come to fruition. Paramount executives insisted that they were only interested in the film if Lee would change the violent ending. Lee felt that Paramount Pictures "want an ending that won't incite a giant Black uprising. They are convinced that Black people will come out of the theaters wanting to burn shit down" (Lee and Jones, 1989, p. 76). Paramount also seemed concerned that the film would not bring in the kind of profits that they wanted. Lee sent the script to Touchstone pictures but they turned it down, saying that it was not worth the seven to ten million dollar budget that Lee was looking for. Instead they suggested that the film was only worth a three to four million dollar budget (Lee and Jones, 1989), approximately 20% what the average Hollywood film cost during the late 1980s. Despite Lee's proven ability to earn money for Hollywood corporations, he found himself still facing many of the same obstacles that black artists have historically encountered from American media institutions. As with his previous productions, however, Lee was determined not to be derailed by these obstacles. He was fully aware of what he was dealing with as he wrote, "It's important that I follow up *School*

Daze right away. This is crucial, no recent Black filmmaker has been able to go from film to film like the white boys do" (Lee and Jones, 1989, p. 79).

Finally Lee found a company, Universal Studios, willing to support the script and to agree to his demand for final cut—the crucial power of the director to approve the final version of the film that is released to the public. Universal's interest in Lee was not, however, motivated by a desire to support socially relevant filmmakers. The head of Universal was upfront about his company's economic interest in Lee as a filmmaker who could make profitable films on a low budget: "We're not some crusading studio out looking for social issues...we can't afford to make movies if we can't make money on them" (Pollock, quoted in Matthews, 1989). This attitude was reified by Universal's strict limitations on Lee's budget and their insistence that they would go no higher than 6.5 million dollars, a figure that represented about a third of the cost of the average Hollywood film of the era. Lee was cognizant of the racial implications of the obstacles that he was encountering. In his journal Lee wrote:

> Universal is dicking me around. They won't budge from the $6.5 million budget, won't go a penny over it. It's ridiculous. White boys get real money, fuck up, lose millions of dollars, and still get chance after chance. Not so with us. You fuck up one time, that's it. After the commercial successes of *She's Gotta Have It* and *School Daze*, I shouldn't have to fight for the pennies the way I'm doing now (Lee and Jones, 1989, p. 87).

Universal made other demands as well. They insisted on an eight-week shooting schedule rather than the ten weeks that Lee felt he needed. More importantly, Universal also attempted to convince Lee to shoot the film in Philadelphia or Baltimore, rather than Brooklyn, but Lee was adamant that the film was about a unique culture and must therefore be shot on a real block in Bedford-Stuyvesant (Lee and Jones, 1989). Lee's refusal to shoot the film anywhere else meant that he would have to compromise in another important area. The local New York City film trade unions were well established, but Lee was not a supporter because he felt that they discriminated against people of color. In fact, there is evidence that Lee's perception was accurate as blacks have historically been a negligible part of the membership of film trade unions (Grant, 1997). Initially Lee wanted to shoot the film with a non-union crew, and while this was not possible, Lee was steadfast in his resolve to resist the prevailing trends of discrimination in the film industry by employing as many black workers as he possibly could. Eventually he was able to get both the National Association of Broadcast Employees and Technicians and the

International Brotherhood of Teamsters to bring more black members into their ranks (Grant, 1997), by any evaluation a significant accomplishment.

Lee was also able to succeed in his demands for how the neighborhood that he was filming in would be treated. All of the scenes in *Do the Right Thing* take place on one imaginary block in Bedford-Stuyvesant during a twenty-four hour period. Lee intended to shoot for a solid eight weeks on one residential block, and he was determined not to alienate those who lived and worked in that neighborhood. Members of the crew met with residents of the block to make them feel that they were a part of the project. Lee also rejected the idea of using a traditional security force or having a large police presence during shooting. Instead, he made the controversial move of hiring the Nation of Islam's security force, the Fruit of Islam. One of the objectives that this group carried out was to peacefully but forcefully close down three crack houses that were in operation on the block (Grant, 1997).

Thus, during the negotiations for, and the production of, *Do the Right Thing*, Lee encountered some of the realities of mainstream media production: racial discrimination, attempts at corporate control over media content, the primacy of profit above all other considerations. Despite these barriers, Lee was able to win hard-fought victories to retain the integrity of his artistic vision, to integrate the film trade unions, and to utilize unorthodox, alternative production strategies. In this way, the story of the production background of *Do the Right Thing* in many ways frames the film as a counter-hegemonic form of media culture more strongly than the images and narrative of the film itself.

Film Narrative

As noted in the previous chapter, *Do the Right Thing* opens with a dance sequence that is distinct from the film's narrative. As the credits appear on the screen, Rosie Perez, an actress who appears in the film as the protagonist's girlfriend, is shown dancing aggressively to a song by the rap group Public Enemy, "Fight the Power." This song, played repeatedly throughout the film, eventually emerges as the film's anthem and an important conveyor of the film's thematic meaning.

In a sequence of establishing shots, Lee depicts various residents of a block in Bedford-Stuyvesant waking up to a blistering hot Saturday. Smiley, a young man with a stutter (Lee's journal identifies him as being "mentally retarded") is standing in front of a church front holding up a historical photograph of

Malcolm X and Martin Luther King, Jr. in a rare face-to-face meeting. Other residents include the protagonist of the film, Mookie (played by Lee), who is first depicted sitting on his bed counting money. He is then shown lying on top of his sister Jade (played by Lee's real sister Joie Lee), playing with her lips to wake her up.

In the next scene a white Cadillac pulls up in front of Sal's Famous Pizzeria and three non-residents of Bedford-Stuyvesant, Italian American Sal and his two sons Pino and Vito, get out and begin opening Sal's restaurant for the day's business. The animosity between Vito and Pino is immediately established when they start arguing about who is going to sweep the sidewalk in front of the pizzeria. Pino expresses his hatred of the neighborhood and in a foreshadowing of events to come Sal says, "I'm gonna kill somebody today" (Lee and Jones, 1989, p. 126). Mookie arrives at Sal's to begin his day delivering pizza, and Pino finds a new target for his anger as he orders Mookie to sweep the sidewalk. Mookie refuses: "Fuck dat shit. I deliver pizzas. That's what I get paid for" (Lee and Jones, 1989, p. 129).

The opening scenes of Do the Right Thing also introduce the characters of the elderly wino, Da Mayor, and his female counterpart and adversary, Mother Sister, an older woman who sits in her window and watches over the neighborhood. While the scenes between Pino and Mookie have already established racial tensions within the community, this is reinforced when Da Mayor attempts to buy beer at a Korean grocery. They don't have the brand he is looking for and Da Mayor confronts the Korean owner: "Doctor, this ain't Korea, China, or wherever you come from" (Lee and Jones, 1989, p. 135).

Other members of the community are also introduced during these opening sequences: Young people hanging out on the neighborhood's front stoops, a trio of unemployed men that Lee calls the Corner Men (Lee and Jones, 1989) because of their propensity to sit on the corner drinking beer and making jokes at each other's expense, and two characters who are instrumental to the narrative: Radio Raheem and Buggin' Out.

Radio Raheem is a very large, muscular young man who is usually shot from below to further emphasize his imposing size. The neighborhood youths go out of their way to be overly respectful to him: "You the man, Radio Raheem. It's your world. In a big way" (Lee and Jones, 1989, p. 134). Radio Raheem is so named because of the giant boombox that he carries wherever he goes. This radio is always blaring at full volume, and it is always playing one song, the film's anthem, "Fight the Power." Every time Radio Raheem appears on the screen the booming of this song is heard seconds before Raheem's image appears.

The other essential character is called Buggin' Out and the scene that introduces him to the narrative is the third instance in the film when racial tensions are apparent. Buggin' Out is shown eating a slice of pizza in Sal's when he notices that a wall in the restaurant is covered with pictures of Italian American popular culture icons: Frank Sinatra, Joe DiMaggio, Al Pacino, Liza Minnelli, and many others. Buggin' Out demands that Sal put up pictures of black icons by the next day and dismissively throws a balled-up napkin onto the floor in Sal's general direction. Sal immediately grabs a baseball bat from behind the counter and starts to go after Buggin' Out when Mookie intervenes and hustles Buggin' Out outside. Buggin' Out begins shouting, "Boycott Sal's. Boycott Sal's" (Lee and Jones, 1989, p. 142). This scene introduces the primary narrative conflict that will come to a climax in the film's controversial ending.

Significantly, two sequences that immediately follow this confrontation could easily be mistaken as incidental asides, but they actually have much relevance to an ideological analysis of the film. Just after Mookie has temporarily placated Sal and Buggin' Out, there is a shot of him walking down the block delivering a pizza. He passes Da Mayor sitting on a stoop and Da Mayor demands that Mookie stop and speak with him. Mookie reluctantly does so and Da Mayor says, "Doctor, this is Da Mayor talkin'...Doctor, always try to do the right thing" (Lee and Jones, 1989, p. 144). With that he lets Mookie go on his way. Immediately after this, Smiley meets Mookie in the stairwell of the building where Mookie is delivering the pizza. He tries to get Mookie to buy one of his photos of Malcolm X and Martin Luther King, Jr. smiling and shaking hands. The juxtaposition of this scene with Da Mayor's invocation of the film's title and the scene of the initial confrontation between Buggin' Out and Sal has much bearing on a deciphering of Mookie's actions during the film's penultimate scenes of violence, which may be read as Lee's commentary on "doing the right thing" and making a choice between the alternate paths symbolized by King and X.

Prior to the climax of the film, however, a series of scenes depict life in this small community on a blistering hot Saturday in July. These scenes signify that this block is more than just a collection of individuals who live near each other. It is a vital community of neighbors who coexist on an intimate level. Lee's vision is not uncomplicatedly pluralistic, however, as throughout this middle section of the film a sequence of adjacent scenes continue to develop the racial tensions that the film has already established, hinting at the potential violence that lies just beneath these surface tensions as the temperature continues to rise throughout the day.

The first scene of this nature occurs when a white motorist attempts to drive past a group of kids playing in an illegally opened fire hydrant and screams at them not to soak his car. As he is driving past they direct the water straight at him, thoroughly drenching both the driver and the interior of the convertible he is driving. He gets out just as a police car pulls up and he complains to the white police officers about the black kids who soaked his vehicle. The police turn the hydrant off and threaten trouble if it is turned back on. Throughout *Do the Right Thing*, the police are generally portrayed as an alien and unwanted presence in the neighborhood. The contempt that is felt on both sides is directly established in a scene shot in slow motion depicting the police cruising by the Corner Men as each group stares at the other with squinty eyes and disparaging facial expressions. Both the police and the Corner Men utter the phrase, "What a waste," in their evaluation of the other group.

In another scene of interracial conflict, Buggin' Out is bumped by a white passerby wheeling a bicycle. The bike's tires run over Buggin' Out's feet leaving a black smudge on Buggin' Out's otherwise meticulous white Nike sneakers. Buggin' Out confronts Clifton, the offender who rudely bumped into him and just kept walking, while the neighborhood youths gather around and urge him on by insisting that his treasured and expensive Air Jordan sneakers are now ruined beyond hope. Buggin' Out goes eye-to-eye with Clifton and demands, "Who told you to step on my sneakers? Who told you to walk on my side of the block? Who told you to be in my neighborhood?" Clifton replies, "I own a brownstone on this block." Buggin' Out and the crowd react with disgust and Buggin' Out responds, "Who told you to buy a brownstone on my block, in my neighborhood on my side of the street? What do you want to live in a Black neighborhood for?" (Lee and Jones, 1989, p. 167).

This extended sequence of scenes of ethnocentrism and racial animosity culminates in a series of shots that break the linear, realistic, narrative flow of the film in a similar fashion to the "Dog Sequence" in *She's Gotta Have It* (see Chapter IV). One by one, representatives of conflicting ethnic groups face the camera and let loose with a litany of stereotypes and insults directed toward other cultures. All of these scenes of barely suppressed intergroup violence and cultural and racial conflict, culminating in this stylized sequence of shots, work together to move the narrative to what has been established as a logical and seemingly inevitable violent climax.

The introduction to the film's final conflict begins with a scene between Buggin' Out and Radio Raheem. One by one, various residents of the block

have rejected Buggin' Out's boycott proposal until he finally finds support from just two individuals, Radio Raheem and Smiley. The narrative has already established that both have had conflicts in Sal's restaurant. In a previous scene, Smiley had been humiliated, insulted and almost attacked by Pino, Sal's blatantly racist son. Sal and Radio Raheem have also come into conflict over Radio Raheem's massive portable radio, and Sal has forced Radio Raheem to turn his music off against his will. As the film approaches its violent climax, Smiley, Radio Raheem and Buggin' Out walk into Sal's Pizzeria with "Fight the Power" blasting from the boombox. Buggin' Out again demands that photographs of blacks be included on the Wall of Fame. Sal is only concerned about the loud music and yells, "Turn that JUNGLE MUSIC off. We ain't in Africa" (Lee and Jones, 1989, p. 242). Sal then produces a baseball bat from behind the counter, screams racial epithets, and smashes the boombox to pieces. All action and sound stops momentarily until Radio Raheem grabs Sal and pulls his entire body over the counter. Suddenly there is a melee as the neighborhood teenagers and Sal's sons all begin to wrestle and punch each other in one seething mass that spills out onto the street. A crowd gathers as Radio Raheem pins Sal to the ground and begins to choke him. A siren squeals and two police cars screech to a halt in front of the Pizzeria. Several cops grab Radio Raheem and pull him off Sal, putting him in a chokehold with a billy-club crushing his windpipe. This chokehold replicates the actual murder of Michael Stewart by New York City police in 1983. Murder is indeed what is taking place as the camera focuses in on Radio Raheem's Nike sneakers, which are now inches off the ground and trembling as the police literally choke the life out of him and he slumps to the ground dead. The police stand over his inert body screaming at him to get up and kicking at him until the truth hits them, and they quickly throw Buggin' Out and Radio Raheem's corpse into the police cars and flee the scene with the crowd screaming and chasing after them.

In the aftermath of the slaying of Radio Raheem, the camera pans the stunned crowd and one by one residents of the neighborhood come into view intoning the word "murder" and the names of real world victims of police brutality. They are addressing Mookie who finds that he is standing alongside Sal and his two sons. Mookie leaves their side and crosses over to the other side of the street. The crowd is now staring at Sal with menace in their eyes. Sal shrugs his shoulders and says, "You do whatcha' got to do." Da Mayor tries to intervene on Sal's behalf but the crowd will not hear it. Mookie is shown rubbing his face with his hands, then slowly, deliberately, he empties a

metal garbage can and, screaming the word "Hate," he throws it through the plate glass window of Sal's Pizzeria. Lee's script describes the consequences of this action:

> That's it. All hell breaks loose. The dam has been unplugged, broke. The rage of a people has been unleashed, a fury. A lone garbage can thrown through the air has released a tidal wave of frustration (Lee and Jones, 1989, pp. 248–249).

As Da Mayor hustles Sal and his sons across the street behind an iron fence, the crowd destroys Sal's Pizzeria, smashing everything they possibly can. Smiley enters the Pizzeria and lights a match, setting a fire that begins to consume the building. The photographs adorning the Wall of Fame are burning. Even Mother Sister is screaming, "Burn it down. Burn it down" (Lee and Jones, 1989, p. 250).

One of the Corner Men says, "Let's clean house" and the crowd begins to turn on the Korean grocery. The Korean grocer attempts to save his business by insisting that he too is black, and this seems to amuse the crowd enough for them to spare him. Again the police arrive, along with the fire department, and attempt to disperse the crowd. The fire department turns its powerful jets of water onto the crowd, and Lee's script says, "Now we've come full circle. We're back to Montgomery or Birmingham, Alabama" (Lee and Jones, 1989, p. 253). Mookie has not participated in the violence since he threw the garbage can through the window, and he is shown sitting next to his sister on the curb looking stunned and drained.

There has been no music on the soundtrack since Sal smashed Radio Raheem's box, only the sounds of people screaming and cursing, and the ambient noise of violence. Now as the camera pans through the burning remnants of Sal's Pizzeria, "Fight the Power" is heard once again, as Smiley stumbles through the burning debris and pins one of his photos of Malcolm X and Martin Luther King, Jr. on the charred Wall of Fame. A close up shows him smiling with flames burning behind his head. This is the true climax of the film, but like *She's Gotta Have It*, *Do the Right Thing* also ends with a coda.

It is the next morning and the camera pans through the debris-cluttered street where the previous night's unrest took place. Mookie wakes up next to his girlfriend and their son, Hector. Despite Tina's protests he insists that he has to go get his week's pay from Sal. Mookie finds Sal sitting on the stoop of his destroyed restaurant. Mookie strides up, kicks the garbage can that he had thrown through the window and demands his money. Sal blames Buggin' Out,

not the police, for Radio Raheem's death. Sal and Mookie argue and Sal takes bills out of his pocket and balls them up and throws them at Mookie. Finally they stop yelling and Sal asks Mookie what he is going to do now. Mookie replies, "Make dat money. Get paid." (Lee and Jones, 1989, p. 263) and turns to go. The camera pans back to show children playing in the streets amid the debris. It is another day and the neighborhood is returning to normal. Mister Señor Love Daddy, a local radio D.J. announces that the mayor (in reference to New York's real mayor of the time, Ed Koch) has appointed a panel to look into the disturbance and that he has vowed that he will not let property be destroyed. Mister Señor Love Daddy urges his audience to register to vote and dedicates a record to Radio Raheem. The film ends with back-to-back quotes from Martin Luther King, Jr. and Malcolm X scrolling on the screen. First Martin Luther King, Jr.:

> Violence as a way of achieving racial justice is both impractical and immoral. It is impractical because it is a descending spiral ending in destruction for all. The old law of an eye for an eye leaves everybody blind. It is immoral because it seeks to humiliate the opponent rather than win his understanding; it seeks to annihilate rather than to convert. Violence is immoral because it thrives on hatred rather than love. It destroys a community and makes brotherhood impossible. It leaves society in monologue rather than dialogue. Violence ends by defeating itself. It creates bitterness in the survivors and brutality in the destroyers.

Then, Malcolm X:

> I think there are plenty of good people in America, but there are also plenty of bad people in America and the bad ones are the ones who seem to have all the power and be in these positions to block things that you and I need. Because this is the situation, you and I have to preserve the right to do what is necessary to bring an end to that situation, and it doesn't mean that I advocate violence, but at the same time I am not against using violence in self-defense. I don't even call it violence when it's self-defense, I call it intelligence.

The last visual image before the end credits is a close up of Smiley's photo of Malcolm X and King standing next to each other, smiling warmly. Lee follows this image with a dedication to real world victims of racial violence.

Critical Reception

Do the Right Thing was a source of controversy even before its release to the general public. After a screening at the Cannes Film Festival some reviewers

accused the film of advocating violence as a response to racial discrimination. Some even went so far as to suggest that the film should be considered dangerous, and Lee himself should be regarded as an irresponsible provocateur (Patterson, 1992). Finnegan (2011) contends that this sort of antipathy stems from Lee's refusal to provide the standard Hollywood solution to racism as just a matter of overcoming ignorance. Despite the hysterical rhetoric of some critics, audiences at Cannes responded enthusiastically, and *Do the Right Thing* seemed to be clearly headed for the festival's top prize, the *Palme d'Or*. However, the German director, Wim Wenders, serving as the head of the jury, seemed to be primarily responsible for the film being passed over for this award (Patterson, 1992). One of Wenders's chief complaints was that Mookie's act of throwing the garbage can through Sal's window was "unheroic." Implicit in Wender's objection is the notion that Lee (as Mookie) was embodying the "rightness" of this action. Regarding this, Finnegan's critique is insightful:

> The anxiety over whether this single event in a two-hour film is meant to constitute "doing the right thing," and whether the director's casting himself in this role means that Spike Lee as well as Mookie is somehow symbolically committing or endorsing this action, reflects the white anxiety over what "power" would mean for an African American and the assumption that this power will be—indeed, must be—enacted through violence (2011, p. 86).

Lee himself has pointed out that the film that garnered the top prize that year, *sex, lies and videotape* (1989) by director Steven Soderbergh, featured a "hero" who spent his time masturbating while watching videos of women talking about sex.

Do the Right Thing was also passed over for an Academy Award, and at the ceremony the actress Kim Basinger publicly stated that the lack of a Best Picture nomination for this film was a serious omission. Lee wrote in his 1997 autobiography, "I didn't expect the veritable firestorm of criticism that I received for that film. I expected it to be noticed, discussed, I wanted it to have an impact, but I didn't expect to be asked why I was so angry..." (Lee and Wiley, 1997, p. 158). Actually, however, Lee did anticipate some of the most negative reactions to his film as evidenced by several notes in his published 1987/1988 journal similar to this December 27, 1987 entry: "The studios might not want to touch this film. I know I'll come up against some static from the white press. They'll say I'm trying to start a race riot" (Lee and Jones, 1989, p. 33).

In fact, that is exactly what several members of the mainstream press did say about Lee and the film. Reviews that were published in major newspapers and magazines like *The Boston Globe*, *Newsweek*, *Time* and *New York* all accused Lee of trying to inflame the audience and predicted that violence could erupt after screenings (Carr, 1989; Denby, 1989; Klein, 1989; Kroll, 1989; also see Guerrero, 2001; Lee and Wiley, 1997; Patterson, 1992, and Rosenbaum, 1997 for responses to, and commentary on, these reviews). At one Chicago screening, a police paddy wagon was parked in front of the theater before the film even started (Rosenbaum, 1997). Guerrero places this type of overheated response in a larger context:

> When a commercial film depicting a social issue or perspective challenges Hollywood's strategies of ideological containment, that film usually comes under attack for inflaming and exacerbating the very problem that it seeks to expose, engage or change. One of the most common forms of this manoeuvre is to claim that social critique or challenge to the status quo automatically incites reactionary mob violence (2001, p. 19).

In a review of press coverage of *Do the Right Thing*, Messaris (1993) argues many of the critics' responses to the film, when considered in relation to each other, were contradictory. Several critics seemed unable to deal with the ambiguity that is an essential part of the film. Messaris points out that the film represented a more complex view of social conflicts than the usual mainstream media fare because Lee does not present either black or white characters as either uniformly positive or uniformly negative, and he ends the film with a deliberately ambiguous conclusion. Finnegan believes this in fact what put some critics off: "The film does not illustrate what 'doing the right thing' would be; it offers us no role models and at every turn denies us catharsis, resolution, and relief" (2011, p. 90).

Rowland and Strain (1994) make a similar point in their scholarly analysis of *Do the Right Thing* as a rhetorical work that deliberately sets out to provide contradictory perspectives on racial conflict. Rowland and Strain identify Lee's efforts to present conflicting points of view as a strategy of radical polysemy that is necessary in order to present a thoughtful, useful confrontation of social conflict. From this perspective, contradictory interpretations of the film are a natural outcome of the film's radically polysemic messages about violence and racial oppression. The film presents violence as "*both* counterproductive *and* necessary for fighting racism*" (Rowland and Strain, 1994, p. 218) and it presents a thematic message that blacks "both *are* and *are not* responsible for

the endemic social ills that often are referred to as 'underclass culture'" (Rowland and Strain, 1994, p. 218).

Reviewers from major periodicals such as *Newsweek*, *Time*, and *People*, however, interpreted Lee's refusal to present easy answers as a sign of his own shortcomings, both politically and artistically. Several reviewers also criticized the film for failing to present a realistic view of a crime-laden, drug-infested ghetto (Chase, 1989; Corliss, 1989; Denby, 1989; Kroll, 1989) and accused Lee of presenting an unrealistic, nostalgic, whitewashed depiction of inner-city life (Crouch, 1989; McLane, 1989; Morrison, 1989). Contrary to these reviews, some critics, including some black reviewers, felt that the film's portrayal of urban culture was too negative and mean-spirited. Several reviewers wrote that Lee was guilty of perpetrating the same type of racism and bigotry that the film was supposedly exposing. Some of these critics suggested that Lee's portrayal of black characters was demeaning, stereotypical and served as evidence of self-loathing (A-Salaam 1989; Baraka, quoted in Nicholson, 1990; Jones, 1990; Kempton, 1989, August; Kempton, 1989, September; Morrone, 1989; Muwakkil, 1990; Thomas, 1989). Lee has stated that criticisms such as this don't faze him because he has never bought into the simplistic notion of negative vs. positive imagery (Mitchell, 2002). In a 1999 interview with the actor Delroy Lindo, who has appeared in several of his films, Lee said:

> And then I also made a conscious effort not to fall into this whole positive-negative trick bag which a lot of African American artists get caught up in. The fact that we have been dogged out so hard and for so long in films, television, and stuff. You have a faction of people who, in response to that, want every image of African Americans to be a hundred percent pristine—God-like and Christ-like. And I said, "I don't want to do that. Number one, it's not truthful. Number two, it's not interesting either" (quoted in Lindo, 2002, p. 165).

Finnegan also offers a critique of these reviews as simplistic and narrow: "as though the act of representation itself means that the artist is necessarily uncritical of what is being represented. The subtext that emerges here is that an African American filmmaker is apparently obliged to make films that can be used as public service announcements, an updated version of the 1960s social message films" (2011, p. 84).

Ironically, that is exactly what other critics thought Lee had done, as a few reviewers accused Lee of "bullying" the audience with a heavy-handed message (Rafferty, 1989) or even practicing a form of Afro-centric fascism (Crouch, 1989). Other reviewers disagreed with these suggestions that the film

presented a didactic message about what "the right thing" was, but interpreted this as a lack of clarity or artistic ability on Lee's part (Chase, 1989; Corliss, 1989; Denby, 1989; Kroll, 1989). Some, however, did recognize the complexity of the film as a deliberate and necessary strategy on Lee's part (Ansen, 1989; Clark, 1989; Griffin, 1989; Kaufman, 1989; Klawans, 1989; Page, 1989; Rosenbaum, 1997; White, 1989) and a number of reviewers felt that the film was an intelligent and sophisticated confrontation of white racism (Cardullo, 1990; Klawans, 1989; Page, 1989; Perkins, 1990).

I now turn to a structural semiotic exploration of the film *Do the Right Thing* in order to provide an analytic interpretation that can cut through some of the confusing and contradictory responses that the film generated.

Structural Semiotic Analysis of *Do the Right Thing*

The wide-ranging and often contradictory media responses to *Do the Right Thing* highlight that this film is a more sophisticated and complex film than *She's Gotta Have It* (1986), which leant itself to a fairly straight-forward analysis of the oppositional tensions, privileged positions, and preferred ideological stances represented in that film. Certain dimensions of *Do the Right Thing*, however, seem to defy this type of analysis due to Lee's purposefully ambiguous representations of conflicting perspectives. Continuing my contention that films and other forms of popular culture can be regarded as analogous to modern-day myths, I draw on Rowland and Strain's (1994) argument that *Do the Right Thing* can be read as a cultural descendant of Yoruba myths that deal with the uncertain and the indeterminate.[6]

Gates (1988) relates myths of the Yoruba people of Nigeria dealing with a divine figure called Esu-Elegbara who embodies uncertainty and indeterminacy. In one particular tale of two friends, Esu creates discord by passing between them wearing a hat colored black on one side and white on the other. The two friends disagree over the color of the hat and this disagreement devolves into insults and physical battle. Esu reappears to tell the friends that they were both right, the hat was a black hat as well as a white hat (Gates, 1988). This is a particularly apt analogy for a film that resists the usual tendency to clearly distinguish the heroes from the villains (or the white hats from the black hats, the inherently racist system of signification historically employed in Hollywood westerns). In his journal, Lee makes several references to wanting

to avoid rigid distinctions between heroes and villains in this film (Lee and Jones, 1989), instead allowing interpretive space for uncertainty, or to once again refer to Derrida's (1988) critique of structuralist oppositions, undecidability. Another way to put this: we must recognize *Do the Right Thing* as "an open-ended, unresolved text vocalizing issues and diagnosing problems, asking questions rather than posing smug answers in the style of the classic Hollywood ending" (Guerrero, 2001, p. 82), a tendency that can be identified in many of Lee's films (Watkins, 1998).

Nevertheless, there is still merit in an analysis of the oppositional tensions presented in this film. This type of approach can usefully point out what aspects of the film clearly represent ideological oppositions and privilege certain positions over others, and what aspects of the film defy rigid ideological boundaries by not just allowing, but demanding multiple readings and interpretations of Lee's intent (Rowland and Strain, 1994).

Furthermore, even the title of the film suggests a binary oppositional structure. If there is a "right thing" to be done there must logically be a "wrong thing" also. This title is an ideal exemplification of the theoretical position that meaning is found in opposition and absence. Even though the title makes no explicit reference to what the right thing or wrong thing is, the linguistic structure of the phrase itself suggests that the right thing can only be determined in relation to everything that would *not* be the right thing. Drawing on Hall (2013), and retaining the strategy of analysis utilized in the previous chapter, but adding an additional complication, Figure 2 charts the binary oppositions and the hierarchically privileged positions represented in *Do the Right Thing*.

Binary Oppositions in *Do the Right Thing*:
Villainy/*Heroism*
Violence/*Nonviolence*
Neonationalism/*Multiculturalism*
Harmony/*Discord*
Consumerism/*Political Activism*
Communal Humanity/*Individual Property*
Male Agency/*Female Spectatorship*

Figure 2

In Figure 2 the positions in boldface represent the privileged pole of the oppositional tension and italics represent the subordinate position. Oppositions that are left unresolved are indicated by the use of both bold and italic fonts for both poles.

Indeterminacy—Complex Moral and Ideological Positions in *Do the Right Thing*

As noted above, some of the key oppositions encoded in the language, images, sounds, and narrative of *Do the Right Thing* are left open for interpretation by Lee's deliberate use of contradictory or ambiguous signifiers. Rather than presenting a clear demarcation between **heroism** and **villainy**, the "right thing" and the "wrong thing," Lee's more complex representations are signified in the opening moments of the film when Mister Señor Love Daddy announces that he is "doing da yin and yang" (Lee and Jones, 1989, p. 122). The central question that remains after viewing the film is what is "the right thing" after all? In a scene immediately after Buggin' Out calls for a boycott of Sal's, Da Mayor pulls Mookie aside and tells him, "Doctor, always try to do the right thing" (Lee and Jones, 1989, p. 144). Mookie replies, "I got it" (Lee and Jones, 1989, p. 145). Yet, at the climax of the film, Da Mayor and Mookie perform very different actions that signify the undecidability of Lee's representation of "the right thing" through his refusal to clearly delineate between **villainy/heroism**. Mookie initiates the destruction of Sal's Pizzeria by throwing a trashcan through the restaurant's window and then sits down on a curb and simply watches as the crowd rampages. Da Mayor first tries to dissuade the crowd from responding to violence with violence, and then pulls Sal and his sons to safety across the street from the restaurant. Although it is Mookie who the camera reveals to be standing with Sal, Vito and Pino before the riot breaks out, it is Da Mayor who is standing with them during the destruction. Do these actions connote Mookie as a villain and Da Mayor as a hero? Lee's deliberately polysemic representation leaves that question open for interpretation with no preferred meaning encoded into the text of this film. Significantly, these actions take place immediately after the one clearly villainous act—the murder of Radio Raheem.

Prior to these climatic sequences, Lee's choices as an actor, screenwriter, and director have already suggested that both Mookie and Da Mayor have heroic and non-heroic dimensions. Da Mayor is an unkempt, unemployed alcoholic who saves a young boy's life by rushing in front of a speeding car and pushing the boy to safety. Mookie is the protagonist of the film, unafraid to speak his mind, well liked by the community, but also an irresponsible worker and a neglectful father. Who emerges as the hero through their oppositional behaviors at the end of the film? Is Mookie's act heroic because it manifests the crowd's outrage and righteous wrath over the death of Radio Raheem, or,

as Wim Wenders seemed to feel, is he to be considered disloyal for initiating violence against Sal's property? Is Da Mayor a hero for pushing Sal and his sons away from the oncoming mob, much as he pushed the young boy out of the path of an oncoming car, or is he a traitor to the community because of these actions? Lee refuses to suggest simplistic and rigid answers to these questions, as he has refused throughout the film to clearly identify heroes and villains. The police who murder Radio Raheem are perhaps most clearly the villains in this drama, but they actually function more as a plot device than as developed characters.

Sal's racist son, Pino, is the next closest thing to a narrative villain with little in the way of redeeming qualities, but even Pino's shortcomings are somewhat mitigated by Lee's portrayal of him as a highly confused and conflicted young man. Mookie holds a mirror up to Pino when he reminds him that his cultural icons are all black. Pino sputters, "It's different. Magic, Eddie, Prince are not niggers, I mean, are not Black. I mean, they're Black but not really Black. They're more than Black. It's different" (Lee and Jones, 1989, pp. 184–185). Mookie replies, "Pino, I think secretly that you wish you were Black" (Lee and Jones, 1989, p. 185). As Mookie is pointing out the absurd lack of rationality behind Pino's racism, Lee is pointing out the contradictions of an American culture that again and again looks to blacks for inspiration and idolatry and yet simultaneously encourages white supremacist attitudes and practices (Yousman, 2003).

Other than Pino and the police, the rest of Lee's characters, Mookie, Da Mayor, Sal, Buggin' Out, Radio Raheem, Mother Sister, inhabit an indeterminate space, neither hero nor villain, neither entirely righteous or entirely sinful, "da yin *and* yang" as Mister Señor Love Daddy puts it (Lee and Jones, 1989, p. 122). As Esu played with human perceptions in the Yoruba myth, Lee plays with the mainstream Hollywood tradition of clearly demarcating the white hats from the black hats even by dressing Sal's "good" son, Vito, in a black T-shirt and Sal's "bad" son, Pino, in a white T-shirt. This openness or indeterminacy is also present in the film's opposition of **violence/non-violence** as coded through the central image of the film, the photograph of Malcolm X and Martin Luther King, Jr. warmly greeting each other. This photograph is a signifier of the potential for melding the complex moral and philosophical positions represented by each man. This image is used throughout the film to indicate that there is no simple solution to the enigma suggested by the film's title: what is the right thing?

Lee employs Malcolm X and Martin Luther King Jr. as signifiers of the opposing political strategies of non-violent protest versus violence as

self-defense. This is most evident during the last images of the film when Lee dissolves from the photograph of King and X to printed quotes from each man. King's quote appears first and says in part, "Violence as a way of achieving racial justice is both impractical and immoral....It destroys community and makes brotherhood impossible" (quoted in Patterson, 1992, p. 117). This is immediately followed by a quote from X that includes the statements, "I am not against using violence in self-defense. I don't even call it violence when it's self-defense, I call it intelligence" (quoted in Patterson, 1992, p. 118). Although Lee's journal indicates that he sides with the Malcolm X perspective on this issue, "Fuck the turn-the-other cheek shit. If we keep up that madness we'll be dead. YO, IT'S AN EYE FOR AN EYE" (Lee and Jones, 1989, p. 34), and Lee's sequencing of these statements gives X the last word, the film itself leaves this question of violence as a political strategy unresolved.

Initially the images and soundtrack signify that the riot has resulted in a victory of sorts. Public Enemy chant "Fight the Power" as Smiley pins his photograph to the Wall of Fame. But the photograph, like the rest of Sal's, catches on fire and will soon be ashes. In the following scenes Lee indicates that the riot that destroyed Sal's does nothing but leave the neighborhood without a place to get a slice of pizza. The next morning, children are shown playing in the debris-covered streets and activity in the neighborhood is "business-as-usual." Mister Señor Love Daddy emerges as the spokesperson for the community's collective consciousness as his voice is heard on the soundtrack, "Are we gonna live together? Together are we gonna live?"[7] (Lee and Jones, 1989, p. 256). The camera pans to the storefront that holds the WELOVE radio station and Mister Señor Love Daddy is framed in the window over large golden letters that spell out the word, "LOVE." In close-up he yells into the microphone, "WAKE UP!" (Lee and Jones, 1989, p. 256).

These words echo back not only to the opening of *Do the Right Thing*, but to Lee's earlier film, *School Daze* (1988), where they were the final words, signifying a call for unity within the black community. Coming near the end of *Do the Right Thing*, a film that depicts increasingly menacing and violent intergroup conflicts, this favorite injunction of Lee's can now be interpreted as a call for intercultural unity as well. Furthermore, Lee positions the uprising as politically ineffective during the final scenes of the film when Mister Señor Love Daddy reports that the Mayor (Koch) has announced that New York City will not tolerate the destruction of private property. Clearly, the riot's message as a protest against the murder of Radio Raheem has been missed by the real "powers that be" and Mister Señor Love Daddy now urges his listeners

to go to the polls and vote during the upcoming mayoral election. Thus, the film presents an open-ended and ambiguous statement about **violence/nonviolence** both as ideologies and as pragmatic political strategies.

This indeterminacy is also apparent in the film's ideological stance on **neonationalism/multiculturalism**. As noted above, the signifiers utilized in the film, particularly in its closing moments, seem to connote a call for intercultural unity. Lee self-consciously wanted to portray a multicultural environment unlike that of many Hollywood films. He wrote in his journal, "The neighborhood will have a feel of the different cultures that make up the city, specifically Black American, Puerto Rican, West Indian, Korean, and Italian American. Unlike Woody Allen's portraits of New York" (Lee and Jones, 1989, p. 28). Through clothing, music, and other cultural signifiers, Lee stresses this multiculturalism throughout the film. One shot pans across a stack of New York City newspapers whose headlines, in various linguistic styles and languages, all refer to the city's heatwave. Music is a particularly important element in establishing the multicultural milieu of the film (see Johnson, 1997) as Lee incorporates rap, soul, jazz, reggae, salsa and orchestral music into the film's soundtrack.

Yet Lee's representation of life in late 1980's New York City is not uncomplicatedly pluralistic. As noted in the previous section on the narrative structure of Do the Right Thing, these various cultures are not depicted as coexisting peacefully. Rather, cultural groups are depicted as living in an uneasy demilitarized zone that can devolve into violence at any time. This racial and cultural antagonism at times takes on the tone of neonationalist sentiments, as in the film's disparaging treatment of non-English speaking groups. On several occasions characters denigrate those who speak another language in a manner that echoes right-wing anti-immigration groups who foster an agenda that opposes bilingualism in favor of linguistic "purity." In one scene Radio Raheem has trouble purchasing batteries from the Korean grocer and snarls at him, "You dumb motherfucker. Learn to speak English first" (Lee and Jones, 1989, p. 208). In another scene Mookie tells his son's Spanish-speaking grandmother, "English, English! It's bad enough my son is named Hector!" Radio Raheem engages in a battle of boom boxes with a group of Latinos and, through sheer force of volume, his rap music drowns out the salsa coming from their smaller box. Radio Raheem is shown thrusting his arms in victory as a young black boy runs up to him and slaps his hand in a congratulatory salute. This scene reflects both a cultural and symbolically phallic clash between urban males with Radio Raheem's size and volume emerging victorious. Lee also depicts

the young, fashion-conscious black residents of the block wearing Afro-centric medallions and t-shirts. Mister Señor Love Daddy announces at the beginning of the film, "The color for today is Black." Characters greet and take leave from one another with phrases like, "Stay Black" and "Thank you Black man." One of the Corner Men laments the success of the Korean grocer and announces, "I'll be one happy fool to see us have our own business right here. Yes, sir. I'd be the first in line to spend the little money I got" (Lee and Jones, 1989, p. 175). All of these verbal and nonverbal signifiers are indicative of a neonationalist ideological stance contradictory to the multicultural aspects of the film.

Furthermore, in one of the film's most interesting sequences, Lee establishes that Sal is sexually interested in Mookie's sister, Jade. Jade enters the pizzeria and Sal's usual gruffness vanishes as he greets her: "Jade, we've been wondering when ya would pay us a visit...for you I'm gonna make up something special" (Lee and Jones, 1989, p. 206). The camera pans over Mookie and Pino staring at this interplay, and for once, their nonverbal facial expressions convey that they are in agreement in their disapproval of Sal's flirtatious behavior. In a subsequent scene Mookie pulls Jade out of the restaurant and tells her, "Jade, I don't want you coming in here no mo'...All Sal wants to do is hide the salami..." (Lee and Jones, 1989, pp. 218–219). Jade and Mookie exit the frame in separate directions revealing graffiti on the brick wall behind them. The graffiti reads, "Tawana Told The Truth."

This slogan references a 1980s incident in New York when a young black woman reported having been raped by a group of white men. She in turn was accused of having fabricated the event and soon the case seemed to both symbolize and exacerbate racial polarization in New York in a similar manner as, decades apart, high profile interracial murder trials, like those of O.J. Simpson for the killing of Nicole Brown Simpson and George Zimmerman for the killing of Trayvon Martin, were said to exemplify racial divisions on a national scale. The controversial Reverend Al Sharpton adopted the role of spokesperson and defender for Tawana Brawley, and the mainstream media transformed the young woman into a symbol of both racial division and black tendentiousness. Lee's decision to iconicize her during this scene of suspicion and fear of miscegenation seems to signify a support for the identity politics associated with neonationalist ideology. As Dyson points out:

> It is understandable, given Lee's perspective, that he chooses to retrieve this fresh and tortured signifier from the iconographical reservoir of black neonationalists, some of whom believe Tawana transcends her infamous circumstances and embodies the reality of racial violence in our times. Racial violence on every level is vicious now, but

Tawana is not its best or most powerful symbol. Lee's invocation of Tawana captures the way in which many positive aspects of neonationalist thought are damaged by close association with ideas and symbols that hurt more than help (1993, pp. 30–31).

Patterson (1992) has suggested that Lee may have intended this message to mean that Tawana told the truth metaphorically—despite the factual grounding, or lack thereof, in her specific allegations, her accusations about white society and its treatment of black women may generally resonate as true. Regardless of Lee's specific intentions behind this provocative paradigmatic choice, his representations regarding interracial sexual relationships, when read intertextually and sequentially from this film to later films like *Jungle Fever* (1991), *Malcolm X* (1992), *Girl 6* (1996), *He Got Game* (1998) and *Miracle at St. Anna* (2008) can be clearly recognized as supportive of a nationalist rather than a multicultural or integrationist stance. Thus, in this scene between Jade and Mookie, the overall multicultural tone of the film is both complicated and undermined.

The film's indeterminacy regarding **neonationalism/multiculturalism** is perhaps most clearly signified in the stylized sequence of characters of varying ethnic backgrounds facing the camera and letting loose a string of invectives about other cultural groups. The stylized presentation of this scene, the camera zooming in on characters who speak directly into it, along with the cartoonish, absurdly comic slurs voiced by these characters, reinforces the scene's function as a comic break from the narrative thrust of the film. While the comedic aspects of this scene lend an air of celebration to this display of cultural intolerance, the scene ends on a serious, didactic note with Mister Señor Love Daddy shouting into the camera, "Yo! Hold up! Time out! Time out! Y'all take a chill. Ya need to cool that shit out…and that's the truth, Ruth" (Lee and Jones, 1989, p. 188).

While the dimensions of **heroism/villainy**, **violence/nonviolence**, and **neonationalism/multiculturalism** discussed in this section are indicative of Lee's presentation of indeterminate or undecidable ideological positions, in other aspects of *Do the Right Thing*, the preferred meaning and ideological hierarchy favored by Lee is less fluid.

Harmony/Discord

Although the film's conclusions on the efficacy of violence or nonviolence as a political strategy are left indeterminate, Lee presents a clearer stance

on the value of **harmony** over *discord*. Whatever legitimation the film may lend to violence is based on Malcolm X's position on self-defense as a necessary response to violent oppression. Mookie's act of throwing the garbage can through Sal's window, and the subsequent mob destruction of Sal's restaurant are, significantly, the last, not the first violent outbursts in the film. They are a response to the murder of Radio Raheem and, contextualizing these acts within the narrative of the film, as well as in relation to the real world incidents of police brutality that Lee references, they must be interpreted as acts of response not instigation. As Lyne points out, read structurally and contextually, rather than as just an individual choice, "If Mookie doesn't throw the garbage can, someone else will. If no one throws a garbage can, some other violent cauldron will bubble over" (2000, p. 49). Furthermore, although violent discord simmers throughout the film, it is Sal's act of destroying Radio Raheem's boombox with a baseball bat that is the first violent act that actualizes and catalyzes the subsequent acts of violence.

Lee's film then, while remaining ambiguous about violent responses to oppression, simultaneously privileges harmony over discord. Lee makes several references in his journal to the block as a community: "There should be a feeling that the people on this block have lived as neighbors for a long time" (Lee and Jones, 1989, p. 28). Several scenes throughout the film function specifically to portray the harmony of this community: children playing on the sidewalks and in the water from the fire hydrant, Mother Sister keeping an eye on the neighborhood from her window, Mookie knowing and greeting everyone he passes on the street as he delivers Sal's pizzas, Sal's proclamations about having watched the children grow up on his food. Mister Señor Love Daddy and Da Mayor are two sympathetic characters who also perpetuate this sense of community and harmony. Da Mayor saves a careless young boy from being struck by a car and then tells the boy's scolding mother to go easy on him. In another scene he refuses to give in to police questions about who soaked a passing motor vehicle and utters a line that powerfully signifies the unity of the community: "Those who'll tell don't know. Those who know won't tell" (Lee and Jones, 1989, p. 158). Mister Señor Love Daddy tries to unite the community with music under the radio call letters, WELOVE, and chants an inspirational roll call of great black musicians. He also continually calls for peace when racial tensions and discord break through the tenuous harmony that he tries to preserve.

Even Radio Raheem, a character who seems to embody confrontation, delivers a monologue that offers a clear choice between harmony and discord, or as his knuckle rings read, LOVE and HATE. In a scene that Lee admits is an homage to a 1950s film, *The Night of the Hunter* (1955), Raheem explains his rings to Mookie:

> Let me tell you the story of Right-Hand-Left-Hand—the tale of Good and Evil... HATE! It was with this hand that Brother Cain iced his brother. LOVE! See these fingers, they lead straight to the soul of man. The right hand. The hand of LOVE! The story of life is this...STATIC! One hand is always fighting the other. Left Hand-Hate is kicking much ass and it looks like Right Hand Love is finished. Hold up. Stop the presses! Love is coming back, yes, it's LOVE. Love has won. Left Hand Hate KO'ed by Love...I love you, my brother (Lee and Jones, 1989, p. 191).

Radio Raheem himself will tragically be KO'ed by hate not love, but after all of the conflict, the end of the film finally strives to restore a sense of harmony over discord. Mister Señor Love Daddy calls for unity, Mookie and Sal come to a tenuous reconciliation, and, as Mookie walks away the residents of the community filter into the street ready to again begin their daily encounters and activities. The last visual image that Lee leaves the audience with is a final signifier of harmony over discord, the crucial photograph of Malcolm X and Martin Luther King, Jr. in their one face-to-face encounter, sharing a joke and warm smiles. The shot fills the screen, a fleeting moment of American history that seems to contradict everything children are taught about the discordant philosophies of the two men. The image is suspended on the screen, a frozen moment of tremendous potential—love triumphant over hate, harmony triumphant over discord. The impact of this image is reinforced rather than diminished by our knowledge that assassins' bullets will soon destroy whatever promise this moment, frozen in a still photo, seemed to possess.

Ideological Choices and Contradictions in *Do the Right Thing*

As noted above, while *Do the Right Thing* offers a multifaceted view of social issues not all of the ideological positions encoded in the film are deliberately indeterminate. As in the opposition between **harmony** and *discord*, via a number of other dimensions Lee's paradigmatic choices privilege certain positions over others. In two of these dimensions Lee presents what may

be seen as contradictory rather than intentionally ambiguous messages. My structural analysis identifies these dimensions as oppositions between **communal humanity**/*individual property* and **consumerism**/*political activism*. While the climax and denouement of the film clearly privilege life over property, this contradicts a consistent promotion of consumerist values over what are repeatedly framed as misguided impulses behind political activism.

The climactic moments of *Do the Right Thing* make a forceful statement about the value of human life over private property (Kellner, 1995a). The mob destruction of Sal's pizzeria occurs in an explosion of rage over the murder of Radio Raheem. In the scenes just prior to the destruction of the restaurant, the crowd exhorts Mookie, who is standing with Sal and his sons, to respond to the murder in some way. Slowly and deliberately Mookie makes a decision and, with an air of resignation, he methodically removes the garbage from a metal trashcan and hurls the can through Sal's window. Later he will tell Sal, "Motherfuck a window, Radio Raheem is dead." Responding to some of the criticism directed toward the film, Lee has pointed out that those who are appalled by the film's violence often seem disturbed by the destruction of private property but not by the destruction of Radio Raheem's life (Lee and Wiley, 1997). Lee, both as the writer and director of the film, and in his on-screen persona of Mookie, articulates the position that human life must be given higher priority than private property and the narrative and images presented in *Do the Right Thing* manifest this belief. This, however, contradicts the wealth of images and dialogue in the film that privilege **consumerism** while deriding *political activism*.

Do the Right Thing tends to conflate serious economic concerns with consumerist impulses. In the opening scenes of the film, Mookie is shown sitting on his bed counting a stack of money. At the end of the film his sole mission is to confront Sal about getting paid the salary that is owed to him. In between these framing scenes Mookie is constantly making reference to "Makin' that money" and "Gettin' paid." Lee wrote in his journal, "If I'm dealing with the Black lower class, I have to acknowledge that the number one thing on folks' minds is getting paid...Mookie's driving concern is money; how much and how to get it" (Lee and Jones, 1989, p. 63). Sal, however, is also depicted as being devoted to the accumulation of capital. He tells his sons, "There's nothing like a family in business working together" (Lee and Jones, 1989, p. 240) and when Pino complains that his friends make fun of him for working in a black neighborhood, Sal responds: "Do your friends put money in your pocket? Pay your rent? Food on ya plate?" (Lee and Jones, 1989, p. 197).

While this preoccupation with work and money is certainly a legitimate one for all members of the working class who must constantly fight to eke out enough resources to survive the demands of life under capitalism, in *Do the Right Thing*, the political import of these scenes is lost amidst the film's fetishization and glorification of material goods and possessions. As Kellner has pointed out, "Lee tends to celebrate consumption and to define cultural identity in terms of style and consumption patterns" (1995a, p. 169). My analysis of the cultural conflicts that are presented throughout the film supports this position.

A review of the conflicts presented in the film reveals that many are directly related to the consumption or possession of material goods and objects: Da Mayor argues with the Korean grocer over the brand of beer he stocks in his store. Radio Raheem also comes into conflict with this storeowner over purchasing batteries for his boombox. Raheem wages cultural warfare with this large and expensive boombox as a weapon, first with a Latino youth and later with Sal. In the final tragic confrontation in Sal's restaurant the destruction of this portable stereo triggers all of the ensuing violence. A passing motorist is enraged when neighborhood youths soak his fancy convertible car and its leather interior. Buggin' Out almost comes to blows with a white man, Clifton, who smudges his expensive "Air Jordan" Nike sneakers. In this scene, one of the neighborhood youths stokes Buggin' Out's anger by asking, "How much did you pay for them?" (Lee and Jones, 1989, p. 168). When Clifton announces that he owns a brownstone on the block, Buggin' Out and the crowd cannot suppress their outrage. One of the Corner Men, ML, expresses frustration over the Korean's ownership of his grocery and the material success that he derives from it: "I'll be one happy fool to see us have our own business right here. Yes, sir. I'd be the first in line to spend the little money I got" (Jones and Lee, 1989, p. 175). Sweet Dick Willie ridicules ML's concerns when he gets up and announces his intention to purchase more beer from the grocery, "It's Miller time. Let me go give these Koreans s'more business" (Lee and Jones, 1989, p. 175). Later, when Sal's restaurant is being destroyed, Sal yells, "That's *my* place! That's my fucking place!" This cry of outrage over the destruction of his property echoes Radio Raheem's earlier scream of pain when Sal destroyed his boombox.

Thus, most of the characters in the film are strongly motivated by consumerist or material impulses. Only Buggin' Out and Smiley show any signs of political consciousness related to these economic concerns, and both of these characters are ridiculed and dismissed by the rest of the community. Smiley is depicted as a mentally deficient, inarticulate roamer of the streets with an

impulse to commit arson. He is continually interrupting and bothering the neighborhood residents by asking them to buy copies of his photograph of Martin Luther King, Jr. and Malcolm X. The residents see him as a nuisance and cannot be bothered with listening to what he has to say about King and X. Both Buggin' Out's name and his appearance immediately signify that he is a comic figure that no one takes seriously. His name is a slang phrase that was used by East Coast urban youth in the 1980s to designate a person's behavior as bizarre or inappropriate. He himself looks ludicrous. He wears large, thick glasses that make his eyes appear to literally "bug out" of his head and his hair is unruly and sticks straight up from his head.

Buggin' Out's first conflict with Sal is over the cheese on a slice of pizza and Sal's insistence that extra cheese costs extra money. A few moments later, however, Buggin' Out raises a more serious political concern when he complains that there are no blacks on the Wall of Fame. As Mitchell points out, the Wall "signifies exclusion from the public sphere" for blacks (1990, p. 894). But Sal does not accept the public nature of his pizzeria and retreats to the realm of private property by replying, "You want brothers up on the Wall of Fame, you open your own business, then you can do what you wanna do. My pizzeria, Italian Americans up on the wall" (Lee and Jones, 1989, p. 141). Buggin' Out's response is also rooted in economic prerogatives, "Sal, that might be fine, you own this, but rarely do I see any *Italian* Americans eating in here. All I've ever seen is Black folks. So since we spend *much* money here, we do have some say" (Lee and Jones, 1989, p. 142; emphasis in the original). His subsequent call for a boycott, which Guerrero (1993) points out was the most effective strategy of the civil rights movement, is universally dismissed and ridiculed by everyone in the neighborhood except for Radio Raheem and Smiley. Guerrero has argued that by "having the possibility of social action dismissed by the neighborhood youth for the temporary pleasures of a good slice of pizza, the film trivializes any understanding of contemporary black political struggle, as well as the recent history of social movements in this country" (1993, p. 149). While Lee's earlier films, *She's Gotta Have It* (1986) and *School Daze* (1988), presented politically aware characters as flawed but ultimately dignified, while ridiculing the materialism of people like Greer Childs in *She's Gotta Have It*, by the time of *Do the Right Thing*, Lee's ideological stance on these issues seems to have reversed itself, so that it was now political activists who were considered comically short-sighted in a materialistic, consumer-oriented culture. McKelly argues:

The boycott proposed by Buggin' Out, whose name marks him as frantic and impulsive, is a bust in the neighborhood. The action founders because Buggin' Out's critique is unfocused, and offers little more than simplistic rhetoric in addressing a very complex issue (2008, p. 68)

Thus, Lee's preoccupation with consumerism (most clearly signified by the blatant Nike product placement that occurs throughout his films) detracts from a potentially powerful message about political economic concerns regarding ownership and control, thereby preventing him from dealing cogently with the class issues that are hinted at but never fully explored in this film. Lee's film tends to present the problem of racism as divorced from class issues. It should be noted that Lyne (2000) disagrees with this interpretation. Noting the frequent interpersonal confrontations leading up to the film's climactic violent explosion, he states:

These flashpoints are so consistent, punctuating the film like a second sound track, that it is difficult to understand them in terms of individual psychology or imagine them happening in a neighborhood with more wealth, space, air conditioning, and economic opportunity. Lee deploys his incidents in a way that demands that we ask questions about the social and economic forces of Wall Street and Gracie Mansion that have helped shape this block in Brooklyn (2000, p. 49).

But I believe this is an overly generous reading of the interracial conflicts in *Do the Right Thing*, one that is looking for undercurrents of class-consciousness in a film that only infrequently provides evidence for this interpretation. Rather, I argue that Lee generally approaches these tensions from an individualist perspective without ever clearly acknowledging the structural and institutional aspects of racism that lead to its most debilitating consequences. Lee tends to deal with individual prejudice rather than institutional racism in this film and in later films like *Jungle Fever* (1991), *Malcolm X* (1992), and *Clockers* (1995). As Guerrero says, "Rendered here is the *how* of personal bigotry, while the much more powerful and hidden institutional and collective *why* of racism is left unexplored" (1993, p. 154; italics in the original). In the film's depiction of interracial conflicts the nexus between race and class (see Wilson, 1980; 1987; 2010) is almost entirely absent.

While Lee in 1989 called *Do the Right Thing*, "my most political film to date" (Lee and Jones, 1989, p. 21), this lack of attention to class in addition to racial issues limits the political statement that the film is capable of making. This is most evident in Lee's use of the Public Enemy song "Fight the Power" during scenes of Sal's restaurant in flames. The association that is established

through the juxtaposition of this song with the visual imagery on the screen is that destroying Sal's restaurant is somehow a manifestation of "fighting the power."

Defending this scene from its critics, Lyne (2000) reminds us that riots are imperfect expressions of rage, not focused political action. He points out how ridiculous it would have been "if Buggin' Out and Radio Raheem were to lead the crowd across the Brooklyn Bridge and down to Wall Street to fight the real power" (2000, p. 53). Obviously Lyne is correct and the film thankfully (from a narrative standpoint) remains grounded by having the riot occur as it does. At the same time, however, the soundtrack choice offers a false and ultimately vapid articulation. While it is true that Sal, by virtue of his ownership of the restaurant, is better off than most of those who participated in its destruction, he is also clearly not a representative of America's oppressive power structure. While Sal drives up to his restaurant in a Cadillac Eldorado, Lee's script identifies it as being a vehicle that is fourteen years old. In Lee's journal he describes Sal's sons in the following manner: "Both Pino and Vito only made it through high school. They will work in their father's pizzeria probably for the rest of their lives and are ill equipped to do otherwise. They're lower-middle class and basically uneducated" (Lee and Jones, 1989, p. 49). This is not a description of the "Power" that Chuck D. and Public Enemy seemed to have had in mind.

Thus Lee's film focuses on divisive battles between individuals on the lower end of the socioeconomic spectrum, rather than acknowledging the commonalities among these groups. While this is an authentic representation of how conflict often plays out among various ethnic groups in the working class, in his journal, Lee does recognize a class basis for common ground between Mookie and Sal's sons: "Pino, Vito, and Mookie have many similarities. All three are high school graduates and are stuck in dead-end jobs" (Lee and Jones, 1989, p. 48). This common ground that Lee is obviously aware of does not come out in the film, however, which is focused on cultural identity rather than class unity. The only scene where the three show any similarities is a scene that introduces issues of gender and sexuality into the film's narrative and, ironically, the commonality here is based on segregationist impulses. This is the sequence of close-up shots of the faces of Mookie, Pino, and Vito, which signify their mutual distaste for the interracial flirtation between Sal and Jade. In the next section of this chapter I offer an examination of the film's gender representations as they intersect with race and class in *Do the Right Thing*.

Male Agency/Female Spectatorship— A Continuing Theme

It is significant that Mookie, Vito, and Pino are all in agreement in their disapproval of Sal's interest in Jade because this highlights a final area where Lee privileges a regressive stance, both in his negative view of interracial attraction and in his continuing depiction of women as passive spectators in a world that is run by domineering men. Both of these themes are consistent throughout Lee's body of work, cropping up again and again in films like *She's Gotta Have It* (1986), *School Daze* (1988), *Mo' Better Blues* (1990), *Jungle Fever* (1991), *Malcolm X* (1992), *Clockers* (1995), *Get on the Bus* (1996), *Summer of Sam* (1999), *25th Hour* (2002), and *Miracle at St. Anna* (2008). In *Do the Right Thing* only a small number of female characters appear in the film, and none of these women is significant to the film's main narrative conflict. Rather, they function as spectators, observers of male agency and action. Furthermore, most of the women are depicted as nags and harpies, carping and whining about male behavior. Mookie's sister Jade is dignified and intelligent, but Mookie is depicted as having an almost incestuous relationship with her, first through the images of him lying on top of her in her bed, playing with her lips, then in his overly-protective need to keep her away from Sal. Meanwhile, Jade complains about Mookie's behavior, but passively endures his intrusive ways.

Mookie's girlfriend, Tina, is depicted as a nagging shrew in the tradition of Shakespeare's Kate. She alternates between passively allowing Mookie to play with her naked body, and constantly insulting him, denigrating his manhood and whining about his behavior. Tina's role as a sexual object is established right from the start in the film's basically arbitrary opening sequence. Throughout this sequence Perez is depicted wearing a short, tight dress, revealing spandex workout clothes and, at times, boxing gloves and a robe similar to those worn by boxers entering the ring. The sequence continues for almost four minutes as the camera focuses on isolated parts of her body, eventually swinging down to a close-up of Perez's thrusting groin. In reference to a later scene, Lee wrote in his journal, "As usual I gotta have a vicious sex scene. For this one it's gonna be a naked female body with ice cubes. We should shoot it similar to the scenes in *She's Gotta Have It*, with extreme closeups. You'll see these clear ice cubes melting fast on a beautiful Black body. Smoke would be even better— smoke emitting from the body. This female is literally on fire" (Lee and Jones, 1989, pp. 26–27). Aside from the violence inherent in this image of the woman being "*literally* on fire," this notation indicates that Lee had already decided to

include this scene before the story had even been written. The woman, then, could be any female body without any real role or relevance to the narrative of the film. When Tina is not being depicted in this manner she is berating Mookie, attacking his manhood, cursing at him and uttering lines like, "Get a job, Mookie" in a high-pitched whine, despite the fact that Mookie obviously does have a job (which Tina also complains keeps him from seeing her).

The only other even remotely significant female character in the film is Mother Sister who spends her days observing the (mostly male) activity in the neighborhood. She treats Da Mayor with disrespect, rebuffing his attempts to talk with her right until the end of the film when she is depicted as breaking down and losing control in the face of the male violence that she is watching. She stands in the street, screaming "Burn it down" and then becomes hysterical. Da Mayor rescues her by enclosing her in his arms and carrying her away from the scenes of violence, which have become more than she can bear.

A few other women are scattered throughout the film, none of them instrumental to the narrative. One is Ella, the teenage girl who hangs out with the neighborhood boys and is a constant target of their insults and their demands that she "shut up." Like Mother Sister, Ella also stands at the periphery of the film's violent sequences and becomes hysterical, signifying that the role of hysterical spectator is a cross-generational one for women. Two other women also fill the role of shrew in brief scenes in the film. Louise is the mother of the boy whose life Da Mayor saves. She responds by slapping the boy and berating Da Mayor when he pleads that the boy had done nothing wrong. Tina's mother is also depicted as shrewish, continually arguing with Tina and insulting Mookie, even saying nasty things about him to his son. Thus, in *Do the Right Thing*, as in other Lee films, while men perform actions that are essential to the development of the narrative, women are depicted as passive observers, fetishized as collections of disembodied sexual parts, and demeaned as whining obstacles to male achievement.

My analysis of *Do the Right Thing* points out that this film broke significant ground in the mainstream film industry. By capitalizing on his previous financial successes and taking advantage of corporate Hollywood's desire for profit above all other considerations, Lee was able to create a film that not only advanced the momentum of black artists and craftspeople in the film industry, but also presented a complex and challenging vision of race relations and violence in contemporary America. This was an area that few mainstream filmmakers had ever dared to enter as boldly as Lee did in this film. In doing so,

Lee used mainstream media culture to advance provocative questions about the individual and psychological effects of racism.

My analysis also suggests, however, that in crucial dimensions, such as the neglect of the structural and institutional aspects of racism, the symbolic eradication of the nexus between race and class, and the taint of regressive gender politics, *Do the Right Thing* cannot be regarded as a fully counter-hegemonic cultural text. Furthermore, in some areas, such as the celebration of materialism and consumer culture, and the ridiculing and dismissal of collective political action, this 1989 film represents a shift toward mainstream values in comparison to the films that proceeded it. As Lee continued to achieve box-office success, his status as an increasingly powerful Hollywood figure would continue to grow over the next several years. The next chapter continues my examination of Lee's most influential films through an analysis of his sixth film and the first high-budget Hollywood film of his career, 1992's multimillion dollar epic, *Malcolm X*.

·6·
LEE GOES BIG: IDENTITY AND IDEOLOGY IN THE EPIC *MALCOLM X*

In this chapter I examine Spike Lee's sixth major film, 1992's *Malcolm X*. At the time of its debut, *Malcolm X* was Lee's highest budgeted film and the longest, eventually costing over $35 million and running three hours and twenty-one minutes. The previous stages of Lee's career seemed to progressively bring him closer to the point where he was ready to make this epic film, and in 1991 he finally felt able to tackle a project of this magnitude and historical significance. Each of Lee's previous productions had been financially successful, generating profits for the studios and distribution companies that financed them. Lee was consequently able to demand higher budgets for each successive film, peaking with $14 million for *Jungle Fever* in 1991 (Lee and Wiley, 1992). Through the success of his earlier films, and his increasing presence within the American advertising industry and media scene, Lee had established name recognition. Each new Spike Lee "joint," as he calls his films, was an awaited event both for the Hollywood industry and for the audience that sought out his films primarily because of his presence as director, writer and actor. In this manner, Lee had established himself as a contemporary auteur in the manner of Woody Allen (whose work he despises) or Martin Scorsese (whose work he idolizes). By 1992 Lee was one of a relatively small number of filmmakers who consistently attracted audiences to their films, not simply because of the

presence of stars in their casts, or because of the genre or subject matter of the films themselves, but primarily because of their own association with the film. This had put Lee in the position to make a case for himself as the rightful director of a film that had been a long unrealized Hollywood project.

Malcolm X had long been an inspirational presence both in Lee's life (Lee and Aftab, 2006; Lee and Wiley, 1992; Verniere, 2002), and in several of his earlier films. In 2006 Lee was quoted as saying "the most influential thing that I ever read was the *Autobiography of Malcolm X*, as told to Alex Haley" (Lee and Aftab, 2006, p. 12). X is a hero for Nola Darling in *She's Gotta Have It* (1986), and a cultural icon whose contested image and legacy are crucial to the thematic conflict in *Do the Right Thing* (1989). The scene in *Do the Right Thing* of a rioting crowd laughing at, and then sparing, a Korean grocer after he claims he is also black was modeled directly after a passage in *The Autobiography of Malcolm X*. X's early sexual relationship with a white woman, and his later rejection of interracial romances are reflected in the thematic content of *Jungle Fever*. In his book on the making of *Malcolm X*, Lee juxtaposes the anthemic cry of "Wake Up!" that ends *School Daze* (1987) and begins *Do the Right Thing*, with a quote from Malcolm X, "Our people are waking up!" (Lee and Wiley, 1992, p. x). Lee has written that this film represents his personal vision of Malcolm X and that he had long felt that he would someday be the one to bring X's life to the screen: "[T]his was the picture I was born to make—this was the reason I had become a filmmaker" (Lee and Wiley, 1992, p. 2).

Production Background

In the published version of Lee's journal about the production of *Malcolm X*, the first words in Part One are: "It's big. I mean *Big*. You understand big" (Lee and Wiley, 1992, p. 1). Lee is referring here to his initial vision of the film that would become *Malcolm X*. From the start Lee envisioned the film as a sprawling epic. In order to make a "big" film, however, you must have access to "big" money. The highest budget Lee had been awarded for any of his films prior to *Malcolm X* was the $14 million that Universal had invested in *Jungle Fever*. This amount was still several million dollars less than what the average Hollywood film of the early 1990s cost. Lee was determined to not settle for a thin budget for *Malcolm X*, which he believed warranted a substantial investment on the part of Warner Brothers, who owned the rights to the project.

Three years after X's assassination in 1965, a producer named Marvin Worth bought the rights to X's story from his widow, Betty Shabazz, and Alex Haley, the co-author of *The Autobiography of Malcolm X*. Over the next two decades, however, the film remained unrealized. After unsuccessful negotiations with Columbia Pictures, Worth eventually brought the project to Warner Brothers who brought in Denzel Washington to play Malcolm X and Norman Jewison to direct the film. Lee was adamantly opposed to a white filmmaker directing a film about Malcolm X, and he began a media campaign designed to exert pressure on Warner Brothers to sever their contract with Jewison and hire Lee in his stead. In his journal, Lee rationalized that Worth had originally wanted him as the director and that he had stated this in a letter that Lee somehow never received (Lee and Wiley, 1992). Lee initiated a meeting with Worth and Jewison, and Jewison agreed to step down from the project, claiming difficulties in finding an adequate script as his rationale (Lee and Wiley, 1992).

During the previous twenty years, several screenplays had been developed for a potential film based on the life of Malcolm X, but all were flawed in some significant way. Lee would eventually review scripts by James Baldwin and Arnold Perl, David Mamet, Calder Willingham, David Bradley, and Charles Fuller. Lee wrote in his journal that all but the Baldwin and Perl script had too many shortcomings to warrant serious consideration (Lee and Wiley, 1992). He indicated that he was fairly comfortable with the Baldwin and Perl script except for the third act which dealt with X's alienation from Elijah Muhammad and the Nation of Islam. Lee attributed the lack of clarity in this section of the script to Baldwin's reluctance to criticize Elijah Muhammad who was still alive at the time it had been written (Lee and Wiley, 1992). Lee also claimed that the Hollywood screenwriter Arnold Perl helped Baldwin finish the script because Baldwin's drinking problem was impeding his progress.

This version of these events is disputed by Rosenbaum (1997) who cites Baldwin's own assertion that Columbia, the studio that was involved prior to the move to Warner Brothers, had, against his will, assigned a screenwriter to be his collaborator. Baldwin wrote, "As the weeks wore on, and my scenes were returned to me, 'translated,' it began to be despairingly clear that all meaning was being siphoned out of them" (Baldwin, quoted in Rosenbaum, 1997, p. 149). Eventually, Baldwin would quit the project in disgust over how his work was being altered. Lee took the basic script that was credited to Baldwin and Perl and made his own alterations and revisions, eventually publishing this with the credits, "Screenplay by James Baldwin, Arnold Perl, and

Spike Lee" (Lee and Wiley, 1992, p. 169). Baldwin's name was eliminated from the final film's credits, however, in response to his executor's demand (Rosenbaum, 1997). This reaction was not the only negative response from members of the black community that Lee would receive during the production and pre-production phases of *Malcolm X*. While Lee was convinced that a black director must be behind any Hollywood production of Malcolm X's life, not everyone agreed that Lee should be that director.

The poet, playwright, and political activist Amiri Baraka even led a movement to protest Lee's involvement with the film (Ansen, 1991). Just as Lee had campaigned to have Jewison removed as director, Baraka campaigned to have Lee step back from the project. Baraka has generally cast a critical gaze on Lee, insisting that his films privilege traditional middle-class values and are demeaning to the black poor and working class, while simultaneously trivializing organized political resistance (Baraka, 1992; Baraka, 1993).

While Baraka's objections to Lee as the director of the film were motivated by political and ideological conflicts, Lee's journal entries indicate that he viewed them as being entirely personal in nature. Lee attributes Baraka's protest primarily to professional jealousy: "How many people are going to see a play, now, really? With a movie you're talking about reaching millions and millions and millions of people. So because of film, I have far greater access to the masses than he ever does, or ever will. And with the access comes the influence, comes the power, and comes the money" (Lee and Wiley, 1992, p. 100). Lee further attributes Baraka's protest to a previous incident when he rejected a Baraka submission on his film *Mo' Better Blues* (1990) for a collection of essays examining Lee's first five films. Lee admits that he turned the piece down because of its critical nature: "He didn't have one positive thing to say for any of my films" (Lee and Wiley, 1992, p. 101).

Throughout this section of his journal, Lee never acknowledges the political implications of Baraka's protest. In his attempt to find other motivations for Baraka's criticism, Lee also relates an anecdote where X had allegedly criticized Baraka for being involved with a white woman (Lee and Wiley, 1992). Lee briefly notes that Betty Shabazz also objected to Lee's script for the film but here too he dismisses her objections as being personally motivated by her emotional attachment to Malcolm X, and the trauma of having been present in the auditorium when he was murdered (Lee and Wiley, 1992, p. 98).[8]

Lee's aggressive campaign, and the Baraka protest that followed, ensured that *Malcolm X* would generate considerable media controversy regardless of the content of the film itself. Controversy had been a common denominator

for most of Lee's previous films, however, and he seemed to both welcome it and use it as a marketing and promotion strategy. After the film was made, for example, Lee encouraged media debates by announcing that children should skip school in order to attend opening day screenings (Simpson, 1992) and by declaring that he only wanted to be interviewed by black journalists (Cashmore, 1992). By 1992 Lee had become a public relations expert at using the press to help market and promote his films. His journal entries indicate that he was aware that much of the financial success of his films was dependent on his ability to utilize and manipulate the media:

> See, I realize that being a Black filmmaker, I'm never going to have the same amount of money spent to market my films as I would have if I was a white filmmaker with the same number of notches on his gun, the same amount of success...I want my films to be seen by as many people as possible....It comes down to marketing in the end and my activity comes from knowing that nobody is going to spend $20 million advertising and promoting my films....One thing we figured we could get for free—editorial space in the newspapers. That's why controversial or political subject matter can work well at the box office. I'm used to getting out there and pushing my films in any way I can (Lee and Wiley, 1992, pp. 22–23).

Lee was correct in his assessment. Despite his proven record of success, he would still come up against obstacles that many white directors who deal with less controversial themes never encounter. Primarily these obstacles were economic in nature. Hollywood studios in the early 1990s had established a pattern of awarding black filmmakers relatively small budgets that would translate to large profits if the films were successful at the box office. All of Lee's previous films had fit this profile, as did contemporary films like John Singleton's wildly successful *Boyz 'n the Hood* (1991), which was made for six million dollars and brought in $57 million (Lee and Wiley, 1992). Lee originally submitted a budget of $38 million for the production of *Malcolm X*, but Warner Brothers dismissed that immediately and insisted that they would go no higher than $18 million (Lee and Wiley, 1992). $18 million represented the cost of the average Hollywood movie during the 1990s, and Warner Brothers refused to consider that Lee's vision of the film as an epic drama would require more than an average budget. Lee attributes this refusal to a racially motivated double standard that is prevalent among Hollywood studios (Lee and Wiley, 1992). The meagerness of Warner Brothers' offer must be understood in relation to the budget of other Hollywood films of this era. A white comedian and actor, Dan Aykroyd, who had never directed a film, was given a $45 million dollar budget for his first production. Other early 1990s

Hollywood films like *The Bonfire of the Vanities* (1990) and *Havana* (1990), which would be box office failures, had been made for $50 and $60 million (Lee and Wiley, 1992), and *Batman Returns* (1992) cost $100 million (Cashmore, 1992).

The epic scope of *Malcolm X* would prove to be another issue over which Lee and Warner Brothers would come into conflict. Warner Brothers balked at the projected three hour-plus length of the film. Exhibitors often exert pressure on studios to keep films under two hours in length, because films of three hours or more cannot be shown as many times a day, which reduces the box office profit. Lee, however, continually referred to Oliver Stone's film *JFK* (1991), another long epic about an American historical figure in production at the time, as a touchstone for *Malcolm X*. Lee was adamant that his film was as important as *JFK*, demanded the same scope, and that he deserved the same treatment from Warner Brothers as Stone (Lee and Wiley, 1990).

Although Lee would eventually succeed in getting the film released at the length that he thought it required, Warner Brothers initially would not budge from their offer. Lee had managed to cut his budget to $31 million, but he knew all along that his final version of the script would cost at least $33 to $34 million (Lee and Wiley, 1992). Lee was able to sell the foreign rights to the film to the Largo Corporation for eight million dollars. This, combined with Warner Brothers funds, gave him a budget of $26 million to make a film that he knew would eventually cost $33 million. In a bold move, he decided to begin production of the film despite this discrepancy. Lee had become increasingly angry at the treatment that he was getting from Warner Brothers and began referring to them as "the plantation," due to his perception of the racial impulses behind this treatment. Although members of his crew were telling him that they were not ready to begin filming, he wrote in his journal, "Let's not postpone it anymore. Let's go right now before these motherfuckers at Warner Brothers change their minds. Do it now. We've been waiting twenty years already for this film" (Lee and Wiley, 1992, p. 67). Lee was fully aware that previous attempts to bring the life of Malcolm X to the screen had failed, and, with the same determination that was in evidence in his early days as an independent filmmaker, Lee was insistent that this time the film would get made.

Eventually the budget standoff would result in a third party, the Completion Bond Company, entering the arrangement. Bond companies function as insurance for Hollywood studios that films that go over budget will still be made in accordance with the original contracts. Although Warner Brothers

would eventually up their initial $18 million to $20 million for the film, Lee still ended up four million dollars over budget (Simpson, 1992). The contract Lee signed allowed the Completion Bond Company to take over financial control of the film at that point. The bond company tried to exert artistic control as well, attempting to influence Lee to scrap his idea of shooting on location in Africa and substitute beaches in New Jersey for the Sahara desert (Lee and Wiley, 1992). They attempted to get Lee to reduce the length of the film, and a representative of the bond company began appearing at filming sites in order to supervise shooting. Lee continually fought this unwanted intervention into his film, walking out of meetings, ordering the representative off the sites and generally resisting all of the bond company's attempts at control. This dispute would come to a head during the editing phase, when the bond company laid off all of the film's editing crew and refused to provide any more funds toward the completion of the film (Lee and Wiley, 1992). Utilizing financing strategies that he had learned during the production of *She's Gotta Have It*, Lee and Denzel Washington both ended up taking cuts in their own salaries and Lee successfully solicited celebrities such as Michael Jordan, Oprah Winfrey, Bill Cosby, Magic Johnson, and Janet Jackson to donate funds toward the completion of the film (Black Celebs, 1992; Lee and Wiley, 1992).

Lee utilized both his knowledge of the travails of independent filmmaking and the power that he had acquired as a financially successful Hollywood director as weapons in his struggle to fulfill his vision of what a film biography of Malcolm X should be. The final version of his film was three hours and twenty-one minutes in length, covered five decades and two continents, and cost $35 million to produce. Upon its release, the film broke box-office records by earning $2.4 million dollars on its opening day. This eclipsed by 66% the previous record of $1.45 million dollars, which was held by the film that Lee had frequently referred to during his battles with Warner Brothers, *JFK* (1991). While the opening weekend found *Malcolm X* in third place overall, this was still to be reckoned with considering the serious nature of the film and the fact that it was screened in only about half the number of theaters as the top two films (Everett, 2008).

This box-office success was achieved despite the renewal of the racist discourse that had dogged *Do the Right Thing*, that black audiences would be incited to violence by the film. Exhibitors again raised this concern over *Malcolm X* and many theaters hired extra security personnel (Brennan, 1992). A theater chain in Oregon initially refused to run the film, but eventually had to capitulate in the face of protests from the local community

(Simpson, 1992). Another theater had metal detectors installed in their lobby (Crowdus & Georgakas, 1992). In an attempt to quell these concerns Warner Brothers ran advance screenings of the film for a number of police departments, a move that Lee disagreed with (Crowdus & Georgakas, 1992). Despite this resistance, Warner Brothers ultimately released the film on 1600 screens nationwide, making *Malcolm X* the most widely distributed film of Lee's career (Crowdus & Georgakas, 1992). As with many of his earlier films, Lee had successfully stretched the limits and boundaries of mainstream media, both through his presentation of challenging content, and through his use of alternative economic strategies. Yet some of the marketing strategies associated with the success of the film raise crucial questions about whether the radical legacy of Malcolm X had been diluted and commodified in the process.

While Lee identifies his campaign for the directorship of the film as based in cultural and ideological motivations, Rhines (1993) points out that Warner Brothers' primary concern for the film was securing a crossover audience—an audience made up of whites and other cultural groups as well as blacks. In the interest of profit margins, Hollywood corporations will at times willingly embrace an apolitical form of multiculturalism, seeking to maximize their profits by appealing to as broad and diverse an audience as popular. Rhines explains that in the early 1990s a $35 million dollar film had to bring in $90 million to be considered a financial success. By attaching a controversial "name" director to this project, Warner Brothers hoped to achieve a larger audience base. It was the rare individual who went to a film simply because Norman Jewison was the director. Lee's name, however, was a box-office draw. Attaching it to Malcolm X's story seemed like a particularly enticing opportunity as Warner Brothers understood the media attention this relationship would draw. Rhines notes that Warner Brothers' motivation for financing a film about a controversial black political figure directed by a controversial black filmmaker can be represented by simple math:

> [I]f one assumes an average national admission price of $4 [in 1992], and if fifty percent of all thirty million African Americans bought a ticket to see *Malcolm X*, the box office return would be $60 million. If fifty percent of white Americans bought tickets, the return would be $400 million. This nearly sevenfold gap on return determined Warner Bros.' consideration that a crossover audience, and not a black audience alone, was the primary market for *Malcolm X* (Rhines, 1993, p. 18).

Unfortunately, even two decades later *Malcolm X* has "only" made $48 million, a profit certainly, but not the huge profit that Hollywood film companies

seek (Sterritt, 2013). And, in what is most likely a cause and effect relationship, Lee would not be given a truly big budget again for 14 years after *Malcolm X's* release (for the action film *Inside Man* in 2006).

The transformation of Malcolm X's symbolic and cultural heritage into a marketing device and commodity is also problematic, and Lee's marketing strategies may be considered partially if not primarily responsible for this phenomenon. According to Reed, "much of the ubiquity of X trinkets can be attributed to the snowball effects of Spike Lee's marketing campaign" (1992, p. 213). Prior to the release of the film, Lee had devised a distinctive marketing logo, a large silver X emblazoned on a black background. During press conferences and interviews he began wearing a baseball cap with this symbol on the front (X marks the hip, 1992). Lee also distributed hats like this to various celebrities and began retailing them in his own stores (Lee and Wiley, 1992). As Lee began to expand this merchandising into other forms of apparel, there seemed to be a sudden explosion of Malcolm X images and symbols on T-shirts, posters, mugs, even items like potato chips and automobile air fresheners (Boyd, 1992; Simpson, 1992). An article in the October 1992 issue of the business magazine *Forbes* noted that retail sales of Malcolm X memorabilia had the potential to reach $120 million dollars that year. This was all before the film had even been released in theaters.

In a 1992 interview Lee stated, "A whole generation of young people are being introduced to Malcolm X and people who've [only] heard of him or had limited views of him are having their views expanded" (Crowdus & Georgakas, 1992, p. 21). Lee's essentially accurate statement about the cultural and political potential of his film notwithstanding, it is a huge conceptual leap to argue that eating "X" potato chips, or driving a car with an "X" air freshener dangling from the rearview mirror, represents a political act. As Davis (1990) has pointed out, there are numerous unanswered questions about how those who purchase and don Malcolm X's image actually perceive the legacy of the man himself. She has suggested that the passive, consumerist use of this symbology may lead young people of color to believe this equates to political freedom. Marable (1992) sums up the essential problem with Lee's appropriation of Malcolm X:

> The filmmaker's goal was to create a cultural icon, but the black community does not need myths. It desperately requires practical solutions to its pressing problems. Malcolm's feet were always firmly planted on the ground, and he would be the first to reject any notions that his legacy should be praised in a series of baseball caps, T-shirts, and wall posters (1992, p. 9).

Thus, while Lee did accomplish the heretofore unrealized feat of creating an epic cinematic representation of Malcolm X's life and bringing this to a widespread mainstream audience, the methods and strategies he employed while accomplishing this only served to compromise the ideological and political impact that this film seemed to promise.

The marketing strategies employed by Lee and Warner Brothers are reflective of the increasingly common multimedia promotion blitzes that began to accompany most major Hollywood productions in the 1980s and that continue in ever-more intrusive ways in the present. The utilization of this type of marketing for a film biography of a figure of political dissent like Malcolm X, however, points to the tendency for capitalism to commodify everything it touches. In this case, even radical political positions are reduced to the level of consumer behavior. This results in an illusory sort of democratic political engagement where the free exchange of ideas is perverted into the freedom to purchase products. In the next section of this chapter I examine the actual narrative structure of the film that emerged at the culmination of this contested and controversial production process.

Narrative Structure

Like Lee's first commercial film, *She's Gotta Have It* (1986), the narrative of *Malcolm X* can be roughly broken down into three sections and a coda. The three sections prior to the coda encompass three personae that Malcolm X adopted as he recreated himself again and again: the hustler and criminal known as Detroit Red, the faithful Nation of Islam apostle—Malcolm X, and the post-NOI political activist—El-Hajj Malik El-Shabazz. This structure of three main periods and a coda connecting X's legacy to the present parallels *The Autobiography of Malcolm X* by Malcolm X and Alex Haley, the text that has come to define X since its publication in 1964. Although Lee conducted research into X's life, including interviews with X's family and associates, prior to shooting his film, this text is credited as the primary source that Lee drew on as he adapted and revised the Baldwin and Perl script for his film. Many scenes and elements from the autobiography appear in Lee's film, albeit modified or transformed,[9] including material that is considered apocryphal by many scholars (see Dyson, 1993; Locke, 1992; Rosenbaum, 1997).

Lee's film opens with a dark screen. Muslim prayers are heard as the credits appear. A speaker introduces Malcolm X to a crowd that greets him warmly and X begins to speak, denouncing the historical racism that has plagued the

United States. The first image that appears is that of a huge American flag, filling the screen. Initially reminiscent of *Patton* (1970), a film biography of the American general, this image is quickly turned inside out. As X's rhetoric intensifies, the flag begins to burn. Right from the opening seconds of the film, Lee introduces highly controversial imagery that reverses the traditional symbolic meaning of the American flag. Throughout the film, Lee repeatedly inverts the symbolic value of images and concepts associated with patriotism, Christianity, whiteness, and other traditional Hollywood thematic elements.

The symbolic associations evoked by the American flag are further complicated as news footage of the infamous Los Angeles Police beating of motorist Rodney King are interposed with shots of the burning flag. As Everett notes in her analysis of this sequence:

> Juxtaposed in this way the flag and King beating footage perform what [Russian director and filmmaker] Sergei Eisenstein referred to as a form of intellectual montage, in which the imagistic thesis (the flag) and its antithesis (the [King] footage) are conjoined to effect a synthesis: America equals racial brutality and oppression (2008, p. 101).

In his explanation of this anachronistic scene Lee told interviewers that he wanted to establish immediately that the film is not only a backward look at an historical figure but is relevant to current issues and conflicts in American society (Crowdus & Georgakas, 1992). The American flag burns down into the shape of an X, a flaming, red, white, and blue totem to the hypocrisy that is inherent in American history. Yet, as the narrative of the film begins in the next sequence of shots, this indictment itself is touched by its own hypocrisy in the form of blatant product placement.

Part One—Detroit Red

The screen grows dark momentarily before a placard identifies the next set of scenes as taking place in Boston during "The War Years" (Lee and Wiley, 1992, p. 170). The first shot is a long, lingering gaze at a giant billboard advertising Coca-Cola. This blatant use of product placement to open the film's narrative sequences is jarring and contradictory after the ideologically challenging force of the previous sequence. And it should be noted that both Coca-Cola and Nike, exploitative international corporations X would have loathed, are given "special thanks" in the film's credits.

The first character that appears on the screen is the composite character, "Shorty" (played by Lee), who struts down the street in full zoot suit regalia. Lee offers a romanticized vision of the black section of Boston, Roxbury, during World War II. These scenes all are colored with a gauzy, golden hue, and underscored with upbeat, soaring jazz. Right from the beginning of the film there is a significant departure from X's autobiography which opens with X's mother, pregnant with Malcolm, fighting to keep the Ku Klux Klan away from her home. Unlike the autobiography, Lee begins with X's post-adolescent years and references to his childhood occur only in flashbacks.

The first dramatic sequence in *Malcolm X* is set in a barbershop where Shorty is preparing to conk (straighten) Malcolm's hair with a paste made of lye so that it will resemble a "white" hair-do. (In X's autobiography this scene does not occur until page 52 after a considerable amount of attention has been directed toward Malcolm's formative years.) This scene graphically portrays the pain that some black people of this era put themselves through in order to "look white," as Malcolm says when he sees himself in the mirror. It is only after this scene that Lee delves into Malcolm's childhood through a series of flashbacks that depict Malcolm's mother and his Garveyite father.

Immediately after a voice-over of X musing on his mother's mixed blood and white appearance, the next sequence depicts Malcolm and Shorty at a ballroom where Malcolm first meets his white lover, Sophia. Prior to this, Lee presents an extended dance sequence that resembles a scene from a classic MGM musical, even ending with the self-reflexive shot of Shorty sliding through a woman's legs directly toward the camera, which focuses on his smiling upturned face. Sophia beckons to Malcolm across the dance floor, a sultry, seductive blonde in a tight, low-cut turquoise outfit—an embodiment of the iconic popular culture figure of the "Devil in a Blue Dress." Malcolm abandons his black girlfriend for Sophia who introduces him to interracial sex in a convertible. This scene is more explicit as it originally appears in Lee's script than in the actual film version. Lee has indicated that he purposively toned down certain scenes because he wanted to ensure a PG rating that would allow children to see the film (Lee and Wiley, 1992). One dimension retained from the script is the nature of Sophia and Malcolm's relationship. As in Lee's previous film, *Jungle Fever* (1991), their relationship is built entirely on sex and the thrill of breaking the taboo of miscegenation. Both characters are depicted as being obsessed with the race of their partner; Malcolm reveling in controlling, insulting and dominating a white woman, and Sophia deriving pleasure from submitting to a black man's will.

Lee interposes scenes of Malcolm and Sophia's dysfunctional relationship with flashbacks to moments of white-inflicted psychic pain in Malcolm's childhood, and one seemingly incidental sequence that actually establishes Malcolm's obsession with white cultural icons and provides foreshadowing of events to come. Shorty and Malcolm are shown running through a park, playing at being Hollywood gangster actors Cagney and Bogart. Shorty runs after Malcolm, shooting at him with an imaginary gun. An "actual" gun shot echoes on the soundtrack and Malcolm falls face down toward the camera. The camera focuses on his face pressed against the ground and Shorty mutters, "He use to be a big shot" (Lee and Wiley, 1992, p. 183). This sequence foreshadows both Malcolm's introduction to the real world of gangsterism and his eventual assassination by members of the Nation of Islam who may have slain him for being too much of a "big shot." Lee also connects this scene to Malcolm's past by immediately cutting from Malcolm to a flashback of Malcolm's father lying prone across the railroad tracks where he was killed—an event that historians have variously proposed was a murder, an accident, or a suicide. Lee's film presents X's autobiographical version of this event—that his father was killed by white men for his outspoken political views.

Lee briefly cycles through scenes of Malcolm at work as a porter, being insulted by both his white boss and white customers, and enjoying the nightlife in Harlem. In a sequence that bears little resemblance to anything in X's autobiography, Malcolm breaks a bottle over the head of a bar patron who made an indirect comment about Malcolm's mother. This impresses West Indian Archie, a local gangster who takes Malcolm under his wing and teaches him how to be more than just a petty criminal. The first thing Archie does is get Malcolm out of his now ludicrous looking zoot suit and into a fashionable dark ensemble. The evolution from Malcolm Little, country bumpkin, to Detroit Red, gangster, is now complete.

The next sequence of scenes depict Red becoming more and more confident as a gangster and sliding deeper and deeper into the world of drugs, alcohol, and crime. This sequence culminates with Red demanding that Archie make good on a gambling debt. Archie denies owing Red any money and Red insults and patronizes him. In a follow-up scene Archie attempts to ambush Red in a nightclub, but Red escapes and flees Harlem with Shorty and Sophia in tow. He resettles in Boston where he immediately forms a crime ring with Shorty, Sophia, Sophia's sister, and a hoodlum named Rudy. Red announces, "We gone rob this town blind. Anybody want out say so" (Lee and Wiley, 1992, p. 216). Rudy challenges Red for leadership of the gang and Red asserts

his manhood by pressuring Rudy to play Russian roulette. Rudy backs down and Sophia, who is aroused by this display of machismo, mouths "I love you" to Red. As in the previous fight in the bar, this scene establishes Red's masculinity through violence and intimidation.

Subsequent scenes depict the crime ring in action, including a comic sequence when Red slips a ring off a sleeping man's finger. The intent of this recounting of X's criminal career in his autobiography was to establish how depraved he had become prior to his conversion to Islam. In Lee's film, however, these scenes serve to glamorize Red's criminal years by constructing him as a devil-may-care, macho anti-hero, one of the traditional archetypes of Hollywood adventure films. This is antithetical to the purpose of the autobiography, which includes this passage at the end of the section on the Detroit Red years:

> I would not spend one hour in the preparation of a book which had the ambition to perhaps titillate some readers. But I am spending many hours because the full story is the best way that I know to have it seen, and understood, that I had sunk to the very bottom of the American white man's society...(X and Haley, 1964, p. 150).

Lee's glamorization of Detroit Red through representations that downplay the most sordid aspects of this part of his life, while highlighting his fashionable clothing and style, his masculine aggressiveness, his confidence with women, and the material success of his criminality, undermines X's own intent of revealing this time as the nadir of his life.

Even Red's arrest is played for comedy. In his autobiography, X states that he was arrested when he went to a jewelry repair shop to pick up a stolen watch that had a broken crystal. In Lee's film, the police invade Red's apartment while Shorty is conking Red's hair. Just prior to the police bursting in, Red has found that there is no running water and, in desperation caused by the burning sensation on his scalp, he has stuck his head in a toilet. This is the posture he is in when the police find him. Red and Shorty are found guilty of numerous counts of robbery, and Lee portrays Shorty as comically passing out upon hearing his sentence. In the initial prison sequences, Red defies the white prison guards and is brutalized by them and thrown into solitary confinement. After days in isolation his spirit is finally broken, although in his autobiography X states that he preferred the time in solitary and regretted there was a legally imposed limitation on how long a prisoner could be kept in isolation (X and Haley, 1964). It is in prison that Red discovers the Nation of Islam and begins the second transformation in his life, from Detroit Red to Malcolm X.

Part Two—Malcolm X

Although Malcolm X wrote that his siblings introduced him to the Nation of Islam, in Lee's film a prisoner named Baines first informs Detroit Red about the teachings of Elijah Muhammad. Baines is another composite character created by Lee, loosely based on a prisoner named Bimbi in X's autobiography, who convinces Red that he should use his time in prison to educate himself. In the film Baines replaces both Bimbi and X's siblings and, later, becomes the first member of the NOI to betray him. In this way Lee avoids X's complicated family relationships (two of his brothers also end up betraying him), and, importantly, avoids any mention of Louis Farrakhan, who would eventually call for Malcolm X's assassination in a Nation of Islam publication.

Scene by scene, X gradually learns to question his earlier beliefs and practices, becoming more accepting of the path put forth by Elijah Muhammad. In one scene, as X is reading a letter from Muhammad, a glowing apparition of him appears in X's cell. This religious vision signals that the transformation from Detroit Red to Malcolm X is complete. X sends letters to all of his old acquaintances telling them of his conversion. In a letter to Baines he writes, "Tell the Messenger of Allah that I have dedicated my life to telling the white devil the truth to his face" (Lee and Wiley, 1992, p. 243). Subsequent scenes depict X's post-prison years: meeting Elijah Muhammad face-to-face, preaching the rhetoric of the Nation of Islam to increasingly larger crowds, and reaching higher and higher levels of importance and power in the NOI. Lee incorporates excerpts from several actual Malcolm X speeches throughout these scenes. This section of the film also portrays X's first meeting with, and subsequent courtship of, Betty X, a NOI member who would become his wife. In one climactic sequence, X leads a troop of disciplined Nation of Islam men and a crowd of unruly others to a standoff with the police after a black man is beaten by white police officers. When he is finally satisfied that the victim has received proper medical care he dismisses the crowd with one small wave of his hand. Observing this, a white police officer mutters, "That's too much power for one man to have" (Lee and Wiley, 1992, p. 149).

In the following sequences, we see X traveling the country, attracting larger and larger crowds. These fragments are connected by voice-overs of excerpts from several of X's historic speeches. As in classical tragedies, Lee's version of X's life reaches its high point just before the onset of his eventual downfall. Elijah Muhammad appoints him National Minister and Betty agrees

to marry him. The first hint of the coming break with the NOI comes when Baines and Elijah Muhammad are watching X on a televised talk show and Baines mentions that X is becoming too powerful: "The brothers asked me to tell you Malcolm is getting too much press. The brothers think he thinks *he* is the Nation of Islam, that he has aspirations to lead the Nation. It was you who made Malcolm the man he is" (Lee and Wiley, 1992, p. 275).

The final split occurs, however, after X learns of Elijah Muhammad's impregnations of young female members of the NOI. Sticking closely to the text of the autobiography in this section of the film, Lee depicts X's interviews with the women, his confrontation of Elijah Muhammad, and his subsequent silencing by the NOI after X told the press that the Kennedy assassination was a case of "the chickens coming home to roost" (Lee and Wiley, 1992, p. 288; X and Haley, 1964, p. 301). Lee also begins to introduce hints of government surveillance, as from this moment on he includes sporadic, brief shots of a tape machine running during X's phone conversations.

The final break occurs when a young member of the NOI confesses to X that he had been sent to assassinate him:

> They gave me a mission. But I couldn't do it. I love y'all...To wire your car so it would explode when you turn the ignition. The Ministers say you are spreading untruths about the Messenger. The Ministers say you are a great hypocrite, Judas, Benedict Arnold. The Ministers say your tongue should be cut out and delivered to the Messenger's doorstep (Lee and Wiley, 1.992, pp. 289–290).

Although this scene is drawn directly from X's autobiography, Lee omits a crucial point that X himself was not afraid to reveal: "[A]ny death-talk for me could have been approved of—if not actually initiated—by only one man" (X and Haley, 1964, p. 303). It is implicit in the autobiography that X is referring to Elijah Muhammad, but Lee steers clear of making this association.

Lee follows this scene with X holding a press conference to reveal that he is no longer associated with the NOI. This is the symbolic beginning of X's third transformation as he announces, "In the past I thought the thoughts, spoke the words of the Honorable Elijah Muhammad, that day is over. From now on I speak my own words, and think my own thoughts" (Lee and Wiley, 1992, p. 290). An immediate change in political strategy is indicated as X announces that he is forming a new organization, Muslim Mosque, Inc., and that he will now willingly work with other black organizations, and even, on a limited basis, with some whites. In this scene, Lee sticks close to X's autobiographical version of these events.

Part Three—El Hajj Malik El-Shabazz

In the following scenes Lee depicts Malcolm X's fateful trip to Mecca, the holy city of the Islamic people. According to both Lee's film and X's autobiography this journey was the primary catalyst for X's eventual repudiation of his earlier separatist beliefs. Lee was granted special permission to film in Mecca, a city that only true Islamic followers are allowed to visit, and the film truly takes on the sweeping grandeur of a Hollywood epic in these scenes, with wide-angle shots of crowded bazaars and throngs of traditionally garbed multicultural worshippers at prayer. In other scenes from the region the immense dimensions of the pyramids and the Sphinx fill the screen. Lee also shows X under surveillance from white government agents throughout this trip and in scenes set after his return to the United States. Most of X's journey features a voice-over of X speaking about his new religious and ideological perspectives:

> You may be shocked by these words, but I have eaten from the same plate, drunk from the same glass and prayed to the same God with fellow Muslims whose eyes were blue, whose hair was blond and whose skin was the whitest of whites. And we are brothers, truly; people of all colors and races believing in One God and one humanity. Once before, in prison, the truth came and blinded me. It has happened again...(Lee and Wiley, 1992, p. 293).

Just as the vision of Elijah Muhammad in Red's prison cell symbolized his transformation to X, this revelation symbolizes X's transformation to El-Hajj Malik El-Shabazz, the final persona that he would adopt in his life.

Lee depicts the increasing levels of threats directed at Shabazz after he has returned to the United States and shared his new political stance with the press. He is constantly under surveillance, he receives numerous threatening phone calls and, in a scene that is interspersed with a flashback to his father's defense of his home against the Klan, a bomb is thrown through his window and his house is destroyed by flames. Lee hints at the controversy associated with this historical incident when he presents alternate scenes of Shabazz blaming the attack on the NOI and Baines suggesting that Shabazz set the fire himself. Shabazz's own perceptions of these events are unrecorded, because the autobiography ends prior to this time, and the subsequent events leading up to Shabazz's assassination are covered in a epilogue written solely by Alex Haley. Lee's cinematic version of this last part of Shabazz's life is thus drawn from Haley's accounting and the interviews that he himself conducted.

Immediately after the destruction of Shabazz's home, Lee cuts to a scene of Nation of Islam members in a basement, cleaning and loading guns. These are the men who will soon assassinate Shabazz during a speech at the Audubon Ballroom in New York. While this last section of the narrative has moved at an extremely quick pace up to this point, Lee now slows the tempo to almost a crawl as the tension builds to the final climactic scenes of Shabazz's death. The camera lingers on Shabazz's distressed face, and he moves slowly and in an exceedingly deliberate manner as the hour of his death draws near. In the script, Lee describes the scene of Shabazz arriving at the Audubon in the following manner:

> Malcolm parks his car, it's four blocks away. He turns off the ignition and sits there... It's as if he is frozen in his car.... Malcolm finally gets out of the car, locks the door and walks a couple of steps, then stops...Malcolm has stopped in his tracks, like some unseen force has overcome him, which prevents him from moving. Malcolm is paralyzed....His eyes are closed and the street noise begins to build to a deafening *roar*. Then it stops (Lee and Wiley, 1992, p. 304).

Shabazz finally continues on to the auditorium, floating, gliding toward the camera without seemingly moving his legs, a technique that is used frequently in Lee's films (Abrams, 2011). In this film, Lee's presentation of these scenes in this way serves to enhance Shabazz's status as a legendary martyr who sensed his own impending death. In Lee's published screenplay just before he proceeds to the auditorium where he will be executed Shabazz says, "The way I feel, I ought not go out there today" (Lee and Wiley, 1992, p. 306) this is a line that is taken directly from Alex Haley's accounting of these events in the epilogue to *The Autobiography of Malcolm X*. The filmed version of this scene is even more explicit as Shabazz says, "It's a time for martyrs now, the way I feel I shouldn't go out there today," and then wraps his bodyguard in a deep embrace.

Moments after Shabazz takes the stage the assassins strike. In an onslaught of gunfire Shabazz is slain. Just before the first bullet tears open his chest, Shabazz's eyes focus on an assassin charging toward him, a gun in his hand. The camera is close on Shabazz's face and, in a curious moment, the slightest, quickest hint of a smile crosses his lips before he is brought down. Chaos erupts throughout the hall and the realist narrative section of the film ends with black and white cinematography that evokes a 1960's news broadcast. A hospital spokesperson announces, "The person you know as Malcolm is no more" (Lee and Wiley, 1992, p. 309). In a move that recalls the iconography

of *Do the Right Thing* Lee ends this section of the film with actual news footage of Martin Luther King, Jr. lamenting Shabazz's execution.

Coda

Lee's film does not end there, however, but continues with a collage of images, symbols and discourse serving the dual purposes of eulogizing Malcolm X and connecting his legacy to the present. This section begins with the voice of actor Ossie Davis reciting the eulogy that he actually delivered at X's funeral, as a combination of black and white still photographs and newsreel footage depicts real scenes from X's life and the black struggle for liberty and equality in the United States. Color fills the screen again when Lee shifts to scenes of African villagers celebrating X's memory, and children standing at school desks and addressing the camera with the slogan, "I'm Malcolm X" (Lee and Wiley, 1992, pp. 311–312). Nelson Mandela, "playing" himself, then appears at the front of a classroom and addresses the students:

> As Brother Malcolm said, "We declare our right on this earth to be a man, to be a human being, to be respected as a human being, in this society, on this earth, in this day, which we intend to bring into existence..."(Lee and Wiley, 1992, p. 312).

A quick cut flashes from Mandela to the real Malcolm X finishing the above line with the famous quote, "...by any means necessary" (Lee and Wiley, 1992, p. 312). Lee had wanted Mandela to deliver the entire quote but Mandela refused to say the last phrase, prompting Lee's decision to cut to X finishing the statement (Lee and Wiley, 1992). Lee's X symbol fills the screen and the credits scroll over it, intercut with photographs of Malcolm X. Aretha Franklin is heard on the soundtrack singing the Donny Hathaway/Edward Howard song, "Someday We'll All Be Free," which segues into the rap group performing their song, "Revolution." The final images during the credits are of black celebrities such as Michael Jordan, Magic Johnson, Janet Jackson, and Bill Cosby, who helped finance the completion of the film. They are all wearing "X" baseball caps.

Critical Reception

As with many of Lee's previous films, *Malcolm X* received mixed reviews, with some critics lining up quite passionately on opposite sides and others

expressing strong opinions about both the shortcomings and virtues of the film within the same review. One area of commonality among most of the reviews, however, was the tendency for the reviewers to insert their own political perspectives on the history and current state of American race relations into their discussions of the artistic success or failure of the film. Many of the reviews also seemed to be inflected with the critic's own particular position on Malcolm X, the man, which they transferred to their review of *Malcolm X*, the movie. These tendencies support the argument proposed by several critics (Dyson, 1992; Kennedy, 1993; Taylor, 1992) that the film would successfully catalyze public discourse on the issues of Malcolm X's legacy and race in America. One frequent response was that regardless of the aesthetic success or failure of the film, just having a film about Malcolm X produced and financed by a major Hollywood studio was itself a fact to be lauded (Cashmore, 1992; Hardy, 1993; Jones, 1992; Kauffmann, 1992). A review in *The New Republic* typifies this sort of response: "The prime fact about *Malcolm X* is the most obvious one: it exists" (Kauffmann, 1992, p. 26). Another reviewer wrote, "That this man is the subject of the first big budget Hollywood movie on the life of a black historical figure is, in and of itself, nothing short of a coup" (Jones, 1992, p. 10).

However, several reviewers, even some who were otherwise positive in their regard for the film, expressed disappointment in *Malcolm X's* strong resemblance to a traditional Hollywood biography (Corliss, 1992; hooks, 1993b; Jacoby, 1993; Jones, 1992; Locke, 1992; Romeny, 1993). Corliss wrote in *Time* magazine that, after all of the media attention and controversy associated with the film prior to its release, "the big surprise about *Malcolm X* is how ordinary it is" (1992, p. 64). Many critics (particularly those who contributed to a special forum in the film journal, *Cineaste*) believed that Lee attempted to appeal to as wide an audience as possible, thus avoiding the most radical, dangerous aspects of X's life and ending up presenting a diluted version, safe for mass consumption but, in comparison to X's real story, essentially defanged (see Boyd, H. 1992; Boyd, T. 1992; Georgakas, 1992; hooks, 1993b; Johnson, 1993; Locke, 1992; Marable, 1992; Reed, 1993; Rhines, 1993). Reed wrote, "The effect is to depoliticize a historical figure whose claim on public attention was his political insurgency" (1993, p. 19) and Boyd (1992) pointed out that Lee's avoidance of X's anti-capitalist and anti-imperialist positions has allowed neo-conservatives to co-opt the symbolic power of his image.

These criticisms relate to another shortcoming that many reviewers pointed out: the film's historically inaccurate narrative, which is the consequence

of its overriding impulse to mythologize X's story. A number of critics argued that various moments in the film ignored or distorted history in order to preserve Lee's own agenda (Boyd, 1992; Georgakas, 1992; hooks, 1992a; Jacoby, 1993; Lester, 1992; Locke, 1992; Lyne, 2000; Marable, 1992; Reed, 1993; Simon, 1992; Steele, 1992), although some pointed out that this was true of the X and Haley book also (Locke, 1992; Lyne, 2000; Marable, 1992; Simon, 1992), and it could be further argued that this is a general tendency of biography as a literary genre. Many of those who felt that Lee presented a very loose interpretation of this historical figure argued that the film attempted to turn X into a legendary or mythological entity (hooks, 1993b; Horne, 1993; Lester, 1992; Marable, 1992; Reed, 1993; Steele, 1992), which, as Marable (1992) pointed out, could only serve as an obstacle to realizing the political value of his legacy.

Several reviewers had particularly negative responses to the coda (Dyson, 1992; Jones, 1992; Kauffmann, 1992). Jones wrote, "For all of the contrived meanings he would have for parading a pan-African chorus of schoolchildren in front of the camera only to announce, 'I am Malcolm X,' and a rather bizarre cameo by Nelson Mandela, the fact is that Lee still doesn't know how to end a picture" (1992, p. 11). While Lee's film was criticized for all of these shortcomings, as well as for being overly didactic (Klawans, 1992), critical response was by no means completely negative. As noted above, much of the criticism about specific elements appeared in reviews that were otherwise favorable to the film.

Many critics felt that the film was both aesthetically successful, and a sweeping, grand and important statement (Dyson, 1992; Hardy, 1993; Kauffmann, 1992; Kennedy, 1993; Marable, 1992; Simon, 1992). Several reviewers were particularly impressed with Denzel Washington's portrayal of X (Cashmore, 1992; Johnson, 1993; Jones, 1992; Kauffmann, 1992; Klawans, 1992; Marable, 1992; Simon, 1992). Others lauded the film as a grand work of cinematic art. Dyson wrote, "Spike Lee's *Malcolm X* is a stunning achievement. It is a richly textured and subtly nuanced evocation of the life and times of a supremely American paradox..." (1992, p. 1187). Simon (1992) opined that *Malcolm X* was the first Lee film to make a significant contribution to the body of contemporary American cinema.

Some of the critical praise that was directed toward Lee and *Malcolm X* was based on the belief that the film would direct public attention to the pressing issue of race relations and thereby stimulate public discourse on this difficult subject (Dyson, 1992; Kennedy, 1993; Taylor, 1992). An article that

appeared in *The Economist* noted, "The release on November 18th of Spike Lee's controversial film biography of Malcolm X, the radical Black Muslim leader who was murdered in 1965, has set America buzzing....And when people talk about Malcolm X, they are not concerned merely with the man; they are talking, openly and at last, about race" (Future in Their Past, 1992, p. 11). Although not quite as optimistic, Jones' review also suggests the cultural import of Lee's film: "What Spike Lee has finally been able to do in *Malcolm X* is to interject into our cultural history a hypnotic character, flawed and gracious, who is capable of world-altering change" (1992, p. 11). Proceeding from the postulations of those critics who identified the film as a mythic narrative, and those that felt the film was an important contribution to the public discourse on race, in the following section of this chapter I offer a structural analysis of *Malcolm X* in order to explore the preferred ideological positions articulated semiotically in this film.

Structural Analysis of *Malcolm X*

Lee's film has a tripartite structure, with the major divisions based on three identities or personae that the man born Malcolm Little would adopt during his lifetime. These identity phases and the transformations between them provide the primary structure for the film (Hoerl, 2008; LaRocca, 2011). Lee's paradigmatic representations of these identities—Detroit Red, Malcolm X, and El-Hajj Malik El-Shabazz—provide fertile ground for a structural semiotic analysis of the preferred ideological positions encoded within the film. Additionally, I contend that *Malcolm X* derives narrative and ideological power from a reversal of Hollywood iconography in matters related to identity, race and ethnicity, and a reinforcement of traditional Hollywood representations regarding gender and sexuality. While signifiers of race, gender, and sexuality are readily apparent, a fourth crucial dimension of identity formation and social position, class, is virtually ignored throughout the film. At the end of this chapter I discuss the apparent absence of class consciousness in Lee's 1992 film, and I argue that this absence is in fact crucial to understanding the preferred meaning of *Malcolm X*.

Figure 3 charts the structural oppositions semiotically encoded in this film in the crucial areas of Malcolm Little's identity transformations and the reversal and reinforcement of Hollywood iconography. As in previous chapters, positions highlighted in bold represent dominant positions, while positions in italics may be considered subordinate (see Hall, 2013).

Identity:
Detroit Red/*Malcolm Little*
Malcolm X/*Detroit Red*
Malcolm X/*El-Hajj Malik El-Shabazz*
Iconography:
Blackness/*Whiteness*
Madonna/*Whore*

Figure 3. Oppositional Tensions in *Malcolm X*.

Identity—*Detroit Red*/Malcolm Little

Unlike the X and Haley autobiography, which opens with a description of the Ku Klux Klan terrorizing Malcolm's pregnant mother, Lee's film begins with his late adolescence, a time spent as a zoot-suiter, a street hustler, and a criminal. The years of Little's childhood are dealt with in brief and isolated black and white flashbacks. While the use of black and white photography in this context does serve the purpose of identifying these scenes as memories, it also relegates them to a secondary status, as exposition and momentary distractions from the "real" polychromatic narrative that begins with a glorified portrayal of the high life of a young man on the make in the big city. In this manner, Detroit Red is established as the preferred persona in the **Detroit Red**/*Malcolm Little* opposition. Malcolm Little appears briefly in this film, in flashback scenes as a child victimized by the white world, and for a few short moments at the opening of the film as a wide-eyed, nappy-headed, poorly dressed country bumpkin. The Malcolm Little who appears in the first dramatic sequence of the film, the hair-conking scene, is a naive and slightly ridiculous young man who cannot deal with the burning of the lye that Shorty plasters on his head. Later scenes of Detroit Red conking his hair just before his arrest and in the jail's shower room depict a man who presents a stoic front as he calmly endures the pain inflicted by sociologically complex fashion imperatives. (Although this calm does disintegrate in the arrest sequence when he realizes he has no running water to wash the lye out of his hair, and ends up being caught by the police with his head in a toilet bowl, a comic yet telling sequence.)

Fashion also operates as a signifier of Detroit's Red status in this section of the film, first as he enjoys the nightlife of Roxbury and Harlem dressed in flashy zoot suits, and later when West Indian Archie teaches him how to be a

real criminal and dresses him in muted, elegant suits. As the transformation from Malcolm Little to Detroit Red progresses, Denzel Washington portrays the character as increasingly more confident, poised, and virile. Whereas Malcolm Little is depicted as a victim, Detroit Red is an aggressor who wears his masculinity on his sleeve. In one scene, he breaks a bottle across the head of bar patron who insults him. As Rosenbaum points out, this scene is pure fiction: "[A] quintessential Oscar-movie moment—complete with macho childishness, violent excess, and a comfortable irrelevance to history, setting, and character" (1997, pp. 149–150).

In another scene, Red challenges Rudy, an ambitious member of his crime ring, to a game of Russian Roulette, and calmly puts the gun up to his own head as he pulls the trigger repeatedly. A close-up shows his girlfriend Sophia looking on, her face dripping with desire, mouthing the words "I love you," after he has won his testosterone-laced battle for manhood and leadership. While this scene is modeled after a passage from X's autobiography, Lee alters the moment in a way that completely changes its meaning and intent. In Lee's film, this scene is a macho struggle between Rudy and Red that establishes Red as the more powerful man. The next scene depicts Red showing Shorty that he had palmed a bullet and the gun was actually empty. In the X and Haley book there is no sexual heat generated by this game, and no indication that the gun was not loaded. Instead, this scene is one of many in the book that establishes the depths to which Red had sunk and his disregard for human life during this period.

Furthermore, Lee's use of upbeat music, dance sequences, and broad comedy in this first section of the film inverts its function as a mini-morality play in the autobiography and instead glorifies the Detroit Red years as a time of thrills and adventure. Even Red's arrest and trial are cast as slapstick comedy, with scenes of Red being caught with his head in a toilet and Shorty passing out during sentencing. Meanwhile, Lee avoids any direct representations of the seamier side of Red's career: prostitution, pimping, and a debilitating drug addiction. In a voiceover Red says, "I was an animal," but the images that Lee presents contradict rather than reinforce this statement. The absence of the ugliest aspects of Detroit Red's life, combined with the portrayal of Red as a swaggering, powerful ladies man, dressed in the latest fashions and in control of all situations, serve to represent this persona as a figure of glamour and legend. Lee seems enthralled by this aspect of X's life. While Malcolm Little is represented only through brief flashbacks, Reed (1993) points out that the Detroit Red phase commands more than a third of the entire film.

Identity—*Malcolm X*/Detroit Red

Like Malcolm X's own recounting of his life, Lee's film represents a process of transformation, however, and, in the second phase of *Malcolm X*, the persona of *Detroit Red* takes on a subordinate position to that of Nation of Islam faithful, **Malcolm X**. Nearly half of Lee's film is devoted to the prison transformation of Detroit Red and the rise through the NOI of Malcolm X. More closely in line with the tenor of the X/Haley text, this section of the film recasts the Detroit Red era as years of sin for which X must atone. His transformation to Malcolm X is explicitly signified by the ghostly vision of Elijah Muhammad visiting him in his prison cell. The reborn X sends letters to his old colleagues and enemies attempting to share his newfound wisdom with them. In one particularly significant sequence X is briefly reunited with Shorty who tells him of the sad fates of his former acquaintances as Lee presents images of Sammy lying dead on top of a hooker, Cadillac in a mental institution, and Sophia trapped in a marriage without passion. In the next scene X visits West Indian Archie who is extremely ill and half-deranged. X is depicted as kind and loving to this man who had once tried to kill him. These scenes hint at the tragedy that awaited X if he had not abandoned his sinful ways and connote the positive rebirth that he has experienced.

As the opposition between Detroit Red and Malcolm Little was signified visually through style and fashion, the opposition between Malcolm X and Detroit Red is also encoded through visual images. After the visitation by the apparition of Elijah Muhammad, X has his conked hair shaved off. Upon his release from prison he is depicted wearing the conservative, well-pressed garb of the Nation of Islam faithful: a plainly cut, simple dark suit, white shirt, and a dark tie. He also wears heavy glasses that seem to soften his eyes. Denzel Washington portrays X as quieter than Detroit Red, at peace with himself and even more self-assured, charming, and confident. As X is shown rising through the ranks of the NOI, his charisma and power are signified through scenes of larger and larger crowds responding to his ever-increasing command of language and rhetoric. Whereas Detroit Red had the admiration of his small group of petty criminals, Malcolm X is portrayed as the powerful leader of a growing band of devoted followers. In one scene he leads a virtual army of disciplined Nation of Islam men, followed by a barely controlled crowd, to a protest in front of a hospital where a black victim of police brutality is being held. This confrontation is established as both a challenge to X's manhood and a signifier of black unity, as the catalyst for his decision to get involved

occurs when a woman scornfully tells him, "Muslims talk a good game, but they never do nothing, unless somebody bothers Muslims" (Lee and Wiley, 1992, p. 259).

The struggle for masculine power is encoded in this scene through a militaristic march through the streets to the hospital, and an eye-to-eye standoff between Nation of Islam men, led by X, and white male police. The martial drum music that underscores this sequence further reinforces the masculinist nature of this scene. As in his earlier phallic battles, X is depicted as winning this skirmish, as he is given assurance that the victim is being properly cared for and will recover. However, where previous scenes showed Detroit Red having to elaborately defend his masculine power through physical violence and weaponry, X is depicted as having the ability to command a crowd with a single nonverbal gesture. A single wave of his hand and the crowd disperses into the night as X's steely eyes stare down his masculine rivals on the police force.

In the next scene, a young black man who observed this victory rushes up to X in a coffee shop and adoringly expresses his desire to join the NOI: "I want to be one, like you" (Lee and Wiley, 1992, p. 265). This scene echoes the earlier shot of Sophia mouthing "I love you" to Red after he displayed victory over another man, but now the masculinist underpinning is further reinforced through the all-male makeup of these scenes. Significantly, Lee sandwiches these scenes between sequences that depict X's courtship of Betty Shabazz, his proposal of marriage, and their subsequent wedding. Through their syntagmatic placement in the narrative, these scenes provide a counter to the all-male universe that Lee has constructed while signifying X's masculine power, and they make X's heterosexuality explicit. X is configured as the conquering hero who takes possession of Betty Shabazz as one of the spoils of his victory. The film's construction of X's black woman (the faithful, spiritual Betty Shabazz), as the moral superior to Detroit Red's white woman (the worldly, sinful Sophia), further serves to reinforce Lee's construction of this phase of X's life as the core of his shifting identity. This privileging of the X phase of Malcolm Little's life is apparent as well in the last section of Lee's tripartite film, despite a final transformation.

Identity—*Malcolm X*/El-Hajj Malik El-Shabazz

The Malcolm X persona was not the last identity that Malcolm Little would adopt in his life. Subsequent to his break with the Nation of Islam and his

spiritual journey to Mecca, X would adopt the name El-Hajj Malik El-Shabazz. During this period of his life Shabazz distanced himself from the Nation of Islam's biologically essentialist view of race and their ideological agenda of racial separatism. He began to adopt a radical pan-African political philosophy and agenda that would never be fully realized due to his 1965 assassination. Several commentators note that Lee's film speeds through this last, politically crucial section of Shabazz's life (Dyson, 1995; Hardy, 1993; Kellner, 1995a; Reed, 1993) in stark contrast to the detailed, lingering expositions devoted to Shabazz's previous incarnations as Detroit Red and Malcolm X.

In addition to the brevity of this last section, in several other ways Lee's paradigmatic and syntagmatic choices tend to position this stage of Shabazz's life as subordinate to previous stages. Similar to the film's portrayal of Malcolm Little's childhood, Shabazz is constructed as a victim of fate. Denzel Washington plays the bearded Shabazz as more introspective, but also more confused and less powerful and charismatic than Malcolm X. Lee's camera work reinforces this sense of Shabazz as a man stripped of agency and control, drifting helplessly toward tragedy. In one scene, a close-up of Shabazz staring into the camera begins to revolve on a 360-degree axis, connoting Shabazz's life spinning out of control. In another, Lee uses a disorienting effect that pops up repeatedly in his films, what has been called his "signature shot" (Abrams, 2011). As Shabazz heads toward the Audubon Ballroom, the place of his execution, his figure is stationary and it is the background that moves. This effect frames Shabazz as heading inevitably and passively toward his own death, a victim who is helpless to change the flow of events. Moments later, as the assassins charge the stage firing bullets into his chest, Lee zooms in on Shabazz's face and a brief smile crosses his lips, as if welcoming and accepting of his fate.

In an earlier scene depicting a firebombing of his home, Lee interposes a flashback to the Klan attack of Shabazz's childhood home. The circle is drawn between Malcolm Little the child and helpless victim and El-Hajj Malik El-Shabazz who is equally victimized. Lee's representations of Little's childhood and the Shabazz stage are also marked by absences, Little's childhood appearing only in brief flashbacks and Shabazz's radical denunciations of global capitalism and imperialism left out entirely (see H. Boyd, 1992). Thus, two crucial stages in X's life, his boyhood and the final identity that would emerge after numerous metamorphoses, become secondary to the middle phases of criminality and nationalism in Lee's construction of this narrative.

The overall effect of these choices is to declaw and depoliticize the Malcolm X story, opting instead for a mythological, Horatio Alger-like

representation of an "up-from-the gutter" cultural legend. Lee's privileging of the middle stages of this complicated life signifies two crucial dimensions of ideological conservatism in this film. First, the neglect of Little's childhood and the glamorization of his adolescent criminality restrict the film from ever clearly dealing with the circumstances of poverty and racism that lead to the destruction of so many black youth, both in Little's day and in the present era. Second, the privileging of Malcolm X's career with the nationalist Nation of Islam over his more radical and complicated incarnation as El-Hajj Malik El-Shabazz, prevents Lee from acknowledging the powerful and radical political potential that this stage in Shabazz's life represented before reactionary violence snuffed it out.

Hollywood Iconography—Race and Ethnicity

Despite the conservatism embedded in Lee's representations of the various personae that Malcolm Little adopted during his life, other aspects of the film, specifically those related to race and ethnicity, do offer a challenge to traditional Hollywood semiotics. As in X's autobiography the tension between **blackness**/*whiteness* is resolved in favor of blackness and against the grain of hegemonic conceptualizations of white supremacy. This is most explicitly realized in a scene that depicts Baines instructing Red about the hegemony of supposedly non-ideological lexical definitions of black and white:

> *Black*, (blak), adj. Destitute of light, devoid of color, enveloped in darkness. Hence, utterly dismal or gloomy, as "the future looked black."...Soiled with dirt, foul; sullen hostile, forbidding—as a black day. Foully or outrageously wicked, as black cruelty. Indicating disgrace, dishonor or culpability. See also *blackmail, blackball, blackguard*...
>
> White (whit), adj. Of the color of pure snow; reflecting all the rays of the spectrum. The opposite of black, hence free from spot or blemish; innocent, pure, without evil intent, harmless. Honest, square-dealing, honorable (Lee and Wiley, 1992, p. 232).

Through representations of the moral superiority of blacks over whites (virtually every white character in the film is morally reprehensible or villainous), Lee's film attempts to reverse this hegemonic distinction. In several scenes Lee depicts X waging ideological warfare over the traditional Christian representation of Jesus as a white man. X challenges the prison chaplain regarding this sacred icon by referring to historical and scientific evidence that the early Hebrews were people of color. In a number of scenes

the image of Jesus is further reversed as a signifier of repression rather than salvation. While X is caged in solitary confinement, the chaplain tells him to remember that he has a friend in Jesus. X replies, "Jesus can kiss my ass." Later, as he walks toward the site of his death, a woman stops him on the street and proclaims, "Jesus will protect you" (Lee and Wiley, 1992, p. 305). Shabazz looks away. His eyes signify that he knows this not to be true. The following scenes of his violent death verify the impotence of this reliance on faith. Thus, the equating of whiteness with Jesus and salvation is ruptured in favor of an association of whiteness with evil and sin. This is realized through Lee's reversal of the symbology of images of Jesus, as well as through dialogic references to the NOI rhetoric regarding whites as "devils," and the representation of all the whites that Malcolm encounters from childhood up to the moment of his spiritual reawakening in Mecca as untrustworthy and hateful.

Lee's reversal of hegemonic conceptualizations of blackness and whiteness also represents a challenge to historical cinematic images and iconography. Flashbacks to scenes of the Ku Klux Klan riding on horseback into the huge moon looming over the horizon both evoke and deconstruct D.W. Griffith's racist film, *The Birth of a Nation* (1915). Lee's script describes this scene: "The Klan breaks all of the windows in the house then rides off into the glorious D.W. Griffith *Birth of a Nation* moonlit night" (Lee and Wiley, 1992, p. 174). The opening shot of a huge American flag that fills the screen initially recalls the opening sequences of the 1970 military film, *Patton*, but this association is quickly upended as the flag begins to smolder and burn around the edges, eventually burning down to a flaming red, white, and blue X. Again, Lee first evokes, and then flaunts, convention through this controversial symbology of a burning American flag.

In another reversal of Hollywood iconography, Lee's depiction of Detroit Red's white girlfriend is initially evocative of Marilyn Monroe, from her blonde hairdo, to her low-cut seductive evening gown, to the gauzy backlighting that envelops her image in a diaphanous glow. The halo of light that surrounds Sophia in this scene is no indication of angelic purity. Lee transforms and demonizes the traditional imagery of the glamorous Hollywood blonde through his representation of Sophia as a manipulative, lustful, race-obsessed, drug-addicted harlot. However, while this symbology represents a challenge to Hollywood racial iconography, it simultaneously reinforces the prototypical Hollywood representation of heterosexual female sexuality through the binary opposition of **Madonna**/whore.

Hollywood Iconography—Gender and Sexuality

Lee's challenge to traditional Hollywood representations of blackness and whiteness extends to his depictions of black and white women throughout *Malcolm X*. These portrayals parallel a binary scheme that clearly divides the **Madonna** or "good" woman, virginal and submissive, from the "bad" woman, who is a *whore* and/or a harpy. Black women in *Malcolm X* tend to signify all that is good in womanhood while white women signify all that is bad. This is most clearly represented in the film's early juxtaposition of Red's relationships with Sophia and Laura. Sophia is the classic Hollywood whore, sexually aggressive and provocative. When she first appears she is watching Red from across the floor of a crowded ballroom. Dressed in a revealing, skin-tight gown, she beckons Red to come dance with her. Red willingly abandons his girlfriend Laura to dance with Sophia who Lee's script describes as "a gorgeous white chick asking for it" (Lee and Wiley, 1992, p. 179). Sophia is clear about her intentions as she breathily tells Red he should take Laura home and then come back: "Just walk. Don't run. *It* will be here when you get back" (Lee and Wiley, 1992, p. 179; italics added). When Red tells Laura he will call her in the morning Laura replies, "What for? I ain't white and I don't put out" (Lee and Wiley, 1992, p. 180).

A subsequent scene depicts Red and Sophia in Sophia's car. Lee's original script is more explicit than the actual scene that appears in the film, and his description and dialogue clearly establish Sophia as obsessed by both race and sex:

> Sophia pulls her tight sweater over her head to expose two full ripe *white breasts*. Malcolm's eyes are popping out of his head. NOTE: It's very unusual for women not to wear a bra back in that day but you might say Sophia was way ahead of her time.
>
> SOPHIA
> Malcolm, look at them. Have you ever seen white breasts like these?...Put your black hands on them (Lee and Wiley, 1992, p. 180; italics in the original).

In later scenes, Sophia is depicted as a cocaine addict who is completely submissive to Red, even when he abuses her. In one scene he orders her to kiss his feet and feed him while he is lying in bed: "You one of them white bitches can't get enough black dick. Is that what you are?" (Lee and Wiley, 1992, p. 184). Lee's notes describe her response to this insult: "Sophia smiles. She aims to please" (Lee and Wiley, 1992, p. 184).

This scene of a mean-spirited, dysfunctional interracial sexual relationship is immediately followed by a sequence of Red and Laura strolling romantically on a beach, expressing their tender love for one another. They collapse in an embrace as the waves move toward them, a scene that evokes the classic Hollywood love story *From Here to Eternity* (1953). As in other Lee films, particularly *Jungle Fever* (1991), interracial relationships are drawn as dangerous and unhealthy, while true romance is reserved for heterosexual relationships that do not cross cultural lines. This distinction between the goodness of black women and the evil perpetrated by white women is reinforced by the flashback that is interposed into scenes of Red's date with Laura. Malcolm Little's mother is shown nobly trying to feed her children when a white female social worker invades her home and tells her she is taking her children away from her. Although this scene is drawn from events described in X's autobiography, the juxtaposition of it in a syntagmatic sequence that begins with Red's unhealthy relationship with Sophia, moves to his romance with Laura, and then flashes back to this scene of black and white women embattled against each other, reinforces the opposition between good (black) women and evil (white) women. While this continues and extends Lee's challenge to hegemonic racial thinking, this is mitigated by his construction of the opposition between purity (**Madonna**) and immorality (*whore*) that pervades his representations of women in this and other films.

Laura, for example, falls from the revered status of **Madonna** later in the film, when Red spots her in a bar giving money to her drug-addicted boyfriend. She is on the verge of becoming, literally, a *whore* as Lee's dialogue reveals. Red asks a waitress, "Is she hooking?" and the waitress replies, "Not yet. But the way things are going, that boy gonna turn her out any day" (Lee and Wiley, 1992, p. 206). Lee's description of Laura in this sequence equates self-confidence and independence in women with a fallen status: "It's Laura, but not the Laura we last saw. She is still young, still vulnerable, but she is bolder, more self-assured, more vividly dressed" (Lee and Wiley, 1992, p. 205). Now that Laura has tumbled off the pedestal that both Red and Lee had placed her on, Red must move on. Eventually she is replaced by Betty, who is established as virtuous and pure in the following dialogue when X is introduced to her for the first time: "The Sister lectures our Muslim women in hygiene and diet. The Sister stresses care of the body and regular eating habits" (Lee and Wiley, 1992, p. 253).

During a scene of X and Betty in a restaurant X lectures Betty on the shortcomings of women. Lee cuts back and forth to close-ups of Elijah

Muhammad preaching to X and Malcolm X uttering the same proclamations to Betty:

ELIJAH
Women are deceitful. They are untrustworthy flesh. I've seen too many men ruined or tied down or messed up by women.

MALCOLM
Women talk too much. To tell a woman not to talk is like telling Jesse James not to carry a gun or a hen not to cackle. And Samson, the strongest man that ever lived, was destroyed by the woman who slept in his arms (Lee and Wiley, 1992, pp. 254–255).

These alternating shots between X and Muhammad speaking nearly identical words establish X as nothing but a parrot of Muhammad and simultaneously allow Lee to exonerate the legendary figure that he is creating for promulgating sexist ideology. Indeed, Lee avoids the sexist nature of the Nation of Islam entirely in this film. In one scene at a large NOI convention a banner proudly proclaims, "We Must Protect Our Most Valuable Property Our Women." This is presented in passing, without commentary, visual or otherwise, that would indicate any ironic intent. While this might be a historically accurate signifier, it is left unanswered whether Lee to some extent embraces the hypocrisy and sexism inherent in the NOI's equating of women with property. While it is a mistake to assume that every discourse represented by a filmmaker is an endorsement, we must also consider these scenes within the larger contexts of American filmmaking and Lee's body of work.

Generally, Lee's depictions of women throughout *Malcolm X* are consistent with both traditional mainstream Hollywood representations and those of his own portfolio. *Malcolm X*, like the vast majority of Lee's other films, makes a clear distinction between the favored **Madonna** who is domesticated, desexualized, servile, passive and victimized (Little's mother, early Laura, Betty) and the denigrated *whore* who is either a sinful temptress representative of Eve or an emasculating harpy (Sophia, late Laura, Betty in certain scenes when she upbraids X for his naiveté and their lack of material possessions). Thus, while *Malcolm X* does represent a counter-hegemonic perspective on race and race relations, in dimensions of gender and sexuality, there is little question that the film reinforces a traditional, patriarchal ideological stance.

The Invisible Dimension—Class and Class Consciousness

Finally, the issues of class and economic inequities that were vitally important to Malcolm X (and particularly to El-Hajj Malik El-Shabazz) are virtually invisible in Lee's film, which concentrates on the middle-class values and lifestyles of the Nation of Islam leadership and neglects the important working-class constituency of this group. Even the Detroit Red years of hustling and criminality appear motivated by thrill-seeking impulses rather than by survival imperatives, and the connection between poverty and crime is a non-existent one in Lee's representation of American history.

Hoerl argues that Lee recreates Malcolm X as a Horatio Alger type figure (even mainstream film critics pointed this out, usually approvingly) and thus invokes conservative notions of the American Dream:

> Through depicting Malcolm X's life as a series of transformations, Lee's film suggests that even the most disenfranchised individuals may become great leaders.
>
> According to the movie, Malcolm X's emergence as a prominent black leader was wrought through his intellect and determination. This narrative structure fits with the patterns of other narratives that have evoked the American Dream myth by depicting hard work as the solution to problems of poverty and discrimination. Despite the film's controversial content, Malcolm X is one of Lee's most conventional films (2008, p. 361).

Hoerl goes on to posit that through the representation of Malcolm X's challenges to white hegemony, embodied, for example, in snippets of his actual speeches used in the film, Malcolm X the movie simultaneously critiques but, ultimately, reifies the mythology of the American Dream. Regarding this point, a scene that appears in Lee's published screenplay, but not the final version of the film, alludes to X's awareness and concern regarding economic injustice:

> Malcolm is talking to a group of PEOPLE who are having a rent strike.
>
> MALCOLM
> When you live in a poor neighborhood, you're living in an area where you have poor schools.... When you have poor schools you have poor teachers. When you have poor teachers, you get a poor education.

CUTAWAY TO THE DESPAIR OF HARLEM—SLUMS, TENEMENTS, GAR-
BAGE, RATS

>MALCOLM (contd)
>Poor education, you only work on poor paying jobs and that enables you to live again in a poor neighborhood.

CUTAWAY TO BLACK FACES

>MALCOLM (contd)
>So it's a very vicious cycle. We've got to break it (Lee and Wiley, 1992, pp. 276–277).

This isolated reference to X's class consciousness, which forms an important part of his autobiography and many of his speeches, however, never appears in the version of the film that was eventually released. Thus, through this and other absences in *Malcolm X*, Lee avoids any real indictment of the system of free-market capitalism that has pushed many blacks into a second-class economic and political status. This despite the film being a biography of a man whose political agenda represented a serious challenge to capitalist structures.[10] In this way, as well as through his aggrandizement and mythologizing of the gangster portion of X's life, and his patriarchal representations of women, Spike Lee turned the life of an American radical into an ideologically conservative, mainstream Hollywood biopic.

In the next two chapters, I consider the conclusions drawn from my preceding analyses of Lee's key films as I place these films into the context of Lee's entire body of work. Finally, I discuss the implications of my analysis in relation to the popular discourse that positions Lee as a politically radical Hollywood outsider.

· 7 ·
SPIKE LEE AND THE PARADOX OF THE ALTERNATIVE MAINSTREAM

In previous chapters I offered in-depth analyses of Spike Lee's most important early films in an exploration of the ideological standpoints and positions privileged through these texts, their production processes, and their critical reception. One of the guiding impulses behind this inquiry was to identify the location of these films, and Lee's overall status as a cinematic auteur (see Sarris, 1976; Wollen, 1972), within Raymond Williams' (1977) framework of dominant, emergent, and residual culture (also see Gitlin, 1994; and Chapter III of this book). More broadly, this analysis uncovered hegemonic and counter-hegemonic aspects of Lee's vision through a critical approach to the ways media texts both reinforce and challenge dominant ideologies about race, class, gender and sexuality (see Kellner, 1995a).

In this chapter, I place these key films within the context of Lee's overall body of work, both in film and advertising, in order to trace the underlying ideological positions that are articulated throughout his cinematic project and his activities outside of the film industry. My analysis of Lee's films suggests that Lee, as might be expected of any accomplished screenwriter/director, offers viewers a panoply of rather complicated or ambiguous representations of gender, sexuality, race, and class. Nevertheless, I also discovered that certain identifiable dominant, emergent, and residual patterns emerge through close reading and analysis.

Gender and Sexuality—Spike Lee's Marginal Women, Violent Men, and Repulsive Gays

Harris notes: "Spike's women are subject to the whims and fantasies of men. The women are controlled by men. Men are the actors, and women the acted upon" (2009, p. 27). In *She's Gotta Have It* (1986), the lead character, Nola Darling, is initially represented as a strong-willed, independent female character who flaunts traditional Hollywood stereotypes of women, particularly black women. This representation could be considered an alternative to that most often offered by the mainstream Hollywood cinema. However, a closer analysis of this film suggests that Nola's self-determination is restricted to her bedroom and the sexual acts that she performs therein. Furthermore, the narrative of the film progresses toward scenes of Nola being emotionally and physically punished for her acts of sexual liberation. All of this harkens back to mainstream Hollywood's framing of female sexuality, suggesting that rather than depicting a new or emergent cultural discourse, Lee's film is more reflective of what Williams would have called dominant, or even historically residual, cultural patterns.

When comparing Nola to other female characters in Lee's body of work, it becomes apparent that she is only the first in a series of women who are punished for being independent, sexually or otherwise. Scenes of rape or other forms of sexual violence infuse other Lee films such as *School Daze* (1988), *Girl 6* (1995), and *Old Boy* (2013). In *Girl 6*, one of only a handful of Lee's films in addition to *She's Gotta Have It* to feature a female protagonist, the title character is a failed actress turned phone-sex operator who derives sexual pleasure from her simulated intercourse with male callers. As she becomes increasingly involved with these men, one caller becomes abusive to her. In scenes that feature extreme close-ups of her lips as she breathily talks and moans on the phone, she is depicted as a willing participant in his abusive, misogynistic fantasies. This caller then stalks her and, in the film's climactic scenes, she narrowly escapes being raped, or perhaps murdered, when she flees her apartment.

In another depiction of both psychological and physical punishment being meted out to sexually liberated women, Italian American Angie in *Jungle Fever* (1991) is severely beaten by her father after he finds out she is sexually involved with a black man. Viewing Lee's films chronologically, Angie emerges as a precursor to Sophia, Malcolm X's white lover who is subjected to violent threats and emotional abuse by X. Sophia and Angie are punished not only for their sexuality, but also for miscegenation. They commit the sin that

Mookie in *Do the Right Thing* (1986), had warned his sister Jade about, when he chastised her for flirting with Sal. Lee's residual stance on interracial romance is even encoded within his depictions of black women of varying complexions, as in *Mo' Better Blues* (1990) where the protagonist, Bleek, has two lovers: one light-skinned, manipulative, and unfaithful, and one with darker skin who is loyal and committed. The light-skinned woman betrays him in order to further her career, while the darker woman supports him through times of crisis and becomes his wife. In the closing scenes of this film, their domestic bliss is signified through a series of shots of their life together raising a family, while John Coltrane's "A Love Supreme" provides a musical reference to these idealized scenes of patriarchal domesticity.[11] In *School Daze* (1988) also, black women with fair complexions are depicted both as morally inferior and sexually more promiscuous than dark-skinned women.

The apparent disdain for women found in many of Lee's films is not restricted merely to either sexually liberated or fair-complected women, however, as most of the female characters depicted throughout his films are drawn as either passive observers, like Jade, Mother Sister, and Ella in *Do the Right Thing*, or as nagging, emasculating harpies, like Tina in that film, or the mother figures in *Do the Right Thing* (1989), *Mo' Better Blues* (1990), *Crooklyn* (1994), and *She Hate Me* (2004). The parental figures in *Mo' Better Blues* (1990) and *Crooklyn* (1994) parallel each other with a kindly, loving father figure and a carping, nearly abusive mother figure. The mother in *Crooklyn* is another woman who is punished before the film ends, in this case by a terminal illness. The female child in the film assumes the role of domestic caretaker for the family. In *Mo' Better Blues* the mother figure merely vanishes after the opening scenes, without any reference to what happened to her, while the father continues to play an important role in Bleek's life. This vanishing act prefigures the symbolic disappearance of women in later films like *Clockers* (1994), *Get on the Bus* (1996), *He Got Game* (1998), and *25th Hour* (2002), which focus on masculine worlds where a few female characters appear briefly but are mostly absent from the screen and the internal world of the film. These gender patterns embody Williams's notion of cultural forms that are the residue of earlier social structures.

Thus Lee's films, viewed as a body of work, tend to construct a universe where women fall into a small number of narrow categories, most of which are negative. Cobb and Jackson have stated, "This precarious positioning of women in Spike's films is not limited to a single offering. It is pervasive" (2009, p. 256). As Bambara noted about Jane in *School Daze* (1988): "The bases of

her characterization are classic features in the construction of the feminine: narcissism, masochism, and hysteria" (2008, p. 18). Most of the women in Lee's films are some combination of whore, harpy, or passive spectator. A few, like Clorinda in *She's Gotta Have It* (1986) and Troy in *Crooklyn* (1994), are not subjected to such harsh portrayals, and yet their virtues are those of loyalty, family, and domesticity, reflecting a residual patriarchal stance on women and gender relations that is reestablished and reinforced in film after film.

One exception to this pattern is the character of Dionna in *Summer of Sam* (1999), who starts out as the passive wife of the cheating Vinny, but ends up forcefully standing up for herself and rejecting his pleas to stay with him after he has repeatedly lied to her. Another exception to Lee's general ill treatment of women is the aforementioned Troy of *Crooklyn* (1994); a young woman who is clearly representative of Lee's sister in this semi-autobiographical film written by Lee and his sister and brother. As hooks (1996) points out, it is rare indeed for American films to show us the world as seen through a young black girl's eyes and this is a signal accomplishment of this film. Yet hooks also argues that Troy represents "all the desirable elements of sexist-defined femininity" (p. 41) and ends up indicting Lee for an "insidious anti-women, anti-feminist vision" (p. 45).

Thus, aside from a few exceptions, when it comes to gender politics, Lee's films fit very comfortably within the Hollywood mainstream as they contribute to the reproduction of the patriarchal hegemony of American culture.

Even some of Lee's close associates have noted problems with Lee's depictions of women, including Lisa Jones who worked with Lee on the published version of his film journals. As Lee and Aftab sum up her criticisms:

> The problem for Lisa Jones was that Spike, in common with various rappers and black nationalists who could identify prejudice and oppression when it came in the guise of race or class, either did not want to deal with—or completely overlooked—the tendency of the mainstream culture to encourage males of whatever color to believe that they enjoyed a rightful position of dominance over the female of the species (Lee and Aftab, 2006, p. 115).

Closely related to Lee's overwhelmingly traditionalist representations of women, my analysis also uncovered recurrent elements of homophobia and a representation of masculinity as intertwined with physical aggression and violence in Lee's films. Many of these films, including *She's Gotta Have It* (1986), *School Daze* (1988), *Mo' Better Blues* (1990), *Crooklyn* (1994), *Clockers* (1995), *She Hate Me* (2004), and *Old Boy* (2013), present stereotypical, heterocentric, or

denigrating images of, or derisive dialogic references to, homosexuality and lesbianism. Lee has defended himself from charges of homophobia by arguing that creating homophobic characters is not the same as endorsing those views:

> I remember having an argument with some critic from the gay magazine *The Advocate*, who accused me of being homophobic because I had one of my characters call another a faggot. I was accused of being homophobic for just depicting homophobia—I don't understand that kind of thinking (quoted in Lee and Aftab, 2006, p. 125)

Lee raises an important point about media criticism here. We should not suggest that depicting antisocial behavior (prejudice, discrimination, violence), equates to celebrating that behavior. Filmmakers might depict homophobia on film because it is a real phenomenon or, more didactically, to criticize it.[12] This in fact, is what Lee does in *Summer of Sam* (1999) as homophobia is depicted as part of an overall mix of debilitating fears that rent New York during the 1970s. Yet, there are many more instances where this sort of critique does not seem to be what Lee is after. For example, as I discussed in Chapter IV, neither Nola's disgusted reaction to Opal in *She's Gotta Have It* (1986) nor the depiction of Opal as predatory can truly be read as a critique of homophobia. And, as Lubiano noted about *School Daze* (1988):

> Lee has constantly defended his film against criticism of its homophobia by claiming and privileging its facticity, by defending realism: Those (frat) guys really are that way. In so doing, he lets himself off the hook for the selection criteria at work in any representation. I respond as simply: Yes, some African Americans are like that; some are not; therefore, to what particular end is this specific "real" content being mined? If it is intended as a critique of African American homophobia, "how" (in form and/or content) is the critique available? (2008, p. 51)

Furthermore, Lee repeatedly privileges a form of masculinity that equates "manhood" with both physical aggressiveness and heterosexuality. In *Malcolm X* (1992) for instance, Lee avoids the slightest hint of X's purported homosexual encounters (see Marable, 2011; Perry, 1991; Simmons and Riggs, 1992) and instead offers viewers a masculinist, physically violent, swaggering version of his career as a hustler in Boston and New York. Stevens (2009) argues that Lee's film constructs Malcolm X in both hypermasculine and heteronormative terms and erases the crucial roles that actual women played in X's life.

This privileging of machismo, "manhood," and physical force is a common characteristic of many of Lee's men including Jamie Overstreet in *She's Gotta Have It* (1986), Dap in *School Daze* (1988), Detroit Red in *Malcolm X* (1992), Jake in *He Got Game* (1998), and Joe in *Old Boy* (2013). The only Lee film to

date that makes any attempt to provide a multidimensional view of gay men is *Get on the Bus* (1996), one of his first films written by an other screenwriter. As Watkins notes "If Lee's attitude toward gay men can be read as indifferent or even hostile in his earlier work, *Get on the Bus* represents an effort to strike a more inclusive tone. The film, albeit in problematic form, asserts that gay men are a part of the black community" (2008, p. 153). Exemplifying the problems that Watkins alludes to, even in this film the gay characters only gain acceptance from other men after one of them, an ex-Marine, "proves his masculinity" in a fight where he efficiently defeats his opponent (see Gilroy, 1997). Furthermore, this resolution of conflict through violence is a common thematic element of Lee's films, most of which feature at least one scene of climactic violence. Thus, as with his representations of women, Lee's heterosexist and violently masculinist representations may also serve to reinforce and reproduce dominant or even residual ideologies about gender and power.

Race and Racism—"Us vs. Them"

Since his first commercial film in 1986, Lee has been praised for bringing a black sensibility to an American film industry that had long been indifferent to black perspectives, stories, and culture (see, for example, Cripps, 1993; Elise and Umoja, 2009). As Glicksman noted about Lee's first entry into Hollywood: "All of the characters in the film are black. Unlike Steven Spielberg's *The Color Purple*, *She's Gotta Have It* neither needs white context nor white audiences to which blacks have been invited. This time, black women talk to black men, and whites are invited—to learn something about blacks, and also about themselves" (2002a, p. 4). But some have also criticized him for being "race obsessed"—a ridiculous label to attach to any filmmaker who is interested in telling compelling tales about American society. Cobb and Jackson contend that what many critics seem unable to cope with is Lee's investment in black culture:

> What critics understand as an "obsessive" invocation of racial/ethnicity politics occurs through the music that scores Spike's films, the speech of his characters, their styles of dress and body language, their artistic expressions, and other purposeful representations of black popular culture portrayed on camera (2009, p. 258).

While accusations of racial obsession are meant by some to be disparaging, race is in fact a thematic line that runs from film to film, one of the distinctive

elements that mark his identity as an auteur. Several of Lee's films, including *School Daze* (1988), *Do the Right Thing* (1989), *Jungle Fever* (1991), *Malcolm X* (1992), *Get on the Bus* (1996), *4 Little Girls* (1997), *Bamboozled* (2000), *When the Levees Broke* (2006), *Miracle at St. Anna* (2008), and *If God Is Willing and da Creek Don't Rise* (2010), deal directly with issues of race and racism as key narrative elements. In others, such as *She's Gotta Have It* (1986), *Mo' Better Blues* (1990), *Clockers* (1995), *Girl 6* (1996), *He Got Game* (1998), *Summer of Sam* (1999), *25th Hour* (2002), *Inside Man* (2006), and *Red Hook Summer* (2012), the focus is not on race relations, but race and ethnicity still inflect the interactions between characters and the narrative conflicts in the films.

As I noted in previous chapters, Lee is one of the few filmmakers working in mainstream Hollywood who is willing to present challenging and controversial material that directly confronts issues of racial identity, racial animosity, racial discrimination, and racial polarization. Furthermore, Lee's presence as an important and recognized media figure in an industry that has historically marginalized blacks and other people of color, in and of itself represents an emergent challenge to dominant institutional trends in the American culture industries. When asked in 1991 about the primary purpose behind his films, Lee said: "I try to show African American culture on screen. Every group, every culture and ethnic group needs to see itself on screen. What black filmmakers can do is show our culture on screen the same way Fellini's done for Italians and Kurosawa's done for the Japanese" (quoted in Richolson, 2002, p. 26).

Through his films and production practices Lee is able to provide a diverse audience with representations of black life that are created and produced by primarily black artists and craftspeople. This is not just a personal achievement, reflective of a long-term goal of reaching as many people as possible with his films (Lee and Wiley, 1997), but also the realization of the goals of much alternative media that seek to provide disenfranchised groups in a society with the means to enter into the realm of public discourse through establishing control of their own visions and voices (see Kessler, 1984). In this way, Lee's films may be considered a counter-hegemonic antidote to a long list of Hollywood films like *The Color Purple* (1985), *Cry Freedom* (1987), *Mississippi Burning* (1988), *Glory* (1989), *Ghosts of Mississippi* (1996), *Amistad* (1997), *The Green Mile* (1999), *Glory Road* (2006), *The Blind Side* (2009), and *The Help* (2011) that represent black struggles through the perspective of white directors, white screenwriters, and/or white heroes (see Madison, 1999; Rosenbaum, 1997).

Furthermore, as noted in the previous chapter's analysis of *Malcolm X*, Lee's films often reverse Hollywood traditions that tend to privilege white cultural icons and symbols over the symbology and iconography of black culture. This is apparent throughout *Malcolm X*, but also in other Lee films such as *Do the Right Thing*, which reconfigures the symbolic meaning associated with Italian American icons like Frank Sinatra. Thus, through both his economic strategies and his cultural representations, Lee successfully pursued alternative means of production and provided alternative content while working primarily within the boundaries of a mainstream industry.

Lee's engagement with American racism falls short of being truly oppositional, however, due to his onscreen neglect of structural racism. Lee's focus tends to be on the prejudicial attitudes manifested in personal struggles. This is often between characters of similar socioeconomic status whose conflicts are motivated purely by prejudice rather than class or economic disparities. While perhaps reflective of particular conflicts in American society, Lee rarely takes the next step of acknowledging that these personalized ethnic and racial tensions serve as a distraction from class and race-based economic and political repression.

Lee tends to ignore the deep and complicated connections between race and class in American society. While concentrating on individual acts of prejudice, Lee often ignores the oppressive power of economic and political institutions that continually reproduce the conditions of production and consumption that have resulted in a society that consigns a vast number of both whites and non-whites to poverty. While films like *Malcolm X* and *Clockers*, which is about drug-dealing in urban America, seemed to have the potential to address some of these issues, Lee's reliance on traditional Hollywood personalization tropes in constructing these films impedes him from presenting a coherent indictment of structural inequities.

Lee's overall treatment of drug-trafficking and addiction in black communities provides a useful example of how his films often fall short of presenting a counter-hegemonic indictment of American racism. First, in many of his films Lee has refused to acknowledge that drugs are an inescapable part of the American urban landscape as it exists under latter-day free-market capitalism. Thus, films such as *Do the Right Thing* (1989), *Mo' Better Blues* (1990), and *Crooklyn* (1994) represent drug-free urban neighborhoods, which Lee has defended by stating that he wishes to avoid stereotypes of drug-infested black communities: "as if drugs were the complete domain of black people. How could you do a film set in Bed-Stuy without any drugs? Easy. We black people

aren't the only people on drugs...why have I never read of any white filmmakers being chastised for not having drugs in their films?" (quoted in Mitchell, 2002, p. 49).

While his refusal to abide by traditional Hollywood stereotypes serves him well in other dimensions of his films,[13] in this case Lee incapacitates himself from presenting a perspective on a problem that is both an empirical fact and a crucial and debilitating aspect of contemporary urban existence.

Second, in his films that do acknowledge the reality of drug-trafficking and addiction, such as *Jungle Fever* (1991), *Malcolm X* (1992), *Clockers* (1995), *25th Hour* (2002), and *Red Hook Summer* (2012), Lee generally ignores the sociological and structural aspects of the problem. In *Jungle Fever*, for instance, drug addiction is depicted as a personal moral failing, rather than as a result of both personal and societal factors, by Lee's representation of two brothers raised in the same familial and socio-economic situation, one who is a successful architect and the other who is a depraved crack addict. The issue here is not that this is a completely impossible scenario, but rather that Lee employs these characters in a fable-like subplot, a mini-morality play in a film that is already a parable about the evils of interracial sex, suggesting that those who succumb to the temptations of drug addiction do so only because of their own personal moral failings. This type of discourse neglects the social causes of drug addiction and fits very neatly into the conservative ideology of laissez-faire capitalism. Similarly, in a later film, *Clockers*, Lee attempts a portrayal of the misery associated with drug abuse in impoverished black communities, but here he presents drug dealing and addiction as one of the primary *causes* of this devastation rather than symptomatic of larger issues of social neglect and institutional oppression.

Finally, Lee falls short of presenting an oppositional stance on racism through his privileging of biological and essentialist perspectives on race and culture rather than recognizing that race is a social construction that has historically been employed as a rationale for oppressive and divisive political practices (see Bonilla-Silva, 2014; Delgado and Stefancic, 2001; Downing and Husband, 2005; Ewen and Ewen, 2006; Feagin and Vera, 1995; Ferguson, 1998; Fuentes, 2012; Gandy, 1998; Hall, 2013; Jensen, 2005; Jhally and Lewis, 1992; Omi and Winant, 1994; Smedley, 1993; West, 1994; and Wise, 2010). According to Dyson, Lee's films privilege "a vision of 'us' and 'them' in which race is seen solely through the lens of biological determinism" (Dyson, 1993, p. 25). This is most apparent, perhaps, in Lee's depictions of interracial sexual relationships as unhealthy, lust-driven obsessions that are doomed to tragic failure.

While Lee has said that he was "not trying to condemn interracial relationships" in *Jungle Fever* (quoted in Richolson, 2002, p. 29), the representation of interracial romance as immoral/dangerous/doomed-to-failure is a familiar and recurrent theme in Lee's films, showing up again and again in *Do the Right Thing* (1989), *Jungle Fever* (1991), *Malcolm X* (1992), *Girl 6* (1996), *He Got Game* (1998) and *Miracle at St. Anna* (2008). This theme is central to a position that Kellner has provocatively dubbed "quasi-segregationist" (1995a, p. 171), and, it should be noted, when asked in 1991 about not wanting his future kids to attend white private schools, Lee said "there is definitely an argument for being around your own people" (quoted in Mitchell, 2002, p. 55).[14]

Dyson (1993) argues that Lee reduces race to a simplistic, one-dimensional, either/or categorization that ignores the importance of such factors as gender, class, age, sexuality, religion, and geography and closes off the potential for effective coalitions and collaborations that can fight racism and oppression in all of its manifestations (see also Kellner, 1995a). Lee's films pit oppressed groups against one another as institutional forces of repression go unrecognized and unchallenged.

It is important to reiterate, however, that Lee's tendency to focus on cultural and racial divisions does provide a much needed antidote to the impulses of most mainstream films that present a false picture of America as a post-racial society where all have an equal opportunity to survive or fail based on hard work and individual merit. These films, such as the Eddie Murphy vehicle *Trading Places* (1983), or more recently Will Smith's *Pursuit of Happyness* (2006), tend to reify the ideology of those conservatives who argue that racism is no longer an obstacle to personal freedom and material success.

In films like *Do the Right Thing* (1989), *Jungle Fever* (1991), *Clockers* (1995), *Get on the Bus* (1996), *He Got Game* (1998), *Bamboozled* (2000), *When the Levees Broke* (2006), and *If God Is Willing and Da Creek Don't Rise* (2010), Lee challenges such notions. Yet, at least in his fictional films, Lee generally demonstrates a refusal to go one step further in acknowledging systemic, institutional, and structural racism and repression. Finnegan proposes *Do the Right Thing* does in fact reveal that overcoming personal ignorance and prejudice does not end racism "precisely because racism is still built into our social, political, and economic institutions such as education, banking, housing, and even family systems" (2011, p. 79), but my analysis offered in Chapter V does not support this contention. There is little evidence of a critique of these institutions in *Do the Right Thing* and, as Lubiano noted about the climactic moments of the film (the murder of Radio Raheem by the police and

the subsequent riot): "Lee has said also that, if Raheem had just turned down the radio, none of this would have happened—so much for any representation of systemic racist oppression" (2008, p. 49). As for *Jungle Fever's* exploration of interracial romance, Guerrero argues, "the film limits its exploration of racism to personal expressions of anger without ever taking on its much more powerful and relevant political and institutional dimensions" (2008, p. 86).

In some of his production journal entries and interviews Lee does acknowledge structural racism:

> Black people can't be racist. Racism is an institution. Black people don't have the power to keep hundreds of people from getting jobs or the vote. Black people didn't bring nobody over in boats. They had to add shit to the Constitution so we could get the vote. Affirmative action is about finished in this country now. It's through. And black people had nothing to do with that, those kinds of decisions. So how can black people be racist when that's the standard? Now, black people can be prejudiced. Shit, everybody's prejudiced about something. I don't think there will ever be an end to prejudice. But racism, that's a different thing entirely (quoted in Mitchell, 2002, p. 39).

Despite this awareness his films tend to emphasize individual prejudice rather than institutional racism. This tendency impedes his ability to formulate a truly oppositional political statement about race and racism in his fictional films. In his documentaries, however, Lee has dealt with the devastating effects of structural racism, a tendency that makes his avoidance of this in his fictional films all the more perplexing.

Class Struggle—The Missing Dimension

As Wilson (1980; 1987; 2010) and many other sociologists have demonstrated, race and class are inextricably linked. But Lee tends to avoid this connection in his fictive representations of contemporary social issues. Kellner points out that Lee's focus on racial conflict, as well as his tendency to present a consumerist ideology, while ignoring class distinctions and class oppression, means that he:

> has not been successful in articulating the larger structures—and structural context of black oppression—which impact on communities, social groups, and individual lives. Thus, he does not really articulate the dynamics of class and racial oppression in contemporary U.S. society (1995a, pp. 168–169).

Kellner (1995a) echoes Baraka's (1993) argument that Lee's films are framed almost entirely from a middle class perspective, privileging and naturalizing

middle class values and middle class characters. This is apparent even in films like *Do the Right Thing* (1989) and *Malcolm X* (1992), where much of the focus is ostensibly on the poor and working class. Despite this, everyone in these films always seems to have enough money to be active participants in a consumer culture, and the debilitating effects of poverty are rarely seen. In another film, *Mo' Better Blues* (1990), Lee focuses on a jazz musician who is deprived of his livelihood after a physical assault makes him unable to play the trumpet anymore. Without any other visible signs of income, Bleek still manages to live a comfortable middle class existence and is eventually depicted as achieving all of the trappings of middle class domestic bliss: a devoted wife and loving child, a well-furnished home in an idyllic neighborhood. This resolution, as Baraka (1993) suggests, elevates the traditional values associated with domestic middle class life over the creative, rebellious instincts of dissident artists and musicians.

Starting with his first feature film, many of Lee's movies including *She's Gotta Have It* (1986), *School Daze* (1988), *Mo' Better Blues* (1990), *Crooklyn* (1994), *Girl 6* (1996), and *She Hate Me* (2004), tended to focus almost entirely on the upper or middle classes. In several of these films, such as the above-mentioned *Mo' Better Blues* and a later film, *Crooklyn*, Lee offers a nostalgic vision of an America that never really existed, an America where no one goes hungry, the streets are safe and clean, and all children have warm winter coats. As Cunningham points out about the central family in *Crooklyn*, "Despite their financial problems, the Carmichaels have managed to buy a Brooklyn brownstone and a Citroen [an imported automobile]" (2008, p. 124). Whereas Lee's films have often challenged dominant conceptualizations of race, in regard to class issues filmic representations like these tend to reinforce the Reagan/Bush vision of a "kinder and gentler" America where no one really suffers or lives in misery (or if they do, it's their own fault for not taking advantage of all the opportunities that America has to offer, e.g., Gator, the crack addict in *Jungle Fever*).

None of this is to suggest that the middle class are not a legitimate subject for black filmmakers who must be relegated to producing films about the ghettoized life of the poor. Rather, pointing out this tendency of focusing on middle class values and lifestyles in an uncritical fashion, further aids in grounding an analytic evaluation of Lee's work through an identification of the mainstream tendencies of his films that are so often cited as examples of radical or oppositional media culture (see Lubiano, 2008). The key point is that rather than standing in opposition to conservative, hegemonic values, Lee's depictions of the poor and working class are often filtered through a traditionally

mythic version of the American dream. His representations, then, disguise the most brutal results of poverty while suggesting that any individual can prosper if they will only "pull themselves up by their bootstraps."

Expressing a similar concern, Baraka (1993) has suggested that Lee's films exhibit disdain for those who are permanent members of the working class. This runs contrary to what Lee himself has indicated. For example, he wrote in a production journal for *Do the Right Thing* (1989) that his film focused on the: "black underclass in Bed-Stuy, a community that has some of the highest unemployment, infant mortality, and drug related homicides in New York City. We're talking about people who live in the bowels of the social economic system, but still live with dignity and humor" (quoted in Lyne, 2000, p. 50). Yet despite Lee's awareness, little of this makes it onto the screen. There is no infant mortality or drug-related homicide, in *Do the Right Thing*, and while there are unemployed characters, there is little evidence of the dire effects of joblessness as they all seem to still possess the resources for the many consumer goods that appear in the film. And many of the characters are not particularly dignified, despite Lee's recognition of the dignity of working class existence.

Furthermore, in films like *Jungle Fever* (1991), the only characters who live the dignified existence that Lee refers to are those who are upwardly mobile and middle class, while the sympathetic architect hero of the film treats laborers and the poor with sneering disdain, lending substance to Baraka's complaint.[15] Similarly, Wallace (1988) argues that the film *School Daze* also presents a dismissive and insulting portrayal of working class blacks. Similar critiques could be directed toward the Lee films that seem to be most engaged with the working class and the poor, such as *Do the Right Thing* (1989), *Clockers* (1995), *He Got Game* (1998), and *Bamboozled* (2000).

At least in *School Daze* (1988) there is a brief nod to class conflict, one of the few Lee films to take this on even fleetingly. This dialogue is from a scene where college students and local youth almost come to blows: "We're not your brothers. How come you college motherfuckers think you run everything? You come into our town year after year and take over. We were born here, been here, will be here all of our lives, and can't find work 'cause of you" (quoted in Glicksman, 2002b, pp. 14–15). Oddly, it would be almost two decades before Lee would again directly acknowledge the legitimacy of class conflict in one of his films, the documentary *When the Levees Broke* (2006).

It is possible, however, that Lee is beginning to bring his awareness of class to the screen in a more apparent fashion. Certainly his two post-Katrina

documentaries do focus on class issues and the abandonment of the poor. In a 2006 interview, Lee had this to say about his experiences in Louisiana while making *When the Levees Broke*:

> It's made me realize that the Bush administration does not care about poor white people either. More and more I think that class is catching up to race as far as America goes. Well, before I used to think that everything was based on race, now class is just as much; if you are a poor person, black, white, Latino, whatever—this government and administration do not have your best interest at heart (quoted in Lee and Aftab, 2006, p. 393).

Spike Lee—Advertising Man

In relation to these concerns about Lee's cinematic representations (or lack of representations) of class struggle, Lee's advertising ventures must also be considered when discussing issues of dominant culture and class-based inequalities. Lee has always been brand friendly and even considers himself a brand (quoted in Leitch, 2012). Watkins says that Lee "typifies the entrepreneur who has transformed marginality…into opportunity…" (1998, p. 107). de-Waard offers an explanation of how a challenging filmmaker who generally operates on the margins of Hollywood has been able to achieve a remarkable level of prolificacy and financial success:

> Lee's own increased economic power has been due in large part to his skill in branding the Spike Lee name, resulting in his transformation into a valuable commodity. From his ability to create controversy incessantly to his numerous and various commercial enterprises, Lee has exploited his celebrity in order to continue his prolific cinematic output over the years (2009, p. 346).

It should not, then, be overly surprising that Lee has not shied away from collaborating with Fortune 500 companies while working in the advertising industry. Even in his first feature film, *She's Gotta Have It* (1986), Nike sneakers are prominently featured as the camera reveals that Mars Blackmon (played by Lee) even keeps his Nikes on while making love. Lee has in fact had an ongoing collaboration with the Nike corporation since his earliest successes as a filmmaker, and he has produced several highly lucrative advertising campaigns for Nike that helped boost them into the position of being the world's top athletic wear company (number 126 on the Fortune 500 list in 2013).

In 1987, Nike began releasing Lee-produced advertisements that featured the fictional Mars Blackmon alongside the NBA superstar Michael Jordan.

Nike's CEO, Phil Knight, credited Lee's advertisements with saving Nike as a brand and assisting in their rise to dominance (Lee and Aftab, 2006). In addition to a Lee character appearing in Nike ads, Nike products are often featured prominently in Lee's films as well. Lee's commercials were the first step in associating Nike with NBA stardom and black celebrity and thus must be considered one of the most important factors in establishing Nike as the preferred brand for black youth (Christensen, 1991; Coleman and Hamlet, 2009; Cole and Hribar 1995; Madden, 2012; Stabile, 2000). Gabbard notes that "throughout the 1990s, Spike Lee and Michael Jordan were the two public figures most associated with Nike sports shoes (2008, p. 182). This lucrative pairing continued into the 21st century, when Lee performed as the Master of Ceremonies at the unveiling of a new Michael Jordan Nike sneaker in 2012 (Madden, 2012). Lee's collaboration with Nike now extends past film and television advertising into the realm of social media like Twitter. Lee tweeted: "Ladies and Gentlemen, Boys and Girls Introducing Da Air Jordans 28. It's Gotta Be Da Shoes. Do Ya Know," alongside a photograph of himself with the shoes.

When considering the high cost of Nike footwear and the targeting of often low-income urban consumers, Lee's long-standing participation in this exploitative practice seems to contradict any notion that he is a radical, or even progressive, media figure. Furthermore, the collaboration has thrived despite Nike's well-documented exploitation and abuses of employees in impoverished nations, and in total disregard of an Operation Push sponsored boycott of the company over discrimination against blacks in their employment practices (Christensen, 1991; Reilly, 1991; Stabile, 2000). When asked in a 1991 interview about some highly publicized incidents of children being murdered and robbed of their expensive Air Jordan sneakers, Lee deflected any notion of responsibility or the power of advertising: "It's my fault, it's Michael Jordan's fault, that kids are buying those shoes? That's just the trigger. There's more to it than that. Something is wrong where these young black kids have to put so much weight, where their whole life is tied up—their life is so hopeless—that their life is defined by a pair of sneakers" (quoted in Mitchell, 2002, p. 52).

Yet Lee's work has in fact encouraged the commodity fetishism he was critiquing and he and Nike have been intimately intertwined since the late 1980s. Lee has said he considers Phil Knight to be a friend, and he has consistently defended Nike when confronted by criticism of their use of sweatshop labor in overseas factories (Lee and Aftab, 2006). In 1996, Nike aired a commercial that drew on imagery from *Malcolm X*: "the film's ending set piece of a

rainbow of children telling the camera 'I am Malcolm X' became a television commercial with inner-city children using the same cadences to chant 'I am Tiger Woods' in an effort to sell sporting goods for Nike, one of Lee's long-standing employers" (Lyne, 2000, p. 56). In 1997 Lee posed for the cover of a book while prominently sporting a pair of Nike sneakers. Nike helped fund a 2002 documentary on the football player Jim Brown that Lee made for HBO, and Phil Knight is personally thanked in the credits. In 2007 Nike created a limited edition sneaker, the Spi'zike, named for Lee and celebrating the Mars Blackmon commercials (Colapinto, 2008). And, as noted above, he continues to do promotional work for the corporation at public and private events and through social media.

Even a biographer that collaborated with Lee has asked:

> And yet, if Spike really believed that the exploitation of child labor and of minorities was indefensible, surely it would be expected that he would be calling for the boycott of Nike? It seems that Spike's love of basketball and his respect for business have wrought a certain kind of havoc upon his beliefs (Lee and Aftab, 2006, p. 291).

But it's not just the business of basketball for which Lee seems to have a soft spot. Gabbard defends Lee's business practices by pointing out: "For an artist to survive today in any marketplace without some connection to corporate interests is scarcely possible" (2008, p. 183). While there is a certain truth to this assertion, Lee has often connected himself to corporate interests in a seemingly indiscriminate fashion. In another example of Lee's seeming disregard for corporate exploitation of the poor, in 1997 America's most powerful brewery, Anheuser-Busch, announced their plans to concentrate on marketing beer to black and Latino communities with a new advertising strategy that involved Spike Lee directed commercials (Arndorfer, 1997). As an astute observer of the American social scene, Lee is certainly aware that the alcohol industry deliberately targets poor and working class consumers (Alaniz and Wilkes, 1998; Hackbarth, Silvestri, and Cosper, 1995). In fact, he has noted this himself. In *Malcolm X* he depicts X telling a black crowd that alcohol is used by the white power structure to pacify black communities. In reference to satiric fake ads that appear throughout *Bamboozled* (2000), Lee said: "They are still selling that malt liquor, that liquid crack, predominantly to African Americans" (quoted in Lee and Aftab, 2006, p. 337). Still, he willingly participates with the alcohol industry and other corporations that prey on the inner city. Similarly, U.S. military recruiting strategies deliberately target young men and women in poor and working class communities

(ACLU, 2008), yet Lee actually bid to make recruiting advertisements for the U.S. Navy (Auther, 1999).

As his career progressed, Lee became more and more active in, and derived more and more income from, the advertising industry (deWaard, 2009). In addition to Nike, Lee made commercials for the Gap, Levi's, Diet Coke, Pepsi, Snapple, AT&T, ESPN, Kmart, TNT, Philips Electronics, Quaker Oats, American Express, Taco Bell, Pizza Hut, Ben & Jerry's, and many others. In a 1996 speech, Lee said:

> People ask me why do I do music videos and commercials. I really don't make a separation between film and commercials and music videos. To me they all come under the heading for me of cinema because I try to have a narrative in all three. The only difference is that the commercials you got thirty seconds, the music videos you have four minutes, and the movies you got three hours—if you're lucky. Also they pay a lot of money (quoted in Coleman and Hamlet, 2009).

Shortly after he delivered this speech, a 1997 *New York Times* article reported that Lee was establishing his own advertising agency in cooperation with the firm, DDB Needham Worldwide (Hirschberg, 1997) explicitly to target the "urban market." On the Spike DDB website, Lee (or a public relations copywriter posing as Lee) describes the mission of his agency, focusing on his close relationship with Nike, his love of advertising, and his devotion to the "bottom line" of several multi-national corporations:

> In 1988, I got an opportunity to work with Nike and the one and only Michael Jordan. Our groundbreaking Air Jordan campaign was my first taste of the ad game, and I was hooked.
>
> In 1997, I partnered with DDB to create Spike DDB—a boutique ad agency with the big gun backing of a global agency network. So, of course, we do things a little differently.
>
> Our mission is to create positive, thought-provoking work that entertains and helps boost our client's bottom line. But we've also made it our business to help marketers stay on top of the cultural shifts in America that other guys ignore until it's too late. For over 15 years, we've done so for clients like Pepsi, Jaguar, State Farm, HBO, TNT, Mountain Dew, Johnson & Johnson, Cadillac and Chevrolet (Lee, no date, http://www.spikeddb.com/about-us/, no pagination).

Shortly after Lee formed Spike DDB, after a screening of *Do the Right Thing* in 1998, I had a chance to ask Lee if he believed his work in the advertising industry in any way compromised the political thrust of his films. Lee appeared

irritated by my question and offered a very terse response. His reply extolled the virtues of free-market capitalism and his right as an American to try to earn as much money as he can. Lee compared himself to the Rolling Stones and asked why white artists aren't criticized for making commercials but he is (Lee, personal communication, March 9, 1998).

Based on this evidence I argue that those who have offered a critique of Lee as a "sell out" are purveying a shortsighted and simplistic analysis. Selling out implies that someone has given up his or her values in order to achieve personal profit. While Lee has certainly profited from his work in advertising, looking at this in conjunction with the values he has expressed in interviews and the ideologies valorized in his films (right from the beginning with the "in-your-face display" of Nike sneakers on Mars Blackmon in *She's Gotta Have It*), I argue that Lee never possessed the anti-corporate values or the radical alliances that many of his most vocal fans and academic defenders have ascribed to him. deWaard (2009) contends that selling out is in fact Lee's *goal*, because he has always wanted to compete on the same terms as mainstream white filmmakers who have had the privilege of the full largesse of corporate Hollywood.

Thus, in both his films and his advertising ventures, my analysis suggests that Lee's work embodies the spirit of dominant and residual cultural forms much more than it represents truly emergent challenges. Yet, Lee is still regarded by many as a radical and oppositional filmmaker. The final chapter delves deeper into this enigma while placing Lee's work in a larger cultural context.

·8·
THE MAINSTREAMING (?) OF SPIKE LEE: CHALLENGE AND INCORPORATION

In this final chapter I explore how Lee's films may or may not have changed as he progressively became more incorporated within the mainstream film industry. In addition, I discuss Lee's career in relation to larger issues related to the possibilities of counter-hegemonic cultural production within the mainstream film industry. It is perhaps the case that much of the public perception of Lee as an oppositional media figure (see Lubiano, 2008) is based on impressions formed during the initial stages of his emergence as a media figure, and that as he has become a successful player in the Hollywood milieu the ideological and political subtexts of his films have become increasingly mainstreamed. This is what Lyne argued in 2000 when he posited that Lee is able to "make peace with the corporate power structure while maintaining a veneer of militant dissent" (p. 45).

Thus, as I set out to examine Lee's work one of the central questions I was interested in exploring is whether a chronological analysis of Lee's career reveals any significant ideological shifts as he moved from a position of independence to one of incorporation. After all, Watkins has pointed out:

> Occasionally, studio executives find it necessary to cut a scene, rephrase a piece of dialogue, or alter some other element considered too risky. This filtering process is an example of how the creative process is routinely purified by industry gatekeepers as

a means of staying within the normative boundaries of dominant social and cultural values (1998, p. 116).

Again it is necessary to move beyond the analysis of his key films in order to fully engage with this question. While the films focused on in earlier chapters were purposively selected as representative of Lee's most important work, they were all produced within the first decade of his emergence as a major American director. For the purposes of examining this question it's necessary to put these films into the context of Lee's chronological and historical development as a filmmaker, an advertiser, and a media icon from 1986 to the time of this writing in 2014.

By examining Lee's career from this perspective, it is possible to identify some specific trends. Lee's first three commercially distributed films, *She's Gotta Have It*, *School Daze*, and *Do the Right Thing* all show evidence of both mainstream and alternative ideologies as discussed in previous chapters. *She's Gotta Have It* (1986) offered an alternative to mainstream Hollywood representations of black gender politics, albeit in a limited and somewhat contradictory manner. *School Daze* (1988) exposed controversial intragroup prejudices among black communities and directed harsh criticism toward black colleges and universities that were slow to divest from South Africa (still under the tyranny of apartheid when the film was released). *Do the Right Thing* (1989) presented a complex and multifaceted discourse on the morality and efficacy of violence in the face of racist oppressive forces. In these aspects each of these films clearly represented an alternative to both dominant ideologies and to the standard Hollywood fare of the day.

Despite this, within these three films there were already indications of a mainstreaming impulse in Lee's work. With each of these films Lee's financial successes and his status as a filmmaker and media figure continued to grow as he gradually began the move toward incorporation into the mainstream Hollywood industry, relying more and more heavily on corporate funding of his artistic vision. In a parallel to this trend, this period also saw the beginnings of Lee's advertising work for major corporations such as Coca-Cola, Nike, and the Levi's clothing company (Reilly, 1991). Subsequently, Lee would set up his own advertising agency and even open his own retail stores. As McKelly (2008) points out, in the 1988 screenplay for *Do the Right Thing*, Lee noted "Radio Raheem, like the large majority of Black youth, is the victim of materialism and a misplaced sense of values" (quoted in McKelly, 2008, p. 63). Yet, Lee would soon become a purveyor of materialism himself, as McKelly points to "Lee's highly visible and controversial promotion of various product

lines (including his own) which vigorously target the young African American male demographic..." (2008, p. 63).

Lee's changing economic and social status plays out even in his early films as his positions on consumerism and political activism seem to undergo an ideological reversal. In *She's Gotta Have It* (1986), for example, Greer Childs, a character who exemplifies an upwardly mobile consumerist sensibility, is a figure of ridicule and the butt of Lee's comic barbs, both in the film's dialogue and in the use of visual imagery that satirizes Childs's vanity and self-absorption. In contrast to this, the protagonists of this film and *School Daze* (1988), Nola and Dap, respectively, exhibit strong tendencies toward political consciousness and activism. Although Dap's friends tease him about his intense political beliefs, both he and Nola are dynamic, charismatic characters that others admire. *Do the Right Thing* (1989), however, reverses this dichotomy by depicting politically aware characters as social deviants and misfits who are ridiculed and dismissed by the community, while the protagonist and figure of community admiration, Mookie, is fashion-conscious, money-obsessed, and apolitical. Even Mookie's seemingly defining act of throwing a garbage can through Sal's window, and thereby sparking a civil upheaval, is born of frustration, not from a political agenda. As Finnegan points out:

> Mookie's act is not an act of power; it does not change the structure of power in the community. To suggest that Lee thinks it does strikes me as bizarre. Mookie's action is precisely the act of the powerless; it has psychological but not political force (2011, p. 86).

School Daze and *Do the Right Thing* also display a further regression from the attempt of *She's Gotta Have It* to present strong-willed, independent female characters. Women in these two later films are relegated to the status of passive observers of male agency and sexualized totems of male control over female bodies, as the underlying patriarchal ideology of Lee's first film becomes more obvious and pronounced as his own power as a filmmaker grows.

School Daze in particular presented an intensely demeaning and sexist depiction of college-age females (Bambara, 2008; Wallace, 1988). As Wallace points out, the women in *School Daze* "take no apparent interest in either politics or culture except as passive consumers" (1988, p. 801). Bambara noted "the film's agenda to make a wake-up call is undermined by its misogynistic and gay-hating sensibility" (2008, p. 12). Demeaning representations of women have occurred so frequently in Lee's films subsequently that they must be considered almost integral to the Spike Lee "brand."

While each of Lee's first three films did possess at least some ideologically dissident elements, his fourth film, Mo' Better Blues (1990), eschews explicit politics, even though it deals with jazz musicians who have historically presented artistic, social, and sometimes explicitly political challenges to dominant hegemonic culture. Lee's earlier films had all generated controversy over the challenging material that he was presenting, but the most controversial aspect of Mo' Better Blues was its stereotypical representation of two Yiddish-speaking nightclub owners that led to media accusations of anti-Semitism (Corliss, 1991). Although Lee has attacked prejudice in his films, he has never accepted any critical responses to his own depictions of race and ethnicity and in this case his reaction was no different. He initially wanted to open his next film, Jungle Fever (1991) with a scene where he directly addressed those who accused him of anti-Semitism with the response: "They can kiss my black ass" (quoted in Corliss, 1991). Furthermore, as discussed above, Mo' Better Blues is the first of several Lee films that glorify domestic middle-class life-styles through representations of a Reaganesque America where individual attainment of goals is the supreme achievement.

This privileging of conformist, middle class values continues and is advanced throughout most of Lee's later films including those of the early 90s: Jungle Fever (1991), Malcolm X (1992), and Crooklyn (1994). This time period represents a conservative period in American political history, and Jungle Fever (1991) presented twin morality tales that could easily have served as templates for a speech by the incumbent Republican presidential candidate George H.W. Bush. Jungle Fever mostly focuses on a doomed and sordid interracial sexual relationship, but the subplot of this film is about the personal responsibility that "failures" such as drug addicts in American society must shoulder, and the core theme is that people of different cultural groups should "stick to their own kind." In his analysis of Jungle Fever, Guerrero makes note of what he calls "a subtle refrain of black neo-conservatism always faintly resonant in Lee's films and interviews" (2008, p. 81).

As discussed in detail in the previous chapter, by the time of his next film, Malcolm X (1992), Lee had become a major player in the Hollywood industry and despite this film being inspired by one of America's most oppositional historical figures, Lee presents X's life as a mythic tale of individual achievement. This was an "up from the gutter" iconization of X that made it possible for even staunch conservatives like Clarence Thomas to co-opt X's legacy for his own purposes (Williams, 1992). Lee followed up this biographical film with a partially autobiographical story, Crooklyn (1994). Crooklyn was co-written

by Lee and two of his siblings, Joie and Cinque, as a fictionalized portrayal of their childhood. As with *Mo' Better Blues*, there is little overt political content in this film, despite its attempt to portray the highly politicized eras of the late 1960s and early 1970s. Instead *Crooklyn* offers viewers an idealized version of domestic, middle class life that further reinforces the patriarchal ideologies of Lee's earlier films.

Lee's next film, *Clockers* (1995), is a particularly interesting example of the ideological trajectory of Lee's films. With few exceptions, Lee had previously avoided making films that focused on the most negative aspects of urban American life such as drug-dealing and gang-related violence. He had also expressed disdain for movies of the Blaxploitation era that focused on just such elements (Lee, cited in Patterson, 1992). But during the post-*Malcolm X* phase of his career, the profits generated by Lee's films had, for the first time, begun to decline. While each film up to this point had brought in progressively larger sums at the box-office, *Crooklyn* (1994) only grossed $13.6 million after *Malcolm X* (1992) had grossed $48 million (Croal, 1996). While Lee himself continued to prosper financially and actually diversified his influence on American media culture by increasing his involvement in the marketing and advertising industries, his position as a revenue generator for Hollywood began to suffer. Meanwhile, other black filmmakers, Mario Van Peebles and John Singleton, produced the top-grossing films *New Jack City* (1991) and *Boyz n the Hood* (1991), which earned over $47 and $57 million, respectively. Other films by black directors that came out within a year of *Crooklyn*, such as the Hughes Brothers' *Menace II Society* (1993) and Singleton's *Higher Learning* (1995) earned almost $30 million each. Even Lee's former protégé, Ernest Dickerson, created a film, *Juice* (1992), that earned more than contemporary Lee films (Giles and Miller, 1993; Guerrero, 1993; Rhines, 1996).

Perhaps in response to these numbers, Lee seemed to retreat from some of his earlier positions by adapting a Richard Price novel, about the violent lives of young black drug dealers, into the film *Clockers* (1995). Whereas earlier Lee films had often reversed traditional Hollywood representations of blacks and whites, this film is at times striking in its resemblance to Hollywood racial codes. Most of the black youth are criminals, liars, drug-dealers, and murderers. While one black police officer is a strong, moral character, he plays an auxiliary role, and the most heroic character in the film ends up being a white detective, Rocco, who adopts a paternalistic concern for the black kids in the housing projects. Rocco is a prototypical Hollywood icon, the seasoned cop who is crusty on the outside but has a "heart of gold." Rocco's benevolence

stands in stark contrast to the exploitative, and eventually murderous, attention paid to the film's drug dealing protagonist, Strike, by an older black hoodlum. In this film, then, the filmmaker who had once railed about the paternalism of films like Mississippi Burning (1988) that depicted blacks as dependent on the graciousness of white heroes to rescue them (Patterson, 1992) recreates just such a pattern in the images and narrative of his own film.

Clockers also recreates a mythic American dream through its representation of Strike's only non-criminal interest—a love of trains. In images that are evocative of the Western genre, the final scenes of the film depict a sun-bathed Strike, drinking in the scenery, smiling as he rides a train across America's fruited plains, seemingly content after being liberated from the ghetto by Rocco's benevolence. Left unanswered is what will become of Strike, a young black man, uneducated, with a criminal past, and a severe stomach illness that he has been fighting throughout the film. Where is this train that he loves so much bringing him? What utopian prospects are we supposed to believe await poor black men in America?

However, it is important to note that despite its traditionalist moments, Clockers did differ from the "hood" films that preceded it (Boyz n the Hood (1991), New Jack City (1991), Menace II Society (1993), to name just a few), in its refusal to romanticize the gangster drug dealing lifestyle, its avoidance of a purely dystopian vision of urban America, and Lee's conscious decision to not use violence as an entertaining spectacle (Harris, 2008; Massood, 2009). Lee said at the time: "This movie is the exact opposite of the big-budget action films you see, which are full of cartoony killings. We weren't going to treat life cheaply in Clockers, because when you take a life it's forever. There are too many kids being killed on the streets of this country, and it's no joke to me" (quoted in Pizzello, 2002, p. 100).

From the very opening of the film, Lee does not shy away from depicting the awful consequences of gun violence, without the glorification or celebratory tone of most Hollywood "hood" films. As the opening credits roll, Lee juxtaposes smooth soul jazz with horrible close-ups of slain young black people, bloody bullet holes disfiguring their corpses. Scott argues that unlike Clockers, previous hood films recreated rather than deconstructed black stereotypes:

> [T]he conformity of the craft and aesthetic paradigm of the early hood films to those made by the industry limits their effectiveness in critiquing Hollywood images of African Americans and in creating "thoughtful" cinema. These films corroborate Hollywood's villainization of "some black men" by demonizing and villainizing certain hood residents on the sound and image tracks (2009, p. 229).

Scott (2009) argues that Lee's film avoids the action film trap and its related stereotypes and instead presents a multifaceted and emotional story that operates as a critique of both the U.S. war on drugs and the hood genre itself. Lee in fact said "It was always our intention that if we succeeded with this film, that this might be the final nail in the coffin and African American filmmakers would try telling new stories" (quoted in Massood, 2009, p. 172). Perhaps because of its differences from other films about drug-dealing black youth, which tended to fit more comfortably into the gangsta/action genre, *Clockers* only grossed $13 million dollars after having cost $25 million, continuing the trend of decreasing receipts for Lee's films but also reflective of a general mid-1990s sag in movie attendance as new forms of media began to vie for audience's discretionary expenditures.

Lee's next films, *Get on the Bus* (1996) and *Girl 6* (1996), both written by others but still clearly marked by Lee's vision, also failed to regenerate substantial audience interest in Spike Lee's films as Hollywood studios increasingly concentrated on developing action-oriented, blockbuster pictures featuring big-name stars or expensive special effects (Watkins, 2008)

By the time of *Girl 6*, Lee seemed somewhat desperate to recover the mystique that he seemed to have lost—opening and closing this film with scenes of an auditioning actress delivering Nola's opening monologue in *She's Gotta Have It*. This film does try to offer a critique of the sexist exploitation of women in two multi-billion dollar media industries—pornography and mainstream cinema. But despite being written by a black woman, Suzan Lori-Parks, *Girl 6* simultaneously and ironically continues the ugly pattern established by earlier Lee films such as *She's Gotta Have It* (1986), *School Daze* (1988), and *Jungle Fever* (1991) of punishing and humiliating women who act on their sexual desires.

Hoffman (2011), for example, points out many similarities between the characters of Girl 6 and Nola Darling:

> Like Nola, Girl 6 does not seem to possess sexual fantasies of her own, other than in a derivative sense: she wants to be wanted...It is not clear that she desires meaningful personal relationships with other women, however...Like Nola, Girl 6 seems to be somewhat alienated from other women and lacks close female friends....As in *She's Gotta Have It*, *Girl 6* seems to suggest that women who are too sexually active or attractive will be punished by at least the threat of physical violence (2011, pp. 114–115).

Thus, while Lee may have intended for this film to critique sexism in the movie industry, he ends up objectifying his protagonist in much the same manner

as many other women have been objectified in his films. As Sterrit points out, when the protagonist shows up for an audition: "Judy is objectified, demeaned, and humiliated by the director's demand to see her breasts and Lee shows his sympathy for the mortified actress by—showing her breasts!" (2013, p. 137). Thus, in the decade that had passed between *She's Gotta Have It* and *Girl 6*, despite his maturation as a filmmaker, Lee's representations of women, sex, and sexual politics remained somewhat static.

Unlike *Girl 6*, Lee's other 1996 film, *Get on the Bus*, written by Reggie Rock Bythewood, was well received by critics and its focus on male characters at least was consistent with the topic of a group of black men traveling to the 1995 Million Man March in Washington, D.C. *Get on the Bus* also returned Lee to the realm of telling compelling stories of the diversity found in black America that was a signature of his first decade of filmmaking. Beckles-Raymond argues:

> Thus, although the film's premise is a journey to the Million Man March, it becomes clear that any generalizations about a homogenous black community would be overly simplistic and inaccurate and should be guarded against. Being black is seemingly the only the only thing the riders have in common, and as their differences illustrate, this identity is not sufficient to engender a collective or unified social perspective or political agenda (2011, p. 43).

Despite this, Beckles-Raymond admits that the men all share a sense of racial identity, and I would contend that by the end of the film Lee and his screenwriter do allow the men to develop a close bond, partially because of their shared experiences during the bus ride, but also because of their shared experiences as black men trying to survive in white America. *Get on the Bus*, then, includes some of the contradictions and ambiguities that make Lee's best films so compelling. Critics generally responded well to this quiet and engaging film but general audiences, perhaps mistaking it for a documentary on the Million Man March, did not seem particularly interested.

Lee's next film, *He Got Game* (1998), starring Denzel Washington as Jake Shuttlesworth, an imprisoned father who accidentally murdered his wife during an argument, represented a box-office revival, becoming Lee's first film since *Malcolm X* (1992) to open in first place. Well received by critics, *He Got Game* was also was the first film since *Jungle Fever* (1991) where Lee was credited as the sole screenwriter. While Lee tells an emotional tale of alienated fathers and sons, the plot revolves around an unlikely scenario. Jake's son Jesus is the number one high school basketball prospect in the country.

Jake is given a temporary release from prison because the governor wants him to convince Jesus to commit to playing for the ridiculously named Big State University. Some observers believe *He Got Game* offered a sharp critique of big time college athletics and the commodification and exploitation of young athletes (Holt and Pitter, 2011).

During the opening credits Lee shows us beautiful images of ball players from around the U.S.; black and white, male and female, urban and rural. Lee presents the world of basketball as gorgeous, expansive, and multicultural. But the film soon makes it clear that, particularly for young black men, the notion of basketball as a pathway to fame and fortune is one that is fraught with danger as Lee's protagonist, Jesus Shuttlesworth (portrayed by NBA player Ray Allen) is forced to navigate his way through an obstacle course of exploitative and untrustworthy friends, family members, agents, and coaches, all aiming to benefit from his talent and skills.

However, the gender politics of *He Got Game* are regressive, as the film also continues Lee's frequent disparagement of female characters, particularly Jesus's girlfriend, Lala, who is cheating on him and luring him into illegal dealings with a predatory sports agent. Some of the female characters in *He Got Game* are depicted sympathetically, including Jesus's spunky little sister, supportive aunt, and deceased mother. A prostitute that Jesus's father, Jake, gets involved with, is also a character that the audience can feel empathy toward as she is drawn as a cynical but good person, albeit one who is a passive victim of an abusive pimp. However, despite these portrayals, the film takes a generally suspicious tone toward women, embodied by Jake's words of advice to Jesus: "Many a great man, son, their downfall was because of a woman." Jake's warning is prescient as Lala betrays Jesus for promises of financial rewards. Lee also includes many scenes of sexually promiscuous young women throwing themselves at Jesus to seduce him into committing to their school. These women are used as props in the film, to signify the temptations that Jesus must avoid (the biblical allusions are clear here), but also the untrustworthy nature of sexually assertive women.

He Got Game also privileges hypermasculine representations of men engaged in macho contests of domination. We see Jake humiliating and feminizing Jesus, throwing a basketball at his face, calling him "little bitch," and otherwise terrorizing him in his drive to make Jesus a great basketball player while also fighting his own personal demons. This all could be read as a criticism of hypermasculine posturing in sports, and between fathers and sons, but instead any potential critique is mitigated both by the sympathetic portrayal of

Jake and by the outcome of this treatment: Jesus becomes the best high school ball player in the nation even though he despises his father (Gabbard, 2008).

Lee's last film of the 20th century, *Summer of Sam* (1999), continued this trend of representing hypermasculine worlds where women exist only on the margins. But *Summer of Sam* is more able to offer a critique of hypermasculinity through its representations of thuggish men whose violence is actually motivated by fear. *Summer of Sam* also represented another major change for Lee, being his first film with a primarily white cast. Despite this, Flory (2008) argues that *Summer of Sam* was still a film about race and racial conflict in its metaphorical representations of lynching motivated by fear of the Other.

Fear is at the heart of *Summer of Sam*, which is set in New York during 1977 when serial killer David Berkowitz was terrorizing the city with a series of murderous attacks and bizarre letters left behind at the crime scenes. Lee's film focuses on an Italian American neighborhood and the manner in which fear is transformed into hatred and violence directed at one of their own neighbors, Richie, who is perceived as different and strange because of the punk clothing styles he adopted after being away from the neighborhood. When Richie comes back to the neighborhood wearing a Union Jack t-shirt and a Mohawk hairstyle, members of his old gang call him a freak and tell him "You're not that welcome around here." As fear spreads throughout the city they become increasingly hostile and suspicious of anyone who seems different.

Lee depicts neighborhoods that are transformed by escalating terror as the police seem unable to stop the killings. During the famous 1977 New York blackout, the fear that has been gripping the city turns into unbridled chaos, and Lee juxtaposes scenes of black and Latino looters smashing windows and robbing stores with images of Italian American vigilante gangs roaming the streets with baseball bats, targeting anyone who is different, anyone who is Other. When Richie's best friend Vinny is reluctant to join their hunt, the gang draws a clear demarcation between Us and Them: "There are people getting killed in OUR neighborhood. Are you with us or not?"

Throughout the film Lee repeatedly alludes to his core theme of fear of difference while evoking iconic aspects of New York in the late 1970s. In one scene he contrasts a line of punks waiting in line to get into CBGB with a line of disco glamsters trying to get into Studio 54. Echoing scenes of the Corner Men and the police in *Do the Right Thing* (1989), both groups have nothing but contempt for one another. Just as in *Do the Right Thing*, this contempt plays out across both sides of the cultural divide through the visual gaze. One

of the punks sees Vinny's wife, Dionna, staring at her and says "Look at her looking at me like I'm a freak."

Richie's alienation from his old friends also plays out visually. Vinny tells Richie "Normal people don't dress the way you do," and says "I don't know you Richie, I don't know who you are." This lack of reliable and comforting normality, as defined visually by the neighborhood, makes anyone who doesn't look "right" an automatic suspect.

Flory argues that a surface reading of *Summer of Sam* would suggest the film is not about race:

> However, Lee introduces the element of race into the film by thematizing this suspicion of difference through noir narrative, thereby transforming this Bronx tale into a parable for racial lynching. With scenes of white neighborhood gangs roving the streets with baseball bats looking to beat up anyone who might not "belong" there and individuals who look different being refused service at diners while police officials collude with vigilantism and mob hysteria, the allusions to the history of Black lynchings are striking (2008, p. 203).

Flory's interpretation is, of course, not accepted by all. Palmer, for example, argued "it is hard to imagine that if the never-reticent Lee were eager to make a film about lynching he would never have chosen to approach it in such an oblique and indirect fashion that soft-pedals its horrific, shameful nature" (2011, p. 63). Yet there is actually very little soft-pedaling in the climax of *Summer of Sam*. Lee brilliantly juxtaposes scenes of Berkowitz being captured by the police, crowds of angry New Yorkers raging at him as he is taken into custody, and Vinny's gang brutally assaulting Richie. The real killer is off the streets but the violence continues. Lee seems to be demanding that we ask ourselves who are the most dangerous monsters. Whom should we fear the most: deviant, rare, serial killers, or our old friends and neighbors, who want everyone to be just like themselves? It's hard to deny the analogies to racial fears and violence in *Summer of Sam*.

Lee's next film left absolutely no doubt that the focus was explicitly about race. *Bamboozled* (2000) does not rely on parable or metaphor to make its concerns with racism (in this case in the television industry) clear. Even the title refers back to a quote from Lee's *Malcolm X* (1992). In Lee's earlier film X addresses a black audience about problems in the black community: "You been had, you been took, you been hoodwinked, bamboozled, led astray, run amok..." Sterritt argues that *Bamboozled* "sets forth more pungent themes and takes more cinematic risks than almost any other movie of its day" (2013, p. 158).

Bamboozled is the satirical story of the sole black executive at a fictional television network who is told by his black-culture-loving yet racist white boss, Dunwitty, that the network needs to exploit the black audience more effectively by harkening back to the days of Amos 'n' Andy. Hoping to be fired, and thus released from his contract, Delacroix attempts to subvert the industry and expose his network's racism by creating a contemporary black minstrel program, hoping it will be so offensive it will fail. Instead, it becomes a huge hit and Delacroix finds himself defending it. Through this plot, and a mise-en-scene crowded with artifacts of disgustingly racist paraphernalia from the past, Lee forces the audience to confront the racism of American media and popular culture. The film was so forthright in its representations of degrading imagery of blacks, and in its indictment of both whites and blacks in perpetuating this degradation, that many critics and audience members seemed unable to cope with it (Nyong'o, 2008, Smith-Shomade, 2008). The New York Times even refused to run ads for the film that included a stereotypical image of a "sambo"-like cartoon figure holding a large slice of watermelon (DeLue, 2009).

In addition to utilizing racist iconography of the past, Bamboozled also viscerally demonstrates the ultimate consequences of racism—destruction and death. The film ends with a spate of violent murders, but as Thomas notes, "The white puppeteers are left alone, tellingly. Lee can kill no white characters at the hands of Black folk, evidently, and get his film made in Hollywood" (quoted in Smith-Shomade, 2008, p. 239). Bamboozled also continues Lee's ongoing ridicule and dismissal of radical black social movements in its degrading depiction of the "Mau Maus," a group of poorly informed, violent, so-called "revolutionaries," who all end up murdered by the police... except for their one white member. Leonard differs from Smith-Shomade in his interpretation of the survival of the one white Mau Mau:

> Angered by the decision of the police to spare his life, he screams, "Kill me...why don't you kill me. I'm black." In this instance, Lee poignantly illustrates how minstrelsy in all its forms reflects a process where whites accept or endure everything but the burden of blackness. The failure of the police to shoot him (which is based on a real incident in Riverside, California, where the police shot several members of a gang, all who were youth of color, sparing the one white participant) not only reveals the privilege of whiteness but the absurdity of the notion that he or Dunwitty or Isaac could be black irrespective of knowledge of black history, African art, or understanding of hip-hop (2006, p. 174).

Smith-Shomade and Leonard's conflicting interpretations are indicative of the complex nature of this film. As DeLue (2009) points out, Bamboozled is

challenging and thorny, blatantly self-reflexive in its attempt to grapple with the consequences of racist imagery and representation. DeLue, in discussing the film's aesthetics, notes: "the world of *Bamboozled* is askew, seen from above and below or from around the corner, under the table, or way, way, way down the hall. Such skewing, in that it draws attention to the manner in which a lens frames and constructs a scene, makes the viewer palpably aware of the camera's presence and, by extension, its looking" (2009, p. 69).

Bamboozled is thus a meta-representation, a cinematic representation about representation itself (Chidester and Bell, 2009). Like mirrors that are arranged facing one another, when we look into it we see both ourselves (our own racism), and its own images of race reflected back and forth endlessly. Even as we laugh at its absurdities the images of the New Millennium Minstrel Show "push audience members to reflect on why they would laugh at such racist humor, which violates beliefs about equality and justice that most of them would otherwise explicitly hold" (Flory, 2011, p. 173). Perhaps, then, the sharpest of *Bamboozled*'s barbs (and the discomfort they caused), are aimed not at overt racists but at liberal viewers who somehow thought themselves above it all.

Lee himself has noted about *Bamboozled*:

> I want people to think about the power of images, not just in terms of race, but how imagery is used and what sort of social impact it has—how it influences how we talk, how we think, how we view one another. In particular, I want them to see how films and television have historically, from the birth of both mediums, produced and perpetuated distorted images. Film and television started out that way, and here we are, at the dawn of a new century, and a lot of that madness is still with us (Lee, quoted in Crowdus and Georgakas, 2002, p. 217).

In many ways, *Bamboozled* was Lee's most ambitious confrontation of race, one that deliberately left viewers discomfited and almost bewildered in attempting to resolve their own reactions to the film. Chidester and Bell (2009) argue that both audiences and professional film critics seemed stymied by the explicitly racist imagery that the film simultaneously critiques and displays. As Keeling noted:

> *Bamboozled* recycles offensive imagery in ways that collapse the historical distance between the images in widespread circulation today and those images from the past that we claim to abhor. In so doing, it creates an uncomfortable position for its spectators, not unlike the one Frantz Fanon described as a black spectator of Hollywood films in the 1940s...(2009, p. 197).

Critics generally derided *Bamboozled* as a failed attempt at confronting issues of race and representation, but Chidester and Bell conclude, approvingly, that *Bamboozled* was the "first true postmodern satire" and note that this "speaks for Lee's power as not only a successful filmmaker but as a skilled scholar of contemporary rhetoric as well" (2009, p. 206). In the end, *Bamboozled* must be considered one of Lee's most politically provocative films as it refuses to let anyone, regardless of race or political ideology, off the hook for the continued power of racist imagery. *Bamboozled* thus seemed to set the stage for Lee's transition into the 21st century, suggesting a renewed emphasis on challenging themes of race and inequality. But, if nothing else, Lee has always been unpredictable, and the next decade found him pursuing numerous and disparate directions.

After taking on issues of race, representation, and racist iconography in such a complicated and controversial manner in *Bamboozled*, Lee's next film, while still telling a compelling story, offered a much more traditional narrative and did not focus on issues of racism, at least not as its driving force. *25th Hour* (2002), distributed by Disney, tells the story of a white drug dealer, Monty Brogan, who is about to be sent to prison for seven years. As the film opens he has one last day until he must show up at an upstate prison to be processed and incarcerated. The film follows Monty and his friends through his last hours of freedom and ends on an ambiguous note—while Lee suggests that Monty turns himself in, we cannot be entirely sure that he does not flee, as his father implores him to do.

Written by the novelist David Benioff (based on his 2000 novel of the same name), as envisioned by Lee *25th Hour* is set in a post-9/11 New York, and the fear and despair of the days just after this event hang over the film both aesthetically and narratively. Monty's stockbroker friend, Frank, lives in an apartment overlooking Ground Zero and in one scene, when Monty's fate is being discussed, we look through the window as the camera moves across the gaping hole in the ground. Mournful music swells as Frank says Monty's life is over and he will never return to normal. The allusion to America after 9/11 is clear.

Although Lee has at times been criticized for avoiding representations of the problem of drugs in urban communities in some of his films, *25th Hour*, in some ways even more clearly than *Clockers* (1995), does take on the abuses of the so-called "War on Drugs." Conard (2011) notes that in *25th Hour* Lee clearly expresses a belief that contemporary drug laws are too severe and that drug enforcement agencies are often corrupt. New York's harsh Rockefeller

laws, mandating severe sentences for drug crimes, are explicitly mentioned in the film. Yet, I would argue that by focusing on a white protagonist who is being sent to prison, the film glosses over the very real targeting of black communities by institutions of the drug war.[16]

While race relations is not a central theme of *25th Hour*, one nod toward Lee's previous films that does explicitly dealt with racism occurs when Monty faces himself in a mirror and begins ranting about all of those who he believes have wronged him, including Asians, Middle Easterners, Jews, Latinos, Italians, and blacks. As Sterritt (2013) points out, this sequence invokes the moment in *Do the Right Thing* (1989) when a series of characters spew racist invectives directly at the screen. Sterritt believes this scene in *25th Hour* is cinematically superior and he offers a compelling description and analysis:

> Monty is not inveighing against abstract caricatures, moreover; his stream-of-consciousness tirade boils with overwhelming rage against very real people, from Osama bin Laden and his terrorist ilk to "nigger" gangs, "towel-head" taxi drivers, and all of the Others who populate a city that was filled not long ago with white immigrants like his father, like his friends, like himself. Seen from behind as his body slumps into a stooped posture reflecting his humiliation, Monty excoriates them all in the strongest imaginable terms before admitting that his guilt stems from his own actions and that his fate rests on his own shoulders. The proper curse, he realizes, is not *fuck you* but *fuck me*. The scene is vastly more powerful than its quasi-counterpoint in *Do the Right Thing* owing to the excellence of its execution and to Lee's characteristic boldness in unmasking the prejudices embedded in American culture, in world history, and (one suspects the filmmaker is acknowledging) in himself (2013, p. 175).

Another interpretation of this scene is that it reveals the responsibility of whites in perpetuating racism against all of the myriad people of color who they believe pose a threat to them. After raving about black and brown-skinned people, Monty finally has to admit that he is the real problem. A more conservative reading, however, might suggest that the monologue is really about taking sole personal responsibility for one's actions—a perspective that ignores the structural and institutional foundation of issues such as drug dealing and addiction that have resulted in Monty's impending imprisonment.

Regrettably, *25th Hour* also continues Lee's neglect of female characters. Women play a marginal role in the male-dominated world of *25th Hour*. The only people that Monty fully trusts are men—his father and his two best friends. His girlfriend stays by his side even when he wrongly suspects that she was the one who turned him in, but Naturelle is a thoroughly passive

character, waiting for Monty to come home, wearing what he tells her to wear, being quiet when Monty tells her to be, significant only for her beauty and her loyalty. For his part, Monty seems more concerned about losing his connection to his father, his male friends, and even his dog, than he is about leaving his devoted girlfriend.

The only other female character with more than a line or two of dialogue is a sassy high school girl who flirts shamelessly with her teacher, Monty's friend Jacob. Mary wears provocative clothing, showing off a large tattoo on her bare midriff, as she tries to get Jacob to give her a better grade in his class. Mary's only significance to the film is as a symbol of the ways that men are tempted to commit unethical acts. After Jacob kisses Mary she has fulfilled her purpose, and she disappears from the screen and the narrative world of the film entirely.

Despite its conservative gender politics and overly simplistic stance on personal responsibility, 25th Hour is a masterfully told story that was generally well regarded by critics—a New York magazine feature ranked it as his third best film after Do the Right Thing and Malcolm X (Leitch and Grierson, 2012). However, 25th Hour made less money than it cost (13 million dollars versus 15 million), continuing Lee's box-office decline of the late 1990s and early 2000s.

Lee's very next film, She Hate Me (2004), was both a critical and box-office failure. New York magazine ranked it as the worst of all Lee's feature films, accusing it of being "nothing but half-formulated provocative notions that refuse to congeal" and calling it "misogynistic and shrill" (Leitch and Grierson, 2012). She Hate Me, co-written by Lee and Michael Genet, is about a pharmaceutical executive, Jack Armstrong, who turns whistleblower when he discovers that his company, Progeia, is falsifying data in order to rush a bogus AIDS vaccine onto the market.

When Jack phones an ethics commission to report what he knows, he is fired and finds that his bank accounts have all been frozen. Just as he is becoming desperate for money his ex-fiancée, Fatima, approaches him with a stack of cash. Fatima and Jack broke up when he caught her with another woman. Now she wants him to impregnate both her and her lover for 5,000 each. Jack initially balks, but in his desperation, and still in love with Fatima, he gives in. While Fatima's partner wants artificial insemination, Fatima insists on having sex with Jack, a steamy scene involving lingerie and passionate, aggressive, intercourse. Jack is soon having sex with over a dozen lesbian women as Fatima sets herself up as his manager/pimp for ten percent of the proceeds.

She Hate Me had the potential to be a funny and biting critique of the corrupt practices of big business and corporate capitalism. The film opens with extreme close-ups of money, rippling and undulating under an orchestral jazz score reminiscent of the music in *Do the Right Thing* (1989). The last note to appear on the screen features George W. Bush on a three-dollar bill. The colloquial phrase "queer as a three dollar bill" is clearly intended here, and this one image encapsulates the failure of this movie; a satire about corporate corruption strangely laced with homophobia and heterosexual male fantasies.

She Hate Me jams two narratives together, one intensely serious and dramatic, one absurdly comic, leaving audiences with a messy, unfocused film. One film, the story of Jack turning whistleblower, is indeed a critique of moneyed elites like the Bush family, who run America from corporate boardrooms and the halls of governmental power. The CEO of Progeia, Leland Powell, is a racist, corrupt, deceitful thief who shifts into smooth public relations doublespeak whenever necessary. During a meeting after news of the crisis has gotten out, one employee invokes real world corporate corruption when he shouts "Is fucking Enron or Worldcom hiring?"

Jack's father compares him to Frank Wills, the real security guard who revealed the break-in at the Watergate Hotel in 1972 and died in poverty at the age of 52. Toward the end of the film we see Jack testifying before a U.S. Senate committee. He offers impassioned testimony about the need for an AIDS vaccine and a sharp criticism of the greediness and corruption of the pharmaceutical industry. Lee, through Jack, offers a tribute to whistleblowers and a brief history of the Watergate scandal including a flashback to the break-in and a roll call of the conspirators, and how they prospered in subsequent years, while Wills fell into poverty and despair.

The other storyline in *She Hate Me* is more problematic as the film borrows heavily from pornographic tropes, including those that eroticize "girl on girl action" while keeping male desire and the male gaze dominant. Absurdly, almost all of the women get pregnant immediately, as Jack is depicted as a sexual superman, having vigorous intercourse with five women a night for several nights in a row. His sperm, emblazoned with his face, is even shown in animated clips, heroically swimming toward the women's eggs as valiant music plays. When the cartoon sperm meets the cartoon eggs the women's faces burst into sunshine and smiles, as the women themselves finally achieve fulfillment because of a potent man.

Even though the women Jack impregnates are lesbians, they are all turned on by his muscled body and large penis, and they enthusiastically participate

in sexual intercourse with him, suggesting that all lesbian women secretly crave powerful men. During one particularly low moment of the film, a group of five large, tough, aggressive women, a basketball team, show up at Jack's apartment and bully him into sex. Lee manages to simultaneously reinforce stereotypes of the hypermasculine dyke while also depicting them as loving heterosexual sex.

She Hate Me does, however, attempt to critique sexism and homophobia in places. As Jack strips for a group of women he tries to hide his penis behind his hands as they utter crude comments and he looks humiliated. One of the women says "Now you know what it feels like to be a sexual object." During a conversation about why she left him for another woman, Jack lets loose on Fatima with a series of degrading comments, but Fatima responds assertively, calling him out on his "ignorant homophobia" even as she apologizes to him for cheating. The film also directly acknowledges the difficulty that same sex couples face when trying to adopt, using this as an explanation for why so many lesbian women want Jack to impregnate them. Although, Lee is never able to explain why they insist on having passionate sex with Jack instead of simply purchasing his sperm. And the end of the film offers a scenario that could have come straight from hetero-pornography. Jack ends up with both his ex-fiancée and her female partner. We see the two gorgeous women passionately kissing each other and then each kissing Jack.

Clearly, *She Hate Me* is an ambitious film, attempting to deal with issues of corporate greed and malfeasance and institutional racism in addition to sexual politics, but most critics, both popular and academic, felt that this resulted in an unfocused, sloppy, and naïve mess (Cobb and Jackson, 2009). Although contrary to this Leonard suggests:

> *She Hate Me* successfully links together its multiple narratives through its understanding of race. It convincingly challenges widespread celebrations of the American Dream and those who claim racial transcendence for the black elite, demonstrating the powerful ways race—as detriment, as source of community, and as a basis of cultural identity—continues to operate within contemporary contexts (2006, p. 196).

But Leonard also believes that the film's recreation of the tropes of pornography and heterosexual male fantasies and its ultimate glorification of patriarchal nuclear families "undermines the oppositional potential of the film" (2006, p. 197). Audiences virtually ignored *She Hate Me* as it would earn less than $400,000, compared to other black-oriented comedies of the day like

Soul Plane (2004—$14 million), Barbershop (2002—$75 million), and Bringing Down the House (2003—$133.5 million) (Leonard, 2006).

Surprisingly then, despite the box office and critical disappointments that plagued Lee during the first years of the 21st century, Lee was awarded his biggest budget since Malcolm X in 1992 ($45 million) to direct an action thriller, Inside Man (2006), which went on to become Lee's highest-grossing film ($176 million) (Colapinto, 2008; Tait, 2009). Cobb and Jackson (2009) point out that Inside Man made more money from domestic ticket sales than Do the Right Thing (1989), Malcolm X (1992), Bamboozled (2000), and She Hate Me (2004) combined. Despite the box-office success of this film, it's important to note that Lee's name was buried in the marketing. Instead, the studio emphasized the action aspects of this film about a bank robbery, and the involvement of star actors Denzel Washington, Clive Owen, and Jodie Foster. Gerstner sees this as part of larger trend in contemporary Hollywood, one that he calls the "de-auteuring" of certain filmmakers:

> "[A]uteurs" associated with urban subject matter, over-intellectualized or contemplative narrative style, personal scandal, or political interests viewed as discomfiting to "mainstream audiences" are among those de-auteured (2008, p. 244).

Massood, however, believes that this marketing decision was also about Lee specifically: "Lee has been marked as a difficult filmmaker—he's political, didactic, and controversial—so much so that he was "erased" from the film's marketing campaign, which focused on its stars rather than its director" (Massood, 2008, p. xxv).

Yet, in many ways Inside Man is very much a Lee film, and several film scholars have argued that it is a mistake to write it off as "just" an action film (see Gerstner, 2008; Harrison-Kahan, 2010; Kellner, 2010; Tait, 2009). Tait argues: "While the film could be seen as a success based on what seems to be Lee's abandonment of racial politics in order to cater to a larger, more mainstream audience, it is my assertion that the film is nevertheless as politically charged as any in Lee's oeuvre, if not more so" (2009, p. 41). Tait believes that Inside Man actually represented Lee's most successful political statement precisely because of the manner in which political themes are encoded within the generic form of a bank heist action film. He argues that all heist films are really about struggles between "haves and have-nots" and that Lee in particular frames his film as an allegory about class conflict, the role that institutional power plays in reinforcing inequities, and the ways that this power can be subverted.

For *Inside Man*, Lee used a script by a Hollywood writer, Russell Gewirtz, and, reflecting a relatively large budget, the movie has a slicker look and higher production values than many of Lee's earlier films. *Inside Man* focuses on a bank robbery masterfully engineered by Dalton Russell (Clive Owen), the efforts of New York City Detective Keith Frazier (Denzel Washington) to apprehend the thieves while saving a group of hostages, and the interference of Madeline White (Jodie Foster) a high-priced "fixer" whose specialty is covering up the corrupt practices of wealthy and powerful elites. The social and political aspects of this film are subtle and implied rather than front and center as they were in most of Lee's earlier films.

Inside Man repeatedly displays Lee's awareness of the globalized, post-9/11, nature of daily life in a twenty-first century metropolis. From its opening moments, when a Bollywood song (Chaiyya Chaiyya) underscores scenes of bustling Manhattan, the film embraces multiculturalism. As we move into the interior of the bank that will soon fall into chaos, we see the multiethnic panoply of people that many filmmakers and television producers still ignore when depicting New York. The customers and bank employees alike embody the notion of the multicultural rainbow, including blacks, orthodox Jews, Latinas, Asians, and whites.

Similar to 25^{th} *Hour* (2002), as the action plays out viewers are frequently reminded that 9/11 continues to cast a shadow over life in New York. We see posters of the twin towers emblazoned with the words "We Will Never Forget." The robbers are mistaken as terrorists and the police, clad in riot gear, operate as a paramilitary force as the area around the bank is cordoned off. When a Sikh bank employee is accosted by the police they see his turban and beard and scream "Arab!" Vikram cries out, "I'm a Sikh! Why can't I go anywhere without being harassed?"

In *Inside Man*, as in post-9/11 America, everyone is a suspect. Russell has cleverly forced the hostages to don the same black jumpsuits and white masks as the robbers, so when they are released the police cannot tell who is who. The victims are treated as perpetrators, subjected to intense interrogations and psychological gaming by the police.

Yet, despite these touches the film is limited in its ability to critique contemporary politics and corporate malfeasance. Russell's real target is a stash of diamonds stolen from German Jews during the Holocaust by the bank's owner, the corrupt Arthur Case. Case indeed represents the banality of evil, a seemingly benign businessman who amassed his fortune by cooperating with the Nazis and betraying friends. Some critics and academics praised *Inside Man* for

revealing the corruption of powerful elite institutions, but the corruption here is completely individualized. Yes, Case is corrupt, and the mayor of New York also appears as a character holding dark secrets that he desperately needs to hide, but the problem is simply these individual men, not the structures they represent. Soon after *Inside Man* was released the collapse of the U.S. economy would reveal how truly corrupt the world banking system is, but in *Inside Man* corporate abuses of power are safely set in the past and attributed merely to a bad individual. At one point Case is said to be "no different than half the Fortune 500," but this is a throwaway line that is never justified or explored in the film. Unlike Lee's earlier films, the police in *Inside Man* for the most part do not represent the face of an oppressive institutional force. Behind the riot gear, the cops we meet are the good guys: smart, cool, funny, depicted mostly with great sympathy even when they are roughing up hostages and subjecting them to harsh questioning.

Despite the limitations of its political critique, *Inside Man* is a smart and compelling film that was embraced by audiences and critics alike. 2006 thus demonstrated Lee's command of an incredibly wide range of cinematic genres from the "intelligent action" film *Inside Man* to the Emmy and Peabody award-winning cable television documentary about Hurricane Katrina, *When the Levees Broke* (2006). Campbell and LeDuff point out that much of the news media coverage of Katrina and its aftermath turned out to be inaccurate and misleading, "filled with coded representations of African Americans consistent with the reprehensible images of another era" (2012, p. 200). Contrasting news coverage with Lee's film, they argue *When the Levees Broke* offered a crucial corrective to the media narrative that focused on mythical tales of rampant black criminality while neglecting to provide any historical context about race and class inequities in New Orleans. Most critics agreed that Lee had done something remarkable with this film, citing it as one of his most moving and masterful accomplishments. *New York* magazine ranked it as Lee's fourth best film while noting: "Of all the news stories and human interest tales to come out of the tragedy of Katrina, only Lee's four-hour HBO documentary comes the closest to capturing all the details, from the large and frivolous (Kanye West explaining his 'George Bush doesn't care about black people' comment) to the small and horrifying." (Leitch and Grierson, 2012).

In 2010 HBO aired Lee's follow-up documentary, *If God Is Willing and da Creek Don't Rise*, which was equally ambitious and challenging, taking on both the slow and uneven recovery of New Orleans and the devastation

wrought by the 2010 BP Deepwater Horizon catastrophic explosion and oil spill. Both films were marked by Lee's brilliant use of multiple voices and perspectives to communicate the complexity of these disasters, while simultaneously focusing on environmental racism, class-based inequities, governmental neglect, and corporate profiteering and malfeasance, making this combined eight hours some of the most politically provocative filmmaking of his career.

In between the two Katrina documentaries Lee released a World War II film that did not impress critics in the same way. *Miracle at St. Anna* (2008) opens in 1983 in a Harlem apartment where a dark-skinned Puerto Rican man, Hector Negron, is watching a John Wayne film about D-Day (*The Longest Day*, 1962). As he sits looking at the all-white cast, he mutters, "We fought for this country too." This opening suggests that *Miracle at St. Anna* will be a provocative film, challenging Hollywood's long-standing erasure of the role that black soldiers played in World War II. This was in fact Lee's stated intent. Criticizing two Clint Eastwood films that had come out two years before *Miracle at St. Anna* (*Flags of Our Fathers*, and *Letters from Iwo Jima*, both in 2006), Lee said: "This is the same shit they were doing back in the forties, fifties, and sixties....Really, until Jim Brown was in *The Dirty Dozen*, in 1967. *Home of the Brave* was a great film with a great African American character in it. But if you look at the history of World War Two films we're invisible. We're omitted" (quoted in Sterritt, 2013, p. 187).

Most of the film is told in flashbacks, and through focusing on a black infantry division Lee does indeed confront the racism of the U.S. military during World War Two. Many of the black characters talk openly to each other about their second-class status in the military, a Nazi radio propagandist taunts the black soldiers about their lack of equality at home, and most of the white commanding officers abuse and disrespect the men, treating them as if their lives are more disposable than whites. However, despite these moments Lee falls short of an oppositional stance on war and militarism in this film.

World War Two is the safe war for filmmakers and historians alike. When representing the battle against Nazism and the Axis powers there is little space for any larger critique of the U.S. military. Since Spielberg's *Saving Private Ryan* (1998) it has become almost requisite for Hollywood war films to include long scenes of horrific battle deaths accompanied by sorrowful elegiac music, and Lee's one war film is no exception to this genre. Many mainstream film critics simplistically equate the graphic representation of the agony of death

on the battlefield as a coherent statement against war itself. *Saving Private Ryan* was thus hailed as an anti-war film even as it celebrated the heroism of the U.S. military. But as one reviewer put it:

> *Saving Private Ryan* is not an anti-war film as such, nor did it try to be. Spielberg does not question the morality of war because this might question the morality of the Second World War. One could sympathise with this view, but really few, with the exception of some right-wing loonies and the odd revisionist historian, would seriously claim that the war against Hitler et al. was an enterprise that should not have been undertaken (Voykovic, 1998).

The same can be said of *Miracle at St. Anna*. While Lee does offer criticism of the U.S. military's racial practices of the past, he offers no larger critique of the use of military force or of war itself. This is not surprising considering Lee's advertising for the U.S. Navy. But even Lee's focus on racism in the military is diluted by the World War Two timeframe. By choosing to tell a story of the 1940s Lee misses the chance to confront contemporary racism in the military, including the targeting of young people of color by recruiters, a practice with which Lee himself has been complicit.

Miracle at St. Anna ends up being a remarkably conservative film with an endorsement of the power of faith and miracles, life-saving interventions by an angelic ghost, many light-hearted comic scenes even during the violence of wartime, and not one but two uplifting and contrived happy endings. *Miracle at St. Anna* also continues Lee's longstanding representations of women as untrustworthy and deceptive and once again depicts interracial romance as purely lust-driven attraction, doomed to failure.

Despite the critical and box office disappointments of *Miracle at St. Anna*, Lee collaborated again with the writer James McBride in scripting his next film, *Red Hook Summer* (2012), a film that at first glance seems to reflect Lee's desire to return to his earlier successes. Set in the heat of summer in his beloved Brooklyn, *Red Hook Summer* even includes a cameo from Lee once again as Mookie, the protagonist of *Do the Right Thing* (1989). And, like *She's Gotta Have It* (1986), it was shot in a concentrated time period, in this case just 18 days, on a low budget (Leitch, 2012).

Like many of Lee's earlier films, *Red Hook Summer* shows Lee's obvious love and compassion for the people he grew up with. As such, for long stretches it functions as a paean to Brooklyn and a loving portrayal of the centrality of the church in the black community. But *Red Hook Summer* is in some ways two films in one. Like *Do the Right Thing*, along the way the film takes a

turn into conflict and violence. Whereas in *Do the Right Thing*, the bitterness behind the sweetness revolved around racial violence and police brutality, in *Red Hook Summer* Lee takes on a controversial topic he had never dealt with previously in his long career—the hypocrisy of organized religion when it comes to incidents of pedophilia by religious leaders.

Red Hook Summer tells the story of Flik, a thirteen-year-old boy who comes from Atlanta to stay with his preacher grandfather in New York. For the first two-thirds of the film Lee focuses on Flik's alienation from Brooklyn, and his relationships with his grandfather, Enoch, and a young neighborhood girl, Chazz. Enoch is portrayed as a deeply religious, stern but loving, older man. Then the revelation—fifteen years in the past he had molested a twelve-year-old boy in his congregation. His church was complicit in covering up the incident and offering him money to move away. This temporarily becomes the focus of the film as it careens toward a bittersweet ending. Enoch is beaten by a local gang when they find out about the molestation. And then Lee returns to Flik and Chazz as Flik departs at the end of the summer. Life goes on despite the upheaval, much as it does in the world beyond our movie screens. Unlike *Do the Right Thing*, there is no direct portrayal of racism in *Red Hook Summer*, although there is dialogue that represents a type of class-consciousness that has often been absent in Lee's films. At one point a character reflects on the inevitability of the neighborhood struggles: "poor get poorer despite Obama." There are also moments of casual homophobia, a tendency that Lee has defended in the past by arguing that he is reflecting how people actually talk, not endorsing it (Lee and Aftab, 2006).

Critics generally did not embrace *Red Hook Summer*, many of them complaining that the revelation of pedophilia derailed the narrative. Several reviewers wanted the film to be lighter—a safe and nostalgic view of childhood and young romance. Lee, however, once again defied expectations by exploring a sordid aspect of American society and showing how horror and sweetness coexist in all of our communities. One positive reviewer reflected on his own mixed reactions to the almost off-handed way that Lee dealt with the pedophilia:

> As I became infuriated with Lee for not adequately dealing with his movie's radioactive man, I began to wonder why we, as a society, don't adequately deal with ours. Institutions, be they religious or any other, have time and time again discovered child molesters within their ranks, and they far too often respond in the same way: They deny, deflect, sweep the problem where it can't be seen, let the guilty one go free, ignore what's really at stake. In short, they act like Flik and his mother (Lapin, 2012).

Red Hook Summer did not fare well at the box office, bringing in less than 340,000 domestically. In an interview with *Vanity Fair* when the film opened, Lee reflected on the blockbuster mentality in Hollywood that works against small and intimate films like *Red Hook Summer*: "But that type of film, that type of genre, is strangling the creativity of Hollywood films, which are becoming dominated by special effects, again and again and again. They have a little space for other stuff, but the scale has been tipped way too far in the other direction" (quoted in Guerrasio, 2012, no pagination).

Despite his criticism of the blockbuster mentality, Lee's response to this trend has mostly been to ignore it while continuing to make his own type of film. Yet, with *Old Boy* (2013) Lee plunged into the Hollywood action pool once again, releasing a remake of a 2003 South Korean thriller about a man who is held captive in a prison disguised as a hotel room for 20 years without knowing his captor or the motivation behind his imprisonment. When it was first announced that Lee would be reinterpreting *Old Boy* it seemed as if this film might reverse his recent box-office disappointments. It featured fairly big-name Hollywood stars Josh Brolin and Elizabeth Olsen and, in a smaller role, Samuel L. Jackson, who had not worked with Lee for over two decades. It was marketed primarily as an action/revenge film as Joe Doucett, after being mysteriously released by his unknown captor, sets out to find those responsible for his incarceration. Like with *Inside Man* (2006), Lee's involvement was not emphasized, his name appearing in a relatively small font on the film's poster, which noted that *Old Boy* was a "Spike Lee Film," not a "Spike Lee Joint" as his previous movies had been called.

Unlike Lee's earlier films, or even *Inside Man*, it is difficult to discern any larger social or political concerns in *Old Boy*. Whereas in the past Lee had eschewed overly graphic violence and the tendency for Hollywood filmmakers to use violence as a spectacle, *Old Boy* is a supremely violent film, featuring scenes of torture, brutal killing, mob brawls, and stylized martial arts sequences.

During his captivity Joe watches time passing on a television screen in his cell. We see Bill Clinton taking the oath of office, the 9/11 attacks, George Bush declaring "Mission Accomplished" in Iraq, and the election of Barack Obama. Is Lee developing a metaphor here about Americans being held captive by the televised spectacle of political events? No, in the film this is no more than a backdrop, a shorthand indication that many years are passing while Joe languishes in a pseudo-hotel room.

Eventually Joe, plotting revenge, transforms himself into a muscled killing machine, working out feverishly and practicing martial arts moves by

emulating the movies he watches on television. This is not an awakening to a higher spiritual and political consciousness like the prison transformation depicted in *Malcolm X* (1992), this is merely a set-up for the subsequent scenes of absurd violence where Joe uses his newly buff body and murderous skills to destroy dozens of men, and one woman, intent on bringing him down.

In an obvious paean to martial arts films Lee depicts Joe as a killing machine, able to defeat hordes of dangerous men while sadistically enjoying his newfound power to inflict pain. These scenes could come straight from a Quentin Tarantino film, a contemporary filmmaker who Lee had often criticized in the past. While Lee had included many scenes of violence in previous films, *Old Boy* represents the first time in Lee's career that the violence is used primarily as a spectacle, a way to charge up the audience with the vicarious adrenaline rush so common to Hollywood blockbusters.

The late media scholar George Gerbner coined the phrase "happy violence" to critique the way that Hollywood films and television shows have framed violence as thrilling, fun, and enjoyable. While often associated with a stance that was critical of all mediated representations of violence, Gerbner's actual position was more complicated than that:

> Of course, representations of violence are not necessarily undesirable. There is blood in fairy tales, gore in mythology, murder in Shakespeare. Not all violence is alike. In some contexts, violence can be a legitimate and even necessary cultural expression. Individually crafted, historically inspired, sparingly and selectively used expressions of symbolic violence can indicate the tragic costs of deadly compulsions. However, such tragic sense of violence has been swamped by "happy violence" produced on the dramatic assembly line (2003, pp. 342–343).

Prior to *Old Boy* it would have been mostly unfair and inaccurate to categorize the meaningful violence that Lee depicted in films like *Do the Right Thing* (1989), *Malcolm X* (1992), or *25th Hour* (2002), as this sort of "spectacular, even thrilling" (Gerbner, 2003, p. 343) happy violence. Even when violence was crucial to the narrative, like the rape scene in *She's Gotta Have It* (1986), the beatings, assaults, and murders in *Clockers* (1995), the brutal killings of *Summer of Sam* (1999), or even the action-oriented violence of *Inside Man* (2006) to a certain extent, Lee had generally employed violence as a way to engage issues of power, oppression, or social divisiveness. In *Old Boy*, however, the violence has no larger meaning. Here we descend into graphic, in-your-face mediated violence that bears a stronger relationship to Dirty Harry than Hamlet.

What happened to the socially conscious filmmaker, the one who prided himself on resisting the Hollywood pressure to churn out action-oriented,

violent laden blockbusters? Earlier in his career Lee had directly criticized the type of violence he employs in *Old Boy*. Had recent box-office failures led to Lee craving a big splash with a violent blockbuster? Or did studio pressures result in a compromise of his vision? When asked about why he wanted *Old Boy* released as a Spike Lee Film not a Spike Lee Joint, all he would say was "tough business" (Osenlund, 2013). An article on Variety.com noted:

> Lee reportedly cut an hour out of the movie for producers to the director and Brolin's dissatisfaction. The *"Do the Right Thing"* filmmaker even removed his trademark "Spike Lee Joint" for an unfamiliar and more impersonal "Spike Lee Film" during the editing process, in what appears to be another sign of the filmmaker's displeasure (Khatchatourian, 2013, no pagination).

It is evident that the film that was eventually released was not the same film that Lee had shot. Yet, in an interview with Oprah Winfrey aired shortly before *Old Boy's* release, Lee defended the violence of the film while echoing earlier comments: "I really didn't want to make the violence cartoonish, because there's too many things that happen in this country and the NRA hates me already. But I don't want to trivialize the violence so Josh and I were very particular that the violence could not be cartoonish."

Despite Lee's defense, the violence in *Old Boy* is in fact absurd, over-the-top, spectacular, and, yes, cartoonish. But there is also another way to interpret this film. In structure it is very much like a Greek tragedy, including a fall from power and the ravages brought on by both hubris and incest. Prior to his captivity, Joe had been a rapacious businessman, brutal in his dealings with others, vulgar in his habits and style. He loses none of this from his ordeal as his brutality is channeled into revenge, but he does develop an emotional bond for the first time in his life with a young woman who befriends him. Tragically Joe and Marie fall in love and consummate their romance, but Marie is subsequently revealed as Joe's previously unknown daughter, a woman who, without her knowledge, has been raised to be a pawn in an elaborate scheme.

Like Lee's previous film, *Red Hook Summer* (2012), *Old Boy's* shocking conclusion revolves around sexual abuse, as it is revealed that Joe's captor and his sister had themselves been molested by their father as children, and then shamed by Joe who discovers this while they are all at boarding school together. This is the motivation behind the elaborate revenge scheme, to imprison Joe and engineer a situation where Joe would commit incest himself. Like the protagonist in a Greek drama Joe is brought down by this revelation

and willingly returns himself to captivity, the epitome of an institutionalized and broken man who can only find a semblance of peace in the cage that he so desperately had wanted to escape.

Perhaps Lee deserves credit for being the rare eclectic filmmaker who can create challenging, critical, political dramas and documentaries, amusing social commentary comedies, and violent action spectacles. Lee himself has questioned the tendency for critics to view him as a filmmaker who can only play one note. During a 2012 interview on CNN, Lee said: "I don't think about race 24/7, 365...I know I have that reputation but that's not the case. If you look at my films I've done since 1986 everything I've done is not about race relations in this country. I do care about other things."

Lee's point needs to be taken into account, as there is a tendency in American media to pigeonhole black filmmakers. In 2013 controversy arose after a tweet from USA Today identified *The Best Man Holiday* (2013), a film that did not focus on racial issues, as a "race-themed film" only because it featured a primarily black cast. Lee should not be expected to only make films that deal with racial tensions and social inequality. Yet, in trying to understand Lee as a counter-hegemonic filmmaker it still seems like a long road from *Do the Right Thing* (1989) to *Old Boy* (2013). If nothing else, the pressures that Lee gave into with *Old Boy* are indicative of a move away from his earlier passionate resistance to studio interference and toward begrudging compromise with the Hollywood industry.

These compromises, however, failed to pay off economically as *Old Boy* did not attain blockbuster status, falling far short of the earlier financial success of *Inside Man* (2006). Earning less than a million dollars in its opening weekend, according to the website Box Office Mojo, *Old Boy* opened in seventeenth place. It was widely considered to be a flop. The film's distributor, Film District, bears much of the blame for this failure as they did not provide the marketing that would have helped the film find a larger audience. Variety.com reported that *Old Boy* opened at fewer than 600 theaters and that advertising was "all but invisible." By way of comparison, during the same month the superhero film *Thor: The Dark World* (2013) opened in more than 3,800 theatres after receiving saturation advertising for weeks. Critics, for the most part, also tamped down audiences as they were generally unimpressed by *Old Boy*, claiming that it didn't seem to offer viewers anything new and it had little of the look or feel of the Spike Lee auteur style.

Challenge and Incorporation

Thus, taking a chronological perspective on Lee's films suggests that despite some exceptions (*Bamboozled* (2000), *Red Hook Summer* (2012), the documentaries, a few smaller projects like a 2001 television movie about Huey Newton of the Black Panthers and a short film on the contested 2000 presidential election) the films of his first decade are the most exemplary of his status as an alternative filmmaker challenging the mainstream industry. An overview of Lee's career suggests that many of his later films, with the exception of his documentaries, are more representative of mainstream Hollywood narratives and imagery. My review also suggests that the mainstream elements in Lee's films became more pronounced over time as he was increasingly incorporated into America's cultural industries. As Guerrero wrote, even by 1991:

> Lee's films have grown progressively larger in budget, more consonant with industry productions standards and dominant cinema's narrative and visual conventions, more persistent in seeking out the appreciation of a broad popular audience (1991, p. 2).

In an essay in 2000, Lyne posited that *Do the Right Thing*, eleven years in the past at that point, was Lee's last film to present an oppositional ideological perspective: "None of Lee's subsequent films comes anywhere near a radical political vision...*Do the Right Thing* is much more the exception than the rule among Lee's films in its concern with economic oppression" (2000, p. 54). While there have been contrary examples since then, Lyne's overall argument must still be reckoned with.

Certainly by the time of *Inside Man* (2006) criticisms like Guerrero's (1991) and Lyne's (2000) seem prescient, as Lee was given his biggest budget to date to produce what could be seen as a standard action thriller. Yet, as noted above, even *Inside Man* was actually more complicated than many mainstream critics seemed to appreciate, as they rushed to embrace it as an apolitical entertainment. As Harrison-Kahan notes, even in this post-9/11 action film, "Lee maintains a socially conscious approach to filmmaking in his depictions of racial tensions and profiling in a globalized United States...Lee does not back down from exposing the racial and economic rifts that threaten to divide the nation further in the aftermath of tragedy" (2010, p. 41). Commenting on the film's title, Harrison-Kahan notes that Lee himself moved from outsider to insider status in Hollywood, yet she believes Lee, like the film's protagonist, only appears to be an insider in order to subvert the institution he is "hiding" in.

This example stands as a reminder that there continue to be moments in Lee's films that harken back to his earliest days as a challenging presence on the U.S. popular culture scene. For instance, Watkins argues that rather than being solely about the Million Man March, *Get on the Bus* (1996) "was, in reality, an attempt to engage the state of African American men" (2008, p. 144) in the waning years of the 20th century. Lee found little studio interest in this serious and thoughtful film and responded by utilizing independent financing strategies that had served him well in his struggles to create *She's Gotta Have It* and *Malcolm X* (Croal, 1996; Watkins, 2008). *Bamboozled* (2000), meanwhile, deliberately courted controversy and dealt with issues of race and representation in a manner that was so uncompromising that it seemed too challenging for both audiences and many critics. And in his turn to documentary filmmaking Lee has seemed to find a genre that allows his most progressive social and political sensibilities to thrive as *4 Little Girls* (1997), *When the Levees Broke* (2006), and *If God Is Willing and da Creek Don't Rise* (2010) must all be considered important and politically provocative additions to his body of work.

4 Little Girls (1997), for example, represented Lee's first major foray into documentary filmmaking after a decade of controversial fiction films. Critics extensively praised this film which examined the 1963 murder of four black girls in a church bombing in Birmingham, Alabama. Most germane to my point, *4 Little Girls* is not simply a historical documentary. As Acham notes:

> Spike Lee's *4 Little Girls* succeeds in shaking both black and white viewers out of their contemporary apathy to U.S. racial history. Lee moves the viewer between the personal history of the families of the victims and the more recognized, public, political history of Birmingham....A unique part of the film is that it attempts not to portray the girls as symbols but as flesh and blood, which in turn forces the viewer to become reconnected to the past and to have a renewed appreciation for civil rights struggles. Released in 1997, in the midst of bombings of black churches across the United States, the film also reminds viewers that without vigilance we are forced to repeat our past (2008, p. 162).

Similarly, as discussed above, Lee's two Katrina documentaries, *When the Levees Broke* (2006) and *If God Is Willing and da Creek Don't Rise* (2010) are both powerful explorations of the complexities of the race and class inequities revealed by natural and man-made disasters, and governmental and corporate insensitivity to the human suffering these disasters engender (see Klein, 2007 for a trenchant analysis of how governments and corporations profit from, and sometimes deliberately cause, disaster).

In general, though, and despite these exceptions, it is hard to argue that there is no evidence of a mainstreaming slide in Lee's work as his own status in Hollywood has changed over the years. While it is impossible to prove any cause and effect relationship between his involvement in corporate financed media and the mainstreaming tendencies in his films, it is possible to clearly identify a correlation, and there are in fact documented moments when Hollywood studio executives have directly intervened in the content of Lee's films, despite his usual retaining of final cut (Watkins, 1998). At the time of this writing *Old Boy* (2013) is the most recent example of both Lee's attempt to garner mainstream attention and the limitations of independence in Hollywood.

It is also important to reiterate, however, that even in Lee's earliest and most challenging films there are significant signs of conservative ideological positions, particularly in his patriarchal representations of women, his demeaning and stereotypical references to homosexuality and lesbianism, his seeming distrust of interracial romance, and his celebration of consumerism and free-market capitalism. These elements in Lee's films back up Lubiano's (2008) assertion that academic and popular media representations of Lee as an oppositional, radical figure are basically inaccurate. Denzin has offered perhaps the most vehement criticism of Lee as a conservative media force:

> Lee is opposed to miscegenation, is antigay, endorses a compulsory heterosexual identity politics, regards blackness not as a political category, but as a signifier of cultural identity, and does not imagine a new multicultural America based on a new black militancy....His is a conservative aesthetic that appears radical...Lee's films reproduce long-standing black stereotypes. The problems of race are reduced to liberal solutions, solutions that are remarkably conservative: namely more jobs, hard work, no drugs, no guns, and less prejudice. No black power movement here; blacks just need to stay in their place and aspire to the goals of the black middle class (2009, p. 106).

My analysis of Lee's body of work over the decades leads me toward more nuanced conclusions than Denzin allows. I argue that Spike Lee's films do challenge certain traditions and values of mainstream Hollywood cinema, but he should be recognized as a cultural producer who straddles the boundaries between alternative and mainstream ideological stances, while only rarely presenting truly oppositional or counter-hegemonic challenges to the dominant institutions and ideologies of contemporary American society.

The Conservative Tendencies of Media Culture and the Marginalization of Dissenting Voices

Reid has written that, in general, "American popular culture...promotes middle-class individualism and valorizes racist and sexist imagery" (1993, p. 93). My analysis of Lee's films and career generally supports Reid's contention and establishes that even when media culture offers an alternative to mainstream representations it can still perpetuate some of the same norms and standards. Kellner (1995a) argues that even mainstream media have the potential to offer utopian alternatives to dominating practices and hegemonic limitations on social existence. However, the level of dissent that is tolerated within mainstream cultural industries is limited to relatively safe or compromised positions that do not suggest a radical deconstruction of the existing social system. The fact that Lee does not ever really propose counter-hegemonic responses to dominant institutions and practices, and that his films often recreate the same disempowering stereotypes found in more conventional Hollywood films, in many ways explains why he has been able to attain a large measure of success within the mainstream film industry.

One answer to the question of how an oppositional figure like Lee has thrived while relying on primarily mainstream channels (and here is where I agree with Denzin) is that close analysis shows that Lee is not really the oppositional figure that he is often made out to be and that his perspectives are often congruous with, rather than challenging of, dominant practices and ideas. His extensive work in advertising for major corporations and the U.S. military is noted above. In addition, Lee even opened up his own retail establishments in the late 1980s and early 1990s, selling Nike, Gap, Levi's, and other brands for which he had directed commercials (Lee and Aftab, 2006).

Lee has also made himself into one of the most recognizable of modern day filmmakers, not just through appearing in his own films, but through his constant media presence: at New York Knicks games ostentatiously taunting opposing players; courting controversy through provocative attacks on other filmmakers and celebrities like Clint Eastwood, Eddie Murphy, Will Smith, Tyler Perry, and Quentin Tarantino; posting and tweeting attention-grabbing statements on social media platforms. As Guerrero points out: "Lee has been quite adept and successful at feeding off the media attention generated by the controversies surrounding many of his productions. Not incidentally, this high media visibility has greatly contributed to Lee's star persona and public cachet..." (2001, p. 10).

Several media scholars offer a defense of these practices. For example: "the auteur must also personally play the game of commanding attention.... For Spike Lee, typically taking on commercially unfriendly subject matter [as a filmmaker], any capital he can gain is valuable, and cashing in on his notoriety has been a particularly lucrative form of capital" (deWaard, 2009, p. 356). From this perspective Lee is simply doing what he needs to do in order to be able to keep making challenging films. Watkins concurs: "Lee often relies on his public image as a controversial filmmaker to carve out a market niche and attract media publicity" (1998, p. 134). And it is true, as Lamb argues, that Lee "has built a measure of independence—financial and otherwise—that has allowed him to play by his own rules to a far greater extent than many filmmakers of any background...to create projects that might not otherwise have been made...to provide opportunities and heightened visibility for a multicultural cast of artists, filmmakers, students, and vendors" (2009, p. 384). These defenses are reasonable, and I return to them below, and yet they don't fully explain why a supposed radical like Lee displays so many conservative tendencies in his films, or why he is so willing to work for exploitative corporations like Anheuser-Busch, the Gap, or Nike, or as a recruiter for the U.S. Navy.

By way of another example, rather than radical the tendency to downplay class-based oppression in Lee's films (with just a few exceptions) should be seen as consistent with American media culture's general inability to deal with class issues and its tendency to instead encode class inequities within a discourse that is focused on race and racial divisions. In a similar manner, while Lee does explicitly deal with racial inequities in his films, and his reversal of traditional Hollywood stereotypes regarding black deviance and white supremacy does offer a real alternative to much mainstream media culture, he falls short, however, of entirely deconstructing hierarchies of status and power, instead substituting one set of hierarchical norms and standards for another. While this is a first step toward a true challenge of American social inequities, Lee never moves to the next level of proposing a destruction of hierarchical power itself, which would represent a truly dissenting, oppositional stance.

Thus, the enigma that Lee seems to represent and the oppositional positions that he is thought to embody are primarily indicative of a media constructed radical image that bears only fleeting resemblance to the actual ideological fabric of his films. Even in a film like *Malcolm X* (1992), which focused on one of the most radical opponents of the ideological status quo in U.S. history, "a number of factors indicate that *Malcolm X* was packaged, released, and marketed as a potential blockbuster" (Watkins, 1998, p. 129).

Watkins (1998) points out that *Malcolm X* was specifically shaped for a PG-13 rating, a large number of promotional tie-in products were created for the film, and it was given the type of widespread distribution that is normally reserved for blockbusters. These decisions inevitably influenced the ideological content of the film:

> [O]ne of the main criticisms of the film charged that the representation of Malcolm X was intentionally diluted and made nonthreatening...Lee's decision to make an epic biographical picture made it even more difficult to deal with the intricacies of Malcolm X's life and times. The dominant narrative structure of the biopic, by nature, tends to elevate historical figures over historical context, thus presenting historical struggle as a conflict between Herculean male individuals (Watkins, 1998, pp. 129–130).

The case of *Malcolm X* is just one example of conservative trends in Lee's collaborations with the mainstream American film industry. I discussed many others in the preceding chapters. So, if Lee is not the radical figure that both popular and academic observers of media culture have drawn him to be, what are the consequences of this type of misreading and misrepresentation? Lubiano nails down the answer to this inquiry when he writes:

> The problem of Spike Lee's "sample," his place in the sun, is that his presence, empowered by Hollywood studio hegemony and media consensus on his importance, can function to overshadow or make difficult other kinds of politically engaged cultural work, not because it is impossible for more than one African American filmmaker to get attention at a time, but because of the implications and manifestations of the attention given to his work (2008, p. 32).

One of the implications of the media attention to which Lubiano refers is that constructing Lee as a radical filmmaker serves to marginalize filmmakers who present more avant-garde or politically oppositional work, while simultaneously legitimizing mainstream Hollywood cinema as a site of free and open debate where "all" voices are free to participate. Thus, the media's tendency to pigeonhole Lee as a political radical simply because he is a black filmmaker who sometimes makes politically engaged films that are somewhat aesthetically different than mainstream Hollywood productions, results in other filmmakers, such as Charles Burnett, Julie Dash, Rodney Evans, Kevin Everson, Haile Gerima, Barbara McCullough, or Bill Woodberry, to name just a few, who represent more of a challenge to the status quo, being relegated so far to the margins of what is culturally acceptable that they virtually vanish from the scene. In the process, the definition of what will be considered legitimate

political stances, artistic perspectives, and issues for social debate becomes sharply limited by the boundaries established by mainstream media institutions who can point to a filmmaker like Lee as an example of how democratic the dominant cultural industry really is.

The ideological positions that are a subtext of the preferred meaning of any cultural text should be visualized not as an either/or opposition (either progressive or reactionary, either left wing or right wing), but rather along an imaginary continuum with infinite space for an infinite number of perspectives. Much of the discourse on and about Spike Lee, however, tends to close down, rather than open up, the possibilities for diversity and debate in cultural expression.

In closing, a few final but important points should be made regarding Spike Lee as a cultural producer. Although I adopt a basically critical position that deliberately seeks to uncover the hegemonic aspects of Lee's films, it is important to note that Lee must still be recognized as an important artist and a deeply creative filmmaker whose films, even at their most conventional, still represent a much-needed alternative to the standard Hollywood fare. Gabbard argues that Lee "cannot be expected to survive in the American film industry without making some accommodations with global capital. Nevertheless, he has consistently taken chances in his films, and he is not afraid to experiment at the edges of the Hollywood style" (2008, p. 185).

Through his willingness to address complicated and controversial social themes, and his unflinching demands for respect from an industry that has a long tradition of treating ethnic minorities with disrespect, Lee has pushed at least some elements of Hollywood in a progressive direction. For example, in their discussion of Lee's representations of black masculinity Elise and Umoja write:

> Lee's depictions of black men differ sharply from the images cast by Hollywood. He presents men who inhabit a sexual universe. Released from the celibacy to which they have been confined, they now revel in their sexuality. They have been freed to develop relationships with black women...Lee presents black men in all of their humanity, complete with weaknesses and strengths. He abandons the one-dimensional presentations of the black man as a macho hero, eunuch sidekick, amoral pimp/hustler/thug, and the buffoon. Lee's black man does not exist as the aberrant vision of the white man; he exists for himself, his woman/women, and his community (2009, pp. 298–299).

This reimagining was no small feat in an industry that has historically erased or pathologized black men. More generally, while it is a mistake to interpret

historical events as merely the outcome of individual decisions and actions, Lee's influence on the Hollywood film industry over the last generation should not be ignored. What Rhines has called the "Spike Lee phenomenon" (1996, p. 77) forced the American film industry to take black filmmakers more seriously and expanded the possibilities for mainstream filmmakers to present nuanced and sensitive examinations of important social issues. And Lee has actively worked throughout his career to open Hollywood doors for blacks in a wide range of positions:

> Lee is not satisfied with putting blacks on the screen; he is a vocal advocate for getting blacks jobs behind the scenes as well. He stipulates in his contracts—whether for movies or commercials—that blacks be hired, often in capacities that have not been available to them previously. He insists, for instance, that black artists do the posters for his movies and he has built a loyal repertory company of actors and crew, some of whom have been with him since his days as a student filmmaker (Mitchell, 2002, p. 36)

It would be a serious error to claim that racism and discrimination in the American film industry have been eliminated in the wake of Lee's, and other black filmmakers', successes, just as it is absurd to think that the election of Barack Obama signaled the end of racism in America (Bonilla-Silva, 2014; Wise, 2010). Bobo's (1991) analysis suggests that Lee did not transform the racial dynamics of Hollywood completely or all by himself. However, as one collaborator, Lisa Jones, has said, "I think the most important thing that Spike did was in deciding that he wanted to create an institution. He wanted there to be a legacy. He didn't just get jobs for himself. He allowed a whole generation of young people access to the industry" (quoted in Lee and Aftab, 2006, p. 66).

Regrettably, as Rhines (1996) points out, despite Lee's early impact, black employment in the film industry had taken a step backward by the mid-1990s. While some progress has been made in the ensuing decades, there are still real gaps in how movies by black filmmakers are regarded. For example, in 2007 the American Film Institute listed the greatest films from the first century of American cinema, as determined by polling 1,500 film artists, critics, and historians. Of the one hundred films that appear on this list only one was directed by a black filmmaker, Spike Lee's *Do the Right Thing*, barely cracking the list at #96.

In a 2012 interview with *New York*, Lee didn't disagree when a journalist said "black cinema is worse than it was twenty years ago" (Leitch, p. 102). Lee's response:

There was more variety of subject matter back then. I think it showed more depth to the African American experience...I think there is an audience that would like to see something else. At this moment, those other films have to be made outside the Hollywood studio system. This comes down to the gatekeepers, and I do not think there is going to be any substantial movement until people of color get into these gatekeeper positions of people who have a green-light vote. That is what it comes down to. We do not have a vote, and we are not at the table when it is decided what gets made and what does not get made (quoted in Leitch, 2012, p. 102).

However, it should be noted that in 2013 a front page story in the *New York Times* trumpeted: "Coming Soon: A Breakout Year for Black Films." This article proclaims:

After years of complaint and self-criticism about the shortage of prominent movies by and about black Americans, film companies are poised to release an extraordinary cluster of them across an array of genres in the last five months of 2013 (Cieply, 2013, p. A1).

The author attributes this to both a resurgence of interest in independent filmmakers from major studios and to a growing appreciation of multicultural perspectives on the part of moviegoers. Cieply goes on to say that many black film artists have built a sustainable community and supported one another's efforts even when faced with many years of disinterest from Hollywood.

Of course we have heard this rhetoric about Hollywood's embrace of black filmmakers before: "1991 was the so-called Year of the Black Film. Almost as many films helmed by African Americans were released within those twelve months as had been in all of the previous decade" (Lee and Aftab, 2006, p. 172). Back then, the *New York Times* in a similarly optimistic gesture headlined an article: "They've Gotta Have Us: Hollywood's Black Directors." This seems to be cyclical in Hollywood—proclaiming a new enlightened era and then soon returning to the same patterns of marginalization. Leonard points out that a decade later: "In 2002, Hollywood celebrated the 'end of racism' in the movie industry with awards to Halle Berry, Denzel Washington, and Sidney Poitier. As with America's larger discourse surrounding race, Hollywood insiders and critics alike cited this supposedly historic moment as a sign of America's racial progress" (2006, p. 1). And again, in 2005, several critics declared it a "watershed" year in both black cinema and American history due to several black actors being nominated for Academy Awards (Leonard, 2006).

Thus, whether the latest spate of renewed attention to black filmmakers is really indicative of a transformation, as Cieply (2013) suggests, or just another momentary anomaly remains to be seen. Significantly, while *12 Years a Slave*

won the Academy Award for Best Picture in 2014, black director Steve McQueen was denied the Oscar for Directing. But we should also take note that Lee has already exemplified the notion of shared support and nurturance referenced in the 2013 *Times* article for the past three decades. After the success of his first few films, Lee emerged as a mentor to young filmmakers. Lee calls his film company 40 Acres and a Mule in reference to a failed 1866 Congressional bill that proposed reparations to freed slaves. For Lee:

> The 40 Acres ethos was about more than just making money: Spike wanted to set up programs that would give African American and underprivileged kids opportunities to get professional instruction. Plans were mooted for a summer basketball camp, and Spike inaugurated the 40 Acres Institute, a film program to be taught at the Long Island University campus in Fort Greene...(Lee and Aftab, 2006, p. 130).

And in terms of onscreen content and representation, while my analysis suggests that Lee's films are often not as radical as the mainstream press would suggest, much of his work has brought provocative images and stories to a wide audience. Sterritt argues that Lee's body of work is distinguished by "its continual willingness to raise hard questions and problems confronting contemporary America without claiming to have the illusory solutions and make-believe answers that mainstream media constantly peddle. Lee's pictures are designed to challenge and provoke us, not ease our minds or pacify our emotions" (2013, p. 8).

This is not a statement that could easily be applied to many other mainstream Hollywood filmmakers, which, at the end of the day, is what Lee became. For his many provocative and thoughtful films, his willingness to challenge Hollywood norms and viewer expectations, and his ongoing attempts to fight racial discrimination in the film industry, Lee's films and career deserve much praise even as we ask pointed questions about his ideological positions and his incorporation into the worlds of advertising and corporate filmmaking.

AFTERWORD

In the summer of 2013 Spike Lee was once again trying to raise funds for a new project. This time, however, innovations in digital technology and culture provided him with a new way to generate financial support.

Kickstarter is a web-based platform for crowd-funding, enabling filmmakers, artists, musicians, writers, designers, and others to solicit small donations that can potentially add up to large sums of money. Initially meant for independent artists and non-profit organizations, by 2013 mainstream film producers were using Kickstarter to supplement their studio funding. For the big screen version of a network television series, *Veronica Mars*, for example, producers raised almost six million dollars through Kickstarter, despite the involvement of one of the world's largest media companies, Warner Brothers, as the film's distributor.

Lee started a Kickstarter campaign in 2013 to raise money for an untitled project. Setting a goal of 1.25 million dollars, Lee managed to surpass that, raising over 1.4 million from 6,421 backers. On the Kickstarter website Lee anticipated questions about why an established filmmaker would need donations from fans. Lee posted:

> I'm an Indie Filmmaker and I will always be an Indie Filmmaker. Indie Filmmakers are always in search of financing because their work, their vision sometimes does not

coincide with Studio Pictures. But I do put my own money in my films. I self-financed RED HOOK SUMMER. My fee for MALCOLM X was put back into the budget. The truth is I've been doing KICKSTARTER before there was KICKSTARTER, there was no Internet. Social Media was writing letters, making phone calls, beating the bushes. I'm now using TECHNOLOGY with what I've been doing. I had to do a PRE-KICKSTARTER Campaign to get my first feature SHE'S GOTTA HAVE IT done way back in 1985. The budget was $175,000. I Had to do a PRE-KICK-STARTER Campaign to get MALCOLM X finished in 1991 when the production ran out of money. (http://www.kickstarter.com/projects/spikelee/the-newest-hottest-spike-lee-joint?ref=discovery)

In addition to the ideological and economic tensions in his work and career that have been explored throughout this book, here is still another manifestation of the Spike Lee enigma. Lee insists that he remains an independent filmmaker, a Hollywood outsider who has always needed alternative forms of fundraising. In a 2013 interview on MSNBC film critic David Edelstein seemed to support the outsider framing of Lee, saying "Hollywood doesn't want to do business with him." Yet Lee also makes studio films like *Inside Man* (2006) and *Old Boy* (2013) while continuing to produce advertising for some of the largest corporations in the world. In November 2013, the *New York Times* featured a long story on Lee's career on the front page of the esteemed Sunday Arts and Leisure section (Hill, 2013). Lee cuts a very high profile for an outsider.

Hollywood insider and conservative mini-media-mogul? Anti-establishment, radical, indie filmmaker? Fully incorporated by the system or working as a pseudo-insider to subvert Hollywood norms from the inside? Lee continues to be an enigma.

NOTES

1. Some in fact would say not the modern, but the postmodern world, and point to the media as an elemental part of the transformation from modernity to postmodernity.
2. The Big Eight consisted of the "Big Five" (Paramount, Warner Brothers, 20th-Century Fox, RKO, and MGM) who owned extensive cinema chains, and the "Little Three" (Columbia, Universal, and United Artists), who did not own large chains of theatres but did provide specific types of films to the chains as well as to independent theaters (Ellis, 1992).
3. Exactly how widespread Island's distribution really was is a matter of some dispute. While over 150 prints were circulated to exhibitors nationwide and Lee's journals indicate no dissatisfaction with Island's distribution practices, McMillan (1991) points out that the film initially was only screened in limited theaters in three major urban areas.
4. It should be acknowledged then, that McMillan might have a similar response to my analysis and interpretation of Lee's films.
5. Although, it should be noted that Lee wanted Robert De Niro to play Sal in *Do the Right Thing* and many actors that have appeared in his films have subsequently gone on to achieve star status.
6. Rowland and Strain (1994) first presented this connection to Gates' (1988) explanation of Yoruba myth. Rowland and Strain (1994) introduce Gates' discussion of Yoruba myth in relationship to *Do the Right Thing*, but then move away from this to concentrate on the film's generic resemblance to Greek drama. I contend that the ambiguity of *Do the Right Thing* suggests that the comparison between this film and Yoruba myth is the more compelling of the two frames of analysis.

7. These words that Lee wrote in 1988 seem like a prophetic harbinger of Rodney King's famous quote during the 1992 Los Angeles riots, "Can we all get along?"
8. In a related point, Marable (1992) argues that the film *Malcolm X* similarly elevates the personal aspects of X's life over the political aspects.
9. See Locke (1992) for a discussion of how Lee's film differs from *The Autobiography of Malcolm X*.
10. As Baraka has noted X is a man who once said, "Find a capitalist and you find a bloodsucker!" (Malcolm X, quoted in Baraka, 1992).
11. Coltrane himself was not referencing earthly ardor in this piece of music, whose title is an allusion to his spiritual faith and devotion.
12. Lee, however, has actually been inconsistent in his position on mediated representations of antisocial behavior. He is quoted in Lee and Aftab (2006) as saying: "The alibi that gangsta rap is just reflecting the world we live in is lame. In time, I feel, history will shed light on the damage these gangsta rappers have done to society." This explicit acknowledgement of the power of media images and stories contradicts his own defense of the homophobia represented in his films.
13. Although not in the areas of gender and sexuality where, as noted above, Lee repeatedly reinforces societal and cinematic stereotypes.
14. When it actually came time to send his children to school they did attend private schools, but Lee says that was his wife's decision (Colapinto, 2008).
15. However Watkins (1998) argues that *Jungle Fever* also critiques the black middle class for turning their backs on the struggles of the urban poor.
16. It should be noted that Leonard disagrees with the critique that I offer here. Leonard believes that focusing on Monty allows Lee to make a statement about white privilege because Monty is free on bail and simply told to report to prison at a given hour. Leonard says, "Juxtaposed against *Clockers* (1995) in which Lee shows the unrelenting policing of black youth and inner city communities as part of the war on drugs, the casual treatment of Monty embodies Lee's profound commentary on race in America in the twenty-first century" (2006, p. 193).

REFERENCES

Abrams, J.J. (2011). Transcendence and sublimity in Spike Lee's signature shot. In M.T. Conard (Ed.), *The philosophy of Spike Lee*, pp. 187–199. Lexington, KY: The University Press of Kentucky.
Acham, C. (2008). We shall overcome: Preserving history and memory in *4 Little Girls*. In P.J. Massood (Ed.), The *Spike Lee reader*, pp. 159–174. Philadelphia: Temple University Press.
Adorno, T.W. (1969). Scientific experiences of a European scholar in America. In D. Fleming and B. Bailyn (Eds.) *The intellectual migration: Europe and America*, 1930–1960, pp. 338–370. Cambridge, MA: Harvard University Press.
Alaniz, M.L. and Wilkes, C. (1998). Pro-drinking messages and message environments for young adults: The case of alcohol industry advertising in African American, Latino, and Native American communities. *Journal of Public Health Policy* 19(4), 447–472.
Althusser, L. (1971). *Lenin and philosophy and other essays*. New York: Monthly Review Press.
American Civil Liberties Union (2008). *Soldiers of misfortune: Abusive U.S. military recruitment and failure to protect child soldiers*. http://www.aclu.org/files/pdfs/humanrights/crc_report_20080513.pdf
Ansen, D. (1989, July). Searing, nervy and very honest. *Newsweek*, pp. 65–66.
Ansen, D. (1991, August). The battle for Malcolm X. *Newsweek*, pp. 52–54.
Arndorfer, J. (1997, December). A-B sets $70 million hike in '98 ad spending. *Advertising Age*, p. 68.
A-Salaam, Y. (1989, July 22). Does *Do the Right Thing* have the wrong emphasis? *New Amsterdam News*, pp. 23, 50.

Augarde, T. (1991). *The Oxford dictionary of modern quotations.* Oxford: Oxford University Press.
Auther, J. (1999, May 27). Spike Lee: 'Do the right thing,' join the Navy. *CNN.com* (no pagination). http://www.cnn.com/SHOWBIZ/TV/9905/27/lee.navy/
Babbie, E. (2012). *The practice of social research.* Belmont, CA: Cengage Learning.
Bagdikian, B. (2004). *The new media monopoly.* Boston: Beacon Press.
Baker, H.A., Jr. (1993). Spike Lee and the commerce of culture. In M. Diawara (Ed.) *Black American cinema,* pp. 154–176. London: Routledge.
Balio, T. (1996). Adjusting to the new global economy: Hollywood in the 1990s. In A. Moran (Ed.) *Film policy: International, national and regional perspectives,* pp. 23–38. London: Routledge.
Bambara, T.C. (1993). Reading the signs, empowering the eye: *Daughters of the Dust* and the Black independent cinema movement. In M. Diawara (Ed.), *Black American cinema,* pp. 118–144. London: Routledge.
Bambara, T.C. (2008). Programming with *School Daze.* In P.J. Massood (Ed.), *The Spike Lee reader,* pp. 10–22. Philadelphia: Temple University Press.
Baraka, A. (1992). Malcolm as ideology. In J. Wood (Ed.), *Malcolm X: In our own image,* pp. 18–35. New York: St. Martin's Press.
Baraka, A. (1993). Spike Lee at the movies. In M. Diawara (Ed.), *Black American cinema,* pp. 145–153. London: Routledge.
Barthes, R. (1957). *Mythologies.* Paris: Editions du Seuil.
Barthes, R. (1977). *Image, music, text.* New York: Hill and Wang.
Beckles-Raymond, G. (2011). We can't get off the bus: A commentary on Spike Lee and moral motivation. In M.T. Conard (Ed.), *The philosophy of Spike Lee,* pp. 40–53. Lexington, KY: The University Press of Kentucky.
Bell, D. (1960). *The end of ideology: On the exhaustion of political ideas in the fifties.* New York: Free Press.
Bennett, T. (1982). Theories of the media, theories of society. In M. Gurevitch, T. Bennett, J. Curran, and J. Woollacott (Eds.) *Culture, society and the media,* pp. 30–55. London: Routledge.
Berger, A.A. (1991). *Media analysis techniques.* Newbury Park, CA: Sage.
Berger, A.A. (2012). *Media, myth, and society.* Hampshire, UK: Palgrave Pivot.
Berger, J. (1972). *Ways of seeing.* New York: Penguin.
Bernotas, B. (1993). *Spike Lee: Filmmaker.* Hillside, NJ: Enslow.
Bettig, R.V. and Hall, J.L. (2012). *Big media, big money: Cultural texts and political economics* (second edition). Lanham, MD: Rowman and Littlefield.
Black celebs 'bail out' director Spike Lee's *Malcolm X* film project. (1992, June). *Jet,* p. 30.
Blake, R. (1990, September). Black and Blue. *America,* p. 136.
Bobo, J. (1991). "The subject is money": Reconsidering the black film audience as a theoretical paradigm. *Black American Literature Forum* 25 (2), 421–432.
Bogle, D. (1993). *Toms, coons, mulattoes, mammies, and bucks: An interpretive history of Blacks in American films.* New York: Continuum.
Bond, C. (1993). Language, speech, and difference in *Their Eyes Were Watching God.* In Gates, H.L., Jr. and Appiah, K.A. (Eds.), *Zora Neale Hurston: Critical perspectives past and present.* New York: Amistad.

Bonilla-Silva, E. (2014). *Racism without racists: Color-blind racism and racial inequality in contemporary America* (4th edition). Lanham, MD: Rowman and Littlefield.
Bowers, D.L. (1994). Afrocentrism and *Do the Right Thing*. In Brummett, B. *Rhetoric in popular culture*, pp. 199–221. New York: St. Martin's Press.
Boyd, H. (1992). Malcolm after Mecca: Pan-Africanism and the OAAU (Organization of Afro-American Unity). *Cineaste* 19(4), 11–12.
Boyd, T.E. (1991). *It's a black thang: The articulation of African-American cultural discourse*. Unpublished doctoral dissertation, University of Iowa.
Boyd, T. (1992). Popular culture and political empowerment: The Americanization and death of Malcolm X. *Cineaste* 19(4), 12–13.
Brennan, J. (1992, August 10). Exhibs warn Warners about 'X'. *Variety*, pp. 3–4.
Burks, R.E. (1996). Intimations of invisibility: Black women and contemporary Hollywood cinema. In V.T. Berry and C.L. Manning-Miller (Eds.), *Mediated messages and African-American culture*, pp. 24–39. Thousand Oaks: Sage.
Butsch, R. (2015). Reconsidering resistance and incorporation. In G. Dines and J.M. Humez (Eds.) *Gender, race and class in media* (4th edition), pp. 87–98. Thousand Oaks, CA: Sage.
Campbell, C.P. (1995). *Race, myth and the news*. Thousand Oaks, CA: Sage.
Campbell, C.P. and LeDuff, K.M. (2012). Recoding New Orleans: News, race, representation and Spike Lee's *When the Levees Broke*. In C.P. Campbell, K.M. Leduff, C.D. Jenkins, and R.A. Brown (Eds.), *Race and news: Critical perspectives*, pp. 199–218. New York: Routledge.
Campbell, C.P.; Leduff, K.M.; Jenkins, C.D.; and Brown, R.A. (Eds.) (2012). *Race and news: Critical perspectives*. New York: Routledge.
Canby, V. (1989, June 30). Spike Lee tackles racism in *Do the Right Thing*. *New York Times*, sec. 2, p. 18.
Cardullo, B. (1990, Winter). Black and white, in color. *Hudson Review*, 42, 613–620.
Carr, J. (1989, June 25). Spike Lee spotlights race relations. *Boston Globe*.
Cashmore, E. (1992, November). Malcolm X. *New Statesman and Society*, pp. 31–32.
Chambers, I. (1996). Waiting on the end of the world? In D. Morley and K. Chen (Eds.) *Stuart Hall: Critical dialogues in cultural studies*. London: Routledge.
Chase, C. (1989, August). Movies. *Us*, p. 61.
Chidester, P. and Bell, J.S.C. (2009). "Say the right thing": Spike Lee, *Bamboozled*, and the future of satire in a postmodern world. In J.D. Hamlet and R.R. Means Coleman (Eds.), *Fight the power! The Spike Lee reader*, pp. 203–222. New York: Peter Lang.
Chrisman, R. (1990). What is the right thing? Notes on the deconstruction of black ideology. *The Black Scholar*, 53–57.
Christensen, J. (1991). Spike Lee, corporate populist. *Critical Inquiry*, 17(3), 582–595.
Cieply, M. (2013, June 1). Coming soon: A breakout year for black films. *New York Times*, p. A1.
Citron, M. (1988). Women's film production: Going mainstream. In E. Diedre Pribram (Ed.), *Female spectators: Looking at film and television*, pp. 45–63. London: Verso.
Clark, M. (1989, June 30). Lee's "Right Thing" is the real thing. *USA Today*, p. 1D.
Cobb, J.N. and Jackson, J.L. (2009). They hate me: Spike Lee, documentary filmmaking, and Hollywood's "savage slot." In J.D. Hamlet and R.R. Means Coleman (Eds.), *Fight the power! The Spike Lee reader*, pp. 251–269. New York: Peter Lang.

Coe, J. (1996, July). *Get on the Bus. New Statesman,* p. 43.

Colapinto, J. (2008, September 22). Outside man: Spike Lee's celluloid struggles. *New Yorker,* no pagination, http://www.newyorker.com/reporting/2008/09/22/080922fa_fact_colapinto?currentpage=all

Cole, C.L. and Hribar, A. (1995). Celebrity feminism: Nike style, post-Fordism, transcendence, and consumer power. *Sociology of Sport Journal,* 347–369.

Coleman, R.M. and Hamlet, J.D. (2009). Introduction. In J.D. Hamlet and R.R. Means Coleman (Eds.), *Fight the power! The Spike Lee reader,* pp. xix–xxxi. New York: Peter Lang.

Collier, A. (1991, August). Afro American filmmakers growing in number and stature. *Ebony,* pp. 54–55.

Comolli, J. and Narboni, J. (1992). Cinema/ideology/criticism. In G. Mast, M. Cohen, and L. Braudy (Eds.), *Film theory and criticism,* pp. 682–689. New York: Oxford University Press.

Conard, M.T. (2011). Aristotle and MacIntyre on justice in *25th Hour.* In M.T. Conard (Ed.), *The philosophy of Spike Lee,* pp. 26–39. Lexington, KY: The University Press of Kentucky.

Corea, A. (1995). Racism and the American way of life. In J. Downing, A. Mohammadi, and A. Sreberny-Mohammadi (Eds.), *Questioning the media,* pp. 345–361. Thousand Oaks, CA: Sage.

Corliss, R. (1989, July). Hot time in Bed-Stuy tonight. *Time,* p. 62.

Corliss, R. (1991, June). Boyz of new black city. *Time,* pp. 64–66.

Corliss, R. (1992, November). *Malcolm X. Time,* pp. 64–65.

Cripps, T. (1977). *Slow fade to black: The Negro in American film, 1900–1942.* New York: Oxford University Press.

Cripps, T. (1993). *Making movies black: The Hollywood message movie from World War II to the Civil Rights era.* Oxford: Oxford University Press.

Croal, N. (1996, April). Bouncing off the rim: Spike Lee is making a career of near misses. *Newsweek,* p. 75.

Crothers, L. (2013). *Globalization and American popular culture* (third edition). Lanham, MD: Rowman and Littlefield.

Crouch, S. (1989, June 20). Do the race thing: Spike Lee's afro-fascist chic. *Village Voice,* pp. 73–74, 76.

Crowdus, G. and Georgakas, D. (1992). Our film is only a starting point: An interview with Spike Lee. *Cineaste* 19(4), 20–24.

Crowdus G. and Georgakas, D. (2002). Thinking about the power of images: An interview with Spike Lee. In C. Fuchs (Ed.), *Spike Lee interviews,* pp. 202–217. Jackson, MS: University Press of Mississippi.

Cunningham, M.D. (2008). Through the looking glass and over the rainbow: Exploring the fairy tale in Spike Lee's *Crooklyn.* In P.J. Massood (Ed.), The *Spike Lee reader,* pp. 115–127. Philadelphia: Temple University Press.

Davis, Z.I. (1990). Black independent or Hollywood iconoclast? *Cineaste,* 17(4), 36–37.

De Fleur, M.L. and Ball-Rokeach, S. (1982). *Theories of mass communication.* New York: Longman.

Deggans, E. (2012). *Race-baiter: How the media wields dangerous words to divide a nation.* Palgrave Macmillan.

Delgado, R. and Stefancic, J. (2001). *Critical race theory.* New York: NYU Press.

DeLue, R.Z. (2009). Envisioning race in Spike Lee's Bamboozled. In J.D. Hamlet and R.R. Means Coleman (Eds.), Fight the power! The Spike Lee reader, pp. 61–88. New York: Peter Lang.
Denby, D. (1989, June). He's gotta have it. New York, pp. 53–54.
Denzin, N.K. (1991). Images of postmodern society: Social theory and contemporary cinema. London: Sage.
Denzin, N.K. (2009). Spike's place. In J.D. Hamlet and R.R. Means Coleman (Eds.), Fight the power! The Spike Lee reader, pp. 103–125. New York: Peter Lang.
Derrida, J. (1982). Positions. Chicago: University of Chicago Press.
Derrida, J. (1988). Limited, Inc. Evanston, IL: Northwestern University Press.
Desjardins, M. (1995). Cinema and communication. In J. Downing, A. Mohammadi, and A. Sreberny Mohammadi (Eds.) Questioning the media, pp. 394–412. Thousand Oaks, CA: Sage.
deWaard, A. (2009). Joints and jams: Spike Lee as sellebrity auteur. In J.D. Hamlet and R.R. Means Coleman (Eds.), Fight the power! The Spike Lee reader, pp. 345–362. New York: Peter Lang.
Diawara, M. (1993). Black American cinema: The new realism. In M. Diawara (Ed.) Black American cinema, pp. 3–25. London: Routledge.
Dixon, T.L. (2010). Teaching you to love fear: Television news and racial stereotypes in a punishing democracy. In S.J. Hartnett (Ed.) Challenging the prison-industrial complex: Activism, arts, and educational alternatives (pp. 106–123). Urbana, IL: University of Illinois Press.
Downing, J. and Husband, C. (2005). Representing 'race': Racisms, ethnicities, and media. London: Sage.
Durkheim, E. (1933). The division of labor in society. New York: Free Press.
Dyson, M.E. (1992, December). Malcolm X. The Christian Century, pp. 1186–1189.
Dyson, M.E. (1993). Reflecting black: African-American cultural criticism. Minneapolis: University of Minnesota Press.
Dyson, M.E. (1995). Making Malcolm: The myth and meaning of Malcolm X. New York: Oxford University Press.
Eagleton, T. (1991). Ideology. London: Verso.
Elise, S. and Umoja, A. (2009). Spike Lee constructs the new black man: Mo' better. In J.D. Hamlet and R.R. Means Coleman (Eds.), Fight the power! The Spike Lee reader, pp. 287–302. New York: Peter Lang.
Ellis, J. (1992). Visible fictions: Cinema, television, video. London: Routledge.
Elsaesser, T. (1972). Tales of sound and fury: Observations on the family melodrama. In G. Mast, M. Cohen and L. Braudy (Eds.) Film theory and criticism, pp. 512–535. New York: Oxford University Press.
Entman, R. and Rojecki, A. (2000). The black image in the white mind: Media and race in America. Chicago: University of Chicago Press.
Everett, A. (2008). "Spike, don't mess Malcolm up": Courting controversy and control in Malcolm X. In P.J. Massood (Ed.), The Spike Lee reader, pp. 91–114. Philadelphia: Temple University Press.
Ewen, E. and Ewen, S. (2006). Typecasting: On the arts and sciences of human inequality. New York: Seven Stories Press.

Feagin, J.R. and Vera, H. (1995). *White racism*. New York: Routledge.
Ferguson, R. (1998). *Representing 'race': Ideology, identity and the media*. London: Arnold.
Finnegan, E.H. (2011). (Still) fighting the power: Public space and the unspeakable privacy of the Other in *Do the Right Thing*. In M.T. Conard (Ed.), *The philosophy of Spike Lee*, pp. 75–94. Lexington, KY: The University Press of Kentucky.
Fiske, J. (1987). *Television culture*. London: Methuen.
Fiske, J. (1989a). *Reading the popular*. Boston: Unwin Hyman.
Fiske, J. (1989b). *Understanding popular culture*. Boston: Unwin Hyman.
Fiske, J. (1990). *Introduction to communication studies*. London: Routledge.
Fitzgerald, S. (1995, October-November). Spike Lee: Fast forward. *American Visions*, pp. 20–26.
Flory, D. (2008). Race and Black American *film noir: Summer of Sam* as lynching parable. In P.J. Massood (Ed.), *The Spike Lee reader*, pp. 196–211. Philadelphia: Temple University Press.
Flory, D. (2011). *Bamboozled*: Philosophy through blackface. In M.T. Conard (Ed.), *The philosophy of Spike Lee*, pp. 164–183. Lexington, KY: The University Press of Kentucky.
Frank, T. (1997). *The conquest of cool: Business culture, counterculture, and the rise of hip consumerism*. Chicago: University of Chicago Press.
From Oscar Micheaux to Spike Lee: Black America's rich film history. (1993, February). *Ebony*, pp. 154–158.
Frutkin, A. (1995, October 31). Spike speaks. *The Advocate*, pp. 49–50.
Fuchs, C. (2002). Introduction. In C. Fuchs (Ed.), *Spike Lee interviews*, pp. vii–xiv. Jackson, MS: University Press of Mississippi.
Fuentes, A. (2012). *Race, monogamy, and other lies they told you: Busting myths about human nature*. Berkeley, CA: University of California Press.
Future in their past (1992, November). *The Economist*, p. 11.
Gabbard, K. (2008). Spike Lee meets Aaron Copland. In P.J. Massood (Ed.), *The Spike Lee reader*, pp. 175–195. Philadelphia: Temple University Press.
Gandy, O.H., (1998). *Communication and race: A structural perspective*. London: Arnold.
Garnham, N. (1997). Political economy and the practice of cultural studies. In M. Ferguson and P. Golding (Eds.), *Cultural studies in question*, pp. 56–73. London: Sage.
Gates, H.L., Jr. (1988). *The signifying monkey: A theory of Afro-American literary criticism*. New York: Oxford University Press.
Gates, H.L., Jr. (1991). Guess who's not coming to dinner? In S. Lee (Ed.), *Five for Five: The films of Spike Lee*, pp. 163–169. New York: Stewart, Tabori and Chang.
Georgakas, D. (1992). Who will speak for El-Hajj Malik El-Shabazz?: Hagiography and a missing identity in *Malcolm X*. *Cineaste* 19(4), 15–16.
George, N. (1991). *Do the Right Thing*: Film and fury. In S. Lee (Ed.), *Five for Five: The films of Spike Lee*, pp. 77–81. New York: Stewart, Tabori and Chang.
Gerbner, G. (2003). Television violence: At a time of turmoil and terror. In G. Dines and J.M. Humez (Eds.) *Gender, race and class in media* (2nd edition), pp. 339–348. Thousand Oaks, CA: Sage.
Gerstner, D.A. (2008). De Profundis: A love letter from the Inside Man. In P.J. Massood (Ed.), *The Spike Lee reader*, pp. 243–253. Philadelphia: Temple University Press.

Giannetti, L. (2011). *Understanding movies* (12th edition). Boston: Allyn and Bacon.
Giles, J. and Miller, M. (1993, July). A menace has Hollywood seeing double. *Newsweek*, p. 52.
Gilliam, F. and Iyengar, S. (2000). Prime suspects: The impact of local television news on attitudes about crime and race. *American Journal of Political Science 44*, 3, 560–573.
Gilroy, P. (1991, November). Spiking the argument: The role of Spike Lee's cinema in the ethnic politics of the U.S. *Sight and Sound*, pp. 28–30.
Gilroy, P. (1997, August). Million man mouthpiece. *Sight and Sound*, pp. 16–18.
Giroux, H. (2009). *Youth in a suspect society: Democracy or disposability?* New York: Palgrave Macmillan.
Gitlin, T. (1978). Media sociology: The dominant paradigm. *Theory and Society 6*, 205–253.
Gitlin, T. (1980). *The whole world is watching: Mass media in the making and unmaking of the New Left*. Berkeley, CA: University of California Press.
Gitlin, T. (1994). Prime time ideology: The hegemonic process in television entertainment. In H. Newcomb (Ed.), *Television: The critical view*, pp. 516–536. NY: Oxford University Press.
Gitlin, T. (1997). The anti-political populism of cultural studies. In M. Ferguson and P. Golding (Eds.), *Cultural studies in question*, pp. 25–38. London: Sage.
Glassner, B. (2010). *The culture of fear*. New York: Basic Books.
Glicksman, M. (2002a). Lee way. In C. Fuchs (Ed.), *Spike Lee interviews*, pp. 3–12. Jackson, MS: University Press of Mississippi.
Glicksman, M. (2002b). Spike Lee's Bed-Stuy BBQ. In C. Fuchs (Ed.), *Spike Lee interviews*, pp. 13–22. Jackson, MS: University Press of Mississippi.
Golding, P. and Murdock, G. (1996). Culture, communications, and political economy. In J. Curran and M. Gurevitch (Eds.) *Mass media and society*, pp. 11–30. London: Arnold.
Gramsci, A. (1971). *Selections from the prison notebooks*. New York: International Publishers.
Grant, W. (1997). Reflecting the times: *Do the Right Thing* revisited. In M. Reid (Ed.), *Spike Lee's Do the Right Thing*, pp. 16–30. Cambridge: Cambridge University Press.
Gray, H. (1989). Television, black Americans, and the American dream. *Critical Studies in Mass Communication* 1(4), 392–421.
Greenberg, B.S. and Brand, J.E. (1994). Minorities and the mass media: 1970s to 1990s. In J. Bryant and D. Zillman (Eds.) *Media effects: Advances in theory and research*, pp. 273–314. Hillsdale, NJ: Lawrence Erlbaum Associates.
Griffin, N. (1989, August–September). Film: "Do the Right Thing." *Crisis*, pp. 8–9, 48.
Grossberg, L. and Hall, S. (1986). On postmodernism and articulation: An interview with Stuart Hall. *Journal of Communication Inquiry* 10(2), 45–60.
Guerrasio, (2012, August 14). Q&A: Spike Lee on the child-abuse scene in *Red Hook Summer*, his Michael Jackson documentary, and why he's not nervous for Mike Tyson on Broadway. *Vanity Fair.com* (no pagination). http://www.vanityfair.com/online/oscars/2012/08/spike-lee-on-red-hook-summer-michael-jackson-documentary-mike-tyson-broadway
Guerrero, E. (1991). Black film: Mo' better in the '90s. *Black camera* 6(1), pp. 2–3.
Guerrero, E. (1993). *Framing blackness: The African American image in film*. Philadelphia: Temple University Press.
Guerrero, E. (2001). *Do the Right Thing*. London: British Film Institute.

Guerrero, E. (2008). Spike Lee and the fever in the racial jungle. In P.J. Massood (Ed.), The *Spike Lee reader*, pp. 77–90. Philadelphia: Temple University Press.

Hackbarth, D.P., Silvestri, B., and Cosper, W. (1995). Tobacco and alcohol billboards in 50 Chicago neighborhoods: Market segmentation to sell dangerous products to the poor. *Journal of Public Health Policy* 16(2), 213–230.

Hall, S. (1980). Encoding/decoding. In P. Marris and S. Thornham (Eds.) *Media studies*, pp. 41–49. Edinburgh, UK: Edinburgh University Press.

Hall, S. (1982). The rediscovery of 'ideology': Return of the repressed in media studies. In M. Gurevitch, T. Bennett, J. Curran, and J. Woollacott (Eds.), *Culture, society and the media*, pp. 56–90. London: Routledge.

Hall, S. (1992). What is this "black" in black popular culture? In G. Dent (Ed.) *Black popular culture*, pp. 21–33. Seattle: Bay Press.

Hall, S. (2013). The spectacle of the 'other'. In S. Hall, J. Evans, and S. Nixon (Eds.), *Representation*, pp. 215–271. London: Sage.

Hall, S., Critcher, C., Jefferson, T., Clarke, J., and Roberts, B. (1978). *Policing the crisis: 'Mugging', the state, and law and order*. London: Macmillan.

Hardt, H. (1992). *Critical communication studies: Communication, history and theory in America*. London: Routledge.

Hardy, C. (1993, January). Malcolm X. *Christianity and Crisis*, pp. 434–437.

Harris, E.L. (2002). The demystification of Spike Lee. In C. Fuchs (Ed.), *Spike Lee interviews*, pp. 127–138. Jackson, MS: University Press of Mississippi.

Harris, H.E. and Moffitt, K.R. (2009). A critical exploration of African American women through the "Spiked lens." In J.D. Hamlet and R.R. Means Coleman (Eds.), *Fight the power! The Spike Lee reader*, pp. 303–320. New York: Peter Lang.

Harris, K. (2008). Clockers (Spike Lee 1995): Adaptation in black. In P.J. Massood (Ed.), The *Spike Lee reader*, pp. 128–141. Philadelphia: Temple University Press.

Harris, W.A. (2009). Cultural engineering and the films of Spike Lee. In J.D. Hamlet and R.R. Means Coleman (Eds.), *Fight the power! The Spike Lee reader*, pp. 23–40. New York: Peter Lang.

Harrison, B.G. (1992, October). Spike Lee hates your cracker ass. *Esquire*, pp. 132–140.

Harrison-Kahan, L. (2010). Inside *Inside Man*: Spike Lee and post-9/11 entertainment. *Cinema Journal* 50(1), 39–58.

Hart, R.P. (1990). *Modern rhetorical criticism*. Glenview, IL: Scott, Foresman and Company.

Hartnett, S. (1995). Imperial ideologies: Media hysteria, racism, and the addiction to the war on drugs. *Journal of Communication* 45, 161–169.

Haskell, M. (1987). *From reverence to rape: The treatment of women in the movies*. Chicago: University of Chicago Press.

Hill, L. (2013, November 24). Spike Lee, still gliding to success. *New York Times*, p. 1, 14.

Hirschberg, L. (1997, April 20). Spike Lee's 30 seconds. *New York Times Magazine*, pp. 36–39.

Hitting the hot button: Spike Lee: artist who best captured the ethnic experience in America (1990, July). *U.S. News and World Report*, p. 52.

Hoerl, K. (2008). Cinematic jujitsu: Resisting white hegemony through the American dream in Spike Lee's Malcolm X. *Communication Studies* 59(4), 355–370.

Hoffman, K.D. (2011). Feminists and "Freaks": *She's Gotta Have It* and *Girl* 6. In M.T. Conard (Ed.), *The philosophy of Spike Lee*, pp. 106–122. Lexington, KY: The University Press of Kentucky.
Hollywood's black bard. (1992, November). *The Economist*, p. A32.
Hollywood shuffle (1991, March). *The Economist*, p. 87.
Holt, J. and Pitter, R. (2011). The prostitution trap of elite sport in *He Got Game*. In M.T. Conard (Ed.), *The philosophy of Spike Lee*, pp. 15–25. Lexington, KY: The University Press of Kentucky.
hooks, b. (1992a). Male heroes and female sex objects: Sexism in Spike Lee's *Malcolm X. Cineaste* 19(4), 13–16.
hooks, b. (1992b). *Black looks: Race and representation*. Boston: South End Press.
hooks, b. (1993a). The oppositional gaze: Black female spectators. In M. Diawara (Ed.), *Black American cinema*, pp. 288–302. London: Routledge.
hooks, b. (1993b, February). Consumed by images. *Artforum*, pp. 5–6.
hooks, b. (1994a, August). Sorrowful black death is not a hot ticket. *Sight and Sound*, pp. 10–15.
hooks, b. (1994b). *Outlaw culture: Resisting representations*. New York: Routledge.
hooks, b. (1996). *Reel to real: Race, sex and class at the movies*. New York: Routledge.
hooks, b. (2008). "Whose pussy is this": A feminist comment. In P.J. Massood (Ed.), *The Spike Lee reader*, pp. 1–9. Philadelphia: Temple University Press.
Horkheimer, M. (1982). *Critical theory: Selected essays*. New York: Continuum.
Horkheimer, M. and Adorno, T.W. (1972). *Dialectic of enlightenment*. New York: Continuum.
Horne, G. (1993, April). "Myth" and the making of *Malcolm X. American Historical Review*, pp. 440–450.
Hunt, D. (Ed.) (2005). *Channeling blackness: Studies on television and race in America*. New York: Oxford University Press.
Hurston, Z.N. (1995). *Novels and stories*. New York: The Library of America.
Infante, D.A., Rancer, A.S., and Womack, D.F. (2003). *Building communication theory*. Prospect Heights, IL: Waveland Press.
Jacoby, T. (1993, February). Malcolm X. *Commentary*, pp. 27–31.
Jensen, R. (2005). *The heart of whiteness: Confronting race, racism, and white privilege*. San Francisco: City Lights.
Jhally, S. and Lewis, J. (1992). *Enlightened racism: The Cosby Show, audiences, and the myth of the American dream*. Boulder, CO: Westview.
Johnson, B.D. (1991, June). Jungle Fever. *Maclean's*, p. 55.
Johnson, B.D. (1993, January). Malcolm X. *Maclean's*, p. 56.
Johnson, C. (1991). One meaning of Mo' Better Blues. In S. Lee (Ed.), *Five for five: The films of Spike Lee*, pp. 117–124. New York: Stewart, Tabori and Chang.
Johnson, V.E. (1997). Polyphony and cultural expression: Interpreting musical traditions in *Do the Right Thing*. In M. Reid (Ed.), *Spike Lee's Do the Right Thing*. Cambridge: Cambridge University Press.
Jones, J. (1990). In Sal's country. *Cineaste* 17(2), 34–35.
Jones, J. (1992). Spike Lee presents Malcolm X: The new black nationalism. *Cineaste* 19(4), 9–11.

Jones, J. (1993). The construction of black sexuality: Towards normalizing the black cinematic experience. In M. Diawara (Ed.), *Black American cinema*, pp. 247–256. London: Routledge.
Jones, J. (1996). The new ghetto aesthetic. In V.T. Berry and C.L. Manning-Miller (Eds.), *Mediated messages and African-American culture*, pp. 40–51. Thousand Oaks, CA: Sage.
Jones, K. (1997, January-February). Invisible man: Spike Lee. *Film Comment*, pp. 42–48.
Katz, E. and Lazarsfeld, P.F. (1955). *Personal influence: The part played by people in the flow of mass communications.* New York: Free Press.
Kaufman, M.T. (1989, June 25). In a new film, Spike Lee tries to *Do the Right Thing. New York Times*, p. I11, I120.
Kauffmann, S. (1986, September). She's Gotta Have It. *The New Republic*, p. 30.
Kauffmann, S. (1992, December). Malcolm X. *The New Republic*, pp. 26–27.
Kavanagh, J.H. (1990). Ideology. In F. Lentricchia and T. McLaughlin (Eds.), *Critical terms for literary study*, pp. 306–320. Chicago: University of Chicago Press.
Keeling, K. (2009). Passing for human: *Bamboozled* and digital humanism. In J.D. Hamlet and R.R. Means Coleman (Eds.), *Fight the power! The Spike Lee reader*, pp. 191–202. New York: Peter Lang.
Kellner, D. (1995a). *Media culture: Cultural studies, identity and politics between the modern and the postmodern.* London: Routledge.
Kellner, D. (1995b). Advertising and consumer culture. In J. Downing, A. Mohammadi, and A. Sreberny-Mohammadi (Eds.), *Questioning the media*, pp. 329–344. Thousand Oaks, CA: Sage.
Kellner, D. (1997a). Overcoming the divide: Cultural studies and political economy. In M. Ferguson and P. Golding (Eds.), *Cultural studies in question*, pp. 102–120. London: Sage.
Kellner, D. (1997b). Aesthetics, ethics, and politics in the films of Spike Lee. In M.A. Reid (Eds.), *Spike Lee's Do the Right Thing*, pp. 73–106. Cambridge, UK: Cambridge University Press.
Kellner, D. (2010). *Cinema wars: Hollywood film and politics in the Bush-Cheney era.* West Sussex, UK: Wiley-Blackwell.
Kempton, M. (1989, August 3). Spike Lee's self-contempt. *Washington Post*, A27.
Kempton, M. (1989, September). The pizza is burning! *New York Review of Books*, pp. 37–38.
Kennedy, L. (1993, February). Is Malcolm X the right thing? *Sight and Sound*, pp. 6–11.
Kessler, L. (1984). *The dissident press: Alternative journalism in American history.* Beverly Hills, CA: Sage.
Khatchatourian, M. (2013). Box office: Spike Lee's 'Old Boy' a Thanksgiving disaster. *Variety. com* (http://variety.com/2013/film/news/spike-lees-oldboy-looking-like-a-big-fat-turkey-at-thanksgiving-b-o-1200892692/)
Khoury, G. (2002). Big words: An interview with Spike Lee. In C. Fuchs (Ed.), *Spike Lee interviews*, pp. 146–154. Jackson, MS: University Press of Mississippi.
Klawans, S. (1989, July). Do the Right Thing. *The Nation*, pp. 98–100.
Klawans, S. (1992, December). Malcolm X. *The Nation*, pp. 713–716.
Klein, J. (1989, June). Spiked? Dinkins and Do the Right Thing. *New York*, p. 14.
Klein, N. (2007). *The shock doctrine: The rise of disaster capitalism.* New York: Picador.
Kochberg, S. (1996). Cinema as institution. In J. Nelmes (Ed.), *An introduction to film studies*, pp. 7–59. London: Routledge.

Kroll, J. (1989, July). How hot is too hot? The fuse has been lit. *Newsweek*, pp. 64–65.
Lamb, Y.R. (2009). Spike Lee as entrepreneur: Leveraging 40 Acres and a Mule. In J.D. Hamlet and R.R. Means Coleman (Eds.), *Fight the power! The Spike Lee reader*, pp. 383–398. New York: Peter Lang.
Landler, M. (1990, August). Spike Lee does a lot of things right. *Business Week*, pp. 62–63.
Lang, R. (Ed.) (1994). *The Birth of a Nation: D.W. Griffith, director*. New Brunswick, NJ: Rutgers University Press.
Lapin, A. (2012, August 29). Spike wants you to hate him: In defense of *Red Hook Summer*. The Atlantic.com, (no pagination). http://www.theatlantic.com/entertainment/archive/2012/08/spike-lee-wants-you-to-hate-him-in-defense-of-red-hook-summer/261702/
LaRocca, D. (2011). Rethinking the first person: Autobiography, authorship, and the contested self in Malcolm X. In M.T. Conard (Ed.), *The philosophy of Spike Lee*, pp. 215–241. Lexington, KY: The University Press of Kentucky.
Leab, D.J. (1975). *From Sambo to Superspade: The Black experience in motion pictures*. Boston: Houghton Mifflin.
Lee Counters Claim (1992, June). *Jet*, p. 56.
Lee, personal communication, March 9, 1998.
Lee, S. (1987). *Spike Lee's gotta have it: Inside guerrilla filmmaking*. New York: Simon & Schuster.
Lee, S. and Aftab, K. (2006). *Spike Lee: That's my story and I'm sticking to it*. New York: W.W. Norton and Company.
Lee, S. and Jones, L. (1989). *Do the Right Thing: A Spike Lee joint*. New York: Simon and Schuster.
Lee, S. and Wiley, R. (1992). *By any means necessary: The trials and tribulations of the making of Malcolm X*. New York: Hyperion.
Lee, S. and Wiley, R. (1997). *Best seat in the house*. New York: Crown.
Lehman, S. (1991, February). Who will be the next Spike Lee? *Gentlemen's Quarterly*, pp. 69–70.
Leitch, W. (2012, July 16). In conversation: Spike Lee. *New York*, pp. 18–22, 102–103.
Leitch, W. and Grierson, T. (2012, August 10). Vulture ranks all 22 Spike Lee films. *Vulture.com*, no pagination. http://www.vulture.com/2012/08/spike-lee-films-ranked-from-best-to-worst.html
Leland, J. (1991, July). A bad omen for black movies? Audience violence could threaten careers of young directors. *Newsweek*, pp. 48–49.
Leonard, D.J. (2006). *Screens fade to black: Contemporary African American cinema*. Westport, CT: Praeger.
Lester, J. (1992). Black supremacy and anti-semitism: Religion in *Malcolm X*. *Cineaste* 19(4), 16–17.
Levi-Strauss, C. (1968). *Structural anthropology*. London: Allen Lane.
Lichtheim, G. (1967). *The concept of ideology and other essays*. New York: Vintage.
Lindo, D. (2002). Delroy Lindo on Spike Lee. In C. Fuchs (Ed.), *Spike Lee interviews*, pp. 161–177. Jackson, MS: University Press of Mississippi.
Lindroth, C. (1996). Spike Lee and the American tradition. *Literature-Film Quarterly* 24(1), 26–32.
Little, B. (1986, October). Brooklyn's baby mogul, Spike Lee, finds the freedom he's gotta have. *People Weekly*, pp. 67–68.

Locke, J. (1992). Adapting the autobiography: The transformation of Malcolm X. *Cineaste* 19(4), 5–7.
Lowery, S. and De Fleur, M.L. (1983). *Milestones in mass communication research: Media effects.* New York: Longman.
Lubiano, W. (2008). But compared to what?: Reading, realism, representation and essentialism in *School Daze, Do the Right Thing,* and the Spike Lee discourse. In P.J. Massood (Ed.), *The Spike Lee reader*, pp. 30–57. Philadelphia: Temple University Press.
Lukes, S. (1975). *Power: A radical view.* London: Macmillan.
Lyne, W. (2000). No accident: From black power to black box office. *African American Review* 34(1), 39–59.
MacCambridge, M. (1992, May 15). They live truths that sear souls. *Kansas City Star*, H3, H10.
Macek, S. (2006). *Urban nightmares: The media, the right, and the moral panic over the city.* Minneapolis: University of Minnesota Press.
Madden, L. (2012, December 5). Spike Lee is still the best Nike Jordan Brand Pitchman. *Forbes.com*, no pagination. http://www.forbes.com/sites/lancemadden/2012/12/05/spike-lee-is-still-the-best-nike-jordan-brand-pitchman/
Madison, K.J. (1999). Legitimation crisis and containment: The "anti-racist white hero" film. *Critical Studies in Mass Communication* 16 (4), 399–416.
Malveaux, J. (1991, September-October). Spike's spite—women at the periphery. *MS.*, pp. 78–81.
Marable, M. (1992). Malcolm as messiah: Cultural myth vs. historical reality in *Malcolm X. Cineaste* 19(4), 7–9.
Marable, M. (2011). *Malcolm X: A life of reinvention.* New York: Penguin.
Marx, A. (1976). *Goldwyn.* New York: W.W. Norton and Company.
Marx, K. (1977). *Capital: Volume one.* New York: Vintage Books.
Marx, K. and Engels, F. (1968). *Selected works.* New York: International Publishers.
Marx, K. and Engels, F. (1981). *The German ideology.* New York: International Publishers.
Masilela, N. (1993). The Los Angeles school of Black filmmakers. In M. Diawara (Ed), *Black American cinema*, pp. 107–117. London: Routledge.
Massood, P. (2008). Introduction: We've gotta have it—Spike Lee, African American film, and cinema studies. In P.J. Massood (Ed.), *The Spike Lee reader*, pp. xv–xxviii. Philadelphia: Temple University Press.
Massood, P. (2009). Which way to the promised land? Spike Lee's *Clockers* and the legacy of the African American city. In J.D. Hamlet and R.R. Means Coleman (Eds.), *Fight the power! The Spike Lee reader*, pp. 171–190. New York: Peter Lang.
Matthews, J. (1989, May 22). The Cannes file: Controversial film for a long hot summer. *Los Angeles Times*, p. 1.
Mauer, M. (1999). *Race to incarcerate.* New York: New Press.
McChesney, R. (2004). *The problem of the media: U.S. communication politics in the twenty-first century.* New York: Monthly Review Press.
McChesney, R. (2013). *Digital disconnect: How capitalism is turning the Internet against democracy.* New York: The New Press.
McDowell, J. (1989, July). He's got to have it his way. *Time*, pp. 92–95.

McGee, M.C. (1998). Fragments of winter: Racial discontents in America, 1992. In C. Corbin (Ed.), *Rhetoric in postmodern America*, pp. 159–188. New York: The Guilford Press.
McGinn, C. (2005). *The power of movies: How screen and mind interact.* NY: Knopf Doubleday.
McGuigan, J. (1992). *Cultural populism.* London: Routledge.
McKelly, J.C. (2008). The double truth, Ruth: *Do the Right Thing* and the culture of ambiguity. In P.J. Massood (Ed.), *The Spike Lee reader*, pp. 58–76. Philadelphia: Temple University Press.
McLane, D. (1989, July). Movies. *Vogue*, p. 77.
McMillan, T. (1991). Thoughts on *She's Gotta Have It.* In S. Lee (Ed.), *Five for five: The films of Spike Lee*, pp. 19–29. New York: Stewart, Tabori and Chang.
McPhail, M.C. (1996). Race and sex in black and white: Essence and ideology in the Spike Lee discourse. *Howard Journal of Communications* 7(2), 127–138.
McQuail, D. (2010). *McQuail's mass communication theory* (6th Edition). London: Sage.
Means Coleman, R.R. and Hamlet, J.D. (2009). Introduction. In J.D. Hamlet and R.R. Means Coleman (Eds.), *Fight the power! The Spike Lee reader*, pp. xix–xxxi. New York: Peter Lang.
Messaris, P. (1993). The polarizing tendency of mass media: Press reviews of *Do the Right Thing*. *Mass Comm Review* 20(3–4), 220–228.
Metz, C. (1974). *Film language: A semiotics of the cinema.* New York: Oxford University Press.
Miller, C. (1992, November). Black filmmakers told to use Spike Lee as a marketing mentor. *Marketing News*, pp. 1–2.
Miller, J.A. (1993). The case of early black cinema. *Critical Studies in Mass Communication* 10(2), 181–184.
Mitchell, E. (2002). Spike Lee: The *Playboy* interview. In C. Fuchs (Ed.), *Spike Lee interviews*, pp. 35–64. Jackson, MS: University Press of Mississippi.
Mitchell, W.J.T. (1990). The violence of public art: *"Do the Right Thing."* *Critical Inquiry* 16(4), 880–899.
Mitchell, W.J.T. (1991). Seeing *Do the Right Thing*. *Critical Inquiry* 17(3), 596–608.
Moon, S. (1997). *Reel black talk: A sourcebook of 50 American filmmakers.* Westport, CT: Greenwood.
Moran, A. (1996). Terms for the reader: Film, Hollywood, national cinema, cultural identity and film policy. In A. Moran (Ed.), *Film policy: International, national and regional perspectives*, pp. 1–19. London: Routledge.
Morrison, M. (1989, August). The world according to Spike Lee. *National Review*, pp. 24–25.
Morrone, J. (1989, September). *Do the Right Thing*. *The New Leader*, pp. 21–22.
Mulvey, L. (1992). Visual pleasure and narrative cinema. In G. Mast, M. Cohen, and L. Braudy (Eds.), *Film theory and criticism*, pp. 746–757. New York: Oxford University Press.
Musser, C. (1990). L-o-v-e and h-a-t-e. *Cineaste* 17(4), 37–38.
Muwakkil, S. (1990). Spike Lee and the image police. *Cineaste* 17(4), 35–36.
Nicholson, D. (1990, February 4). Burden of the black artist. *Kansas City Star*, p. 11.
Norment, L. (1989, October). Spike Lee: The man behind the movies and the controversy. *Ebony*, pp. 140–145.
Norment, L. (1994, May). A revealing look at Spike Lee's changing life. *Ebony*, pp. 28–32.

Nyong'o, T. (2008). Racial kitsch and black performance. In P.J. Massood (Ed.), The *Spike Lee reader*, pp. 212–227. Philadelphia: Temple University Press.
Omi, M. and Winant, H. (1994). *Racial formation in the United States*. New York: Routledge.
Orbe, M.P. and Lyons, A.E. (2009). Father, husband, and social/cultural critic: An afrosemiotic analysis of children's books by Spike and Tonya Lewis Lee. In J.D. Hamlet and R.R. Means Coleman (Eds.), *Fight the power! The Spike Lee reader*, pp. 363–382. New York: Peter Lang.
Orenstein, P. (1989, September). Spike's riot. *Mother Jones*, pp. 32–35, 43–46.
Osenlund, R.K. (2013, November). Interview: Spike Lee. *Slant.com*. (no pagination). http://www.slantmagazine.com/features/article/interview-spike-lee
Page, C. (1989, June 25). Spike Lee's warning about race relations in America. *Chicago Tribune*.
Palmer, R.B. (2011). Monsters and moralism in *Summer of Sam*. In M.T. Conard (Ed.), *The philosophy of Spike Lee*, pp. 54–71. Lexington, KY: The University Press of Kentucky.
Patterson, A. (1992). *Spike Lee*. New York: Avon Books.
Peirce, C.S. (1992). *The essential Peirce: Selected philosophical writings*. Bloomington, IN: Indiana University Press.
Perkins, E. (1990). Renewing the African-American cinema: The films of Spike Lee. *Cineaste* 17(4), 4–8.
Perry, B. (1991). *Malcolm X: The life of a man who changed Black America*. New York: Talman.
Pierson, J. (1995). *Spike, Mike, slackers and dykes: A guided tour across a decade of American independent cinema*. New York: Hyperion.
Pizzello, S. (2002). Between "rock" and a hard place. In C. Fuchs (Ed.), *Spike Lee interviews*, pp. 99–111. Jackson, MS: University Press of Mississippi.
Powell, K. (1991, December). The new nationalists. *Essence*, pp. 58–60.
Powers, S., Rothman, D.J., and Rothman, S. (1996). *Hollywood's America: Social and political themes in motion pictures*. Boulder, CO: Westview.
Premiere of *Malcolm X* rakes in $2.4 million; sets opening day record. (December, 1992). *Jet*, p. 55.
Quart, L. (1992). *Jungle Fever*. Cineaste 19 (4), 99.
Rafferty, T. (1989, July). Open and shut. *The New Yorker*, pp. 78–81.
Reed, A. (1992). The allure of Malcolm X and the changing character of Black politics. In J. Wood (Ed). *Malcolm X: In our own image*, pp. 203–232. New York: St. Martin's Press.
Reed, A. (1993, February). The trouble with X. *Progressive*, pp. 18–19.
Reid, M.A. (1993). *Redefining black film*. Berkeley, CA: University of California Press.
Reid, M.A. (1997). Introduction: The films of Shelton J. Lee. In Reid, M.A. (Ed.), *Spike Lee's Do the Right Thing*, pp. 1–15. Cambridge: University of Cambridge Press.
Reilly, R. (1991, May). He's gotta pitch it: Filmmaker and superfan Spike Lee has thrown some new curves into sports advertising. *Sports Illustrated*, pp. 74–84.
Rhines, J. (1993). Spike Lee, *Malcolm X*, and the money game: The compromises of crossover marketing. *Cineaste* 19(4), 17–18.
Rhines, J.A. (1995). The political economy of black film. *Cineaste* 21(3), 38–40.
Rhines, J.A. (1996). *Black film/white money*. New Brunswick, NJ: Rutgers University Press.
Rhodes, J. (1993). The visibility of race and media history. *Critical Studies in Mass Communication* 10(2), 184–190.

Richolson, J.M. (2002). He's gotta have it: An interview with Spike Lee. In C. Fuchs (Ed.), *Spike Lee interviews*, pp. 25–34. Jackson, MS: University Press of Mississippi.
Riesman, D. (1950). *The lonely crowd*. New Haven, CT: Yale University Press.
Riggins, S.H. (1992). The promise and limits of ethnic minority media. In S.H. Riggins (Ed.) *Ethnic minority media*, pp. 276–288. Newbury Park, CA: Sage.
Right or Wrong? (1989, July). *The Economist*, pp. 88–89.
Robertson, J.O. (1980). *American myth, American reality*. New York: Hill and Wang.
Rodriguez, C. (1996). Shedding useless notions of alternative media. *Peace Review* 8(1), 63–68.
Romeny, J. (1993, March). Malcolm X. *New Statesman & Society*, pp. 34–35.
Rose, T. (2008). *The hip hop wars: What we talk about when we talk about hip hop—and why it matters*. New York: Basic Books.
Rosen, M. (1974). *Popcorn Venus*. New York: Avon Books.
Rosenbaum, J. (1997). *Movies as politics*. Berkeley, CA: University of California Press.
Rowland, R.C. and Strain, R. (1994). Social function, polysemy and narrative-dramatic form: A case study of *Do the Right Thing*. *Communication Quarterly* 42(3), 213–228.
Ryan, M. and Kellner, D. (1988). *Camera politica: The politics and ideology of contemporary Hollywood*. Bloomington, IN: Indiana University Press.
Sarris, A. (1976). Towards a theory of film history. In B. Nichols (ed.), *Movies and methods, volume 1*, pp. 237–250. Berkeley: University of California Press.
Saussure, F. de (1959). *Course in general linguistics*. New York: Philosophical Library.
Scott, E.C. (2009). Sounding Black: Cultural identification, sound, and the films of Spike Lee. In J.D. Hamlet and R.R. Means Coleman (Eds.), *Fight the power! The Spike Lee reader*, pp. 223–250. New York: Peter Lang.
Scott, M.S. (1996, December). Are you ready to invest in the film industry? *Black Enterprise*, pp. 66–71.
Seiter, E. (1992). Semiotics, structuralism, and television. In R.C. Allen (Ed.), *Channels of discourse, reassembled*, pp. 31–66. Chapel Hill, NC: The University of North Carolina Press.
Sender, K. (2004). *Business, not politics: The making of the gay market*. New York: Columbia University Press.
Severin, W.J. and Tankard, J.W. (2000). *Communication theories: Origins, methods, and uses in the mass media*. White Plains, NY: Longman.
Simmonds, F.N. (1988). She's gotta have it: The representation of black female sexuality on film. *Feminist Review* 29, 10–22.
Simmons, R. and Riggs, M. (1992). Sexuality, television, and death: A black gay dialogue on Malcolm X. In J. Woods (Ed.), *Malcolm X: In our own image*, pp. 135–154. New York: St. Martin's Press.
Simon, J. (1991, July). Jungle Fever. *National Review*, pp. 48–49.
Simon, J. (1992, December). Malcolm X. *National Review*, pp. 45–47.
Simpson, J.C. (1992, March). The battle to film Malcolm X. *Time*, p. 71.
Simpson, J.C. (1992, November). The X factor. *Time*, p. 71.
Sklar, R. (1990). What is the right thing? A critical symposium on Spike Lee's *Do the Right Thing*. *Cineaste* 17 (2), 32–33.

Smedley, A. (1993). *Race in North America: Origin and evolution of a worldview.* Boulder, CO: Westview Press.
Smith-Shomade, B.E. (2008). "I be smackin' my hoes": Paradox and authenticity in *Bamboozled*. In P.J. Massood (Ed.), *The Spike Lee reader*, pp. 228–242. Philadelphia: Temple University Press.
Stabile, C. (2000). Nike, social responsibility, and the hidden abode of production. *Critical Studies in Media Communication* 17(2), 186–204.
Stabile, C. (2006). *White victims, black villains: Gender, race, and crime news in U.S. culture.* New York: Routledge.
Stam, R., Burgoyne, R. and Flitterman-Lewis, S. (1992). *New vocabularies in film semiotics: Structuralism, post-structuralism and beyond.* London: Routledge.
Steele, S. (1992, December). Malcolm Little: And big. *The New Republic*, pp. 27–32.
Stephens, R.J. (2009). The aesthetics of *Nommo* in the films of Spike Lee. In J.D. Hamlet and R.R. Means Coleman (Eds.), *Fight the power! The Spike Lee reader*, pp. 3–22. New York: Peter Lang.
Sterritt, D. (2013). *Spike Lee's America.* Cambridge, UK: Polity.
Stevens, M.E. (2009). Subject to countermemory: Disavowal and black manhood in Spike Lee's *Malcolm X*. In J.D. Hamlet and R.R. Means Coleman (Eds.), *Fight the power! The Spike Lee reader*, pp. 321–341. New York: Peter Lang.
Storey, J. (2006). *Cultural theory and popular culture* (Fourth edition). Athens, GA: The University of Georgia Press.
Stroman, C.A., Merritt, B.D., and Matabane, P.W. (1989). Twenty years after Kerner: The portrayal of African Americans on prime-time television. *The Howard Journal of Communications* 2(1), 44–56.
Sundstrom, R.R. (2011). Fevered desires and interracial intimacies in *Jungle Fever*. In M.T. Conard (Ed.), *The philosophy of Spike Lee*, pp. 144–163. Lexington, KY: The University Press of Kentucky.
Tait, R.C. (2009). Politics, class, and allegory in Spike Lee's *Inside Man*. In J.D. Hamlet and R.R. Means Coleman (Eds.), *Fight the power! The Spike Lee reader*, pp. 41–60. New York: Peter Lang.
Taubin, A. (2002). Fear of a black cinema. *Sight and Sound* 12(8), 26–28.
Taylor, C. (1992). The Malcolm ghost in the media machine. *The Black Scholar* 22(4), 37–42.
Tester, K. (1994). *Media, culture and morality.* London: Routledge.
Thomas, L. (1989, August 15). The glorification of self-hatred: Reflections on "doing the right thing." *Carib News*, p. 15.
Thornham, S. (1997). *Passionate detachments: An introduction to feminist film theory.* London: Arnold.
Travers, P. (1986, October). She's gotta have it. *People Weekly*, p. 10.
Turner, G. (2006). *Film as social practice* (4th edition). London: Routledge.
Van Peebles, M. (1991). Right on, as in right on time. In S. Lee (Ed.), *Five for five: The films of Spike Lee*, pp. 6–7. New York: Stewart, Tabori and Chang.
Verniere, J. (2002). Doing the job. In C. Fuchs (Ed.), *Spike Lee interviews*, pp. 79–85. Jackson, MS: University Press of Mississippi.

Voykovic, M. (1998). *Saving Private Ryan*: Review. *Baha'i Studies Review* (8). (no pagination). http://bahai-library.com/voykovic_saving_private_ryan

Wallace, M. (1988, June 4). *She's Gotta Have It* and *School Daze*. *The Nation*, pp. 800–804.

Wallace, M. (1992). *Boyz 'n' the Hood* and *Jungle Fever*. In G. Dent (Ed.), *Black popular culture*, pp. 123–131. Seattle: Bay Press.

Wallace, M. (2008). Spike Lee and Black women. In P.J. Massood (Ed.), *The Spike Lee reader*, pp. 23–29. Philadelphia: Temple University Press.

Watkins, S.C. (1998). *Representing: Hip hop culture and the production of black cinema*. Chicago: University of Chicago Press.

Watkins, S.C. (2008). Reel men: *Get on the Bus* and the shifting terrain of black masculinities. In P.J. Massood (Ed.), *The Spike Lee reader*, pp. 142–158. Philadelphia: Temple University Press.

Watson, R. and Brown, C. (1998, Summer). The 100 best of 100 years. *Newsweek*, pp. 17–21.

Waxman, C.I. (1968). Introduction. In C.I. Waxman (Ed.) *The end of ideology debate*, pp. 3–9. New York: Funk and Wagnalls.

West, C. (1994). *Race matters*. Boston: Beacon Press.

Whitaker, C. (1991, November). Doing the Spike thing. *Ebony*, pp. 82–84.

White, A. (1989, July 12–18). Exiles on Catfish Row. *The City Sun*, p. 13.

White, A. (1991, July). Hollywood fades to black. *Essence*, pp. 47–48.

White, J.E. (1996, October). Black men finance Spike Lee's film about the Million Man March. *Time*, p. 78.

White, M. (1992). Ideological analysis and television. In R.C. Allen (Ed.), *Channels of discourse, reassembled*, pp. 161–202. Chapel Hill, NC: The University of North Carolina Press.

Williams, P. (1992). Clarence X, man of the people. In J. Woods (Ed.), *Malcolm X: In our own image*, pp. 190–202. New York: St. Martin's Press.

Williams, R. (1976). *Keywords: A vocabulary of culture and society*. New York: Oxford University Press.

Williams, R. (1977). *Marxism and literature*. Oxford: Oxford University Press.

Wilson, C.C., Gutierrez, F., and Chao, L.M. (2013). *Racism, sexism, and the media: Multicultural issues into the new communications age*. Los Angeles: Sage.

Wilson, W.J. (1980). *The declining significance of race: Blacks and changing American institutions*. Chicago: University of Chicago Press.

Wilson, W.J. (1987). *The truly disadvantaged: The inner city, the underclass, and public policy*. Chicago: University of Chicago Press.

Wilson, W.J. (2010). *More than just race: Being black and poor in the inner city*. New York: Norton.

Winseck, D. (2008). The state of media ownership and media markets: Competition or concentration and why should we care? *Sociology Compass* 2(1), 34–47.

Wise, T. (2010). *Colorblind: The rise of post-racial politics and the retreat from racial equity*. San Francisco: City Lights.

Wise, T. (2012). *Dear white America: Letter to a new minority*. San Francisco: City Lights.

Wity, S. (1988, Spring). Spike Lee, 'the instigator'. *Life*, p. 100.

Wollen, P. (1972). *Signs and meaning in the cinema*. Bloomington, IN: Indiana University Press.

Wollen, P. (1992). The auteur theory. In G. Mast, M. Cohen, and L. Braudy (Eds.), *Film theory and criticism*, pp. 589–605. New York: Oxford University Press.
Woollacott, J. (1982). Messages and meanings. In M. Gurevitch, T. Bennett, J. Curran, and J. Woollacott (Eds.), *Culture, society and the media*, pp. 91–111. London: Routledge.
X, M. and Haley, A. (1964). *The autobiography of Malcolm X*. New York: Ballantine.
X Marks the Hip. (October, 1992). *People*, p. 87.
Yousman, B. (2003). Blackophilia and blackophobia: White youth, the consumption of rap music, and white supremacy. *Communication Theory* 13(4), 366–391.
Yousman, B. (2005). Beyond *Jungle Fever*: An intertextual analysis of gender, race, and class ideologies in Spike Lee's filmography. In A.A. Tait and G.T. Meiss (Eds.), *Ethnic media in America: Volume 2—Taking control*, pp. 173–193. Dubuque, IA: Kendall and Hunt.
Yousman, B. (2009). *Prime time prisons on U.S. TV: Representation of incarceration*. New York: Peter Lang.

INDEX

4 Little Girls, 163, 204
9/11/01, 54, 188, 194, 199, 203
9 ½ Weeks, 70
12 Years a Slave, 211–212
25th Hour, 119, 159, 163, 165, 188–190, 194, 200
40 Acres and a Mule Filmworks, 212

A

Acham, Christine, 204
Adorno, Theodor, 7, 36–37
afrocentrism, 27–28
Aftab, Kaleem, 75, 160–161, 170, 172, 212, 216
Allen, Woody, 76, 109, 123
Althusser, Louis, 46–49
american dream, the, 155, 169, 180, 192
Amos 'n' Andy, 186
Amistad, 163
Answer, The, 19
anti-semitism, 27, 178
Arrested Development, 141
auteur theory, 4, 20, 34, 47, 56–57, 62, 68, 80, 91, 123, 157, 163, 193, 202, 207
Autobiography of Malcolm X, the, 28, 54, 124–125, 132, 134–140, 143, 145–147, 150, 153, 156, 216
Aykroyd, Dan, 127

B

Bagdikian, Ben, 13
Baldwin, James, 125–126, 132
Bambara, Toni Cade, 23, 159, 177
Bamboozled, 38, 48–49, 163, 166, 169, 172, 185–188, 193, 203–204
Baraka, Amiri, 27, 126, 167–169, 216
Barbershop, 193
Barthes, Roland, 6, 59–60
Basinger, Kim, 101
Batman Returns, 128

Beckles-Raymond, Gabriella, 182
Bell, Jamel Santa Cruze, 187–188
Benioff, David, 188
Bennett, Tony, 47
Berger, Arthur Asa, 58, 60
Berry, Halle, 211
Best Man Holiday, the, 202
Birth of a Nation, 17–19, 151
Birth of a Race, 19
Black Hawk Down, 43
black nationalism, 27, 105, 109–111, 150
Black Panther Party, vii, 203
black power movement, 21, 50, 205
blaxploitation, 18, 21, 179
Blind Side, the, 163
Bobo, Jacqueline, 210
Body Double, 70
Bogle, Donald, 17–19
Bonaparte, Napoleon, 45
Bonfire of the Vanities, 128
Bowers, Detine L., 28
Boyz 'n' the Hood, 30, 127, 179–180
Brawley, Tawana, 61, 110–111
Bringing Down the House, 193
Brolin, Josh, 199, 201
Brown, Jim, 196
Burnett, Charles, 3, 21, 208
Bush, George H. W., 168, 178
Bush, George W., 170 191, 195, 199
Bythewood, Reggie Rock, 182

C

Campbell, Christopher, P., 3–4, 195
Chidester, Phil, 187–188
Cieply, Michael, 211
Clark, Larry, 21
class, viii, 5, 8–9, 25–26, 28–29, 31, 39,
 42, 45–50, 53–54, 58, 103, 114–115,
 117–118, 121, 126, 144, 155–157, 160,
 164, 166–170, 172, 178–179, 190, 193,
 195–196, 198, 204–207, 216
Clinton, Bill, 199

Clockers, 117, 119, 159–160, 163–166, 169,
 179–181, 188, 200, 216
Cobb, Jasmine Nichole, 159, 162, 193
Color Purple, the, 162–163
Coltrane, John, 159, 216
Columbia Pictures, 4–5, 23, 91–92, 125, 215
consumerism, 29, 49, 54, 105, 114, 117,
 177, 205
Cosby, Bill, 16, 129, 141
Cripps, Thomas, 20–21
critical race theory, vii, 34, 52, 56, 58
Crooklyn, 159–160, 165, 168, 178–179
Cry Freedom, 90, 163
cultural studies, 8, 33, 37–44, 46, 55, 58

D

Dash, Julie, 21, 208
Davis, Ossie, 18, 141
DDB Needham Worldwide, 173
Delgado, Richard, 58
DeLue, Rachel Ziady, 186–187
De Niro, Robert, 215
Denzin, Norman, 205–206
Derrida, Jacques, 76, 105
deWaard, Andrew, 14, 57, 170, 174
Diawara, Manthia, 19, 21
Dickerson, Ernest, 179
DiMaggio, Joe, 96
Dirty Dozen, the, 196
Dixon, Ivan, 21
Do the Right Thing, vii, 10, 25, 28–31,
 35–36, 38, 40–41, 43, 47, 49, 56, 61,
 72, 80, 88, 90–121, 124, 129, 141, 159,
 163–164, 166, 168–169, 173, 176–177,
 184, 189–191, 193, 197–198, 200–203,
 210, 215
drug addiction, depiction of, 18, 103, 135,
 146, 151, 153, 164–165, 168–169,
 178–181, 188–189, 205
Durkheim, Emile, 34
Dyson, Michael Eric, 110–111, 143,
 165–166

E

Eagleton, Terry, 45–46, 48
Eastwood, Clint, 196, 206
Edelstein, David, 214
Elise, Sharon, 33, 209
Engels, Fredrich, 45–46
Evans, Rodney, 208
Everson, Kevin, 208

F

Farrakhan, Louis, 137
feminism, viii, 8, 34, 40, 50, 56–58, 75–76, 160
Finnegan, Elizabeth Hope, 90, 101–103, 166, 177
Fiske, John, 7, 41–42, 59
Flags of our Fathers, 196
Flory, Dan, 184–185, 187
Foster, Jodie, 193–194
Frankfurt School of Social Research, 8, 33, 36–39, 41–42, 44
Franklin, Aretha, 141

G

Gabbard, Krin, 171–172, 209
Garnham, Nicholas, 42,
Gates, Henry Louis, 104–105, 215
Genet, Michael, 190
George, Nelson, 25
Gerbner, George, 16, 200
Gerima, Haile, 3, 21, 208
Gerstner, David D., 193
Get on the Bus, 119, 159, 162–163, 166, 181–182, 204
Gewirtz, Russell, 194
Ghosts of Mississippi, 163
Giannetti, Louis, 58, 62–63
Girl 6, 111, 158, 163, 166, 168, 181–182
Gitlin, Todd, 36, 41, 51–52, 54

Glicksman, Marlaine, 75, 162
Glory, 91, 163
Glory Road, 163
Goldwyn, Samuel, 1
Golding, Peter, 42
Gramsci, Antonio, 46, 48–50, 60
Green Mile, the, 163
Griffith, D. W., 17–19, 151
Guerrero, Ed, 24, 28, 47, 59, 89, 91, 102, 116–117, 168, 178, 203, 206
Gunn, Bill, 21

H

Haley, Alex, 28, 54, 124–125, 132, 136, 138–140, 143, 145–147
Hall, Stuart, 17–18, 32, 38–40, 44, 48, 62, 76–77, 105
happy violence, 200
Harris, Heather E., 2
Harris, William A., 75, 158
Harrison-Kahan, Lori, 203
Hart, Roderick, 62
Haskell, Molly, 57–58
Hathaway, Donnie, 141
Havana, 128
hegemony, 44, 48–52, 60, 150, 155, 160, 208
He Got Game, 48, 111, 159, 161, 163, 166, 169, 182–183
Help, the, 163
heteronormativity, see homophobia
Higher Learning, 179
hip-hop, 82, 186
Hoffman, Karen D., 181
Home of the Brave, 196
homophobia, viii, 23, 29, 31, 50, 75, 80–81, 87, 148, 153, 160–161, 191–192, 198, 205, 216
hooks, bell, 29, 31, 44, 75, 78, 160
horizontal integration in film industry, 13
Horkheimer, Max, 7, 36–37
House Party, 22
Hudlin Brothers, 22

Hughes Brothers, 179
Hurricane Katrina, 2, 169, 195–196, 204
Hurston, Zora Neale, 77

I

Ice-T, 30
If God is Willing and Da Creek Don't Rise, 3, 163, 166, 197, 204
Inside Man, 48, 131, 163, 193–195, 199–200, 202–203, 214
interracial romance, depiction of, 28, 59, 61, 110–111, 118–119, 124, 134, 153, 158–159, 165–167, 178, 197, 205
Island Pictures, 23, 67–69, 71, 79, 92, 215

J

Jackson, John L., 159, 162, 193
Jackson, Janet, 129, 141
Jackson, Samuel L., 199
Jewison, Norman, 125–126, 130
JFK, 128–129
Jhally, Sut, 16, 165
Joe's Bed-Stuy Barbershop, 22
Johnson, Magic, 129, 141
Jones, Lisa, 160, 210
Jordan, Michael, 16, 51, 97, 115, 129, 141, 170–171, 173
Juice, 179
Jungle Fever, 28, 59–60, 117, 119, 123–124, 134, 153, 158, 163, 165–170, 178, 181–182, 216
Jurassic Park, 22

K

Keeling, Kara, 187
Kellner, Douglas, 7, 29, 37–38, 40–41, 43–44, 53, 55, 63, 115, 166–167, 206
Khatchatourian, Manne, 201

Khoury, George, 19
Kickstarter, 213–214
King, Martin Luther, Jr., vii, 95–96, 99–100, 107, 113, 116, 141
King, Rodney, 89, 133, 216
Knight, Phil, 171–172
Ku Klux Klan, the, 17, 19, 134, 145, 151

L

Lamb, Yanick Rice, 57, 207
Lang, Robert, 17
LeDuff, Kim L., 2, 195
Lee, Cinque, 179
Lee, Joie, 95, 179
Leonard, David J., 17–19, 51, 186, 192, 211, 216
Letters from Iwo Jima, 196
Levi-Strauss, Claude, 60
Lewis, Justin, 16, 165
Lindo, Delroy, 103
Longest Day, the, 196
Lori-Parks, Suzan, 181
Los Angeles riots, 30, 216
Lubiano, Wahneema, 25, 31–32, 49, 161, 166, 205, 208
Lyne, William, 18, 112, 117–118, 175, 203

M

Malcolm X, vii, 2, 10, 25, 27–28, 30, 38, 41, 43, 55, 111, 117, 119, 121–156, 158, 161, 163–166, 168, 171–173, 178–179, 182, 185, 190, 193, 200, 204, 207–208, 214, 216
male gaze, the, 80, 191
Mandela, Nelson, 141, 143
Marable, Manning, 28, 131, 143, 216
Marley, Bob, vii, 72
Martin, Trayvon, 110
Marxism, viii, 9, 34, 42–43, 45–46, 62
Massood, Paula, 10, 65, 193
mass society theory, 34–35

McBride, James, 197
McCullough, Barbara, 208
McKelly, James C., 116–117, 176
McMillan, Terry, 74
McQueen, Steve, 212
media as myth, 5–7, 60, 81, 104, 143–144, 149, 155–156, 169, 178, 180, 195, 215
media effects theory, 33, 35–36, 44
media saturation, 6–7
Menace II Society, 179–180
Messaris, Paul, 40, 102
Messenger, the, 22, 66–67
Metz, Christian, 58, 60–61
Micheaux, Oscar, 20, 26
Miller, James A., 19–20, 23, 68
Million Man March, 182, 204
Minnelli, Liza, 96
Miracle at St. Anna, 47, 111, 119, 163, 166, 196–197
miscegenation, see interracial romance
misogyny, see sexism
Mississippi Burning, 90, 163
Mitchell, W. J. T., 116
Moffitt, Kimberly R., 2
Mo' Better Blues, 47, 119, 126, 159–160, 163–164, 168, 178–179
Motion Picture Association of America, 70
Muhammad, Elijah, 125, 137–139, 147, 154
Mulvey, Laura, 57
Murdock, Graham, 42
Murphy, Eddie, 166, 206

N

National Film Registry, 10, 56
Nation of Islam, 94, 125, 132, 135–140, 147–151, 154–155
Nichols, Bernard, 21
Night of the Hunter, 113
Nike, viii, 2, 37, 48, 52, 82, 97, 115, 117, 133, 170–174, 176, 206–207
new Hollywood, 13, 69
New Jack City, 179–180

Newton, Huey, 203
New York Knicks, 82, 206
New York Times, The, 74, 173, 186, 211, 214
New York University, 19, 22, 65

O

Obama, Barack, 16, 51–52, 198–199, 210
Old Boy, 70, 158, 161, 199–202, 205, 214
Olsen, Elizabeth, 199
Owen, Clive, 193–194

P

Pacino, Al, 96
Palmer, R. Barton, 185
Paramount Pictures, 92, 215
Parks, Gordon, 18
patriarchy, 8, 23, 29, 39–40, 49, 51, 57–58, 76, 88, 154, 156, 159–160, 177, 179, 192, 205
Patterson, Alex, 111
Patton, 133, 151
Payne Fund studies, 35
Perez, Rosie, 80, 94, 119
Perry, Tyler, 206
Peirce, Charles, S., 59
Poitier, Sidney, 18, 211
political economy of media, 2, 8, 34, 42–44, 55–56, 65, 117
pornography, 7, 75, 181, 191–192
post-racial society, 51–52, 166
Price, Richard, 179
Public Enemy, 80, 94, 108, 117–118
Pursuit of Happyness, 166

R

racism, vii, 5, 8, 16, 27–29, 52, 58, 89–90, 92, 101–104, 107, 117, 121, 132, 150, 162–167, 185–192, 196–198, 210–211
Rambo, 43

Reagan, Ronald, 18, 50, 168, 178
Red Hook Summer, 48, 163, 165, 197–199, 201, 203, 214
Reid, Mark A., 28, 75, 80, 206
Rhines, Jesse, 22, 130, 210
Robertson, James Oliver, 5–6
Rodriguez, Clemencia, 53
Roots, 54
Rosen, Marjorie, 57
Rosenbaum, Jonathan, 15, 25, 125, 146
Rowland, Robert C., 102–104, 215

S

Saussure, Ferdinand de, 59–60
Saving Private Ryan, 196–197
School Daze, 5, 23, 48, 86, 90–93, 108, 116, 119, 124, 158–161, 163, 168–169, 176–177, 181
Scorsese, Martin, 123
Scott, Emmett, J., 19
Scott, Ellen C., 180–181
Seiter, Ellen, 59, 62
semiotics, 34, 56, 58–62, 150
sexism, viii, 18, 23, 29, 31, 57, 67, 75, 78, 154, 158, 160, 177–178, 181, 190, 192, 206
sex, lies, and videotape, 101
Shabazz, Betty, 125–126, 137, 148, 153–154
Sharpton, Al, 110
She Hate Me, 48, 159–160, 168, 190–193
She's Gotta Have It, 1, 10, 22–23, 39–40, 43, 55–88, 90–93, 97, 99, 104, 116, 119, 124, 129, 132, 158, 160–163, 168, 170, 174, 176–177, 181–182, 197, 200, 204, 214
Simpson, Nicole Brown, 110,
Simpson, O.J., 110
Sinatra, Frank, 96, 164
Singleton, John, 22, 30, 127, 179
Smith, Will, 166, 206
Smith-Shomade, Bretta E., 186
Soderbergh, Steven, 101
Soul Plane, 193
Spielberg, Steven, 162, 196–197

Stefancic, Jean, 58
Stephens, Ronald Jemal, 20
Sterritt, David, 1, 27, 185, 189, 212
Strain, Robert, 102–104, 215
Summer of Sam, 49, 119, 160–161, 163, 184–185, 200

T

Tait, R. Colin, 193
Tarantino, Quentin, 200, 206
Terminator, the, 30
Terminator 2, 30
Their Eyes Were Watching God, 77
Thomas, Clarence, 178
Thor: The Dark World, 202
Top Gun, 43
Touchstone Pictures, 92
Townsend, Robert, 22
Trading Places, 166

U

Umoja, Adewole, 33, 209
United States Navy, 2, 47, 173, 197, 207
Universal Studios, 93, 124, 215

V

Van Peebles, Melvin, 21, 26
Van Peebles, Mario, 179
Veronica Mars, 213
vertical integration in film industry, 12–13
Voykovic, Milan, 197

W

Wallace, Michelle, 169, 177
Warner Brothers, 30, 124–125, 127–130, 132, 214–215

war on drugs, the, 181, 188–189, 216
Washington, Denzel, 125, 129, 143,
 146–147, 149, 182, 193–194, 211
Watergate scandal, 191
Watkins, S. Craig, 4, 57, 68, 162, 170, 175,
 204, 207–208, 216
Wayne, John, 196
Wenders, Wim, 101, 107
West, Cornel, 52
West, Kanye, 195
When the Levees Broke, 2–3, 163, 166,
 169–170, 195, 204
white privilege, (see white supremacy)
white supremacy, 43, 50, 51, 58, 150,
 207, 216
Williams, Raymond, 32, 38, 42, 45–46,
 48–50, 157–159
Wilson, William Julius, 167
Winfrey, Oprah, 16–17, 89, 129, 201
Woodberry, Bill, 21, 208
Woods, Tiger, 172

X

X, Malcolm, vii, 41, 72, 95, 96, 99, 100,
 107–108, 112–113, 116, 121–156, 158,
 161, 172, 208, 216

Z

Zero Dark Thirty, 43
Zimmerman, George, 110